THE GLENS OF ANGUS

Jay

[signature]

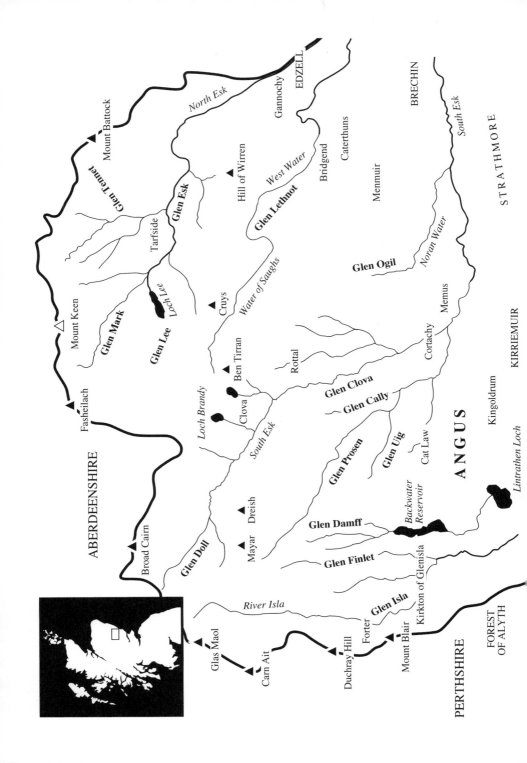

The Glens of Angus

Names, Places, People

DAVID DORWARD

with illustrations by

Colin Gibson

The Pinkfoot Press

Balgavies, Angus

2001

Published in Scotland in 2001
by **The Pinkfoot Press**, Balgavies, Forfar, Angus DD8 2TH
in collaboration with **Angus Council, Cultural Services**

ISBN 1 874012 25 3

Cover
 Detail of 'North Esk, Brig o' Mooran, Autumn' by Allan Ramsay
 Oil on canvas, 1891/2; collection of Montrose Museum
 Photograph by Kim Cessford Studio, Forfar

 © Angus Council

Typset and designed at The Pinkfoot Press
Printed by The Cromwell Press, Trowbridge

Contents

Illustrations

A word about the illustrations. In preparing this study I had been looking forward to the cooperation of Colin Gibson, the Nature Diarist of the Dundee *Courier*, whose knowledge of Angus was unrivalled and whose charming illustrations are still frequently to be seen. On his death in the Spring of 1998 I wrote a letter of condolence to his daughter Gillian and was thrilled to receive a reply to the effect that her father had shortly before his death looked out some drawings from his portfolio for my use. It is a great privilege to have been given Gillian's permission to reproduce some of these, which add considerable interest to the names discussed and greatly enhance the book. Not only that: during my writing and researching I felt more and more the presence at my elbow of the kindly man who had shared with so many of us his knowledge of the countryside. For that reason I preface my Introduction with these words:

In Memoriam Colin Gibson

1 *Colin Gibson 1907 – 1998*

Introduction

If ye've never crossed the Seedlie hills an' looked alang Strathmore
If ye've never seen historic Glamis wi' a' its ancient lore
If ye've never seen the Airlie braes or Cat Law white wi' snaw
If ye've never been tae Kirrie, lad, ye've never lived at a'.

Old Song

Stop at the crest of Carrot Hill or at the top of Lumley Den on a clear day and look north, and you will see a barrier of distant mountains, hazy blue in summer and pure white in winter. Or if like me you live in Fife, make for the Kirkhill of St Andrews and get a wider and more distant panorama. These are the Highlands of Angus, part of the southern Grampian range, and the subject of this book. I remember well the occasion when they first impinged on my consciousness. It was Christmas morning in the year before Hitler's war, and I was a small boy accompanying my father on a car journey to Letham to pick up an elderly relative for the family celebrations. It was a bitterly cold day, with a menacing black sky, and I suddenly caught sight of a range of prodigious white mountains. I have loved them ever since; and, sixty years later, whenever the sky is clear I make for a vantage point near my home in Strathkinness and enjoy them afresh.

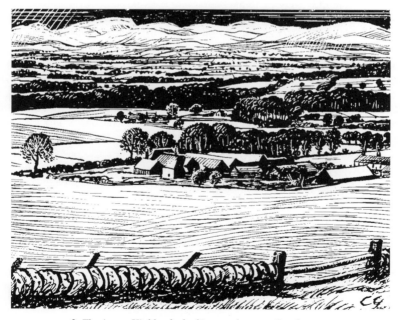

2 *The Angus Highlands, looking north across Strathmore*

1

Closer acquaintance with the landscape, combined with some study of the maps, reveals that of course this mountain massif is more than just a high plateau. It is intersected by what geographers have described as 'a series of deep-gouged trenches'. The three main glens (to revert to a more attractive terminology) are, from west to east, Isla, Clova and Esk. Each is drained by a substantial river – respectively, the Isla, the South Esk and the North Esk, which eventually discharge into the North Sea; and each glen has an important settlement at the point where it debouches into the low country – Alyth, Kirriemuir and Edzell respectively. Each has a castle, to defend the lower glen against marauders from the wilder highlands to the north and west – Forter Castle, in Glen Isla, Cortachy Castle in Glen Clova, and Invermark Castle in Glen Esk. There are numerous lesser valleys, and subsidiary glens branching off the main ones. All the Angus glens have this in common – they lead nowhere. As you make your way upwards, the road gets narrower, the habitation more sparse, the scenery wilder – and eventually you need to get the boots on and the walking-stick out if you are to make the crossing to Mar. The distances are formidable and the public transport at either end virtually nonexistent. But all these are to be counted as advantages. Without through-roads the traffic even at peak holiday periods is light, there are no ski-lifts, no leisure complexes, few caravans or campsites; in short the glens are virtually unspoilt. The down side of this is of course the noticeable depopulation of the countryside; the large numbers of deserted farmhouses, derelict crofts and heaps of stones which were once settlements make the official population statistics all too credible; it is reckoned, for example, that the inhabitants of Glen Esk are less than one-fifth of what they were in 1800. True, there are still plenty of trim-looking houses and crofts in the glens, but very many of them are for summer lets and deserted in winter.

It is a labour of love to study the place-names of the glens, but there is also a sense of urgency. As everyone knows who has ever done toponymic research, local knowledge is one of the most important factors, and there are fewer and fewer old people who are native to north Angus. Reliable information on pronunciation of names is vital in investigating etymologies, and this cannot be obtained from books or from maps. Much local knowledge has been lost and the rate of attrition is speeding up with mortality and migration. There is a vast amount of folklore around which will soon be lost forever unless it is recorded.

Paradoxically, although the Angus glens now have fewer inhabitants than at any time in recorded history, they are frequented by a surprising number of visitors. The shooting lodges may now be underused and the investment in blood sports in jeopardy, but the braes are trodden by hill-walkers in ever-increasing numbers. The car-parks at Tulchan and Braedownie and Invermark are seldom empty, often overflowing; parties of ramblers from Brechin and Forfar may be seen at weekends traversing some of the less-frequented tracks, and the tearooms at The Glenesk Retreat and elsewhere are not short of summer business. People come to the glens for enjoyment and peace and seclusion – which they get in large measure. They may also be interested in the beautiful names which they encounter at every turn, what they mean and how they are pronounced. It is for such people that this book has been written.

The Landscape

'The Glens of Angus' is not an expression that you will see on any modern map, but most inhabitants of the county – and indeed of Scotland – will know exactly what is meant by it. For those who don't, the area covered is the northern part of the County of Angus. Organisationally, it comprises the whole of the parishes of Glenisla, Cortachy and Clova, Lethnot and Navar, Lochlee and the upland parts of Kingoldrum, Kirriemuir, Tannadice and Fern. Most of the terrain is above the 500 foot contour line, rising in the space of a few miles from the Howe of Strathmore to the heights of Glas Maol and Mount Keen, the beginning of the southern Grampians. A useful but old-fashioned term – 'the Braes of Angus' – appears on some ancient maps; an even older one is 'The Mounth', and simply means 'the uplands'.

During the last glaciation (several thousand years ago) the whole of Angus became covered with ice, resulting of course in the destruction of all vegetation and the formation of a totally different landscape. The Grampian peaks were eroded to produce the rounded hills that we see today, and the U-shaped valleys were gouged out to make the familiar Angus glens. The cliffs and the corries (hanging valleys) which are common in the upper slopes of the glens are also the result of glacial action. The most notable characteristic of the landscape is the high plateau that stretches from Glen Shee to Edzell, so vast that a Victorian geologist claimed that 'there is more level ground on the tops of these mountains than in areas of corresponding size in the valleys below'.

In geological terms the terrain with which we are concerned lies beyond the Highland Boundary fault, which in fact amounts to two-fifths of the county of Angus. The Statistical Account of 1791 describes the geology as 'rocks [which] are predominantly mica, schists and gneisses and grits and do not break down into fertile soils: as a result the highland zone is mainly a heather-covered plateau cut into by a series of impressive glens'. Although the heights might be bare the glens were far from being treeless, but lack of roads restricted the value of the extensive timber reserves which existed there; the same Account tells us that 'timber is brought from Norway... because the rugged and impassable rocks prevent its being transported from these places where it grows'. The trees were mainly alder, birch, hazel and willow; with only one plantation of fir (at Cortachy); the extensive conifer forests of the upper glens belong to modern times. The principal sources of fuel were the several 'mosses' consisting of peat, turf and heath, and this is well reflected in such names as **Peathaugh**, **Peat Hill** and **Peat Shank**. An 18th century account tells us that The Mounth 'furnishes the gentlemen whose houses lye in the strath with aboundance of good black hard peats little inferior to coals'.

The real wealth of Angus however lay in the hill pastures 'where oxen, sheep, goats and thousands of unbroken horses are fed, until sold in the fairs at the foot of the mountains'. After the spring ploughing, oxen were 'driven in herds to the Grampian pastures, where they remained until the harvest'. As appears in the Gazetteer (pp. 77–158), many of the place-name elements are descriptive of these historical facts and geographical features.

If this book had been written three centuries earlier it might well have been called 'The Mounth' (a title not calculated to enhance its selling potential). But it is such an important concept in defining the area of study that it deserves mention at this early stage. From the late mediaeval period until modern times the Grampian range was known as 'the Mounth' (with the pronunciation **munth**); and this usage is still to be found in the names of individual summits in the range such as **Mount Blair** and **Monega Hill**. The Mounth was and is the great divide in eastern Scotland: a 12th century charter of William the Lion refers to the burgesses of Aberdeen as dwelling 'to the north of the Mounth'. More important even than the Mounth were the tracks which traverse it; so much so that the term itself came to be applied to these routes – the **Capel Mounth** and the **Tolmount** are two examples. Queen Victoria referred to her route over from Balmoral as 'the Keen Mounth' (a term she must have heard locally) despite the fact that the elegant Mount Keen in its northern aspect is probably the most distinctive summit in Angus. In certain instances Mounth has the specific meaning of a crossing; an example is the Fir Mounth, where there is no reference to a summit. These crossings were just as strategically and commercially important in olden times as was the coastal route by Stonehaven (which was sometimes known as 'Causey Mounth').

The Glens

The three main valleys in Angus – Glen Isla, Glen Clova and Glen Esk – have been noted in the Introduction; all run approximately from northwest to southeast. Of the subsidiary valleys Glen Prosen is perhaps the most notable; but of equal size and importance is the one that is drained by the West Water, which joins the North Esk near Edzell. Everyone in the locality knows this as Glen Lethnot, and it is a picturesque and well-defined Highland glen; but for some reason the Ordnance Survey does not dignify it with a name of any kind. This anomaly is made odder by the fact that the West Water is known in its upper reaches as the 'Water of Saughs', but the river takes a double-bend at Waterhead and undergoes a change of nomenclature in the process. Another curious oddity is that Glen Doll (the most popular tourist spot in the area) is unnamed in most of the early maps, and appears in the Bartholomew series as 'Glen of the White Water'. One normally thinks of the Angus glens as consisting of the main ones of Isla, Clova, Prosen, Esk and Lethnot; but in fact there are over thirty *gleann* names, all belonging to the Gaelic period. Examples range from the long and wide valleys of Mark and Tennet to the short and narrow Glen Effock. (When Dundee Corporation built a new council-house scheme in the King's Cross area in the 1920s, it was decided to name the streets after the Angus glens. This was not at all a daft idea, and certainly lent some beautiful names to the Dundee civic vocabulary; but it had the unintended effect of elevating the importance of some very minor glens, with the result that names such as Glenmarkie, Glenmoy and Glenogil are familiar to thousands of people who would be quite unable to locate the valleys to which they refer. Glenmarkie indeed is a 'lost glen'; and most of Glen Ogil now lies under a reservoir). In addition, a few farms have names like Glenarm and Glenley which appear not to be topographical in origin and probably date from a later period.

4

The term *coire* (the everyday Gaelic word for a cauldron or kettle) can in a toponymic context mean a miniature glen as well as a hollow or hanging valley; there are fully as many *corrie* names as there are glen names in Angus; some of the more familiar ones are Corrie Fee, Winter Corrie and Corrie of Clova all within a short distance of each other. (The Gaelic *coire* as describing a landscape-feature was adopted into the Scots tongue in the 16th century, and it is not always easy to determine whether an Angus place-name embodying this word has a Scots or Gaelic origin.)

The Mountains

Scottish hills over 3000 feet are classified as Munros (after Hugh Munro of Lindertis, who never actually climbed them all). Freestanding hills over 2500 ft are called Corbetts, although the Ordnance Survey's adoption in recent years of the metric system must put these classifications in some jeopardy. The Angus Munros are (in descending order) as follows: **Glas Maol** (3502 ft); **Cairn of Claise** (3484 ft); **Cairn an Tuirc** (3340 ft); **Cairn Bannoch** (3314 ft); **Broad Cairn** (3268 ft); **Creag Leacach** (3238 ft); **Tolmount** (3143 ft); **Tom Buidhe** (3140 ft); **Driesh** (3105 ft); **Mount Keen** (3077 ft); and **Mayar** (3043 ft). A Corbett by definition must have a re-ascent of 500 ft, and their fewness (there are only three in Angus) is no doubt explained by the nature of the plateau: they are: **Ben Tirran** (2942 ft), **Monamenach** (2648 ft), and **Mount Battock** 2554 ft).

It is noticeable that only one of these mountains carries the prefix 'ben', a term which throughout the Highlands usually denotes a dominant and well-defined summit. In fact there is only one other verifiable ben name in Angus – **Ben Reid** (not even a Corbett but, like Ben Tirran, also in Glen Clova). Other apparent 'ben' names, like **Benscravie** and **Bennygray**, are probably masquerading as such; from their topography (both refer to a continuous ridge in Glen Tennet – see **Gazetteer**) – they are likely to represent the Gaelic element *being* or *beingidh* a term meaning bank or ridge (a borrowing from the old Scots term *bink* or *bank*).

As mentioned earlier, the whole of the southeastern Grampian area was known as 'The Mounth', and the term crops up again and again in relation to individual hills such as **Mount Keen**, **Mount Blair**, and **Mount Battock**. The word derives from Gaelic *monadh* meaning a flat-topped ridge and does not imply height (see **Languages** below, p.13).

The characteristic Angus hill-name is *craig* (Gaelic *creag*), denoting a rocky crag-like hill – and there are well over a hundred of them on the map, often with reference to a rock or cliff or precipice. Next common is *cairn* – literally a pile of stones, sometimes just a cairn, but usually a round stony hill: there are about fifty examples often accompanied by an adjective of colour or size.

Tulloch is usually applied to a smaller eminence, and *tom* often refers to a subsidiary summit; the unusual prefix 'Mount' is discussed under the language section. And of course we must not forget the eighty or so eminences designated by the English term hill / hillock; a few of these are pleonastic formations (**Mondurran Hill**, **Tillybuckle Hill**, whose stem comprises a Gaelic word for hill), but most are accompanied by an English adjective of

colour. There are no less than six occurrences of Black Hill in our area, and five of White Hill; very often the remaining element is a settlement name, as in Ascreavie Hill.

There is a notable paucity of *dun* – and *dunadh* – names in the Braes of Angus. The element, meaning a fort-like hill or even a fortress, occurs as a prefix only in Dunlappie in Edzell parish, and as an ending in Braedownie in Clova; Doonies in Glenisla is another example. The spur of a hill is described by the Scots word *shank* ('leg') and there are over twenty such in the Braes of Angus.

Because of the geomorphology, one might expect the term *creag* to occur evenly throughout the Angus glens, and it certainly does; but *carn* is somewhat commoner in Clova and Glenisla than it is in Glenesk and Lethnot. *Tulach* (particularly in its Scots form *tillie*, meaning a hillock, and which usually became a settlement-name) is almost a trademark of the lower glens and is common in Lethnot, Menmuir and Fern as well as in the lower reaches of Glen Esk. *Tom* is a term with similar but more purely topographical meaning, commoner in the western parishes of Glenisla, Cortachy & Clova, and Lintrathen. When we come to a lower elevation we might note that the generic *dal* (a river meadow) is notably less frequent in Glen Lethnot than in the other glens. No doubt it is mainly the topography which has determined the selection of the generic; but a degree of arbitrariness in their distribution might suggest that in the Gaelic-speaking period certain name-giving patterns may have emerged, reflecting more than simply the terrain of the locality in question.

Rivers, Streams and Lochs

For the most part the place-names of Angus are no more than a reflection of the day-to-day lives and occupations of generations of ordinary country-dwellers. The names are therefore, as one would expect, down-to-earth and, in all but a few cases, lacking in imagination. Had these names been devised by an Arts Council committee or chosen by the Scottish Place-name Society they would probably have been rather different: it is unlikely for example that two of the finest rivers in the county should be denoted by the same three-letter word, namely Esk. It is not too difficult to imagine, however, how the existing names evolved.

We tend nowadays, with our classroom-induced knowledge of geography, to think of watercourses lineally, in their progress from source to sea. Thus, the South Esk rises in the Grampians and retains its name until it enters Montrose Basin (although it does not in fact originate in the tarn called Loch Esk). But our early forebears had a different perception. Rivers were places to be settled beside, and even more important to be crossed. And there was no reason why a large stream such as the Water of Saughs shouldn't become the West Water after attaining a suitable size. Indeed it is surprising that this did not happen more frequently with the larger streams as it did with the burns.

It helps if we take a compound name like 'River North Esk' and examine its components. For a start, the term river is an accretion; it is not used in speech but is a convention of the cartographers – probably indeed a translation of the Latin *flumen* which appears in the 16th century maps. Nobody ever talks or talked about the River North Esk.

North and South are merely for differentiation and they might almost equally well have been Black Esk and White Esk (as in Dumfries, or like the Blackadder and Whiteadder in the Borders). The term Esk itself is from primitive Celtic *eiska*, which became Pictish *isca*, Gaelic *easg* and later *uisge* and which basically means water (usually running water – drinking water is normally *burn*). Our Esk recalls other Scottish and English Esks, the Exe in Devon and the Usk in Wales. So, River North Esk indicates merely the northern of two waters; and there is a reminder of this in the surviving name of Northwater Bridge in Kincardineshire, where the river is crossed by the A94. Indeed there is some evidence that the West Water was at one time yet another 'Esk-name' (see note on Esk p.46).

The word *uisge* is one of the commonest Gaelic words, and is the basis (both literally and linguistically) of Scotch 'whisky'. In its Scots/English form 'water' it is frequently found on maps; many of the larger streams are prefixed by the term 'Water', which defines something less than a river but larger than a burn. Thus we have ***Water of Tarf***, ***Water of Saughs***, ***Water of Mark***, ***Water of Lee***, ***Water of Effock***, ***Prosen Water***, ***White Water***, ***West Water***, ***Noran Water***, ***Melgum Water***, and ***Cruick Water***. The interposition of the word 'of' in this class of name seems to be quite arbitrary, and does not indicate the size of the stream, but it perhaps reflects a typical Gaelic word-order.

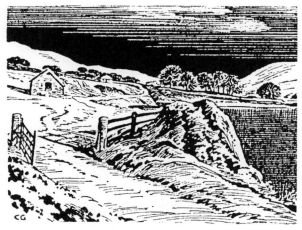

3 *Loch Lee at the top of Glen Esk*

It is similar with the ubiquitous term 'burn', which signifies any smaller watercourse: sometimes we find terms like ***Burn of Longshank***, where the specific involves a hill- or corrie-name. Other examples are ***Burn of Farchal*** and ***Burn of Forbie***. Just as often the formula 'x Burn' is employed, apparently at random – e.g. ***Finlet Burn***, ***Quharity Burn***. Quite frequently the apparently superfluous Gaelic term *allt* (a brook) is incorporated into a name (***Alltanseilich Burn***, ***Altantersie Burn***). But the classic '*allt na* x' construction (so common north and west of The Mounth) is exemplified only in one example on the Ordnance Survey map of Angus; it is in the curiously archaic form of ***Allt na Beinne***

('brook of the hills' – or possibly banks, which occurs twice in Glen Isla). It may be, as has been argued, that 'Burn of x' reflects the Gaelic substratum of this formation, whereas 'x Burn' is a later usage or is even a translation of an earlier Gaelic name. Very often stream-names incorporate the name of a lost settlement (**Minrie**, **Fystie**) and in so doing have prevented such names from vanishing from the map.

The terrain of north Angus is such that there are very few lochs. The largest stretches of water – Loch of Lintrathen and Loch Lee – have been enlarged for the purposes of the public water-supply, and Backwater Dam owes its very existence to this factor. So do the smaller Loch Shandra and Auchintaple Loch. Lochs Brandy and Wharral are typical corrie lochs, and there are numerous tiny mountain tarns which probably do not receive a visit from one year's end to the other. There are areas of the northwest Highlands which have more sizeable lochs in a square dozen miles than has the whole of the Braes of Angus. We make up for it however in spectacular river scenery such as the Rocks of Solitude on the North Esk and Reekie Linn on the Isla, where the river makes a majestic leap over the Highland Boundary Fault.

The Wildlife

We know that in the late 18th century the area abounded in deer, foxes and hares – as it does today – but the place-names reflect this only in a random way. Deer are represented by such names as **Cairn Damff, Craigdamf, Glen Damff, Cordamff** and **Burn of Damff**, which incorporate the Gaelic word for a stag which is *damh* (unfortunately it can also mean an ox, see below). Roe deer (*earb*) appear in **Presnerb**, and **Craig Buck** probably refers to a roebuck. The commonest animal-name is fox – in Gaelic *madaidh* and in Scots *tod*: we have **Cormaud, Corrie Maud, Balmadity** and **Craig Maud**, as well as **Tod Craig, Todhills, Todholes** and **Todstone** (foxes must have been a pest

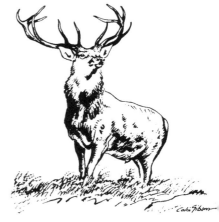

4 *The noblest native of Scotland, a red deer stag in its prime*

throughout recorded history). The Gaelic word *madaidh* can also mean a dog or even a wolf; it is impossible to know which animal is referred to. **Wolf Hill** in Clova is quite explicit, but the two **Dog Hillocks** belong to the post-Gaelic period and doubtless refer to the domestic animal. The records of the Abbey of Coupar Angus show that in the 16th century the tenants of the larger landholdings were bound in their leases to maintain a specified number of dogs (probably wolfhounds) for the destruction of wolves and foxes. Cat names are just as common, both in Gaelic and in Scots (examples are respectively **Corwattie** and **Catstae**). The wild variety is more likely than the domestic moggy; wildcats were said to be numerous at one time around Mount Blair and have recently proliferated in the eastern glens. But note that **Cat Law** probably belongs to a different category of name-giving.

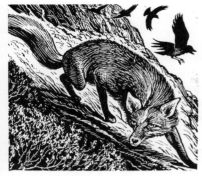

5 *Crows mobbing a fox*

We are also told that in the 17th century the hill pastures of Angus supported 'oxen, sheep, goats and thousands of unbroken horses'; again, the hill names give only meagre evidence of this. The **Water of Tarf** (Gaelic *tarbh*) celebrates not a particular bull but, in its rushing stream, the impetuous qualities of the breed. Horse names occur in **Glen Mark** and **Glenmarkie**; another Gaelic word for horse (*each*) occurs in **Adenaich**, and **Horse Holm** explains itself. We have seen that *damh* can mean both a stag and an ox; since oxen were driven in herds to the mountain pastures from spring ploughing to harvest-time, it is possible that **Craig Damff** and **Cairn Damff** are named after the domestic animal, as is **Oxen Lairs**. Significantly, there are few sheep-names in Gaelic, as these quadrupeds belong to the Scots-speaking period; but there are several ewe-names as in **Ewe Hows** and **Ewe Green**. More common is the pig – in Gaelic *muc*: see **Ashnamuck**, **Mochrie**, **Torrnamuck** and **Dalmochy**. Goat-names (*gobhar* in Gaelic) are represented by **Bada na Goibhre**, **Craigangowan** and **Craigangower**, and the goats in question were almost certainly not domestic ones. Wild goats were quite common until the 1870s, and a few were reported near Loch Lee and up the Water of Unich in the early 20th century.

6 *Wildcat*

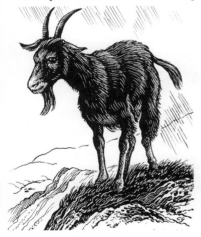

7 *Wild goat*

Bird-names make several appearances, notably the eagle both in Gaelic (**Creag na h-iolaire**) and in Scots (**Erne Craigs**). Other raptors are not represented, but the raven (Gaelic *bran*) is to be found in **Clachnabrain** and **Loch Brandy** (although here the reference may be to the raven-black cliffs). Ptarmigans are referred to in **Tarmach Cairn**, black cocks in **Pullar Cuy**, and pigeons in **Cairn Doos**. The commoner little birds are not deemed worthy of notice although no doubt in mediaeval times they sang as sweetly in the glens as they do now.

Names of cold-blooded creatures occur only sporadically, in **Nathro** (adders, which were common also in the Glen Esk), **Alltvragy** (trout) and **Dalbhraddan** (salmon).

To draw conclusions about wildlife from the evidence of place-names is a hazardous business. We can't infer, for example, that eagles and ptarmigan were common in

9 *Ravens*

Glen Prosen just because they left their names behind – on the contrary it may have been their rarity that made them the distinctive feature of the hills named after them. And there is no point in naming a corrie after a herd of deer when these beasts were to be found in most high valleys. Still, these animal-names, interesting in themselves, do give us a general idea of the fauna of the glens.

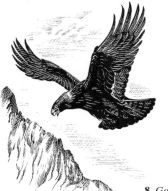

8 *Golden Eagle*

The Vegetation

Place-name evidence in relation to vegetation is somewhat more reliable, since the ecology doesn't change so much over three or four centuries. There are frequent place-name references to the boggy nature of the terrain, and to the type of ground cover: **Auchleuchrie** means a place of rushes in Gaelic, and **Luthrie Burn** is similar; the Scots equivalent is to be found in **Rashiebog** and **Burn of Rashes**. Heath was too common to be a distinguishing characteristic, but the names **Freuchies** and **Freoch** both involve *fraoch*, the Gaelic word for ling and bell heather.

In the drier and milder climate of previous ages the tree-cover was more extensive than now. Trees were able to survive at a level just above the plateau, some five hundred feet higher than at present; and the stumps of ancient conifers can be seen in eroded areas where no tree would now grow. Although there are no traces in the glens of the ancient Caledonian forest (much of which was probably in fact birch) which

10 *Survivors from an earlier pine-forest*

covered large tracts of Scotland, there are a few remains of 17th century forests, which suffered continual depredations from beasts and men (especially during the two world wars). It was only in recent times that systematic replanting began to take place: private forestry schemes have operated in the lower parts of Isla and Prosen for a century, and more recently extensive conifer plantations have been established in Clova. It is generally felt however that the vast and dense forest in Glen Doll has detracted from the openness of the landscape that one remembers from one's youth.

The huge grouse-moors which characterise the area between Glen Clova and Glen Esk and beyond belong (on a geological time-scale) to the modern era. The heather took over from the forests and flourished in the absence of woodland cover. If the decline of grouse-shooting were to cause the practice of moorburn to cease, and if the rewards of sheep-farming were to take a further downturn, there are two possible outcomes: the lower hills and moors would revert to birch scrub, or they would become managed conifer plantations. There are already signs of both of these things happening, particularly in Prosen where some of the older birch woods are extending naturally in parallel with new afforestation schemes. The commonest tree-name is, as you might expect, birch – in Gaelic *beith* and in Scots *birk*; examples are **Balbae**, **Tombay** and **Tombeth**, with **Birkentree** and **Birkhill**. Almost as common is the element *seilich*, meaning willow, which gives **Braeshellach** and **Faschelloch** – not to mention its Scots version in **Water of Saughs**. Hazel (**Cochlie**) and alder (**Fern**) also make their appearance, and berries are represented by **Craig Brawlin** (cranberries) and **Everan Hill** (cloudberries). There are a number of broom-names, which is surprising since that shrub is not widely seen nowadays; the supposition is that broom was grown as a source of fuel in the Scots-speaking period – no broom-names in Gaelic survive. Even more odd is the situation of Scots pine, regarded by Edward (see **The Map Makers**) as a common species in the 17th century; it gives rise to no place-names in the Glens (whereas its Gaelic form of *giubhas* occurs many times in other parts of the Highlands, notably in Kingussie and Dalguise).

Much has been written about the rare Alpine flora of the glens, particularly in the Clova area. Their whereabouts are not advertised and they are now carefully protected in an area of Special Scientific Interest; but a word is in order about the man who first discovered and classified them – George Don of Forfar (1764–1814). Don was a clockmaker and gardener to trade and only an amateur botanist, but his knowledge of the Angus hills was probably better than anybody's before or since. He would be amongst the high tops for weeks on end, living rough, and his discoveries of new species in Scotland were unrivalled by any professional British plant taxonomist. He maintained that the hills of Clova and Doll had more to offer the botanist than any other mountainous part of Scotland.

The Habitations

Settlement was not confined to the more fertile regions, but extended well into the upper glens in areas which would now be considered impossibly remote. In habitation names the generic Gaelic prefix *baile* preponderates; there are over twenty of these, and there

11

must have at one time been many more. *Baile* originally meant an enclosed area of land and ultimately comes from Latin *ballium* meaning a wall; later it came to mean a settlement (sometimes, in the Lowlands, associated with a Norman manor) or even a town (of which there are none in the Angus glens). As might be expected, *baile/bal*-names occur mainly in the river valleys and not on higher ground: examples are **Balfour** and **Balmadity**.

Not quite as common are *achadh* names; although this denotes a field in modern Gaelic, in the Angus glens it often includes the accompanying croft – as in **Acharn**. *Ach/achadh/auch*-names tend to preponderate on higher ground and in the upper valleys: there are none at all in Strathmore and the Mearns.

Dail is less common, and usually indicates a haugh or river-meadow. A prefix which is commoner in Angus than elsewhere is *bad-*, accounting for at least a dozen names. The dictionary meanings of *bad* include 'clump, tuft, thicket'; but on the ground the term has such diverse applications that perhaps 'spot, place' is a safer translation.

In the lower glens the Scots term *toun* often forms the suffix of a settlement (usually a farm) name, almost always modernised or anglicised to 'ton'. Familiar examples are Kirkton, Milton, Midton, and Bogton, sometimes followed by a locational qualifier such as 'of Clova'. Many habitation names go in groups: West, Mid and Easter, or Upper, Middle and Nether, sharing the one proper noun; very often such a formation indicates the break-up of a larger estate.

The Languages

In any place-name study, however rudimentary, the question of language has to be tackled head-on at the outset. Angus is perhaps less complicated than other parts of Scotland but nevertheless has its own particular problems. To put the matter at its simplest, there are three linguistic strata which have to be explored: that of the Picts, the Gaelic-speaking settlers, and the Scots-speaking country folk who inhabited the glens before widespread depopulation occurred in the 19th century.

The Pictish period

Angus (with the Mearns) formed one of the ancient Pictish kingdoms, and there is strong (if largely submerged) evidence of this in the older layers of place-names. Scholars now agree that the Picts must have spoken a form of P-Celtic that is akin to modern Welsh. Few written memorials survive, but it is possible to learn something of this race from the Welsh-sounding place-name elements that are to be found in the middle portion of eastern Scotland which formed historic Pictland. These elements include *aber* (a river-mouth or confluence), *cardden* (woodland), *caer* (a fort), *par* (a piece of land) and *pren* (a tree): examples of these in and around Angus can be found in the names *Aberlemno*, *Kincardine*, *Carmyllie* and *Kinpurnie*. In our particular area of the glens we can also instance *mig* – a bog (**Migvie**, in Glen Esk), *ochil* – high (**Glenogil**), *pant* – a hollow (**Pandewan** in Glen Mark), *preas* – a thicket (**Pearsie**) and *pevr* – fair, radiant (**Paphrie Burn** in Lethnot). The only apparent *aber* name in the Glens (**Abernethan Well**) looks suspiciously like a reduction of Gaelic *tobar* (see **Gazetteer**, p.78).

The most characteristic names associated with the Picts have the prefix *pit-* (meaning a piece or division of land); oddly enough there are only four *pit*-names in our area – **Pitcarity**, **Pitewan**, **Pitlochrie** and **Pitmudie** – which is very strange, since there are at least two dozen in the whole of Angus, and archaeological remains give evidence of heavy Pictish settlement in the county. It may be that the Pictish settlers grabbed the best of the lowland sites, which are to the south of our area of study.

Pictish loan-words into Gaelic are somewhat more numerous, particularly *bad* – a place (**Badadaroch**), *dail / dol* – a field or haugh (**Dalvanie**, **Glen Doll**), *por* – a pasture (**Balfour**) and *mynnyd* – upland, hill (see below for examples).

Perhaps the most pervasive term from the Pictish period, and particularly relevant to the present study, is *mynnyd* (which has been mentioned earlier under its later form of Mounth); *mynnyd* is cognate with the Latin *mons* and passed into Gaelic as *monadh*, with the meaning of 'flat-topped mountain range' or high moorland (which exactly describes north Angus) or even sometimes an upland grazing. It is still found in the Monadhliath and Monadhruadh ranges (the latter now better known as the Cairngorms). The strong association of 'mounth' with its near-homonym in English ('mount') unfortunately meant that the map-makers used that spelling of the term, so we now have the grandiosely-named **Mount Een** and **Mount Sned** which, in mountaineering parlance, do not even rank as Corbetts.

The Gaelic Period

As a matter of history, Pictland was officially subsumed into Kenneth MacAlpin's Scottish kingdom in 848. It is likely that long before then the Scots settlers from Ireland had already begun to migrate eastwards from Argyll bringing their Gaelic language with them, and by the 12th century the whole of rural Angus must have been Gaelic-speaking. Independently of historical records, the place-name evidence tells the same story: Gaelic terms such as *glen*, *loch*, *craig* and *cairn* abound, and can be said to predominate in the glens of Angus. Indeed these words have passed into the vocabulary of most Scots and are not normally thought of as Gaelic. Less familiar are place-name elements such as *ach* or *achadh* (a field), *allt* (a stream), *baile* (a farmtown), *bad* (a thicket), *coire* (a corrie or hanging valley) *ceann/kin* (a head), *dal* (a stance) and *inch* (a field); although they may not occur in ordinary Scots speech, these elements are nevertheless the basis of very many of the place-names in the area. Random examples of each are: **Auchrannie**; **Auldallan**; **Balfour**; **Badandun**; **Corriedoune**; **Kingoldrum**; **Dalbrack**; and **Inchgrundle**.

Gaelic as a written language was rarely if ever current in the glens. As far as one can make out, spoken Gaelic began to die out in Angus before the 17th century, and probably long before then in the towns and on the southern fringe of the county: it survived somewhat longer in the glens, and some of the place-names are illustrative of this fact. The OS maps of Glen Clova and Glen Isla contain names that can be found in any Gaelic dictionary: **Creag an Fhithich**, **Sron Riabhach** and **Cnoc na Cailliche** are examples. The drawback is that since there have been no native Gaelic-speakers in these parts for over two centuries it is almost impossible to know how the names were pronounced (and there is probably no inhabitant of the glens today who would venture a 'correct' Gaelic pronunciation).

There is further evidence that Gaelic lingered longer in the western glens of Isla, Prosen and Clova than in the eastern ones of Lethnot and Esk. An example of this is to be found in the distribution of the terms *sron* and *shank*: both of these words describe the same sort of landform, namely a projecting part of a hill separate from the main summit (*sron* being Gaelic for nose and *shank* being Scots for leg). All of the dozen or so *sron/strone* names in the **Gazetteer** occur in the western glens, and all but two of the similarly-numbered *shank*-names are in the eastern ones.

The Scots-speaking Country Folk

Gaelic died out gradually and naturally, and the older Gaelic-speakers kept much of their native vocabulary. Gaelic place-name elements were retained, but often with a Scots twist. Gaelic *allt* would become Scots *auld* (**Auld Darkney**) and *monadh uidh* appears as **Manywee**. The Scots versions just as often bear no linguistic relation to their Gaelic originals, and the inference is that they were by the 19th century ceasing to be understood. This can result in pleonastic formations such as occur in **Hill of Mondurran** and **Burn of Fasheilach** where the term for hill or burn has unwittingly been duplicated. A prize example is **Burn of Adiedazzle** which sounds like a new soap-powder but is in fact an

14

accurate phonetic rendering of the Gaelic words *alltain deasail*; it simply mean 'south-flowing stream', and consequently the 'burn' prefix is unnecessary

However, one of the joys of this survey has been the discovery of old Scots words which are the basis of place-names. Already mentioned is *shank* (literally a leg, but in place-names the downward spur of a hill); another example is *grain*, which means a side glen or branch streamlet, and *latch* a bog-stream. *Hare* in Scots can mean hoary, so a name like **Hare Cairn** may not have animal connections. *Sneck* (a notch) is a Scots word still in common use and so possibly is *glack* (a hollow); Scots terms for animals and plants have already been noted. In general it may be said that Scots-speakers in the glens are becoming almost as rare as Gaelic-speakers, and we should be grateful that some at least of the diminishing Scots vocabulary is preserved in place-names.

A word of caution – the language-situation is not quite so simple as I have described. It would be a mistake to think that the Picts (wherever they came from and whenever they arrived) entered upon an empty landscape. There is some archaeological evidence of earlier settlements dating from the Neolithic period onwards, and these must have had names although none have survived. It is fairly certain however that the names of the major rivers (Isla and Esk) were already current; and indeed scholars believe that these pre-Celtic names expressed simple concepts of 'wet' or 'flowing'. At the other end of the time-scale, we have to reckon with the influx of English names into the Scottish landscape, although they have made no significant penetration into the Angus glens. Some recently-built houses have been given contrived names, and possible examples of creative name-giving from a slightly earlier period are **Craigisla** (a Victorian country estate) and **Noranside** (one of HM prisons).

Decline of Gaelic

From earliest times there has been in official circles a strong prejudice against the Gaelic language: in 1498 the Spanish ambassador to the Court of James IV described it as 'the language of savages who live in some parts of Scotland'. This attitude persisted in some quarters until well into the 20th century.

When did Gaelic die out in the Angus glens? The answer must be, at different times in different places, and starting as always with younger generations; in other words, gradually and sporadically. We know from several 15th century boundary-charters that the Scots language was beginning to make inroads into official usage and that Gaelic was retreating to rural areas up the glens. So, to take a snapshot date of 1600, it seems likely that the inhabitants of the Angus glens, like those of neighbouring parts of Perthshire and Aberdeenshire, were still solidly Gaelic-speaking. There are scraps of historical information which confirm this – for example, in 1618 an Englishman named Taylor (see p.29) 'lay one night at an Irish (Highland) house in Glen Esk where the people could speak scarcely any English'; and a century later this would probably have still been the case. We are told that 'in 1683 in Glenshie the Minister always preaches in the afternoons in the Irish (Gaelic) tongue', with the inference however that he was bilingual. But Ochterlonie, writing in 1684 says that 'Irish is not their native language, for none speak

Irish there except strangers that come from other parts' (which seems to hint that Gaelic was still understood if not always spoken). Presbytery returns show Glen Isla as still predominantly Gaelic in 1705, but by the end of the century 'there is hardly a word of Earse now spoken', the language having given way to Lowland Scots. By the later 18th century the evidence of the disappearance of Gaelic is fairly conclusive; in connection with the Eastmiln murder trial in Glenisla in the 1760s it was mentioned that a washerwoman had been engaged whose distinguishing feature was that she 'could speak nothing but Gaelic'. And by this time the preaching in the glen was exclusively in English.

The place-name evidence corroborates this approximate time-scale, but occasionally points to a somewhat earlier date for the intrusion of English. Timothy Pont in the 1580s records a settlement in the wilds of Glen Clova with the thoroughly Anglo-Saxon name of 'Whytemyre'; and Edward's map of Angus (1678) contains numerous Scots/English terms in its more northerly section ('Black Hill', 'West Water', 'Long Drum'); and some of the Gaelic names ('Krandrit', 'Krich') are more mercilessly anglicised than they were two and a half centuries later when the more erudite map-makers of the Ordnance Survey moved in.

It seems that Gaelic died out much sooner in the Angus glens than in neighbouring Highland Perthshire and Aberdeenshire. One has only to compare Edward's map with Robertson's map of Kirkmichael and Glenshee (c1650) to see that the retreat of Gaelic in Angus was much more rapid than in the glens immediately to the west. Some of us indeed can remember from our childhood meeting native Gaelic-speakers from Strathtay and Braemar who were able to correct our mispronunciations of local place-names; but the last native speaker of Angus Gaelic died long before anyone can remember. The motto of the Glenisla Highland Games is impressive – *Clann na Gaidheal, ri guallibh a cheile* ('Highlanders, stand shoulder to shoulder') – but it probably belongs to the 19th century (the games were first held in 1865) and should not be taken as evidence of a late outcrop of vernacular Gaelic in the glens.

History, Archaeology and Landownership

As in other parts of Scotland, very few Angus places take their names from persons. In the glens we have some references to the shadowy St Drostan, whose abode by tradition was in Glen Esk (see **Droustie**, and elsewhere in the **Gazetteer**); and in Tannadice parish there is a hill called after a nonexistent **St Arnold** (it should really be 'St Ernan's Seat'). **Mowat's Seat** in Fern parish is a reference to a 12th century baron of that name; moving to a later period, **Cairn Gibbs** probably refers to the Gibbs family who have for many years owned Glenisla House, **Gibs Knowe** may or may not refer to an unknown Gilbert, and **Winter Corrie** is named after a local worthy. **Bessie's Cairn** is often taken to be a dog's grave, but the true story is given in the section headed 'Some Interesting Names'. There are few others: and we should not be taken in by appearances, such **Falls of Drumly Harry** (which refers to no person, living or dead), **Loups of Kenny** (which does not commemorate an agile Kenneth) and **Meg Swerie** (which is something of an enigma).

A few a historical events are referred to, in such names as **Beattie's Cairn** in Fern, **Donaldson's Den** in Menmuir and **White's Pool** in Lochlee, which each commemorate an unhappy case-history. **Shank of Donald Young** is known to refer to the death of a cateran in a 17th century cattle reiving exploit. The Queen's Well was built to celebrate Queen Victoria's visit to Glen Mark in 1851, and the Airlie monument on Tullo Hill is well documented. The only archaeological reference that comes to mind is **Caterthun**, whose name implies the existence of a hillfort.

Angus, Glen By Glen

Your favourite Angus glen is probably the one that you last visited; so, for the sake of objectivity let us discuss the three main ones individually in alphabetical order. Practically none of their history is reflected in their place-names, but it is fundamental to an understanding of life in the area. Although the glens have several characteristics in common, and of course share a similar landscape, each one is quite distinctive. This may be partly because they are formed into several separate parishes: 1. Glenisla parish (which extends from Glas Maol to Lintrathen); 2. the parish of Cortachy and Clova (which also takes in Glen Prosen); 3. Lochlee parish, which takes in the upper part of Glenesk; 4. Edzell parish which covers lower Glen Esk; and 5. the parish of Lethnot and Navar which takes in Glen Lethnot. These parochial divisions were at one time of great importance in the civil and religious administration of Scotland, and have played some part in determining the ethos of each area.

Clova and Prosen

Clova was granted by Robert the Bruce to his nephew, the earl of Mar, in 1324; the lands passed to the earls of Crawford in 1398; for a time it was a Lindsay domain (see **Glen Esk**, below), then acquired by the Ogilvies in 1445-6. James 7th Lord Ogilvie of Airlie was created Earl of Airlie and Lord Ogilvie of Alyth and Lintrathen by Charles I. The new earl joined Charles II at Scone in 1650 and was captured at Alyth by Cromwell's troops and imprisoned in the Tower of London until 1657.

11 *At the Head of Glen Clova*

The Ogilvy earls of Airlie take their title from an estate on the southern fringe of the Braes of Angus, with Cortachy Castle as the seat of the clan; although Clova was and is the heartland of the Ogilvies there were Lindsay clansmen in the Glen long after the chiefs had sold up: Glasslet for example remained with the Lindsays until the mid 17th century. Clova deer-forest was sold to the Gurneys in 1876-7, and Bachnagairn became part of the Balmoral estate. The rest of the glen is still Ogilvy territory.

The Statistical Account of 1791 notes that 'the stupendous height of the mountain(s), contrasted with the delightful narrow plain below, exhibits a scene of grandeur and beauty united'. Glen Clova at that time supported about 8000 black-faced sheep, not to speak of deer, hares and foxes. A little later *McFarlane's Geographical Collection* reported that 'the whole paroch of Cortachie and Clova except for a very little, belongs to the Ogilvys. Cortachie has been the principal dwelling of the Ogilvys of Airlie for about a hundred years. In the Montrose wars, the earl of Airlie commanded a troop of horse which consisted of brave gentlemen mainly of his own name'. In the early 17th century Glen Prosen belonged to the Grahams of Fintry (from whom descended the Claverhouse line); but later it became Ogilvy territory, when Donald Ogilvy of Clova took up residence in the mansion house of Balnaboth. The Ogilvies were fervent Royalists and Jacobites, but it was the Wedderburn ownership of the lands of Pearsie which enabled them to raise the men of Glen Prosen to form a battalion for the Airlie regiment in 1745.

Glen Esk

Glen Esk has a very long recorded history: Sir John of Glenesck (he had no surname) did homage to Edward I of England in 1296; his family was succeeded by the Stirlings, who married with the Lindsays in the 14th century. Glen Esk is still sometimes known as 'The Land of the Lindsays', no doubt because it was this family who built the castles of Invermark and Edzell and others. The chronicler Holinshed and the historian Buchanan both claim that Bruce passed through the glen and fought a skirmish in upper Glen Esk with the earl of Buchan on Christmas day 1307 (Lang Howe is supposed to mark the spot). Alexander, who was Lord Lindsay and Master of Crawford, had a charter of Glenesk and other lands in 1474; but his descendants, notably the 12th or 'Prodigal Earl', alienated most of the family property around 1608. David, the last Lindsay laird of Edzell, who inherited the lands in 1699, ended a life of dissipation in 1716; the lands were sold to the earls of Panmure who were responsible for the building of modern Edzell (a 'planned village').

The Third Statistical Account describes Glen Esk as 'one of the prime areas of heather moorland in Britain. Unlike the infertile peaks of the Cairngorms, much of the Glen is underlain by highland schist, a rock which produces fertile soils and springs'. The middle reaches of the glen are characterised by wide green haughs, now mainly used for grazing, and this is reflected in many of the place-names e.g. **Haughend** and **Greenburn Haugh**. There are traces of more considerable cultivation in earlier times; but arable farming – 'tearing up the miserable soil' – became less and less profitable, and by 1791 there was 'no wheat and but little barley'. The trade in black cattle had also declined, to be replaced

by sheep-rearing; the only other profitable activity was communal forestry. In addition there was the hostile human element: the parishes of Edzell and Glenesk had been infested by caterans in the 16th and 17th centuries, and in 1645 Montrose took refuge in the glen and his troops were quartered on the people; the district was laid waste and the old church at Lochlee was burned. There was a repeat performance a century later, after Culloden.

12 *Gannochy Bridge, foot of Glen Esk*

With the Victorian era came the creation of large sporting estates. Invermark Lodge was built in 1854 by Lord Dalhousie, and the whole northwestern part of Glenesk became a deer forest 'which, united with the royal preserves of Balmoral and those of the neighbouring lands of the earl of Airlie and of the Marquis of Huntly forms one of the most extensive sporting fields in Britain'. Lower down the glen the main sporting estates are those of Millden and Gannochy, with considerable hill-farming interests as well. Sporting developments, although bringing much-needed income into the community, tended to speed the depopulation of the glen, and in particular in its northern offshoots: Glenlee, once the largest clachan in the parish, now consists of scattered ruins. Glen Tennet and Glen Effock, though never as populous, are now virtually deserted.

Although Glen Esk is today a quiet glen of birches and bog myrtle, the large number of rickles of stones indicate the presence of vanished clachans most of whose names will never be recovered. There are many deserted crofts which look as though they had been in ruins for a century or more, but this is often deceptive, for older inhabitants can sometimes recall the names of their last occupiers. Glen Esk, despite its great beauty, illustrates all too clearly the familiar Highland story of depredation, decline and depopulation.

Glen Isla

The ownership of Glen Isla is more complicated. Originally the lands belonged to the abbey of Coupar Angus, whose last abbot was a son of the earl of Argyll; according to the practice of the time his illegitimate offspring were given endowments of abbey land, and thus it came about that parts of Angus were in the hands of Campbells of Argyll. This is the basis of the feud between the houses of Argyll and Airlie which lasted for at least a century. In 1591 the 5th Lord Ogilvy had his Glenisla lands despoiled by Argyll's clansmen; and the feud reached its climax in 1640 with the burning of Forter Castle ('the Bonnie Hoose o' Airlie' of the ballad). The Campbells had been incensed by the building in the 1560s of this castle, which impeded access to the clan's heartland in the west. The earl of Airlie, chief of the Ogilvies, was with the army of Charles I at York, when the earl of Argyll, chief of the Campbells, took advantage of his position as a Covenanting leader to pursue a private feud, and with 5000 men destroyed the Ogilvie properties of Airlie and Forter and 'left him not in all his lands a cock to crow day'. The ballad describes, with embellishments, exaggerations and some inaccuracies, the destruction wreaked by the Campbells.

Before and after this Campbell atrocity the Ogilvies held sway in the lower glen, particularly Craigisla and Forter, but part of the upper glen was the preserve of the McComies or clan Thomas, who were connected by marriage to the Campbells. The McComies built the castle of Crandart in the 16th century and would have remained a power in the glen but for a disastrous battle with the Farquharsons at Forfar in 1673; thereafter the McComies of Glenisla migrated to Aberdeenshire and disappear from the pages of history. Most of Glen Isla passed to the Airlies, with Caenlochan as one of their extensive deer-forests, although as late as the 19th century Glenmarkie was still

being referred to as part of the 'Argyle barony'; and one of the Duke of Argyll's almost innumerable titles is Viscount Glenisla.

Glenisla parish was at one time divided into Over Glenisla (Tulchan and Caenlochan, an area of moors and hills) and Nether (Auchrannie, Craig and the Kilry area – possibly the greenest and gentlest part of all the Angus glens). Ochterlonie's *Account of the Shire of Forfar 1684–5* tells us something of the way of life: 'Small heritors of Over and Nether Glenyla... live most on butter, cheese and milk; they kill much venison and wyld foull, The summer they goe to

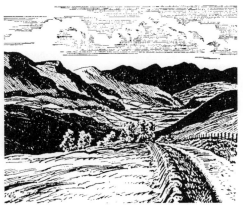

13 *Mountains at the head of Glen Isla*

the far distant glens which border upon Braemar and [there] live grassing thir cattle in little houses which they build upon their coming and throw down when they come away,

called shiels'. Today the larger farms are owned by the lairds, but the smaller properties are still mainly owner-occupied. In the early 1900s Glen Isla became a fashionable place for the aspiring Highland laird: Bellaty Lodge and Cammock Lodge both date from this period, and Glenisla House and Alrick were enlarged about this time. The lower glen is still well-populated – but mainly by incomers; the last statistical account (c1950) reported that there were practically no persons under twenty whose families were native to the glen.

Other Landholdings

Dalhousie is a Lothian place-name which was adopted as the title of the landed family of Ramsay during the reign of David II. Sir George Ramsay became Lord Ramsay of Dalhousie in 1618 and his son earl of Dalhousie in 1633. Of the Hanoverian persuasion, they fought on the losing side at Killiecrankie but afterwards attained great distinction in military and political spheres. The family residence was Dalhousie Castle near Dalkeith in Midlothian. It was marriage with the Maule family, earls of Panmure, that gave them a foothold in Angus. The 4th earl of Panmure had been one of the most ardent Jacobites at the beginning of the 18th century, and had bought the lands of Edzell, Glenesk and Lethnot for the specific purpose of acquiring additional swordsmen to fight for King James. After the failure of the Rising of 1715, the extensive Panmure estates were forfeited but later repurchased by a collateral branch of the family. When the male Maule line came to an end in 1782, the Panmure lands devolved on a Ramsay nephew who had recently succeeded as 8th earl of Dalhousie. Thus it came about that the upper part of Glen Esk (all the land north of The Burn) passed to the earls of Dalhousie, who remain the most extensive proprietors in the area.

Cadet branches of the house of Airlie at various times held lands around Lintrathen and Inverquharity, as is made clear in the muster-roll of the Airlie regiment in 1745/6. The family of Deuchar of Deuchar claimed to have had an ancestor who fought at Bannockburn; they owned their Angus lands as vassals of the Lindsays until 1819 when the last Deuchar emigrated to the colonies. Among minor landowners deserving a mention are the Kinlochs of Kilry and Logie, the Shaws (an offshoot of clan Farquharson) who held lands around Lintrathen, and the Stormonths who owned Lednathie and Kinclune.

The Angus Jacobites

It is important to recognize that the great Angus magnates were not clan chiefs but dynastic families, some (like the Ogilvies) of Celtic origin, others (like the Lyon earls of Strathmore and the Lindsays lairds of Glenesk) of Anglo-Norman stock. And most of them were related by blood one to another: Lord Ogilvie, heir to the earl of Airlie, was cousin to the earl of Strathmore, and the Carnegie earls of Southesk had influential kinsmen, one of whom was able to recover the family estates after their forfeiture following the Rising of 1715. Kinship was a powerful force in consolidating the Jacobite loyalties of the Angus gentry: for example, Mary Maule, sister of the earl of Panmure, was the mother of the earl of Mar, the leader (if that is not too flattering a term) of the

Jacobite forces in the '15. Up to the 18th century minor proprietors in the glens tended to be either sons or offshoots of the landed families – mainly the Ogilvies – who, according to ancient Celtic custom had been allotted portions of land as their patrimony. Although strongly royalist and Jacobite in sympathy, Angus was not (except in its most northerly reaches) a Highland area, and it would be wrong to overemphasise the patriarchal nature of its society. The formation of a 'Forfarshire' regiment in 1745 was the result of the activities of one great family (the Ogilvies of Airlie) and a few other Lowland Jacobite lairds. The regiment's muster-roll contains many Ogilvy officers, but the rank-and-file have most of them the same familiar Angus names – Anderson, Webster, Smith, Crighton and Edward – that you will find in today's telephone directory. In other words, recruitment was mainly from tenantry and not from clansmen; and the regiment's uniform of black and red check tartan probably owed its inspiration more to the newly-formed Independent Companies than to the notion of clanship.

A curious feature of the muster-roll (compiled from official records after the failure of the Rising) is that it contains very few names from Glen Esk, known to be a hotbed of disaffection. During the '45, a Jacobite called Ferrier had taken up his quarters in the glen and raised over 300 men from between Esk and Prosen for the Prince's army. In 1746 Cumberland accordingly sent out a force of 300 men who were with difficulty persuaded from burning Glen Esk from end to end. It has been conjectured that the reason for the anonymity of Glenesk rebels is that the officials (mainly excisemen and clergymen) were inhibited by the presence of large numbers in the glen of Jacobite sympathisers who would not have hesitated to bring retribution on any informers. Six months after Culloden the Presbytery of Brechin were seeking protection from 'the bands of insurgents who were roaming the country and had just harried several farms about Edzell'.

Kinnaird Castle near Brechin is rather outside the present area of study, but no account of Jacobitism in Angus could omit mention of the earls of Southesk. Sir David Carnegie became Lord Carnegie of Kinnaird in 1616 and a few years later was elevated to the earldom of Southesk. The Kinnaird lands have been held by the Carnegie family since 1409, except for a brief intermission when they were forfeit after the '15 Rising. The 5th earl proclaimed James VIII as king at Montrose in 1715 and entertained him as his guest at Kinnaird that winter; one of the earl's exploits in the Rising earned him the title of 'The Piper o' Dundee', giving him a posthumous fame beyond his historical importance. A member of the cadet branch of the family was James Carnegie, who is noticed in the **Gazetteer** under his landed title of *Balnamoon* (see also p.34).

The Written Records

One problem which is particularly acute in an underpopulated area such as ours is the sparsity of written records from an earlier period. The early maps show the Mounth as a great empty space, and even Timothy Pont, the 16th century cartographer, was clearly more interested in settlement rather than topographical names. Similarly, the vast repertoire of place-names in the Great Seal of Scotland from the 15th century onwards are mainly those of feudal holdings such as estates and farms and not landscape features or watercourses. We have to remember also that names of little hills and sub-streams probably changed from generation to generation, and most of them were not written down until the Ordnance Survey began its work in the 1840s. By this time Gaelic had been in retreat for the best part of two centuries, and many of the topographical names had either been lost or had undergone translation. Pont lists large numbers of settlement names in now-deserted glens; a few of these are included in this **Gazetteer**, but not those where there is difficulty in establishing a precise location.

One is tempted to imagine that the Ordnance Survey maps of North Angus reflect the existence of an already somewhat depopulated terrain, with many landscape features whose Gaelic names had fallen into disuse and had been forgotten. The ones that are named tend to be those which were of particular significance to shepherds, farmers and stalkers. It is most unlikely for example that *Dog Hillock* (there are two of them) is a translation from Gaelic, or that *Burn of Berryhill* records some ancient usage, or that *Peat Shank* refers to anything beyond a useful fuel-source.

The Scots-speaking inhabitants (like the Gaelic-speaking ones before them) were interested simply in identification, and had no thought of picturesqueness. Adjectives of colour are employed to define rather than to describe: Green Hill means a grass-covered one, Black Hill a heather-covered one, and White Hill a bare one. These hills in effect chose their own names, and were probably not the subjects of any conscious naming-process. Other hills may take the name of the nearest croft or farm, in many cases where all sign of habitation has now vanished. Similarly, stream names usually refer to the valleys which they drain; and very often the valley-name has itself disappeared. The name of many a lost glen is preserved only in crofts which happened to survive depopulation; examples are *Glenley*, *Glenarm* and *Glencuilt* which are now purely settlement names.

The Lost Names

The first step in producing a book on the Angus glens was the construction of a database. The one that I have roughed out contains some 1200 headwords (for an example, see note on *Eggie*); since approximately half of these headwords have one or more derivates, the total must run to well over 2000 names. This is of course only a small fraction of the names that exist or have existed in the past: even the 6" maps do not disclose topographic names that were ephemeral or of only local currency, and there are many obsolete names which never found their way on to the current maps. An example is to be found in a 16th century account (Coupar Angus Abbey Rental) of the bounds of an estate in Glen Isla:

'fra Water of Melgevin, up Dowra to the Calfe rysk south our the hill to Bawshadder Cairn, upon the west and... syne west to Culmaddery'. Not one of these places is now identifiable. The same account mentions settlements of Aldglew, Laron, Cowfurd and Solzare Moir – not to be found, to my knowledge, on any existing map. Take a walk up any of the Angus glens and you will come upon dozens of nettle-covered stone-piles each representing some long-lost dwelling, which must at one time have had a name. Most of these names are now irretrievable; but to find an elderly inhabitant who can recall one or two of them is, as may be imagined, one of the great delights in the game of onomastics or name-spotting.

The Map-Makers

Up till the end of the 17th century, travellers to Scotland from the continent were predisposed to think of us as inhabiting an island separate from England – a larger one at that – and tilted towards Denmark and Norway. Most of us will have seen, in antiquarian bookshops or museums, crude early maps of the British Isles, where Scotland is turned on its side (with the west coast facing north) and with vast and imaginary estuaries separating us from England. The most famous of these maps is that of the Greek geographer Ptolemy, who lived in Alexandria in the first century of the first millennium. The surprising thing is not that his drawings are so inaccurate as that he was able to attempt them at all.

The first map to have any relevance to our study of North Angus is a manuscript drawing dating from about 1360, now in the Bodleian Library in Oxford and known as the Gough Map (after its 18th century discoverer). The drawing is vague and the detail poor, but the map does include several place-names, all of which suggest a connection with the expeditions of Edward I into Scotland in the early part of the 14th century. In particular, 'Monthe Capell' (the Capel Mounth) appears as one of the crossings of the Grampians, and which the English king was once thought to have taken in his attempt to subdue the northern part of Scotland (see p.29).

The cartographic breakthrough came in the 16th century, when maps and charts began to be more accurate and detailed, and the engraving less indecipherable. Rivers, lochs and mountains appear for the first time, with indications of the major settlements. Mercator's world atlas of 1595 contains three maps of Scotland, which were to be the basis of Scottish cartography for the next half-century. Mercator ('the most famous cartographer after Ptolemy') was a Dutchman, the first of a long line of scholars from Holland; his work was continued by a fellow-countryman Willem Blaeu, whose atlas covered every part of the known world. (It was a typically Scottish misfortune that the maps and plates of the volume relating to our country were destroyed by a fire in the building in which the atlas was printed. However, his son Joannis Blaeu published in 1654 a collection of 46 maps of Scottish regions, most of them based on hand-drawn sketches by a remarkable man named Pont, who was the first person, so to speak, to put Scotland on the map).

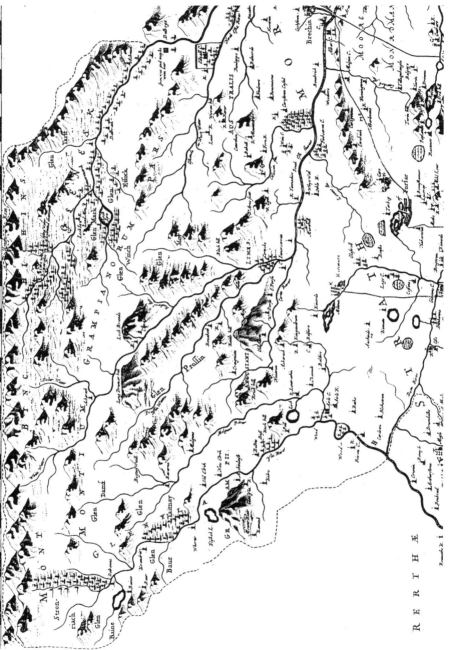

Timothy Pont, born around 1565, was the eldest son of a leading Scottish churchman, educated at St Andrews University and himself destined for the ministry. Between graduation and ordination he took some 'time out' which he spent traversing on foot the entire length and breadth of Scotland and recording his observations in drawings. This was an almost incredible achievement, and it is sad to relate that Pont's work had to wait many years before its worth was appreciated. He could find no publisher in his lifetime, and his heirs were less than diligent in their custodianship of his drawings after his death, which occurred while he was no more than fifty. Pont's manuscripts were sold by his family, and half of them were lost and others damaged. Those that survived passed through several hands before being incorporated in Blaeu's Atlas: they had not been prepared for engraving, and the task of doing this was entrusted to Robert Gordon of Straloch in Aberdeenshire, another leading figure in Scottish cartography.

It is at this point that maps emerge as being of real importance in a study of the place-names of North Angus. Of the seventy-seven surviving Pont sheets now in the National Library of Scotland, one (No.28) shows Glen Isla and Lintrathen; another (No.30) has several sketches showing the glens from Prosen in the west through Clova to Glenesk in the east (almost the entire area covered by the present book – a remarkable piece of good fortune). These maps have been reproduced with an extended commentary by Jeffrey Stone of Aberdeen University in a volume called *The Pont Manuscript Maps of Scotland*. The majority of the names relate to settlements, kirks and mills, but physical features such as glens, streams, lochs and woods also figure. As well as being attractive in themselves, the maps are a valuable source of information on vanished crofts and early spellings.

Robert Edward's prettily-drawn map of *The Shire of Angus* (1678, and dedicated to the earl of Panmure) is valuable for the southern part of the county but contains hardly any place-names in the glens. Somewhat more informative is a map engraved (but not surveyed) by a Dutchman Hermann Moll of *The Shire of Angus or Forfar* of 1725. Both Edwards and Moll have graphic outlines of the higher hills, and both show the shire of Angus as bounded on the north by a range called 'Mont Binchichans'. This mysterious and romantic-sounding term is a grotesque rendering of **Beinn nan Ciochan** ('hill of the paps') which was the old name for the Lochnagar massif, including the White Mounth, just over the county march.

But the most fascinating of the antique maps is that of John Ainslie of 1794, whose work made obsolete most of the earlier ones. Ainslie was a land surveyor and engraver who was born in Jedburgh in 1745 and practised in the New Town of Edinburgh for most of his working life. He produced several maps of Scotland, concentrating on roads rather than physical features or settlements, but correcting many important topographical details as well. In partnership with his brother as bookseller and stationer he had his own successful publication outlet in St Andrew Street. In 1794 he surveyed the county of Angus in connection, it is said, with the proposed construction of a 'Navigable Canal from the Harbour of Aberbrothock (Arbroath) to near Forfar... the rise being only 196 feet above the level of the sea and the whole expence Estimate at £17788 Ster. a very triffling sum...'. Predictably, the canal venture never materialised, but it left us with a magnificent map, beautifully engraved and with a brave array of mountains and woods, and dedicated

'To the Nobility and Gentry of the County of Forfar'. This map has been indispensable in the writing of this book; it shows dozens of vanished settlements, correctly indicates the origin of the name Glen Doll and gives the line of some now-vanished hill tracks.

After Ainslie we are approaching the era of the Ordnance Survey, whose work is the true basis of any place-name study. In passing however we must take note of the various military surveys which were carried out in an attempt to pacify the Highlands in the Jacobite period. The chief of these is the Military Survey of General William Roy (usually known as 'Roy's map'); its purpose was to prepare for the construction of roads and military forts in the Highlands. William Roy was born near Carluke in 1726; apparently he trained as an engineer and surveyor before joining the team formed to carry out the project. At first this was in a civilian capacity but from the age of 30 he rose rapidly through the ranks. The large scale of Roy's map (1" to 1000 yards) allows for considerable detail, and the use of different colours for buildings, fields, roads, moors, hills, woods and water justifies his own description of it as 'magnificent'.

The Military Survey was completed in 1755 and it led directly (but with considerable delay due to the American War and other factors) to the formation of the Ordnance Survey in 1791. It took more than another fifty years for the trigonometrical survey of Scotland to be completed; thereafter a stream of magnificent OS maps have come to the aid of the place-name scholar.

It would be difficult to over-emphasize the enormous effect that the Ordnance Survey has had on our place-names. For centuries these had been fluid, changing from generation to generation; but the Survey (conducted with scrupulous care, by people by no means insensitive to Scotland's Celtic heritage) created a corpus of 'official' names which have lasted for the best part of two centuries. Hills, streams and settlements have been put into categories, and their names spelt in a form accessible to non-Gaelic speakers. For the most part this has been useful and beneficial, even if etymologies

15 *A beech glade at the foot of Glen Moy*

have had on occasion to be obscured. Where a Gaelic orthography has been artificially preserved – as in **Creag na h-Iolaire** in Glen Esk – the name has become virtually unpronounceable and hence to non-Gaels largely unusable. This is a problem which awaits a satisfactory solution.

The 20th century has seen a proliferation of maps for every conceivable purpose. But many of us who reached maturity in the immediate post-1945 era have a soft spot for the Bartholomew half-inch-to-the-mile series, produced in Edinburgh from the 1890s and

28

available until the 1970s. The maps are still to be found on second-hand bookstalls and can be picked up in jumble sales; beautifully produced, they are likely to become collectors' pieces. And the fact that the older editions fail to show motorways, conurbations, new towns or airports matters to the place-name enthusiast not one little bit.

Travellers and Writers

There were many visitors to Scotland in the late mediaeval period, but they left no written documents. Edward I of England's visit in 1298 ('Voyage of Kyngge Edwarde') was chronicled by the diarist who accompanied him, but what survives would hardly rank as a travel brochure. In any case, although Edward certainly spent some time in Aberdeenshire, he appears to have taken the coastal route north and to have returned by the Cairn o Mount to Kincardineshire (but see p.25). A much less august but more interesting English visitor crossed the Mounth four hundred years later. He was a rollicking fellow called John Taylor, 'of mountain belly and prodigious waist' who came here as the result of a wager, the condition being that he would bring no money and live without begging or borrowing. A ferryman by trade and a poet by pretension, he published in 1618 an account of his trip under the title of 'The Pennylesse Pilgrimage' by the 'Water-Poet'. He was a social climber of the most determined and successful kind, and his booklet makes amusing reading. More to the point, Taylor travelled through Glen Esk to Invermark where he had a night's lodging at the hands of Lord Lindsay (in an Irish [Highland] house which was not over clean). On the way he traversed 'the side of a hill, so steepe as the ridge of a house, where the way was rocky and not above a yard broad in some places, so fearful and horrid it was to looke down into the bottome, for if either horse or man had slipt, he had fallen a good mile downright'. Allowing for some poetic exaggeration, this seems likely enough, but it is impossible now to identify which part of the route up Glen Esk is being described. Next morning, having been deprived of a long lie by the attentions of bed bugs, Taylor climbed Mount Keen; the weather had been pleasantly warm in the glen, but at the summit 'my teeth beganne to dance in my head with cold, like virginals jacks [keys on a spinet]; and withal, a most familiar mist embraced me round, that I could not see thrice my length any way'. The rough terrain meant that it took him and his guide four hours to make the crossing to Mar: '… the way so uneven, stony, and full of bogges, quagmires, and long heath, that a dogge with three legs will out-runne a horse with foure'. Taylor's experience of returning soaked from the Angus hills is familiar to most of us: it only remains to add that he lost his wager, having scrounged his way from Moffat as far north as Elgin and back again.

The Reverend Robert Edward, minister of Murroes (who is mentioned in the Maps section) wrote a description in Latin of the shire of Angus, which was published in 1678. His account is somewhat idealised, contains an amount of material on the county families, and has little to say about the northern part of the shire. A member of one of these families, Ochterlonie of that Ilk, was proud of his ancient lineage, claiming that his ancestor had received a call to arms from William Wallace '…we will have use for you and other honest

men in the countrey within a short tyme'; unfortunately this missive has disappeared, but Ochterlonie's *Account of the Shire of Forfar* (1684–5) is worth reading and is quoted throughout this book.

The Statistical Account of Scotland was the brainchild of Sir John Sinclair of Ulbster, Bt. (1754–1835), who wished 'to assess the Natural History and Political State of Scotland', 'to ascertain the quantum of happiness of its inhabitants' and 'to prepare for a better future'. To this end he sent to nine hundred ministers of the Established Church a questionnaire containing more than one hundred and sixty items, relating to geography, climate, natural resources, fauna and flora, population, social conditions, social habits (including even moral issues) and antiquities. The records were compiled county by county and parish by parish, and the resultant volume has been described as 'Scotland's Domesday Book'. But certain allowances must be made: belonging to the days when clergymen were rulers in the community, some of their comments may nowadays appear patronising. Others are merely quaint – see the notes on **Kingoldrum** and **Glen Ogil**. The contributions on place-name derivations are, it has to be said, almost wholly unreliable ('the Esk is the *Aesicum* of the Romans'); and the same remarks must apply to some extent to the New Statistical Account, which appeared in the 1830s. The Third Statistical Account (from 1948 onwards) involved the participation of the Scottish universities and is altogether a much more professional job but of course lacks the antiquarian interest of its predecessors. Although variable in quality, these accounts make interesting reading and we are indeed fortunate to have them.

Not to be overlooked are the visits made by Queen Victoria and Prince Albert to the Glen Esk area. As a result, the district became much more widely known; and indeed there is still the occasional whiff of Balmorality to be detected around Edzell and Invermark. In her Highland journals the Queen wrote perceptively of the Glens, and one or two snippets from them will be found in this book. Her Majesty's spelling may seem erratic, but she probably heard the names spoken by her Highland servants; her spellings may usefully be treated as phonetic renderings from the mid-19th century – for example 'Glen Effoch', 'Cairn Glaishie'.

There is, sadly, almost no creative writing devoted to the Angus glens. They did not receive from a Walter Scott the treatment that he gave to the Trossachs, and nobody made them into a mystic landscape in the way that Lewis Grassick Gibbon did with the neighbouring Mearns, transforming the very names into poetry. True, Scott set *The Antiquary* in Arbroath, and its (admittedly perfunctory) plot turns on a swindle relating to mining activities in a thinly-disguised Glen Esk. He also made his hero Quentin Durward a native of 'Glen Houlihan', which can be identified as Glen Isla, but this is hardly central to the plot. (Scott was always very careful with historical details – see **Durward's Dike** in the **Gazetteer**). Poems such as those of Alexander Ross of Lochlee or the lexicographer John Jameson who wrote *The Kelpie* (see note on **Shielhill Bridge**) reflect the taste of a bygone age and cannot engage modern readers. Violet Jacob wrote beautifully of Angus, but not the Highland part. It is not until J M Barrie published his 'Thrums' tales that we get a real picture of bygone days in Kirriemuir and occasionally of the nearby glens; *The Little Minister* is worth reading for this alone. Glen Quharity

16 *The Fairy-piper of Tillyoram*

however cannot be the one that is so-called on the map, but is an idealised picture: some readers see it as Glen Clova, but a more likely place is Prosen. Barrie became a playwright and a thoroughgoing Londoner, but towards the end of his life wrote a novella entitled *Farewell, Miss Julie Logan*, which transforms Glen Prosen into a magical other world. In the same category is *The Sheltering Pine* by John Angus, set around **Tillyoran** in Glen Esk and suffused with a benign supernatural quality (the fairy-piper which Colin Gibson drew especially for the author is reproduced here). Colin Gibson's own *Highland Deerstalker* is not fictional but is a charming account of the life and times of his old friend Alan Cameron, the stalker at Moulzie. It is a great pity that these last two books have been allowed to go out of print.

Perhaps it might be argued that beautification is unnecessary and that our Angus scenes and place-names have enough attraction in themselves. What makes these names distinctive is this: in most of the Highlands the native Gaelic language was supplanted by English; in Aberdeenshire and Angus it was Broad Scots that took over. North Angus abounds in dens, dykes, faulds, glacks, haughs, heughs, holms, knaps, lairs, knowes, muirs, shiels and touns – terms which, combined with the surviving Gaelic elements, give the map its distinctive character and incidentally what endows our place-names with their own peculiar music.

Genesis

They say, when God the father made the earth,

 He rolled between His palms its rocks and clays

Then breathed upon it to give life a birth.

 And it was done, and set into its place.

But ere he sent it spinning into space

 He gave it one last little pat in love;

And there the mark remains, upon the face

 Of Angus – the thumb the Tay, and then above:

Glen Isla, Prosen, Clova, Esk, these four

 God's fingers fashioned, and His palm, Strathmore.

Four fair green glens reach far into the west,

 And of them all, the loveliest and best

In Esk – Glen Esk by loving gesture given,

 God's little finger left the mark of heaven.

John Angus
(Reproduced by permission of the Angus family)

31

Some Interesting Names and the Stories behind them

The place-names of the Angus glens are interesting in themselves, even though some meanings may seem prosaic. All the discoverable names are listed in the *Gazetteer* at the end of this book. The following names are of popular interest and invite more detailed discussion; often there is background information of an intriguing kind. What follows should be read with reference to the *Gazetteer*.

Airlie Although Airlie is a parish name, with its Kirkton, Mains, Newton and several other components, the castle is its most notable feature. The derivation proposed in the **Gazetteer** seems to be reinforced by the early forms of 'Erolyn' and 'Eroli' (1242), and the description 'on the ravine' perfectly fits the topography. Sir James Ogilvy of 'Erolly', son of Sir John Ogilvy of Lintrathen, was the first to take the Airlie title. The original part of the castle, the 'tower of Airlie', was built by the Ogilvies early in the 15th century, but there have probably been several fortifications on this site (which is one of great natural strength) since earliest times. The castle was destroyed by the earl of Argyle in 1640 and thereafter remained a ruin for many years; but a late 18th century addition and restoration enabled the author of the First Statistical Account (1791) to remark that 'there is only one gentleman's seat in the parish [of Cortachy and Clova] but Airly castle will soon make another'; this duly happened, and a much more recent restoration made it one of the showpieces of the county. A century ago the Den of Airlie was a favourite resort of visitors, who were able to walk from the castle grounds past the Slug of Auchrannie (a narrow and dangerous stretch of rapids) to the even more fearsome Reekie Linn. The Den used to be one of the best examples of semi-natural woodland in Angus, with mature specimens of oak, elm and hazel; but now all is overgrown and lacking a visible footpath. It is a pity that the estate has no open days (as do the grounds of Cortachy Castle) and that the Den is no longer available to walkers, who have to make do with the short stroll from Craigisla Bridge car park to the Linn.

Aldararie Borrowed from *Allt Dararie*, or the Dararie Burn, a tributary of the River Muick which it joins more than five miles to the north, over the watershed forming the boundary with Aberdeenshire. It is a good example of the not uncommon occurrence of a stream-name in one area becoming a hill-name in an adjoining one. *Lair* is a Scots term which nowadays usually denotes a plot of ground in a cemetery (a 'place for lying'), but in this instance refers to a level greensward near the summit of the county march, probably a grazing for cattle. There is a well-established tradition that until relatively recently the inhabitants of the glens of Muick, Clova and Esk would meet there to compete in high-level Highland games. Nicknamed 'The Boolin Green', but a wild inhospitable place for any such pursuit.

Angus The name of the county is thought to derive from the Gaelic takeover of the southern Pictish region and may well embody the name of Cenel nOengusa, one of the three main kinship groups moving into the area after 843AD. Early forms of the county name are Engus (1150), Anegus (1175), and Enegus (1200). Until 1928 it went under the

name Forfarshire, and with regionalisation in 1969 became Tayside. Mercifully the ancient historic name has now been restored.

Ardoch This name occurs frequently throughout the Highlands, which is not surprising since it just means 'high place'. Earlier forms in Glen Esk were Ardache (1511), Ardach (1539), Ardo (1588). The farm was once part of the lands of Carrecross (see *Cairncross*). The 'Birks of Ardoch' are frequented nowadays by visitors to the adjacent *Retreat*, but they were also known as the location of a stone where Robert the Bruce is supposed to have sharpened his sword after a legendary engagement in the glen (see *Cross Stone*). Much more recently a chapel was built at Ardoch, mainly through the generosity of the Dalhousie family.

Auchmull This farm in lower Glen Esk would in later times have been called 'Milton' (see *Gazetteer*). Nearby are the sparse remains of a 17th century castle, where the young earl of Lindsay took refuge after the murder of Lord Spynie in the High Street of Edinburgh in 1607. The castle came into the hands of a local farmer who found it so inconvenient that he obtained permission to reconstruct it to his requirements. Queen Victoria refers to 'the Castle of Auch Mill... which now resembles an old farm-house, but has traces of a terrace garden remaining'. Further depredations in the interests of fencing and draining have resulted in the unremarkable place which we see today. Early forms include Auchmule (1535), Achmul (1678) and Achmull (1724).

Bachnagairn A shooting lodge was built here in the wilds of upper Glen Clova in 1819; there are still a few traces of it, but very little remains. After it fell into ruin, some of its fabric including doors and slates were brought down the glen to Moulzie by the stalker and re-used there. A coniferous wood once sheltered the old lodge; it had been planted at too great an altitude (1700 ft) and was not expected to thrive, but in fact the larches grew to maturity in the shelter of the corrie. The wood dwindled after a century and the remainder was flattened in the great gale of 1968; but a new generation of larches, undeterred by the fate of their predecessors, is growing up to grace this beautiful alpine location. Bachnagairn Lodge belonged to earls of Airlie but the land is now part of the Royal Deer Forest of Balmoral, with a keeper's house at Moulzie in upper Glen Clova. One of the few remaining man-made features of Bachnagairn is the Roy Tait Memorial, a splendid wooden bridge over the South Esk, strategically placed at the point where the track to Broad Cairn diverges from the one joining Jock's Road.

Backwater The Back Water ('subsidiary stream') at the foot of Glen Isla was the name of the burn before it was dammed in 1969 to enhance Dundee's water supply; the name is still applied to the outflow from the reservoir. 'The Backwater' was also the name used locally to refer to the now-flooded glen (properly *Glen Damff*), and the burn itself forms the upper Melgam Water – an illustration of the fact that place-names are not fixities. Clintlaw, Ley, the two Scithies and the three Ravernies are the lost names of submerged farms and crofts.

Balfour The castle was an Ogilvy property from the 15th century; all that survives is a six-storey round tower attached to Balfour Mains. It is traditionally but erroneously

supposed to have been built by David Beaton, Cardinal Archbishop of St Andrews in the early 16th century for his mistress Marion Ogilvy and their children. Previously the whole district was known as the 'thanage of Newdosk'. Although the lexical meaning of Balfour (as a place-name) is 'pasture village', in this case it probably comes from the surname, which in turn derives from the barony of Balfour in Fife. The surname takes the stress on the first syllable. There are at least five other places in Scotland named Balfour.

Balhangie This 'lost' name (it doesn't appear on modern maps) is interesting for several reasons. Balhangie (also written Belhangie and Bathangie) is the old name for Tarfside, shown as a croft in Ainslie's map of 1794. This map also shows 'Balhangie Inn', which probably acted as a sort of hospice for travellers over the Fungle and Firmounth tracks to Deeside. The inn lost its licence in 1854 'after an indecent brawl'; details of this incident are not known, but its consequences must surely have been a great disadvantage to inhabitants of the glen, who now have to resort to Edzell to slake their thirst. The name 'Tarfside' is, like *Noranside*, a modern construction and something of a linguistic intruder.

Balintore Charles Lyall the geologist became the owner of extensive properties in Angus in 1791, including Balintore. The castle was built in 1860 by David Lyon MP and was later owned by the Stormonth Darlings. A gloomy and derelict Victorian pile, it is redeemed only by its magnificent situation overlooking the Sidlaw Hills to the south.

Balnaboth A mansion built by Donald Ogilvy of Clova on the site of an older house. A summer lease of this white-walled, grey-roofed house on the Prosen Water was taken by the ailing J M Barrie in 1933, with a house-party of several friends including the Asquiths. Among many visiting celebrities were Prime Minister Ramsay Macdonald and a royal party comprising the Duke and Duchess of York and their two daughters. Of more lasting interest perhaps is the ruined chapel at Balnaboth, built as an Episcopalian meeting-house in 1607 and served by the minister of Clova, whose own manse and kirk were four miles away over a hill track starting at Prosen village. A pleasant walk starting from Prosen kirk is signposted *The Minister's* **Road**; but it must have been tiring to conduct a service at both places and with a double journey. The Balnaboth chapel later became the mausoleum of the Ogilvies of Clova. The word *both* in Gaelic can have the additional meaning of tabernacle, and it has been suggested that the name Balnaboth refers to the old chapel. But the place-name (which dates back to 1180) must surely predate by several centuries the place of worship.

Balnamoon James Carnegie, having prudently placed the ownership of his Menmuir estate of Balnamoon in the hands of his wife, joined the Airlie regiment of the Jacobite army in Stirling in 1746; for the previous few months he had acted as Lord Lieutenant of Forfarshire in the absence of Lord Ogilvy, colonel of the Airlie regiment. Captain Carnegie (known by his title of 'Bonnymune') took part in the battles of Falkirk and Culloden; although his estate escaped forfeiture on the collapse of the Rising, Carnegie himself had to take refuge in the wilds of Glen Mark, where he had several hair's-breadth escapes; Balnamoon's Cave is 75 ft above the Water of Mark below the Craig of Doune (and you won't find it unless you are really looking). It was only Carnegie's popularity

with the collaborative country folk that allowed him to survive to a ripe and bibulous old age and to become the subject of many anecdotes which still enliven the folklore of Angus.

Beattie's Cairn Beattie is a Scots surname, a diminutive of Bartholomew. Apparently this Beattie was a retainer on the estate of Balhall who incurred the wrath of the laird by giving false witness in a boundary dispute. The unfortunate Beattie paid the ultimate penalty for his crime of perjury, and was buried on the hillock which now bears his name. The date of this event is unknown; but the story may be the same as the one which lies behind the popular etymology of *Mansworn Rig*.

Bessie's Cairn The inscription reads 'essie's Cairn, 1852'; the name is now thought to be that of Lady Elizabeth Londonderry, who used to accompany her husband and his friends while they were stalking deer on the high hills above Caenlochan and Canness. The story goes that the kindly stalkers built a cairn to shelter Lady Bessie from the bitter winds and driving rain which are not uncommon in these parts; the rectangular base has a stone seat on each face, providing an outlook in all directions. Many years later, long after Bessie had any use for the cairn, it was all but destroyed in an avalanche; but the stonework was reassembled by a stalker and the inscription rescued – all, that is, but the initial 'B'.

Bonhard A slightly different etymology is possible from the one suggested. The old name of the Carnegie earls of Southesk was de Balinhard, derived from the lands of that name near Arbirlot. Variously spelt Balindard and Balnehard in the 13th century, it could be Gael *baile na ceard* ('tinker toun'). Later spellings include Banhard (1511), Bonehard (1539) and Bauchard (1648), all pointing to the 'tinker' derivation. Another Balinhard (in Arbirlot) also became Bonhard.

It is said that the former crofts of Bonhard in Clova disappeared under one of the rockfalls that are so prevalent in this area. A glance at the terrain makes this appear very likely. Colin Gibson describes the place as 'a shadowed corrie that holds snow well into the spring and, being unfrequented, is favoured by golden eagles'.

Brewlands A habitation called 'Brewhouse' is recorded as early as 1234. This is a strange name to find in Glen Isla, and representing one of the earliest intrusions of the English language into the glen. The explanation is to be found in the place's connection with an abbey in the Lowlands. In 1508 the 'breulandis of Auchenleishe' were leased by one John Jamieson. Over and Nether Auchenleish are included in the 1561 account of the rentals of the abbey of Coupar Angus 'excepting the brewlands thereof' (the monks presumably having arranged to obtain their beer from a source nearer home). The picturesque old Brewlands Bridge was replaced by a modern one in the 1930s.

Bridgend This hamlet, with its school and post office, is the largest settlement in the parish of Lethnot & Navar (formerly two separate parishes but conjoined in 1723). The story goes that the Presbyterian congregation of Navar in an attempt to convert the natives of Episcopalian Lethnot built a new church on the Lethnot side; to avoid the inconvenience of fording the river, the minister is said to have insisted on the building of a bridge. The result was the 'Auld Brig', which was built in 1725 and served for over

two centuries before it collapsed through age and neglect. The modern bridge is more functional but less attractive. The chapel of Lethnot had become a Jacobite meeting-house and was destroyed by Cumberland's troops in 1746; it is now a ruin. Half a mile to the south, across the West Water the church of Navar is in a similar state, the congregation having been united with Edzell in the 1900s.

Caenlochan The name Caenlochan has been used for a National Nature Reserve, which in fact covers a much larger area than the so-called 'Caenlochan Glen'. Timothy Pont in the 1590s calls it 'Caed lochen', which is not inconsistent with its accepted etymology of 'pass of the tarn'. Queen Victoria calls it 'Cairn Lochan' – an accurate but not very helpful rendering of its modern mispronunciation. The OS maps show Caenlochan Glen and Forest; but the 'glen' bit is superfluous, since it is a spectacular but narrow gap distinguished by a little tarn not much bigger than a tennis-court. The 'forest' is of course treeless: it was a traditional deer-forest, originally belonging to the Airlies, which became a sheep-run at the time of the Clearances but later reverted to sporting use. Nowadays you can see literally thousands of deer in its lonely fastnesses.

The Haughs (river-meadows) of Caenlochan are below the confluence of the Caenlochan and Canness Burns; they produced good grass, and MacCombie Mor (see *Crandart*) in 1660 is reported to have grazed 'besides divers horses, twenty milch kine and more than a hundred oxen'. The Airlies later let the grazings to Farquharson of Broughdearg in Glenshee, whose land marched with Caenlochan. It was in Caenlochan that Professor Balfour, a noted 19th century botanist, found the snow gentian (*G. nivalis*).

Cairn Inks According to old superstitions, this was the gathering-place of a large colony of Loch Brandy witches, who would hurl their spells from its dark and frowning heights. Apparently this gave the witches an excellent view of the successful results of their diablerie in the valley below. See also *Witches' Knowe*. (It is noticeable that place-name references to the supernatural are always in Scots, never in Gaelic – indicating that the names are post 17th century.)

Capel Mounth Although marked on the maps as a hill (2240 ft), the term nowadays is mostly used to refer to the track between Clova and Ballater via Glenmuick; the old (and correct) pronunciation of **caapel maunth** is now rarely heard. Once an important drove-road, it has for many years been frequented only by walkers. It is difficult to imagine this lonely place being traversed by men in their hundreds; but it was the route

17 *Loch Brandy Witches*

36

taken by the army of Montrose in 1645; a century later the Airlie Regiment of the Jacobite army crossed these hills on 12 February 1746 on its way north after the retreat from Derby. The regiment returned by this route five days after Culloden, to disband at Clova.

In 1892 a party of sixteen cyclists crossed 'the Capel' from Glen Muick to Clova, pushing their cycles all the way over the track and finishing at Forfar. This was reckoned to be the first such crossing; and even with the advent of mountain bikes it can nowadays hardly be a common occurrence.

An alternative and non-Gaelic etymology of 'Capel' was offered eighty years ago by the librarian of Aberdeen University; he argued that the hospice at the Spittal of Muick, established by the Bishop of Aberdeen, must have had a chapel, and that this gave its name to the hill, the burn and the Mounth crossing. But the 'horse' derivation seems altogether more likely.

Carlochy There are two places of this name, both mountain lochans but very different in terrain. The Carlochy in Glen Mark is reached by crossing the Water of Mark (on foot, so choose drought conditions for your visit); it is a natural mountain tarn, although there has been at some point an attempt to dam it, and it is the haunt of small trout and the rarer char, known locally as 'reid wymes' (red bellies). It has been described as 'a lake of crystal purity... filling what appears to have been the centre of a volcanic outburst'. Aeons later Carlochy was the site of an old whisky bothy, and is now part of the Dalhousie deer forest. The Carlochy in Glen Lee is a place of extraordinary beauty, and hardly more than two hours away from Dundee (although the latter part of the excursion is something of a footslog). The tiny lake is overlooked by the gigantic cliffs and corries of Craig Maskeldie. These are thought to have been where the last glaciers were formed, 'when ice 200m thick... moved down the glen'.

Both names are pronounced as written, with the stress on the second syllable. The meaning seems obvious, but the Gaelic term *lochaidh* can also mean 'black goddess' – not inappropriate for these unearthly spots, two of the loveliest in all Angus.

Carrecross The term *cathar* means a piece of mossy, broken ground; it has been pointed out that this would contrast with another word *caoin*, pronounced **keen** and meaning smooth. Thus the 'moss road' would be differentiated from the 'smooth road', which in anglicised Gaelic would be Keen (see **Mount Keen**). The 'moss road' became known as the Fir Mounth, from the northern portion which traverses the fir-woods of Glentanner in Aberdeenshire.

Cat Law This hill, with its domestic-sounding name is one of the most prominent of the south Grampian foothills. The writer of the Statistical Account (1791) makes the extravagant claim that 'no Scottish mountain can rival either the extent or the variety of views from the summit'. There is local pride behind this statement, resulting in some pardonable exaggeration; nevertheless, the view in all directions is undeniably impressive. A century later J M Barrie wrote of Cat Law that 'nowhere else is the heather quite so blue, nor do the burns flow quite so pleasantly'.

Fashions have changed, even in landscape: this modest hill of 2264 ft is now neglected and largely unvisited. For many years however it was one of several identified as the locus

of the battle of Mons Graupius, where in AD 83 the Roman general Julius Agricola defeated the Caledonian host of 'more than 30 thousand' tribal warriors and determined the course of Scottish history. (Modern scholarship tends to favour a more northerly site for the battle such as Bennachie, but the Cat Law, commanding as it does the mouths of the glens of Isla, Prosen and Clova, is still a strong contender.) It is even claimed that 'cat' is a mistake for Gaelic *cath*, meaning battle; this is not necessarily special pleading, and the mediaeval spelling 'Carincadlouer' certainly doesn't rule out such a possibility. The prefix probably represents the Gaelic *carn* (describing a large ring-cairn on the summit) and the stem seems to contain the *cath* (battle) element.

Even the 'law' suffix is problematical: the old-fashioned pronunciation of the name was **Catlie**, which invites comparison with Cairn Caidloch. Since directions for the ascent of this hill are hard to find, here is a brief guide: take the unclassified road leading from Kirriemuir to Pearsie and Glenprosen village, and park the car near the bridge over the Lednathie burn; follow an old Landrover track to the west, which climbs steeply to Nowtslairs wood and skirts its eastern side; ignore two side tracks through the wood; follow the main track till it comes close to a boundary fence, at which point you leave the track and hug the fence till you come to a wooden gate; climb the gate and follow a rough track westwards till it peters out, at which point the flattish summit of the Cat Law will be visible; make a beeline for the top, over hummocks of rough grass and heather; at the top is a very large cairn of stones in circular form, possibly used either as a place of worship or an observation point. (Time – two hours up, one hour down.)

The Cat Law was the hiding-place in 1746 of Robert Wedderburn, 2nd son of Sir Alexander Wedderburn, Bt., of Blackness (in Dundee), who raised recruits for the Glenprosen company of the Airlie regiment. In later times Cat Law was a notorious haunt of smugglers. Both of these pieces of intelligence are somewhat surprising, since the Cat Law is essentially a bare and smooth hill, offering little by way of cover. But in more peaceful times Catlaw mutton became known for its 'superior delicacy and flavour'.

Caterthun The 'dark and mysterious Caterthuns' are two hill-forts, standing like sentinels before the southern Grampians. The White and the Brown Caterthun have together been described as 'among the finest prehistoric ruins in Britain'.

The White Caterthun, the more formidable of the two, may well have been an Iron Age headquarters or even a tribal capital. Oval in shape, with two timber-laced ramparts, the interior is grass-covered and contains the remains of a well. The fort takes its name from the scree of light grey stones which have tumbled from the ruined walls.

The Brown Caterthun (so called because of its dark heather covering) is noted for the complexity of its defences, which consist of three ramparts and a ditch, surrounded by two additional circuits of outer defensive walls. Since these Iron Age forts date from around the beginning of the first millennium and have been prominent landmarks for some two thousand years, one would assume that their names are of some antiquity also. The etymology offered in the ***Gazetteer*** (consisting of two old Celtic words meaning fort) may be less than satisfactory, but at least these words would have been current in the Pictish period. A local historian attempted to derive the name Caterthun from the modern Gaelic *cadha eader da dhun* ('pass between two forts') and explained that it referred to the track

now replaced by the unclassified road from Brechin to Bridgend in Lethnot and which crosses the saddle between the two forts. Although novel and ingenious, this etymology fails to convince: it would be the equivalent of saying that 'Stonehenge' comes from the old name of the A360.

Clacknockater This splendid name recalls Maggienockater in Aberdeenshire, which also embodies a reasonable phonetic rendering of the Gaelic words *an fhucadair*. Fulling (the occupation referred to) is the process of scouring and thickening cloth. Ainslie spells the Angus name 'Claughnicketer' (not quite so apt) and adds the prosaic alternative of 'The Byre'. The lands were part of 'Argyle's Barony' in Glen Isla (see p.21).

Clintlaw There are two separate occurrences of this name: the first is the old farm and sawmill of Clintlaw, flooded by the Backwater Reservoir in the 1960s and represented on current maps only by a corrie and a plantation. The other is a knoll called Clint Law in Lintrathen which gives its name to the adjacent farm of Clintlaw.

So much for the locations, neither of which is very inspiring. But as a name Clintlaw offers much scope for the type of problem-solving beloved of place-name enthusiasts. It must have originated as a hill-name, and indeed Timothy Pont's late 16th century map shows a 'Schee of Klintla'; *shee* means a hillock (as in Glen Shee), but it is no longer identifiable, modern cartographers having ignored it.

The proposed derivation of the name from the Scots terms *clint* ('crag, precipice, cliff') and *law* ('hill') seems unassailable. *Clint*, we are told, is cognate with a Scandinavian form *klint*, and *law* is a familiar enough term deriving from Old English *hlaw*. But the rental of Coupar Angus Abbey of 1250 shows the name in the form 'Clentolach'. This strongly indicates a Gaelic derivation, such as *claon tulach*; *claon* is an everyday word meaning squint or oblique or slanting, and *tulach* is a knoll, giving something like 'crooked little hill'. *Claon* is not related linguistically to *clint*, but is a loan-word from Latin *clino*, meaning 'I incline'. *Tulach* and *law* however both mean much the same, so it is not hard to imagine that Scots speakers would prefer the more familiar generic.

For good measure, there was before the inundation of the Backwater valley a waterfall known as 'The Clints' or 'Klyons'; the first of these supports a Scots etymology and the second a Gaelic one.

Clochie The name appears in 1511 as Clochy, and in 1554 as Cloquhy; Timothy Pont spells it 'Cloichy'. It was the site of an Episcopal meeting-house, destroyed by Government forces in 1746 because of its Jacobite associations. There was a local tradition that the soldiers forced the farmer of Clochie, who was a fervent Jacobite, to 'carry burning peats from his own hearth and straw from his own barn, to set fire to his own meeting-house'.

Clova For the etymology of this difficult name, see **Glen Clova**. From the 13th century there was a chapel in the glen, regulated as part of the diocese of St Andrews but granted extensive rights on account of its distance from the mother church of Glamis. As commonly happened, a clachan grew up round the kirk, and the hamlet became known as Kirkton of Clova. This usage still continues to some extent although the map shows 'Kirkton of Clova' as a sort of eastern suburb (not the location of the present kirk.). The

village appears on old-fashioned maps as Milton ('mill town') of Clova (the mill-wheel still exists). Nowadays the settlement together with the neighbouring holdings of **Roineach Mor** and **Arntibber** is just plain Clova. The thanage of 'Cloveth' was granted by Robert the Bruce to Donald, earl of Mar in the 14th century. Half a mile up the glen from the village are the remains of the much earlier Peel (castellated tower) of Clova, a former Lindsay residence, said to have been sacked by Cromwell's troops in 1650. Thereafter Clova became the heartland of the Ogilvy clan; in 1684 Sir David Ogilvy, 3rd son of the 1st earl of Airlie, built a mansion near the site of the old peel, no trace of which remains.

Colmeallie Visitors should not be put off by the lack of signposting for this impressive monument: it is possible to park beside the entrance to the Colmeallie farm road and easy to walk the few hundred yards up the hill to the site. The stone circle is thought to be Bronze Age, and in its centre is what appears to be the site of a cist burial. A very atmospheric place, beautifully situated with views up and down the glen. Its ecclesiastical associations are confirmed by the presence nearby of a Kirkhill, a Kirk Burn and Kirkshank to the north, but the spelling Kilmeallie ('Mallie's cell') is an aberration. Early forms are Culmaly (1554) and Culmalie (1632).

Cortachy Early forms are: 1257 Cortachyn, 1320 Carcathie, later Quartachy; Edward has 'Cortoche'. The Barony of Cortachy was granted by James III to Thomas Ogilvy of Clova, whose descendants held the honours and lands until 1625, when they sold out to the earl of Airlie, chief of the clan. After the destruction of the 'Bonnie Hoose o' Airlie' in 1640, the earl and his family moved to his castle at Cortachy. Further vicissitudes were its ransacking by Cromwell's troops in 1651, and the forfeiture of the estate on account of the Ogilvies' heavy involvement in the '45 Rising, after which the castle was occupied by Hessian troops; nevertheless this beautiful building, much restored, in its wooded grounds on the South Esk continues to be the Scottish seat of the earls of Airlie. The parish of Cortachy was united with that of Clova in 1648.

Courtford The name (also written Coortford) refers to a crossing of the Noran Water, which was replaced by a bridge in relatively modern times; 'coort' would no doubt refer to a cattle-court or pen. Still later came the adoption of the name Courtford Park for a nearby residence. According to tradition, Coortford was the place where, in the 12th century, a local hero slew a wolf with his gigantic sword; such was the gratitude of the laird that the swordsman was awarded the adjacent 200-acre estate of Deuchar, from which he then took his surname (see **Deuchar**). The sword itself acquired several other legendary accretions, including its prowess at Bannockburn and Red Harlaw and sundry later combats; such is the stuff of our Scottish folklore.

Craig Breostock This crag is one of the notable features of Glen Mark, overlooking the Queen's Well from the south. The spelling of the name has varied over the years from Bristach to Braestock – and the current one used by the OS is not really an etymological improvement. The fissures implied by the original spelling bore lead and silver, and an account written in 1678 refers to 'a rich mine… where eighteen miners are digging deeper

every day. This vein seems to be inexhaustible'. Alas, the vein proved to be neither durable nor profitable.

Craig Soales The reason for the name is the bright colouring given by the quartz and mica traces which abound on the hill.

The map shows 'Old Workings' at NO 505 803; this refers to opencast mining for lead and silver, which, local tradition tells us, was carried out during the 17th century at a spot called Clashmaroy (which is no longer named on the map, but which can be identified as a natural gash on the hillside).

Craigancash Since *cas* is a common word in Gaelic, with many different forms and meanings, there are several possible etymologies of this name apart from the obvious one given in the *Gazetteer*. One authority would probably opt for *cas* meaning quick, giving the form *creagan caiseag* or 'crag of the little swift (stream)'; another prefers *caiste*, meaning twisted, and refers to the curly nature of the rock-ridge. What is certain is that this is the same name as *Creagan Caise* in Glen Isla.

Craigendowie The name dates from 1617, and has been taken as a reference to a stone circle which stood in the field in front of the farm building. But the existence of a nearby rockface called Creagan Dubha, and marked on the map as such, might indicate that this is the source of the farm-name; and in any event, *creagan* is not normally the term used for standing-stones. It may be added that the folklore surrounding these gloomy black rocks has the usual mixture of kelpies, demons and fallen warriors.

Craigisla The mansion and barony were formerly known as Craig of Glenisla, an Ogilvy stronghold. The former castle of Craig (up-river from Airlie Castle and across from the Peel of Lintrathen) had a disastrous history. Sir John Ogilvy of Craig was instigator of a plot to mount a large Spanish invasion in support of a rising of the Catholic nobles Huntly, Errol and Angus; as a result, the sheriff of the county of Angus ordered the demolition of the castle, and this was carried out through an attack by a Dundee mob in 1594. The castle was duly restored and its owner pardoned; but Ogilvy of Craig was a notorious Jesuit, and the castles of Craig, Forter and Airlie became the nerve-centres of the order in Central Scotland. Craig Castle, along with Airlie and Forter, was destroyed in 1640 by the Campbells during the troubles associated with the 'Bonnie Hoose o' Airlie', and this time it was for ever. The estate appears on the OS map of 1926 as 'Craig'. It is quite likely that the name 'Craigisla' was adopted to distinguish it from the better-known Barony of Craig near Montrose.

The present Craigisla Bridge was known as 'Bridge of Craig' as late as the 1850s, and this usage is preserved in the nearby Nether Craig (now an attractive caravan park) and Easter Craig. Mains and Bridge of Craigisla also appear on current maps; the present house known as Craigisla seems to be what was formerly known as 'House of Cotton Craig'.

Crandart Crandart was originally a fortalice built in 1660 by the McComies, one of the last clans to hold sway in Glenshee and Glenisla; it was locally known as 'The Ha' – ('hall' – another indication that Gaelic had by this time retreated from the glens). The

McComies moved to Aberdeenshire after a disastrous clan battle with the Farquharsons in Forfar in 1673. The property then passed to the Robertsons; and the young John Robertson, an ardent Jacobite, was reckoned to be 'the handsomest man in the Prince's army'. The property became part of the Glenisla estates of the Airlies. Moll's map (1725) has 'Krandrit'; and the name appears in 1850 as 'Crundirth'.

Creag na h-Iolaire This is a doubtful name; it has sometimes been written and pronounced 'Craigenhuller', which is a not very convincing Scots version of a Gaelic original. Also, the unusual purity of the written Gaelic makes this name a bit suspect; an alternative form has been put forward – Craigenshoillear or 'clear/bright craigs'.

Cross Stone The stone, sometimes referred to as Drostan's Cross (see *Drosty*), is to be found on the old road between Tarfside and the Maule monument on the Rowan; it is

said to have been moved there in the 19th century from its original location further up the glen. Bearing a Latin cross on its north side, in the Columban style, its connection with St Drostan's religious establishment is probably genuine enough. A much less reliable legend (related by the chronicler Holinshed) links it with a supposed battle between Bruce and the Red Comyn in the winter of 1306, the king having planted his banner on the stone; for good measure, the stony mounds surrounding the place are pointed out as the burial places of those who fell in battle.

18 *The Cross Stone*

Cullow At the entrance to Glen Clova there is an intriguing notice indicating 'Cullow Market Stance'. It is now a car-park and picnic site, but the term is borrowed from an old livestock-market which was a short distance to the west on a site now covered by a plantation. 'Cullew Fair' as it is otherwise called, was held annually in October, when flocks and herds were driven south over the Mounth and down the glens. In earlier times these would be cattle, but latterly mainly sheep.

Cuys The remains of a cave on the north side of upper Glen Mark, formerly called Johnny Kidd's Hole. Nobody now remembers Johnny Kidd, but he was probably either a freebooter or a shepherd. Writing in 1678 a parish minister described the cave as 'having a roof of stone, from the chinks of which there drops some water which petrifies into a substance resembling crystal, of the form of diamonds'. The cave has, over the centuries, fallen in and the crystallised diamonds are lost forever.

Dalbog This farm near Gannochy was once a little township – as well as being the locus of an ancient stone circle.

 Early (but unreliable) forms are 'Dulbdok' and 'Dulbrothoc'. The lands at first

consisted mainly of hill-grazings, but as early as the 13th century Dalbog had become a chapel in the rural deanery of Angus and diocese of St Andrews. At the nearby wood of Dalbog there was evidence (now removed) of a former Lindsay stronghold. The map shows an Oldtown of Dalbog, but Mains of Dalbog appears no longer to exist; nor do the smelting furnaces of an attempt to establish an iron mine here in the early 1600s.

Dalforth A croft, of which there is now no trace, is shown on Ainslie's map somewhere around NO 57 77. Dalforth was in fact the site of a long-deserted village, with traces of an old water-mill and smiddy; there was also an ancient burial-ground. The term *coirthe*, as well as meaning a pillar (no longer to be seen), can also be a standing stone or stone circle, and it may well be that the reference is to the neighbouring farm of **Colmeallie**. The proposed etymology of the name is confirmed by its 16th century spelling as 'Dalquorth'.

Dalhastnie The name of this old-established settlement is recorded in 1511 as Dunhasny, in 1588 as Dilhaisnie and in 1648 as Dilhasin. Its Sassenach connection probably implies no more than that it was a stance for drovers, some of whom were no doubt Lowlanders. (The Gaelic *Sasannaich* is of course a loan-word from the English 'Saxon', i.e. a non-Gael; *Sasunn* means England.) The usage is also to be found in **Tom Tessny**.

Dalvanie The croft (formerly a hamlet) probably takes its name from Glen Beanie, which is thought to mean middle glen. Dalvanie was the most northerly holding in Glen Isla, its pasture rights having been retained by the Abbey of Coupar Angus; the tenant of Dalvanie also had charge of the pasturings at Glascorrie. In 1745 Dalvanie was occupied by the Shaw family. (1521 Daluanie; Ainslie has Dalvenie.)

Deuchar In 1369 Sir Alexander Lindsay of Glenesk granted a charter of the lands of 'Deuhqwhyr' to William (this being in the days before surnames had become universal in Scotland). The family of this William had occupied the lands (probably as vassals of the Mowats) for a century and a half, and claimed to have fought at Bannockburn; they eventually took a surname from their property, styling themselves Deuchar of that Ilk (i.e. 'of the same'). The family remained in ownership of the property until 1819, when they emigrated to the colonies. This is a classic example of a territorial surname which has become more celebrated than the property from which it was derived. See also **Courtford**.

Donaldson's Den Donaldson was the name of a man who committed suicide in Balzeordie in the 1750s, and according to custom was denied Christian burial. The corpse was put on the back of a pony for conveyance to an unhallowed spot, but during the journey it fell off in a den near Kilgarie. The superstitious populace fled in fear, whereupon the laird ordered the body to be interred where it fell, in the presence of the tenantry who were to attend by his command. Donaldson thereby achieved some local fame, through no achievement of his own.

Doonies This ancient name is recorded in 1234 as Downy and in 1309 as Duny (still the modern pronunciation) and appears in 1561 in the rental of Coupar Angus abbey. In the Jacobite era the 'Doonie Lands' belonged to the Farquharsons of Broughdearg in

Glenshee, and later to the Rattray family. The property formerly (1807) consisted of Meikle and Little Doonie.

Doune In the Angus glens this term nearly always represents the Gaelic *dubhan* – 'little black (stream)'. Occasionally it can be *deubhan*, from *deubh* (pron. **jiav**), to shrink or dry up; only the topography can indicate which etymology is the appropriate one, since there is nobody left to tell us the Gaelic pronunciation.

Doune is a water-word, but it has given a name to at least four different hills in the Glenesk-Lethnot area. Queen Victoria, in her progress over the Keen mounth in 1861, admired the 'Hill of Doun', which she described in her journal as 'a very fine isolated craggy hill – overtopping a small and wild glen'; she was actually looking at what is now called Craig of Doune, which frowns over the narrow Glen Mark. (In fairness it may be added that the Queen probably did not carry a map, and would take the names of landscape-features from her Highland servants; this would also account for the somewhat odd phonetic spellings which she occasionally used).

Downie Park The property of the earl of Airlie, it was sold at the beginning of the 19th century to one of the Rattrays of that Ilk, who built a splendid mansion on the hitherto vacant ground. Colonel Rattray had been in the East India Company's Bengal Service, and had the reputation in the glens of being a nabob who had made his fortune 'by killin' fowk an' takin' their property and money oot o' their pockets in the East Indies'. The old soldier survived his numerous younger relatives, and on his death was buried in a green sward near Inverquharity. His grave was disturbed in a sudden spate, and such were the superstitions of the local people that the remains had to be re-interred elsewhere, and finally in the Howff of Dundee. Downie Park was rejoined to the Airlie estates, and as far as one knows the nabob's soul rests in peace.

Driesh Driesh and its neighbour Mayar are two unspectacular summits, together forming a continuous ridge; but because of their entitlement to be classified as Munros and their proximity to Dundee, they are familiar to most hill-walkers. Their etymologies are almost completely obscure; and the accepted derivation of Driesh from Gaelic *dris*, a thorn or bramble, hardly fits in with the barren nature of the terrain. Seen to best advantage from the entrance to Glen Prosen, Driesh and Mayar don't really deserve their contemptuous nicknames of 'dreich and mair dreich'; and indeed the northern corries of Driesh are quite picturesque and offer some good scrambling. The ascent of the Scorrie buttress is classified as 'mild severe'.

Drosty The association of St Drostan with Glen Esk is based on tradition rather than historical evidence. In popular belief, Drostan was a Pictish convert to Christianity who lived in the glen for a period around 600AD, and preached as a missionary in the Tarfside area; his name came to be associated with several features of the landscape. Drousty was the name of an inn at the south end of the Mounth road, later applied to the manse built on the site (now rather grandly known as the House of Mark). In the vicinity were Droustie's Meadow and Droustie's Well. Still later, the Episcopal church at Tarfside in the diocese of Brechin, replacing an earlier chapel on the Rowan, was consecrated as St Drostans (1880). See also notes under the ***Cross Stone***.

44

Drumwhallo This is without doubt the same name as Drumfollow, but neither form gives much of a clue as to the etymology. There are at least four possible interpretations of the second syllable: *folach* (rank grass); *falamh* (empty); *falach* (concealment) and *falach* (the genitive of *fail*, meaning a ring). Drumwhallow is the form to be found in Ainslie's map, without the Shank element. The current OS map gives both Shank of Drumwhallo (on the Prosen side) and Shank of Drumfollow (on the Clova side) as two separate hills; but together they form the long ridge followed by Kilbo track.

The Shank additive clearly belongs to the post-Gaelic period, and it looks as though the 'whallo' form is probably more reliable than the 'follow' version. If one were forced to spin the mental coin the choice would probably be 'empty ridge', which is certainly a fair description of the terrain.

Dunlappie A former ('suppressed') parish, and a rectory in the diocese of St Andrews (1574 'Dunloppie'). Dunlappie Dyke, a 14th century linear earthwork, stretched for over two miles, possibly as far as Auchenreoch where, according to tradition, a battle was fought between the army of David I and the rebellious Mormaer of Moray. The dyke itself, which is recorded as early as 1319, is thought to have marked the boundary of a royal hunting forest.

Durward's Dike The lands of Lintrathen in the early 13th century belonged to the powerful magnate Alan Durward, at one time earl of Atholl and a claimant to the Scottish throne. The dyke formed the boundary of his mediaeval deer-park, and the remains of it can still be seen running across the east side of Formal hill. A stone erected by the Airlie family in 1881 marks the point where the dyke crossed the Craigisla-Bridgend road. The nearby Peel farm is on the site of the Durwards' castle.

19 *The Durward Dike Stone, Lintrathen*

In 1401 Sir Walter Ogilvy of Auchterhouse married the Durward heiress and so acquired the whole barony of Lintrathen. This signalled the rise of the Ogilvy family, who became established in Glenisla, and later in Airlie and Cortachy.

East Mill of Glenisla In 1745–6 the property was occupied by Thomas Ogilvy, a descendant of the House of Airlie; imprisoned after Culloden, he died in 1754 while attempting to escape from Edinburgh Castle. His third son, Thomas, became laird after the death of his two brothers, and in 1765 he married an Angus heiress. Thereafter follows a series of scandalous and horrifying events beginning with a curse being put on the family and culminating in a public execution for murder. Along the line this sordid story (too complicated as well as

unseemly to relate here) involved malicious gossip, perjury, suicide, incest, arsenical poisoning and a botched hanging in the Grassmarket in Edinburgh.

Edzell Nowadays the name refers to a parish, village and castle; originally Edzell was the centre of the late-mediaeval lordship of Glen Esk. Old Edzell was at the site of the castle, a mile west of the present village and at the entrance to Glen Lethnot. The present village was feued and laid out by Lord Panmure in 1839; prior to that it had been known as Slateford (a reference to the slab-like stones which provided a crossing of the North Esk). Since 1715 the Dalhousie family have been the landowners; the memorial arch was erected in 1887 in memory of the 13th earl and his countess.

20 *The Dalhousie Arch, Edzell*

Earlier forms of the name are not in short supply – 1204 Edale, 1250 Adel, 1267 Adall; and Pont has 'Edyell'. It is nowadays pron. **ed** zell, although formerly it was more like **aigle** (the letter z in Scots always being a guttural). Among the simpler explanations which have been put forward are the Gaelic *ath dail* ('ford land') and the Scots 'Esk dale', i.e. a piece of land pertaining to the Esk. But as yet there's no agreement among the experts.

Eggie This isolated Clova farm must have been part of a fair-sized township at one time. Timothy Pont's map (*c*1590) shows 'O', 'M', 'N Eygy' (which presumably mean Over, Mid and Nether Eggie), and also 'Fettyreygy' (***Fettereggie***). Ainslie's map (1794) has 'W. Agie' and 'Lit. Agie'. The current OS map has only Wester Eggie; Little Eggie has gone; and Colin Gibson noted that 'the locus of Easter Eggie is known to few'; (in any case, perhaps the association of Easter with egg began to sound altogether too comical). The name Eggie would originally refer to a single estate, which was subsequently divided (in this case into no less than five parts). Eggie is (in the terminology of the ***Introduction***) the 'headword', and the others are derivatives.

Esk In the ***Introduction*** it is explained how it comes about that two of the main rivers in Angus share the same name. The note on ***West Water*** reveals that Angus may at one time have had a third River Esk. A common usage is to be found in the writings of Ochterlonie, who speaks about 'water of Northesk' and 'water of Southesk' as well as 'West Water'. The Statistical Account (1791) however refers to the North Esk as the 'East Water', and describes it and the West Water as 'the two radical branches of the North Esk'.

Visitors do still get confused with the Esk terminology, and would probably prefer to revive an idea of one of the early map-makers who names the South Esk as 'Clova River'. Not a bad idea, except that Montrose Basin, where the South Esk debouches, is a far cry from Glen Clova.

46

Falls of Drumly Harry Timothy Pont has 'Drymnahary' and Ainslie has 'Drumblie-harie'; so a Gaelic etymology such as *drum liath na h-airidh* seems to be the likely one ('Harry' was formerly written 'Airy'). If you insist on a Scots derivation, you might come up with the adjective *drumly* ('troubled') and would have to find a person called Harry who answers to that description. The concept of 'trouble' and unrest was probably associated in the popular imagination with the name of the nearby Dowf Hole – *dowf* being a Scots word for dreary, gloomy. Indeed it is a somewhat melancholy place.

Finbracks The 'false man' etymology is corroborated by the occurrence of this concept in other parts of the Highlands, the nearest being *Mudlee Bracks*. Most of the dry-stone columns referred to as 'false men' have long since collapsed, but one is still to be seen above the Clash of Wirren. Apparently they were erected less as guide posts than as decorative landscape features; and from a distance they look strangely like human figures.

Finnoch The name is descriptive of the croft's sunny position in Glen Lethnot, and is said to contrast with *Tilliewhillie* on the other side of the glen. Pont's spelling of 'Finnheuch' hints at the Scots *heugh* (crag); but this doesn't at all fit the terrain.

Fornethy Pont calls the place 'Fornate', and it was also known as 'Fornichty'; the name also recalls Forneth in Perthshire; see also *Middleton*. Since 1965 this property has been a residential school for convalescent children from Glasgow in need of a holiday.

Forter Forter has a long recorded history, its position being of some strategic importance as guarding the pass to Glen Shee; in the 13th century it appeared as 'Fortuhy' and in 1470 'Forthir'. Originally the land was in the possession of the Durwards of Lintrathen, who (uncharacteristically for such go-getters) made it over to Coupar Angus abbey; the 1561 rental of the abbey includes *inter alia* the farms of 'Little and Meikle Fortar'. The present castle was a 16th century Ogilvy stronghold, destroyed in 1640 in circumstances narrated in the well-known ballad *The Bonnie Hoose o' Airlie*. Thereafter the barony of Forter was acquired as clan territory by the McCombies of Glenisla; but the Ogilvy castle, having been occupied for only eighty years, stood derelict until it was restored in the 1990s.

Freuchies A heathery place near Kirkton of Glenisla. The Gaelic name of the shrub has given rise to place-names wherever the language was spoken, from Freuchie in Fife to Fraoch in Kintyre. The Angus name dates from as early as the 13th century, when it appears as 'Frucuchy'; it figures in the Coupar Angus abbey rental in 1451 as 'Ffrohym' – a holding consisting of Eastmiln, Kirkton and Tulloch. At a later stage the hamlet comprised Milton of Freuchie (a meal mill and limekiln) and the farms of East and West Freuchie. The modern usage reflects the subsequent amalgamation of two of the farms; West Freuchie is now a residential steading-development.

Gallow Hill There are over a hundred place-names in northeast Scotland containing the term 'gallows', and at least four in our area. While there is seldom evidence of their having been used as places of execution, they appear to have been important meeting-places or even the site of a court in Pictish times.

Gannochy The Gannochy estate now owns much of the land in lower Glen Esk. Of more interest to the reader is Gannochy Bridge, with its spectacular views up the Esk gorge. According to the First Statistical Account, the bridge was built in 1732 at the expense of a local farmer named James Black, who also constructed the parapets with his own hands. Before that the crossing of the North Esk had involved a long detour and a dangerous ford at which several lives had been lost the previous year. There was a local tale to the effect that Black received nocturnal visitations from the spirits of the drowned, instructing him to build a bridge at the location of the present crossing; the bridge was widened in 1895 by the riparian proprietors (without the necessity of supernatural exhortation).

21 *View from Gannochy Bridge, Edzell*

Gella It is really a water-name, cf. Gelly Burn, Lochgelly, Glen Geldie. Gella may once have been the name of the (now anonymous) clear stream on which the croft is situated. Ainslie's map has 'Getlaw', which looks like an aberration.

 The old Gella Bridge as seen from the west is a beautiful single-arched span; from the east it is obscured by the squat concrete bulk of its modern replacement.

Gilfummen A source of lead in bygone times. Edward writes in 1676 that the miners in Gilfummen were 'digging deeper every day'; but like all the other attempts at mineral exploitation in the glen, this led to no profitable outcome. Remains of a mining complex, including the open entry to the mineshaft, are still to be seen at the cliff at Gilfummen.

Glack This element is the Gaelic word *glac*, which has basically an anatomical meaning, to wit the palm of the hand, or sometimes the angle between thumb and forefinger. In a landscape context it usually has the meaning of a dip, a hollow, or even a ravine; and the Scots derivative *glack* is almost always used in this sense.

Glad Stane There are several 'Gled Stanes' in Scotland; it was Gledstanes in Lanarkshire that was the origin of the celebrated surname. The Glenisla stane is an immense boulder at West Mill; according to legend it was hurled from the summit of Mount Blair by the local giant.

Glas Maol The highest point in our area of study (by a few feet) and the meeting-place of three counties – Angus, Perthshire and Aberdeenshire. Despite this, as a summit Glas Maol is something of a nonentity. Its smoothness is its most notable characteristic; there is no discernible path to the cairn, and you could push a pram over most of its terrain. It is only fair to add however that its west crag is (in the words of a knickerbockered Victorian climber) 'of perpendicular abruptness... thickly coated with scree'.

The alternative etymology of 'grey bald head' is one that commends itself from a toponymic if not a linguistic angle; the occasional spellings 'Mhill', 'Mile' and 'Mell' seem to indicate a pronunciation which confirms the *meall* etymology.

Gordon's map of 1664 gives the hill no mention, and Colin Gibson did not bother to sketch it. The prosaic truth is that the summits on this high rolling moorland were never of much account; if grid references had existed in the 18th century probably nobody would have bothered to give them names; and if the Ordnance Survey hadn't committed these to paper they might well have all been forgotten – as some of them undoubtedly were.

Glen Beanie This prominent side-glen near Forter has given its name to a loch on the other side of the Glenshee watershed. Loch Beanie was formerly called Lochan Schechernich, probably from Gaelic *sidh charnaich*: *sidh* is the type of 'fairy hill' that gave its name to Glenshee, and *carnaich* describes the stony nature of these moraines.

Glen Brighty The name was formerly written 'Brichty'; Timothy Pont's map gives 'Brachty'; both of these seem to corroborate the *bruaich* derivation, which also fits the topography. In Scots it would have been 'brichty' (as in 'Crichton'); the modern pronunciation has no doubt been assimilated to 'bright' and Brighton.

In 1558 the forestership of the glen was let to one John McAllan, with permission to graze one hundred cattle beasts; but cattle from Glenshee and Strathardle were not to be admitted.

Glen Clova Although the early forms are well documented (1328 'Cloveth', 1450 'Clovay') there is no agreement on the derivation of the name; there are not even any convincing suggestions. The most ingenious of them is that the name comes from the Gaelic word *clobha,* meaning tongs: the basis of this derivation is that the road up the glen divides into two parts at Gella and rejoins at Clova village, in the shape of a pair of blacksmith's tongs. This is imaginative folk etymology combined with a modicum of scholarship; and what makes the suggestion impossible is that the name Clova must precede the construction of the road by many centuries.

Glen Clova, drained by one of the largest rivers in the county, is considered by many to be the jewel in the Angus crown, and is certainly the one most frequented by climbers and other visitors.

Glen Doll A somewhat contrived modern glen-name. Edwards' map of 1678 and Moll's of 1725 both show 'Dolar Water', but this is probably a mistake as both men use the name to refer to the part of Glen Clova north of Braedownie. General Roy's Military Survey of 1755 shows Glen Doll; forty years later Ainslie's map leaves Glen Doll nameless, but shows it as the course of the White Water; with 'Dole' shown as a croft at the foot of the glen. (Interestingly, the old pronunciation of the glen name was **Dole**). As recently as the Bartholomew maps of the 1960s it is called 'Glen of the Doll', and it seems clear that it was the habitation known as 'The Doll' (NO 279 759) that gave its name to the glen. The etymology must remain uncertain.

The name of Glen Doll is now firmly established in the vocabulary of visitors; traversed by Jock's Road, it is a favourite with long-distance walkers and was the subject of a notable triumph by the Scottish Rights-of-Way Society over a landowner who tried to close the route in the 1880s. The glen is also famous as the habitat of rare arctic-alpine plants.

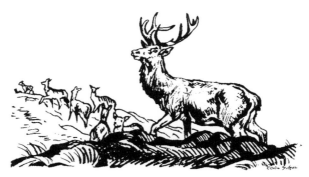

22 *Red deer in abundance*

Glen Effock The name of this estate appears in the Register of the Great Seal of Scotland for the year 1511 as 'Glen Effo' and 'Glenoffy'.

The overabundance of red deer on the Angus hills is a recent phenomenon. It is recorded that in the early 19th century they were so scarce that in 1853 three dozen deer calves were brought to this glen in carts from the Breadalbane estates on the Black Mount; the rest is (natural) history. The glen was also famed for its illicit whisky stills.

Glen Lee In topographical terms the glen extends from Muckle Cairn near the Aberdeenshire march right down the Water of Lee and along Loch Lee to Invermark. This once-populous valley had communities at Dochty, Littlebridge and Glenlee, all of them now deserted. Further up the glen, the Stables of Lee were built by the Dalhousies around 1870 as a shelter for stalkers and a stable for ponies. They apparently are still used when deer-carcases are brought down from the hills.

Glen Moy The glen was thickly forested with Scots pine and larch, most of which were felled between 1939 and 1945. With Glenmoy farm (NO 403 647, formerly called 'Hindhaugh') now empty, this potentially beautiful glen today has a strangely desolate look.

Glen Tennet A very remote and desolate vale, running north from Tarfside to the Aberdeenshire border, unrelieved by any spectacular summits. It was once quite well-populated, and the place-names (***Arsallary, Lochylinn, Linnbeg***) give evidence of crofting and cattle-rearing. Now it is a vast sheep-run.

The 'fire' element in the name Tennet seems to relate to the stream; but Ainslie's map calls the glen 'Tinmount', hinting at an earlier form such as *teine monadh*, which would mean 'fire hill'. The glen was part of the lands of Carrecross.

Glencally The name of a croft at the foot of a side-glen of Prosen, now derelict but clearly shown on Pont's map. After the Scottish defeat by Cromwell at Dunbar in 1650, the twenty-year-old and yet-to-be crowned Charles II gave his Presbyterian minders the slip and made for Cortachy, where he expected to meet the Angus nobles with a loyal army behind them; when this failed to materialise he travelled up the glen. There is however some doubt as to whether his destination was Clova or Prosen. A contemporary account is graphic, but short on place-name evidence:

'The King's majestie, as if going out hawking, went away from St Johnstone [Perth] on[e] horsse backe about haffe ane houre past one in the afternoone, accompanied only with these following servants: ...the Earle of Buchan and Vis[count] Didope conwayed him to Cortuquhay, the dwelling-place of the Earle of Airlie, ane excommunicant papist, quher, after a little refreshment that same night, he rade with a guard of 60 or 80 heighlanmen upe the glen to ane doure cottage belonging to the Laird of Cloua; in al from Perthe, the way he went some 42 myles before he rested. On Fridayes night, 4 Octob. [1650] a little befor day having layed him to reste his weiried bodey, laying in a nastie roume on[e] ane old bolster aboue a matte of segges and rushes over weiried and very fearfull, he was found by L[t]. Collonell of Sa'nfurd and Colonell Bynton, ane Englishman'.

There used to be a tradition that this was on Glencally land, and a century ago a local historian reported that the ruins were still to be seen. With the kindly help of an elderly local lady I discovered a rickle of stones that might well be the remains of the 'doure cottage' which afforded shelter to the not-so-merry Monarch.

Glencuilt A lonely farm in a branch of Glen Moy. No such valley as Glencuilt is shown on the map, and the name seems to derive from a nearby habitation called 'Cult', shown on Timothy Pont's map; the old name is preserved in the 'Burn of Cuilt' which drains the valley. Other examples of similar unmarked glens are ***Glenarm*** and ***Glenquiech***.

Glencuilt is now totally deserted, and the foundations of its surrounding crofts are barely discernible in the encroaching heather. Missing even from the map is the track that once led over the hill to Glen Clova, a bare two miles away.

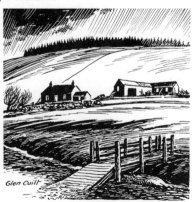

Glen Cuilt

23 *Glencuilt – the glen that never was*

Glenisla The church of 'Glenyliff' or 'Glenylit' at the foot of the glen was dedicated to the Blessed Virgin and was annexed to the abbey of Coupar Angus. A scattered hamlet grew up round the church, becoming the Kirkton of Glenisla; it is the only village-sized settlement in the glen, and now boasts two small hotels, a school and a post office. The present Glenisla House is a 19th century mansion, built on the site of old house of Inverharity. See also under *Isla*.

Glenmarkie Only the lodge remains on current maps; the glen is not marked, and its burn is called 'Newton'. The estate of Glenmarkie is of some antiquity: it is recorded in 1514 as 'Glenmerky' and later in the same century Pont calls it 'Glenmarky'. At one time three-quarters of these lands belonged to the earl of Argyll, and indeed for many years were known as 'Argyle's Barony' (see p.21).

Glenogil Wester Ogil was the site of a former castle; it belonged, along with the rest of the estate, to the Lyons, a branch of the family of the earls of Strathmore, and who were at one time thanes of Tannadice. Glenogil House was built in 1857 and demolished just over a century later.

Glen Ogil reservoir was formed by damming the Noran Water so as to provide a piped water-supply for Arbroath (this was at the suggestion of Provost Webster who used to holiday there in the early 1900s). Another reservoir, in the side glen known as Den of Ogil, was created to supply Forfar. No doubt these arrangements have long since been superseded. But read on.

The Statistical Account of 1791 contains an interesting and surprisingly topical observation: it appears that 'the unfortunate dwellers in the Glen of Ogil' are afflicted with the 'louping ague' which apparently 'resembled St Vitus Dance' and which resulted in the sufferers 'leaping in a very surprising manner while in paroxysm', even as high as the rafters. This alarming condition could be induced by any 'sudden noise such as the clattering of tongs'. The parish minister who wrote this account, had he lived two centuries later, might have been advised that the ailment was in fact related to *spongiform encephalitis*, whose prototype is scrapie in sheep and which leads to BSE in cattle and Creutzfeld-Jacob disease in humans. It is fair to add that scrapie, though endemic throughout Scotland for centuries, only came to prominence with the misguided and dangerous practice of including sheep carcases in cattle feed. Gratuitously, one might add that scrapie was so called because the woolly sufferers scratched themselves bare.

Greenbush *Bush* in Scots could mean a thicket or clump of trees (see *Birkenbush*). An odd feature of upper Glen Mark is that the precipitous hillsides just below the Queen's Well are studded with self-sown birches; the terrain keeps them permanently stunted, and the rocky backdrop makes them look unusually green. The name clearly belongs to the Scots-speaking period.

Gryp's Chamber Gryp (strange name) was a reiver who lived in a cave of this name above *Carlochy* in Glen Lee; the story goes that he issued from his 'chamber' at night in order to carry out a systematic depredation of the neighbourhood. He would nowadays have little scope for plunder in this depopulated glen.

Hole The local term for cave seems to have been hole; there are at least eight 'Hole' names in Angus. The Glenisla cave was the legendary abode of a witch; Hole Burn is part of Glenisla forest.

'Hole o' Wemyss' seems to have been almost a generic term for a souterrain or cave, and it occurs in at least two other places in Angus. The most celebrated is Hole o' Weems in Glen Clova, a naturally-formed recess caused by a rockfall from the crags of Red Craig; it was here that the last chief of the Lindsays of Clova took refuge from his enemies in the early 1600s. It is sometimes called 'Charlie's Cave' by the locals; but Prince Charles Edward never got nearer to Clova than when he spent a night at the Salutation Hotel in Perth in the late summer of 1745. The local tradition is possibly a distorted folk-memory of the visit to the glens of his great-uncle, Charles II, a century earlier – see note under *Glencally*.

Inchgrundle A functional sheep-farm at the limits of habitation in upper Glen Esk.

The Angus glens abound in odd and unexpected associations. Inchgrundle was for many years the holiday home of Dr Thomas Guthrie, a man better known in the mid 19th century than now, and whose imposing statue is to be seen in Princes Street Gardens. He was the leading churchman of his day, a noted preacher and apostle of the 'Ragged Schools' movement. Apparently his habit was to hold open-air services at Invermark, to a congregation a hundred times larger than he could possibly expect today.

Inchmill The Gaelic word *innis* is related to Latin *insula* and has the primary meaning of island. In the place-nomenclature of the Angus glens however it always has a secondary meaning such as 'riverside meadow', 'resting-place' or 'green spot', and appears in its Scottish form of *inch* (cf. the North Inch in Perth).

Inchmill is a case in point. The *inch* would have been a meadow where the burn from Glen Tairie joins the Prosen Water, and which provided the power for a corn mill (Gaelic *muileann* – an early form of the name was 'Inchmillne'). Ainslie's map of 1794 shows 'Inch Mill' near the burn mouth, where there is still evidence of a derelict mill. Whatever the original designation of the stream, it came to be called the Burn of Inchmill, and this is the form in which the name survives on the map. The settlement near Inch Mill (which apparently once boasted a hotel) was until the 19th century called Pitcarity; it now goes under the name of Prosen Village.

Inshewan The identity of the eponymous Ewan has not been ascertained. Inshewan being an Ogilvy possession, it followed that the Lowland parish of Tannadice had a strong Jacobite following. It is recorded that in 1746 Captain John Ogilvy led the Tannadice men back to Inshewan and disbanded them there.

Inverharity A complicated name, this one; it closely resembles the better-known **Inverquharity**, and they may share the same origin. Its earliest form 'Innerthariadethyn' is baffling; in the 13th century it appears as Invercharity; Pont has Innerherrity, and Ainslie Inverhardy. Wester and Easter Inverharity ('with the mill thereof') were included in the rental account of Coupar Angus abbey in 1561; there is a separate entry for the 'Quarter of Inverharity'. The land was later a Lindsay barony. According to tradition there was in the early 17th century a house at Inverharity built with their own hands by two brothers

named Downie who were men of gigantic strength; in the 19th century the property got the name 'Glenisla House'. Another of the brothers' recorded feats was the erection of two immense stone gate posts at Gobentor.

Invermark The name refers to the junction of the Water of Mark and the Water of Lee, which together become the River North Esk thereafter. So the name does not imply the existence of a settlement, although there probably was one by the 14th century when Invermark was part of the Stirling lordship of Glenesk. Invermark Castle was built in the early 1500s as a stronghold of the 'Lichtsome Lindsays'; the 9th earl of Crawford died there in 1558. Later it was the hiding-place of the earl's unfortunate grandson, when he was on the run after slaying Lord Spynie (see *Hole o' Weems*).

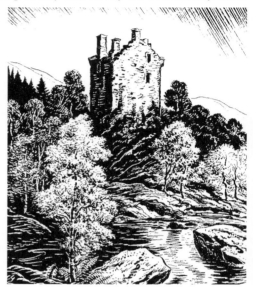

24 *Invermark Castle*

The castle was designed, as the fortifications still show, as a defence for Glen Esk against marauders from the west and north. A contemporary account (Ochterlonie, 1684) tells us that 'the Laird [Lord Lindsay] can, upon very short advertisement, raise a good number of weill armed prettie men, who seldom suffer any prey to goe out of their bounds unrecovered'. There was no door at ground level, the castle being entered by a drawbridge; one end rested on the sill of the castle's first floor and the other on a 12 ft high pier ascended by a flight of steps. The original yett, erected only after royal permission, is still visible on the south side. The castle, having been forfeited in 1746 on account of the involvement in the '45 Rising of its then owner (Lord Panmure), fell into disrepair but was restored sufficiently for it to be occupied by two of his female descendants until 1803; thereafter the stones of its outbuildings were pilfered to erect the nearby manse.

Invermark Lodge, a shooting-box built by the Rt. Hon. Fox Maule, earl of Dalhousie, in 1854, was visited by Queen Victoria in 1861: she described it as 'a new and very pretty house, built of granite, in a very fine position overlooking the glen, with wild hills at the back', – and nothing has changed since then. Glenmark Cottage, further up the glen, is on the site of an earlier stalker's house, described by the Queen as 'a regular Highland cabin, with its usual "press bed"'; she had luncheon there and 'sketched the fine view'. To complete the Invermark contingent, there is the 'House of Mark' which was the old Manse of Loch Lee and which now provides one of the few hotel facilities in upper Glen Esk.

54

In the 19th century the whole of this area became a vast deer-forest when Lord Dalhousie created the Forest of Mark, which included the royal preserves of Balmoral and the adjacent Airlie and Huntly lands. The result was to accelerate the already established depopulation-trend in the glens.

Inverquharity The name signifies the mouth of the Quharity Burn or its confluence with the South Esk; the 'inver' in fact occurs some distance from both the castle and the farm, in the middle of a wild and trackless wood just above Shielhill Bridge. An old rhyme goes 'The Prosen, the Esk and the Carity/Meet at the birken buss o' Inverquharity'; rather strange, as the three do not meet at the same point, and illustrative only of the fact that the rhymester apparently did not recognise that Carity and Quharity are the same name. The etymology is discussed under the entry for *Quharity*.

In 1405, the lands of Inverquharity, part of the barony of Kirriemuir, were resigned by one of the Douglas earls of Angus to Sir Walter Ogilvy of Carcary, Lord High Treasurer of Scotland. Two of Ogilvy's brothers became the founders respectively of the Inverquharity and Airlie branches of the family. Inverquharity Castle, a fine example of early Scottish baronial, was built in the mid 15th century and remained with the Ogilvy family for 300 years until it fell into a ruinous state with the departure of the 8th baronet to Baldovan near Dundee. Inverquharity Castle then passed to the Kinnordy estate, remaining a ruin until the 1960s, when it was restored as a country residence in its beautiful setting on the banks of the burn. There is also a Roman camp site at NO 405 580.

Inzion There are several possible Gaelic etymologies for this odd name: *eanga* – a crook, corner; *innean* – an anvil; *ingheann* – a maiden; and *uaine* – green. What is not in doubt is that the 'z' is a printers' way of indicating a sound like the second syllable of 'onion': this is demonstrated by Pont's rendering of the name as 'Ingyn'. The name may be compared with Enzie (Buckie) and Inshewan. The Inzion Burn was diverted to its present course many years ago by the laird of Balintore in order to make a fishing-loch.

Ireland A Gaelic etymology has also been suggested – *iar* land, or 'west land'; but it has to be said that a Scots-Gaelic hybrid of this kind would be unusual. Colin Gibson recalled when the croft 'housed a shepherd and his wife and family; ...it was a very pleasant place with its burnies near the door, its tall ash-tree and its happy sound of children's voices'. Many a deserted dwelling in the glens could answer to that description.

Isla One of the three main Angus glens, referred to in 1234 as 'Strathyliff'; this is interesting, as it is the only Angus glen wide enough to be described as a 'strath'. There is an abundance of early forms in the records – 1165 Hilef; 1233 Glenylif; 1234 Glenylefe; 1248 Glenylef. Pont's map shows 'Yla', and modern Gaelic is 'Il'. The indications are that this, like so many other river names, was a continental Celtic water-word, possibly from the root *ilio* – to swell. The name of the River Isla may perhaps be compared with the River Ill at Strasbourg.

Jock's Road A relatively modern name for what was traditionally called the *Tolmount* ('Doll moor') pass, a track from Clova through Glen Doll to Braemar via Glen Callater.

55

It was too high and dangerous to be a regular crossing, but was an important drove-road and right of way. It was also the route taken by caterans from the west intent on plunder in Angus and the Mearns. (Raiders from Aberdeenshire would take one or other of the eastern Mounth passes via Glen Esk.)

25 *Old time cattle drover*

There has been much speculation as to the identity of Jock, but the legend goes that Jock Winter, a local man, stood up to the laird of Acharn and insisted on his right to walk the road through Glen Doll to Glen Callater. There is little doubt that such a man existed, and it was probably he who gave his name also to Winter Corrie.

Kedloch The early forms include – 1588 Kaidkach; 1699 Caidlauch; also Ketlo and (in Ainslie's 1793 survey) Kidloch. None of these substantiate the ingenious suggestion of Gaelic *cadal theach* – rest house or hospice, despite evidence of the existence of such a place on the Fir Mounth track. The alternative spelling 'Cuttlehaugh' looks like a perversion, but a comparison with Cairn Caitloch is valid. The burnside was the site of a whisky bothy in bygone days.

Keenie The farm lies on the south side of the Esk and must have been rather inaccessible before the building of the present bridges at Millden and Corharncross. This gave rise to the local saying that 'there's a road to Heaven and a road to Hell, but nae a road to Keenie'. The Burn of Keenie is the largest of the many streams that rise in 'the lang-backit Hill of Wirren' (see **Wirren**). Old forms include 'Inverkeny' (1511, indicating that Keenie was originally a stream-name) and 'Kenie' (1588); Pont has 'Mill of Keny' and also Craig and Burn of Keenie.

Kenny The lands of Kenny appear in the records as early as the 13th century; the owners were the Ochterlonies, a noted Angus family who did homage to Edward I in 1296.

Cardinal Beaton of St Andrews was feudal superior in the 16th century; the property passed to the Ogilvies about that time. The name appears on today's maps only as referring to Meikle Kenny (NO 309 537) and Little Kenny (NO 303 540).

Kilbo Ainslie's map shows 'Shielings of Kilbo', the only habitation in upper Glen Prosen. All that remains is a picturesque ruin and tumbledown sheep-fank in a beautiful part of the glen, where the mountains crowd round the infant Prosen Water. But the ruin is a landmark, which gives its name to Corrie Kilbo and the Burn of Kilbo on the Clova side of the pass and to a track over to Glen Doll. Kilbo also occupies a strategic position as being close to the watershed at the north end of Glen Finlet, and forms a notional half-way-house on a long-distance walk from Glen Isla to Clova through the col between Mayar and Driesh. Roy's survey of 1755 shows 'Glen Kilbuck', by which he probably means the narrow and picturesque part of Glen Prosen, now called White Glen on the map if not in popular parlance.

While the etymology offered is conjectural, the name is unlikely to involve the element 'kil' (Gael. *cil* a cell or church) so common in the west of Scotland; that term had ceased to be productive of place-names by the time that the Gaels had entered Pictland; in any event you would not find a church in such a remote place as Kilbo.

Kilgarie The name of a farm on the southern slope of the Brown Caterthun, it takes its name from the Garie Burn. It was formerly a royal deer-forest; the remains of its boundary-dyke are still to be seen, but all trace of the royal residence have long since disappeared. Unlike later 'deer forests', this one covered the hills of Caterthun and Lundie and much of the neighbouring land.

The earliest spelling is 'Kilgarre' (1319); the pronunciation should tell us that this is completely different from the name Calgary, which is Norse in origin. The prefix *Kil-* is explained in the note to ***Kilbo*** above.

Kilry The barony of Kilry was owned by James Kinloch of Kilry, and later by the Kinlochs of Meigle. Glenkilry was a laird's estate in the 18th century. The present hamlet of Kilry (with its mansion and its post office at Craigisla Bridge) was at that time known as 'Ruthven'. The Hill of Kilry was an important source of peat for the locality. There is also a Burn of Kilry, the farm of Little Kilry, and Kilry Lodge.

An earlier spelling was 'Kilrie'; the prefix *Kil-* is explained in the note to ***Kilbo*** above.

Kinclune The property stands on a shelf above Kirkton of Kingoldrum and commands fine views over the western Carse of Gowrie. It was once claimed that this is the highest area of cultivated land in the United Kingdom.

A Fenton estate in the 1500s; the Ogilvies of Balfour feued the lands in 1558 and sold them in 1618. They passed to the Stormonth family in the 18th century.

Kingoldrum The church lands of Kingoldrum were held by the Monastery of Arbroath under a royal grant of 1178 by William the Lion; the earliest recorded form 'Kingoueldrum' dates from this time. The lands were later owned by the Ogilvies of Balfour, with Cardinal Beaton as feudal superior. Kingoldrum was at one time a royal hunting forest, marching with the Royal Forest of Alyth.

The local minister who contributed to the Statistical Account of Scotland (1791) wrote that the men of Kingoldrum 'possess all the spirit and activity of Highlanders' – an odd remark, since less than fifty years previously there had been complaints about ne'er-do-weel marauders from Gaeldom. In more recent times the hamlet of Kingoldrum was described by J M Barrie as 'the most beautiful village in Scotland'.

Kinnordy The birthplace in 1767 of Charles Lyell, distinguished Victorian botanist and man of letters; and (in 1797) of his son, Sir Charles Lyell the famous geologist.

The Loch of Kinnordy is the site of a Bronze Age crannog; drained in 1730 for marl, it is now a bird sanctuary.

Kirkhillocks Part of 'Argyle's Barony' of Glenisla (see *Glenmarkie*). The lands were gifted to the earl of Airlie by Abbot Donald of Coupar Angus abbey in 1560; they then passed to David Ogilvy of Glasswall. In 1650 they were bought by McCombie Mor (see *Crandart*) and later in the same century were sold to the Rattrays of Rannagulzion.

Kirkton Kirkton was a common name for a village or farm associated with a church – e.g. Kirkton of Glenisla, Kirkton of Kingoldrum. The one at Invermark had a kirk and manse, a dominie's house and a cottage or two. The hamlet is shown on Ainslie's map, but not dignified with a name; and nowadays there is not much permanent habitation hereabouts.

Kirriemuir Kirriemuir was created a burgh of barony in 1459, one of the first places in Angus to attain that distinction. It soon outgrew its village status and is now a small town of some importance (if somewhat less so than the royal burghs of Forfar and Montrose or the cathedral city of Brechin). Roy's map (see *Introduction*) was made for political and security reasons, and one might be tempted to take offence at the appearance of this name with the spelling 'Killiemuir'. But this is not an example of the carelessness of officialdom, for the rogue spelling 'Kylymure' appeared in 1485 and 'Auld Killamuir' remained an affectionate name for the town until comparatively recent times. Nevertheless, the intrusive 'l' is an aberration (probably caused by assimilation to the numerous *Kil-* and *Killie-* names in Scotland) and it is generally agreed that the meaning is 'big quarter'.

Ladder 'The Ladder' (which doesn't appear on any map) popularly refers nowadays to the winding path ascending from the flat bottom of Glen Mark to the ridge of Mount Keen (but who ever saw a ziz-zag ladder?). The true origin is the Gaelic *leitir*, which means a hill-slope, sometimes terraced; this element appears in place-names as 'letter', e.g. Letterfinlay, Findlater. The Ladder Burn takes its name from the slope; this turbulent stream is liable to flash floods, as many climbers making the descent from Mount Keen have found to their cost (the author included).

Ledenhendrie It was the uniform practice in rural Scotland for proprietors and even tenant farmers to be known by the name of their property. The son of the farmer of Ledenhendrie was John Macintosh, born around 1680 and known to history as 'Young Ledenhendrie' (see notes to *Saughs* and *Peathaugh*). His troubles were however not ended by the satisfactory outcome of the Battle of Saughs, for he appears to have come

under what we would now call a *fatwah* in the eastern Highlands and his life was continually at risk from the fellow-clansmen of the vanquished caterans. So much so that the laird, the earl of Southesk, provided him with a fortified dwelling; this however, was not sufficient, and in order to escape a nocturnal ambush he was obliged on one occasion to take refuge in a crevice in the rocks in the den of Trusta – a place which still appears on the maps as Ledenhendrie's Chair.

Lethnot The kirk of Lethnot became a prebend of Brechin cathedral in 1384, the patronage being with David de Lindsay, lord of Glenesk. Its early history was a chequered one, and according to legend, its construction was impeded by the Devil. The old (but not the original) building, dating from the 17th century was replaced in 1827, but it too was abandoned and de-roofed when the congregation was united with Edzell. The old parish of Lethnot joined with Navar in 1723; in 1954 Lethnot-Navar ceased to be a separate ecclesiastical parish and was united with the church at Edzell, which became Edzell-Lethnot parish church. Early recorded spellings are Lethnoth (1275), Lechnoch (1329) and Lethnotty (1359). The 'bare slopes' referred to are probably those of the valley of the West Water south of the present Bridgend; the map also shows a Mill of Lethnot on the Burn of Drumcairn.

What the map persistently fails to show however is Glen Lethnot; this is odd, for it is a well-defined Highland glen, and has been locally known as 'Glen Lethnot' for generations – and not as the valley of the West Water or of the Water of Saughs which is all the Ordnance Survey map-makers allow. However, a helpful notice at the north end of Edzell points the traveller to 'Glen Lethnot'.

The Lethnot in Glen Clova refers to an entirely different 'bare slope' and has apparently no connection with the parish name (unless its former Lindsay ownership is an indication that the name was borrowed from the family's lands in Glenesk). Ainslie's map shows a Wester Lethnot at NO 369 655; and the former holding of Easter Lethnot (NO 376 636) now appears as 'Middlehill' on the OS map. The lands of 'West Lethnot' were an Ogilvy property in the 18th century; there was also a chapel of which nothing seems now to be known.

Lintrathen The etymology of the name is very uncertain, but more likely to be as given than are the alternatives of 'rapid linn' and *linn an-t'abhainn*. Early forms include Luntrethyn (1250); also 'Lantrithyn, Luntrathin'. The Barony of Lintrathen was a vicarage in the diocese of St Andrews; the present church is on the site of a mediaeval chapel built by the Durwards of Peel (see ***Durwards Dyke***). In the late 13th century Sir Walter Ogilvy acquired Lintrathen by

26 *The Loch of Lintrathen*

59

marriage with Isabella, daughter and heiress of Sir Alan Durward, and became founder of the house of Airlie.

In 1581 and for a long time thereafter an annual market was held on 11 November at Bridgend by Act of Parliament, 'that place having been considered most convenient for the districts of Glenisla, Badenoch, Braes of Angus, Mar, Strathspey, and other parts thereabout' (for the convenience of drovers, one must assume). The fair was later moved to Kirkton of Glenisla.

Before 1870 'Lentratham Loch' as shown on Ainslie's map was little more than half its present size, and occupied only the southwestern portion. The loch was duly deepened and enlarged; and in 1875 the 8th earl of Airlie was made a freeman of Dundee in recognition of 'the cordial and equitable way in which he granted a supply of water from Lintrathen' to the city. The honour was well-deserved, for the coming on-stream of Lintrathen solved a severe and long-standing problem affecting Dundee's public health. As well as being a public water-supply, Lintrathen Loch is a favourite resort for anglers and a nature reserve.

Loch Brandy Colin Gibson wrote of its '…primordial look, as if the roar of the Ice Age's avalanches had barely died away'. On a more prosaic note, the loch was said to have an abundance of 'great and good trouts'; indeed 100 years ago it had a boat on it, dragged there by an unimaginable feat of horse transport.

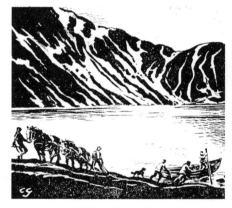

Loch Wharral This corrie-loch, nearly 2000 feet in the hills above Glen Clova, like its companion Loch Brandy 'offers splendid sport amidst utterly magnificent scenery' (as an anglers' guide puts it).

Wharral is however a more puzzling name than Brandy. It is probably descriptive of the Crags and not the loch; but if a Scots etymology is unconvincing one can turn to Gaelic. The word *coireal* in that language also means stone-quarry (and comes from

27 *Loch Brandy*

Scots); but another with the same spelling means noisy or loud-toned. The early recorded forms 'Orell' and 'Churl' go no farther back than the 18th century, and are not of much help with the etymology: but the concept of noise or crying is common in place-names, making the second of the Gaelic derivations perhaps the more probable.

Lochlee The remotest parish in Angus; there were no roads or carts prior to 1794. It was once fairly populous, but the Third Statistical Account relates that 'almost four-fifths of the population [of the parish] have gone, leaving only 126 permanent residents in an area of over 90 square miles; Berryhill is an almost forgotten waste; Glentennet and Arsallary are empty except for one or two weekend visitors; Glencat and Kedloch have been deserted for a century; Glenlee has only ruins to tell that at the beginning of the 19th

century over a score of families made their homes there'. These words were written more than fifty years ago: the situation continues to deteriorate.

Lochlee church, now a picturesque ruin, was sometimes known as 'Kirk of Droustie' – see **Drosty**.

Loups Bridge The Burn estate was owned in the late 18th century by Lord Adam Gordon, who was Commander-in-Chief of the forces in Scotland; at the time of the French

Revolution a number of French prisoners-of-war were held in the locality, and part of their hard labour consisted in blasting and building a footpath along the Esk gorge. It is thought that the footbridge over the Loups was constructed as part of these operations. It is possible in most years to view numbers of salmon leaping up the falls – but not from the bridge, which is now in a highly perilous condition.

Lunkard, The Neither the etymology of the name nor the location of the place is in doubt, nor that it relates to **Cairn Lunkard**, which is slightly higher up on Jock's Road.

28 *The Loups Bridge*

But we can only speculate as to which name came first, and whether the original form was the Gaelic *Carn Longphort* or the Scots *Cairn Lunkard*. The present shelter (also known as 'Jock's Bothy' and 'Davie Glen's Bourach') is nearer to Cairn Lunkard than to the spot marked The Lunkard; but who is to say that there wasn't an earlier one at the lower site?

The old Scots word *lunkart*, particularly common in Angus and Mar, meant a temporary bothy or hunting-lodge. The Water Poet (see p.29) writes about arriving at 'small cottages built on purpose to lodge in, which they call Lonquhards'. They were apparently huts made out of turf.

Mayar Few serious attempts have been made at interpreting the name Mayar; but the presence of the definite article (it is commonly known as 'The Mayar') might suggest Gael. *maor* (Latin *maior*, our 'mayor' or 'major') meaning roughly 'the heid yin'. In Old Gaelic the *maer* was a king's officer in charge of crown land. The Gaelic term *machair* (a plain or beach) seems quite inappropriate. (See also notes on **Driesh**).

Meg Swerie A difficult etymology. It may involve a girl's name plus the Scots adjective *sweir*, meaning lazy or slow (and popular etymology would doubtless postulate a sluttish person of that name) but this is unlikely. Even less convincing are possible Gaelic derivations from *suire* (a sea nymph) or *suirgheach* (a wooer).

Melgam The name of this pleasant stream has been subjected to alteration, and the stream itself to hydraulic surgery. Early forms are 'Melgoner' (1256), 'Melgone' (1458) and 'Melgum', 'Melguns' (1850); another popular spelling was 'Melgund', possibly by

accretion to the castle of that name at Aberlemno. The prefix may incorporate Gael. *maol* (bald) or *meall* (a lump); but no satisfactory etymology for the suffix has been advanced.

The Melgam Water rises in the hills at Glenhead, and for its first half dozen miles has for many years been known as the Backwater Burn (see ***Backwater***). Formerly it was a continuous stream, pursuing its turbulent course through the Loups of Kenny and the Den of Melgam to join the Isla at Airlie Castle. But with the enlargement of the Loch of Lintrathen in 1870 it became a feeder stream for the reservoir from the north, and now issues from it greatly diminished. Its days as a trouting stream have departed.

Melgam House at Bridgend was the former Lintrathen manse.

Menmuir Earliest form is 'Menmoreth' (1280) and later forms include 'Mennyr' and 'Menmore'. The moor-name probably predates that of the church-settlement (Kirkton of Menmuir), which was a vicarage in the diocese of Dunkeld. After the estates were bought in 1360 by a Carnegy, brother of the 1st earl of Southesk, Menmuir was also known as ***Balnamoon***.

Millden There has been a hamlet at 'Mylnedene' (also known as 'Milntoun') since 1648, and probably earlier. Queen Victoria unaccountably calls it 'Mill Dane'. The Lodge was built by Lord Panmure in the 19th century as a summer residence on the North Esk, and taken over by the Dalhousies as a shooting lodge. In the 1930s it was frequented by Neville Chamberlain for salmon fishing.

Milton This holding appeared in an old county rent roll as 'Milltown of Glenesgug', which is probably a scribal error conflating 'Glenesk' and *gille easbuig* ('Gillespie'). Although the name belongs linguistically to the Lowlands, it refers here to a distinctively Highland community. It was at the 'Faulds of Milton' that the Episcopalians had to hold open-air services after the burning of their chapel during the post-Culloden reprisals (see also ***Rowan***).

The large number of Milton Burns in this part of Scotland (twelve of them in Angus alone), reflects the fact that nearly all mills were water-powered; very often the old stream-name would be replaced by this functional one, a case in point being the ***Burn of Calanach***, now known as the Milton Burn.

Minister's Road In the 18th and 19th centuries, the kirks of Clova and Prosen were served by a 'missionary minister', who took the services in both churches. Clova kirkyard contains the tombstones of two of the incumbents. The four-and-a-half miles over the hills between Eggie and Pitcarity must have been a weary trudge for the minister – especially on the not infrequent occasions when he had a service in each kirk on the same Sunday. Nowadays it makes a pleasant afternoon's walk, starting from Prosen kirk, with fine views over the Clova hills.

Modlach Popular tradition is insistent that the etymology is Gaelic *mod* (which means *inter alia* a court or assembly) and Scots *law*, giving 'hill of the baron-bailie court'. In support of this the name of nearby Barron Hill is mentioned. But there is no evidence that this was a 'moot hill' and indeed the location would be an unlikely one for a judicial assembly. Modlach was at one time noted as a source of high-quality granite; there is now a Modlach Plantation near the river.

The old road up Glen Esk from Millden to Tarfside formerly crossed the summit of Modlach Hill, involving a stiffish climb, and it was here that a monument was erected by the Freemasons in 1821 to commemorate the creation of the new Lodge of St Andrew at Tarfside. St Andrew's Tower, a gaunt building embellished with masonic symbols, was intended to serve as a guide and shelter for storm-stayed travellers. Each St Andrew's Day (30 November) the brethren would process to the Tower; Freemasons are nowadays thin on the ground in these parts, but Glenesk had at one time a considerable number of settlements – Lochlee being 'the largest clachan in the parish... now scattered ruins'.

Monega The Monega is the highest of the Mounth crossings, passing over the east shoulder of Glas Maol. Although the etymology of the name is not in doubt, Monega Hill does seem to be devoid of the 'notches' from which its name derives.

From the summit of the pass (3184 ft) it is possible to walk for considerable distances without dropping below the 3000 ft level, and to take in the summits of Creag Leacach, Cairn of Claise and Tom Buidhe, as well as Glas Maol, in the bygoing. It is pleasant to feel that you are cheating nature by remaining at such a height; and the descent through Caenlochan or Caderg is spectacular and strenuous without being dangerous. A spring at the summit of the Monega track is one of the main sources of the River Isla.

29 *Mount Blair*

Mount Blair This elegant hill has the appearance from the south of a perfect triangle; nearer it can be seen to have a rocky slope to the east.

In popular tradition, the hill was the locus of a battle between the Picts (in some versions, the Danes) and the Scots, fought around the 9th and 10th centuries; the fact that the Gaelic word *blar* can mean a battlefield as well as a plain may seem to give support for this tradition, but there is no historical evidence for a battle. In addition, there are legends of a well with magic properties (see ***Corrie Vanoch***). It has been claimed that the summit 'gives a prospect of Edinburgh'.

Mount Keen This is Scotland's most easterly Munro, and lives up to its name as a 'smooth upland'; particularly from the north it is seen as a neat and regular cone. It has been argued that the description 'smooth' was meant to apply to the drove road from Tarfside to Glen Tanar which passes within half a mile of the summit, in contrast to the rougher and wetter Mounth crossings to the east and west; and indeed Queen Victoria in her journal refers to 'the Keen Mounth'. Nevertheless there is no doubt that 'mount' in cartographic terminology invariably refers to a contour and not to a track. This is not to deny the smoothness of the track itself: we are told that 'Highland harvesters used it to take part in the Lowland harvest, then returned to their own harvest a month later. To save their footwear, some of them did this part of their long trek in bare feet'.

Mowat's Seat The barony of Fern was granted to the Mowat family by William the Lion in the late 12th century. In its earlier form the surname was Montealto, later Mouat; the family originally came from Mont Hault ('high hill') in Normandy. So it is entirely appropriate that an Angus hill should bear their name.

Nathro These Glen Lethnot lands, along with *Tilliebirnie*, belonged to a cadet branch of the Douglas earls of Angus. The name, dating from before 1462, was borrowed from a nearby stream, notable for its snakelike course. One would not wish, however, to discount a queer but persistent old folk-tale in the glen of a white adder that led its progeny through a holed stone.

Navar Now that parish-boundaries are no longer defined, this name does not feature on modern maps except in relation to an obscure hill-slope, and you will look in vain for the former church of Navar. It lay on the south west side of the West Water, on the sunny side of Blairno Hill, a mile from the church of Lethnot (also absent from the map). It was this very proximity that led to a union of the two parishes in 1723, and to the demolition of Navar kirk in 1729.

The Navar area was in the ownership of the Panmures in the 17th century, and 'Lord Navar' is one of the titles of the earldom, created in 1646 by Charles I.

Newbigging The Clova place of that name was the site of the old Lindsay castle of Dennyferne. Later an Airlie property, some of the land was made available as a youth

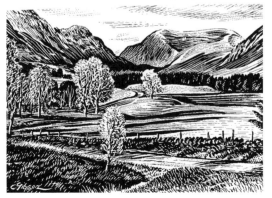

hostel; the chalet-type wooden building was opened by the earl in 1930. It was replaced around 1959 by the one in Glen Doll, which is situated near the junction of the Tolmount and Capel Mount tracks and is therefore more convenient to (and deservedly popular with) long-distance walkers.

30 *Newbigging in Glen Clova*

Noran The fame of this lovely stream is eclipsed by the new settlement of Noranside. The property was part of the forfeited estates of the Jacobite Carnegies of Southesk, and changed hands several times in the following centuries. The mansion was built by John Mill of London in the mid 19th century, and later bought by the Gardynes of Finhaven; it operated as a sanatorium from 1916 to 1960 and in 1963 became a Borstal institution with very extensive outbuildings. Indeed the present hamlet (consisting mainly of staff housing) owes its existence to the prison. Incarceration can never be pleasant, but Noranside must be high on the list of the more desirable bilboes.

Colin Gibson wrote that the Noran Water 'flows through a finely-wooded den, honey-coloured in its deeps, birch-green in its sun-dappled shadows'.

Paphrie The little glen drained by this stream (Ainslie called it 'Pephrie') was not always the deserted place that it is now. Former settlements included 'Ackfernie, Boghead, Corrie, Differan, Drumboy, Rivenreed, Shillhill, Tarryhead, Ward, Wardend and Witelstane', together with the old kirk and manse. None of these are on current maps, and so cannot readily be located.

The Pictish word from which the name derives is more familiar in the place-name Strathpeffer.

Pearsie This estate belonged originally to Arbroath Abbey, passed to the Ogilvies, the Panmure family and the Edwards; more recently it was a Wedderburn property, and now belongs to Lord Granville. The earliest spellings include 'Parthesin' (1214), 'Parcy', 'Percye' and 'Persys' (c1450) and 'Percie' (1502); Edward (whose family owned the property) calls it 'Perse' on his map of 1678. The estate includes Wester Pearsie and Mill and Muir of Pearsie.

31 *The Iron Kirk at Pearsie*

The kirk in the illustration is a curious reminder of the Disruption of the Church of Scotland in 1843, when nearly 450 ministers broke away to do their own thing. The problem was in finding alternative places of worship, and it was at this time that extra 'Free' churches were built all over Scotland; that is why many a village has its second kirk, now unused. In Pearsie they solved the problem by constructing a building of corrugated iron, but it too is now forlorn and deserted and its churchyard knee-high in grass.

The farm of Muir of Pearsie, a mile or so north of the home farm, has a curious tale attached to it. Some time in the 16th century, the gudewife was awakened in the middle of the night by a bleating cry; declining his wife's request to investigate, the farmer declared that the sound emanated from a pet calf, or as he called it, *the croon o' the hawkit stirk* ('the mooing of the white-faced bullock'). Unconvinced the gudewife herself rose and found a male child, a few weeks old, on the doorstep, carefully wrapped in a blanket.

The bairn was brought up as a member of the family (known by the soubriquet of 'The Hawkit Stirk'. although he was thought to be a McGregor or a Cameron) until at the age of sixteen he disappeared. It was not until the Raid of Saughs some years later that the leader of the marauding band was identified by his unmistakeable resemblance to the Hawkit Stirk. Since the leader did not survive the raid, the story ends here. See note under *Saughs*.

Peathaugh This old farmstead in Glen Isla was farmed by James Winter, who fought at the battle of Saughs (see *Saughs*). Winter's tombstone in Cortachy kirk narrates his part in the affray in these terms: 'Here lyes James Vinter who died in Peathaugh/Who fought most valiantly at ye Water of Saugh/Along with Ledenhendry who did command ye day/They vanqis the enemy and made them run away'. A sanitised account of what was a bloody and desperate encounter.

More generally, 'peat' names are commonly found on the lower hills and moors, indicating the importance of this commodity as a fuel resource. There is still plenty of it around, but it is no longer in common use for domestic hearths. While many peat-hags are man made, others are a result of climatic change which brought the damper climate that we have today. The blanket peat bogs to the north and west of Peat Shank are thought to be due to erosion caused partly by the wallowing of herds of deer in hot summers, a sight familiar to walkers in the high Grampians.

Pitcarity The old name of the hamlet which became Prosen Village (but Edward's map calls the area 'Perse' – see *Pearsie*). When the old chapel at Balnaboth fell into disuse in the early 1600s, a new one was erected at Pitcarity. The old one is described in an account written 200 years later: 'The walls were low, had a pavilion roof and it was thacked with heather. The door and two windows were of hewn stone, and there were no seats except one at the east end.' It was replaced in the early 1800s by the charming white-walled kirk that we see today (at a cost of £70, two and tuppence ha'penny). Pitcarity is now the name of a picturesque holiday cottage in the village, on the Balnaboth estate.

Powskeenie This name does not appear on modern maps, but is apparently at the river-crossing now known as ***Dalbrack*** Bridge. Queen Victoria, passing by on one of her pony-treks, calls it 'Poul Skeinnie Bridge' (a reasonably good phonetic rendering), and she also adds that it is 'a regular steep Highland bridge'. It is not clear whether the 'leaping' indicated by the name was done by salmon or people – probably the latter, in the days before the bridge was built.

Priest's Road A hill-crossing from Stonyford in Lethnot to Tarfside in Lochlee, so-called because it was the route used by clerics passing from one parish to the other. Montrose and his Highland followers took this route when they retreated from Dundee to the fastnesses of Glen Esk in 1654. In later years it was known as the Whisky Road, over which convoys of ponies used to transport illicit liquor to the Lowlands for selling-on.

'Road' is something of a misnomer these days, since the track is in places barely visible through the rough grass, heather and rushes which attend its course. It would be a devout

priest or a dedicated whisky purveyor who would nowadays make the journey whether for professional or mercantile purposes.

Prosen Prosen was formerly part of Kingoldrum until it became a separate parish *quoad sacra*; it is now in the parish of Cortachy & Clova. The lands belonged

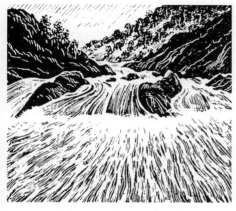

to the Grahams of Fintry until the Ogilvies acquired Balnaboth in the 1600s. Ochterlonie, writing in 1684, describes 'Glenpressine' as 'a fyne highland interest' (estate).

Although it is one of the four main Angus glens, no satisfactory etymology of the name Prosen has been established. The earliest recorded form is 'Glenprostyn' (1463); a century later Pont's map shows 'Prossyn'. Suggested derivations include Old Gaelic *brosn* and *brosnach* ('to stir, excite'), an obvious reference to the turbulence of the river especially in its lower reaches (see illustration, which is a view from Prosen

32 *Prosen Water in Spate*

bridge). The OS map shows 'Glenprosen Village', but the local road-sign directs you to plain 'Prosen Village' (see also note to **Pitcarity**).

Queen's Well The structure commemorates Queen Victoria's visit on 29 September 1861, a few months before her 'great sorrow' (the death of the Prince Consort). The well itself was called *Tobar na Clachangealaich* ('well of the white pebbles' – still visible); although difficult of pronunciation (approximately **clach an gel ach**) it is a pity that this descriptive name has disappeared. The words carved on the stone have, in these irreligious and anti-monarchical days, a somewhat wistful sound: 'Rest, traveller, on this lonely green/And drink and pray for Scotland's Queen'.

Quharity Now for a geographical and philological nightmare. In the parish of Lintrathen there are two burns of this name. The western one seems to rise on Milldewan Hill and flows southwards (through what is called on the OS map 'Glen Quharity') to join the Loch of Lintrathen. The eastern Quharity Burn rises on Strone Hill and joins the South Esk at Inverquharity; the older maps called its upper reaches the 'Carity' burn, but its glen is not dignified with a name. Timothy Pont clearly shows 'Caraty R.' flowing eastward to join the South Esk at an unnamed point which must be modern Inverquharity.

It appears from the modern map that the two streams in the area were continuous prior to the water works in connection with the enlargement of Lintrathen Loch to form a reservoir in the 19th century. The upper part of the stream was diverted to join the Inzion Burn as a feeder for the loch; what remained of the lower part continued to flow through the glen between Balintore and Pearsie as a tributary of the South Esk. The proposed etymology of 'paired streams' is thus given a certain plausibility, except that the name

existed for at least 400 years before the waterworks were thought of. While the etymology is generally accepted, it has never been very convincing; and the confusion caused by having two streams of the same name is considerable.

The name Glen Quharity poses similar problems. It used to be written 'Glen Carity', which represents the modern pronunciation. The earliest form is 'Glencaueryn' (1253); and 'Glenquharady' appears in a Douglas charter of 1406. Timothy Pont's map clearly displays the names 'E glen-wharraty' and 'W glen-wharraty', but it is impossible to locate these with any certainty or to tell whether they indicate settlements or glens. Bartholomew's maps identify the Quharity burn at NO 282 613, but do not name its glen.

Glen Isla's 'Inverharity' must have referred to the confluence of a Quharity burn with the Isla, but the burn is no longer identified. Just to complicate matters, the 'Glen Quharity' in Barrie's *The Little Minister* is usually taken to be an imaginary version of Glen Prosen.

It may or may not be helpful to add that the archaic 'quh' spelling is interesting as showing an old Scots orthography which represents the sound 'wh' and which survives in certain place-names but which became obsolete in ordinary usage. The existence however of alternative spellings such as '-carity', '-harity' and '-arity' shows that the survival of the older spelling was not guaranteed.

Rashiebog Colin Gibson wrote of 'Rashiebog, once the "beinly, winsome hame of that old-timer of the Angus Braes, Dauvit Ogilvie"…Rashiebog was built in 1785 "withoot aither plum or speerit-level, juist by the sicht o' the e'e." The fireplace was in the middle of the floor and the reek was meant to escape through a hole in the thatched roof until Dauvit "made the lum whaur a lum sud be". Dauvit also made his own dykes, steadings, ploughs and carts. The cart ropes were made from his horses' tails.' Dauvit lived till he was 96, and died without revealing the whereabouts of his very own illicit whisky-still.

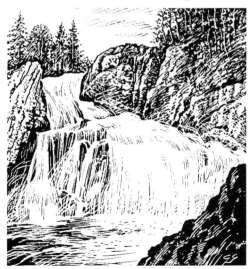

Reekie Linn To be seen rather than described, for no words can convey the grandeur of this, one of the most spectacular river scenes in all Scotland. The name itself is interesting, being at one and the same time descriptive, self-effacing and thoroughly Scots.

Reekie is the adjective from *reek* (smoke – 'lang may yer lum reek') and is familiar as the derogatory nickname for Edinburgh ('Auld Reekie') in the days when air-pollution was more visible if less noxious. The fine spray from the falls is perhaps more like mist than smoke, and in certain conditions can fill the whole chasm.

33 *Reekie Linn*

Linn is a Scots word meaning a waterfall, gorge or chasm; Burns uses it correctly in his song about the unrequited lover Duncan Gray who 'spak o' loupin o'er a linn'. But the word tended to become assimilated with the Gaelic *linne*, which means a pool and is familiar in such place-names as Loch Linnhe and Linwood. *Linn*-names on the map can therefore be either Scots or Gaelic and can mean either a waterfall or pool; but since you seldom find the one without the other, the matter is of no great practical importance.

Nobody knows what Reekie Linn was called when the glens were Gaelic-speaking; but we do know that the Linn o' Dee was at one time called *Eas De* ('waterfall of Dee') and later simply *An Linne* (the pool).

Retreat, The Queen Victoria refers to this place as 'Captain Wemyss's Retreat, a strange-looking place'. Part of the explanation is that it was built early in the 19th century by one of the Wemyss family as a simple summer residence, in contrast to the baronial splendour of Wemyss Castle in Fife. This chap must have done well in the Royal Navy, for he had reached the rank of Rear Admiral when he died in 1854; but why the Queen refers to him as 'Captain' remains a mystery (and in its setting of natural birchwoods, his 'retreat' doesn't nowadays look at all strange).

The Retreat was loaned by Lord and Lady Dalhousie as a community centre, and now incorporates the Angus Folk Museum. It also has an attractive shop and a delectable tearoom, rightly popular with summer visitors

Rome A more direct connection with the eternal city has been argued. It was apparently the practice in early mediaeval times for Irish monks to bring back some grains of soil from St Peter's cemetery in Rome and to scatter them within their own monastery precinct. Such places, having been sanctified, were known as 'Rome' (possibly in their Gaelic version of *Ruam*, which came to mean a burial place of any kind). It would not be in the least unlikely that a similar practice obtained in Scotland.

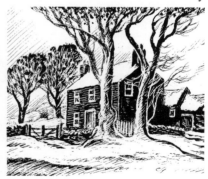

34 *Rome – an oblique reference to the eternal city?*

Rottenhaugh *Rottan* is the Scots (and old English) version of rat, and most names incorporating this word mean just that. No exception can be made in respect of the numerous occurrences of the name 'Rotten Row'. However, attempts are often made to find a more edifying derivation ('*route du Roi*' in the case of Hyde Park); and it has been suggested that the origin of our three examples is the Gaelic *rathad na h'abhaich* or 'waterside road'. This explanation should not be dismissed out of hand, for the earlier forms of the Glen Mark name are Ratnovy (1511), Rotnoquhy (1554) and Rothnaquhy (1588), and all three places occupy waterside locations, i.e. haughs. (It may of course be that 'Ratnovy' is an entirely different name from Rottenhaugh.)

Rowan The Gaelic *rodan* has become confused with the Scots *rodden* (meaning rowan); Hill of Rowan was formerly known as ***Hill of Migvie***. The Gaelic name designated the track between Invermark and Tarfside, which formerly went over the top of the hill. The area has field systems showing Bronze Age cultivation, and must have had some importance as being at the start of several hill paths.

The Rowan Tower is properly known as the Dalhousie or Maule Tower. The earl of Dalhousie accompanied his brother the Hon. Lauderdale Maule from Invermark as far as the Rowan and took leave of him there; Lauderdale never returned from the Crimean War. The tower also commemorates other members and adherents of the Maules, including Lady Ramsay Macdonald. The melancholy Victorian inscription reads 'When it shall please God to call them home'.

Glen Esk was at one time a stronghold of Episcopacy, and there was formerly a chapel on the Rowan, in which no less than 70 persons were confirmed on 16 August 1745 (this was shortly after the Prince's landing in Scotland, when religious and political loyalties had become polarised, even in the remote glens). There is no longer any trace of this chapel, which was burned to the ground by Government soldiers in 1746; its replacement, built on the DIY method, also disappeared; but its very existence did lead to the raising of a public subscription which eventually resulted in the building of the present episcopal church at Tarfside.

Saughs The presence of so many 'Sauchs' names in this parish is a little puzzling, since willow trees aren't much in evidence nowadays. Ainslie's survey of 1794 also shows an upland area, lying between the Adekimore and Easter burns in Lochlee parish, which he calls 'Saughs'.

Returning to Glen Lethnot, the Battle or Raid of Saughs took place towards the end of the 17th century (the precise date has not been recorded) between a party of thirteen Highland caterans and eighteen of the men of Fern, whose cattle had been stolen in a Sunday night raid. Young Macintosh, son of the farmer of Ledenhendrie, rallied his neighbours and led them in pursuit of the thieves. The reckoning came about daybreak, when the Fern men reached the Water of Saughs and caught up with the raiders, who were breakfasting on a stolen cattle-beast. A desperate conflict ensued, after which the Highlanders fled on seeing the death of their chief at the hands of Macintosh.

The encounter took place in a desolate part of Glen Lethnot, near the ***Shank of Donald Young***, mentioned in the note under that name. See also ***Ledenhendrie*** and ***Peathaugh***.

Scrabytie A metathesised local variation of 'Scabbert', the form in which it appeared elsewhere on the map. One is tempted to group such opaque Scots names (many of them in a heavy local dialect) as a class of semi-humorous and disparaging comments on the harsh terrain of the glens or the unremitting toil of the crofter. Other examples in our area are ***Scruschloch*** and ***Clautschip***, and neighbouring ones show Scrapehard, Unthank and others whose conjectural meanings are similar.

Shank of Donald Young At first sight an uncomplicated Angus name: 'shank' is a leg, or a leg-shaped bit of hill and Donald Young is a common forename-surname combination. But there is more to it than that: the name Donald did not belong to the very

limited repertoire of Angus forenames, and almost always indicated a Highlander; and Young was probably not a surname but a qualifying term, equivalent to the American 'Jr.'. So we can postulate that his Gaelic name was Domhnuill Oig, and that his clan surname might have been Farquharson, or MacDonald, or MacGregor or one of the reiving clans to the west. Nothing is known of Donald save that he was a Highland cateran who died from his wounds on this hill as a casualty of the Battle of Saughs at the end of the 17th century (see *Saughs* above). According to tradition, he was buried where he died, on this lonely hillside in Lethnot.

Shanno Earlier forms are Schannache (1511) and Schanno (1554). 'Place of wind or storm' is a fair description of the situation of the ancient castle set high on the rocky southern slope of the hill to which it no doubt gave its name. The remains of a fortification are noted on the map (NO 566 755), but nothing is known of its history apart from the fact that it was one of the numerous refuges of 'Young Lindsay' after the Spynie murder (see *Auchmull, Invermark*).

Shielhill A Lindsay property from an early date until 1629, when it was sold by the earl of Crawford to one of the Ramsay family. The castle stood on a rock on the north side of the South Esk; its site is recognisable from the presence of some cottages whose walls were once part of the castle's foundations.

Shielhill Bridge is celebrated in *The Water Kelpie*, a poem by John Jamieson, compiler in the 19th century of the Scottish Dictionary, and the person who was regarded as the prototype of 'The Little Minister'. The story of a kelpie (water-horse) assisting in the building of the bridge was so appealing to the masons that they carved an image of such a mythical creature on the keystone. The old bridge has been replaced and is not much frequented now, but the kelpie is still to be seen if you look closely enough, surmounted by an ornamental sundial.

Shielin *Shielin(g)* is a Scots (not a Gaelic) collective term, used from the 18th century to mean a high and remote summer pasture, usually with accommodation in the form of huts. The ruined building four miles from the end of the tarmac road up Glen Isla answers this description exactly, and its name is more of a designation (like 'post office' or 'church') than a place-name proper. Apparently the cattle, sheep and goats which grazed here were kept more for dairy products and wool than for meat.

'Shiels' (a similar collective term) appears along with 'Shieling' in such Lowland place-names as Galashiels and Shillinglaw.

Shinfur This odd-looking name (of a farm between Tarf and Tennet) is well-documented: early forms include Schenquhoris (1511), Shanequhir (1539) and Sanquhur (1638). The name has to be compared with Shandford, Sanquhar, Sandford and St Fort; the conjectural Gaelic original is *sian cor* or *car* (literally 'wind-cast'). Shinfur formed part of the lands of Carrecross (see *Cairncross*).

Skelly Most readers will be familiar with the Scots word *skellie* as meaning wild mustard, the yellow plant that pervaded the countryside in the days before it was outshone by the pestilential oilseed rape. Outside Angus the word *skellie* can mean squint, lopsided;

but in a place-name context it is nearly always taken to be the Gael. *sgaoileadh*, meaning spreading, fraying – usually applied to an untidy rocky outcrop There are several other occurrences in the glens (see ***Skuiley***). None of them (on grounds of language and topography) permit a suggested derivation from Old Norse *skali*, a shieling.

Spott With or without a waterfall, this is a lovely 'spot' in Glen Prosen, where the valley broadens out into a green meadow with the kirk at one end and a picturesque mansion at the other. A habitation has existed here since at least as far back as 1454, when somebody styled 'Mircair of Spott' was witness to a charter. There has been a river-crossing over the Prosen Water here for centuries; in 1806 it was described as a 'wooden arch bridge', now replaced by the present one in the illustration on p.149.

St Arnold's Seat This name has undergone several changes over the centuries; Edward's map of 1678 has 'St. Arne', and Moll's map of 1745 has 'St Anne'. The minister of Tannadice in 1744 maintained that his church was once called St Ernan's, and the latest thinking on the subject is that he was probably correct. For a time, this name was confused with 'St Eunandis Seit' in the same parish, which appears in a charter of 1527, but whose location is yet to be identified. 'St. Eunand' is the Gaelic vernacular form of Adamnan, biographer of St Columba; other spellings of this name are Eonan and Younie (which survives as a surname).

There was a burial cairn on the summit of St Arnold's Seat, whose stones were pillaged for the construction of a dyke, and the theory was that the cairn was 'built to commemorate the passing of St Adamnan, a follower of St Columba, who lived and worked in the lands spread out below this noble hill'. However, in the absence of other evidence this can be no more than a pious supposition.

Taidy Although the derivation may seem somewhat absurd, 'Taidy' belongs to a class of stream-name which occurs all over the Scottish Highlands in various forms. The hills and glens abound in tiny streamlets which are so overgrown that they are heard rather than seen, a fact which any hill-walker will corroborate. In Scots, a stream of this sort might be called (by transference of epithet) the Blind Burn. In Gaelic the word is *caochan* – 'the little blind one', and it clearly relates to the Latin *caecus*, meaning blind, and to the medical term *caecum*, which is a blind alley in the gut. Interestingly, neither of these terms has a cognate in English, other than the blind Saint Cecilia and the surname Cecil. To summarise, Taidy Burn is not quite a blind burn nor is it a *caochan*, which is a frequent term for a semi-hidden rill.

After this excursus into the realms of speculation, the possibility remains that Taidy is just the Scots rendering of 'toad-ie' and that the name indicates a stream frequented by amphibious reptiles.

Tannadice The writer of the 3rd Statistical Account (1948) remarks that the parish 'in three generations passed from cruisie lamp to electric light, from horse-drawn trap to streamline Rolls, from two-horse ploughs to tractors'. The parish retains most of its mid-19th century farmsteads, but with unrecognisable changes in agricultural methods and machinery.

This description would fit all the North-Angus parishes, except that you would have to add TV masts on the houses and the occasional jet screaming overhead. The glens have not entirely resisted the March of Progress.

Tarf This river-name refers to the beast's mythic qualities of violence and turbulence (just as its neighbour the Water of Mark celebrates the characteristics of the horse). The Water of Tarf has lived up to its name on more than one occasion: in 1829 it burst its banks and carried away the old bridge.

Tarfside (a modern name for an old settlement) has a post office (at present closed), church and school (and injunctions to motorists to drive carefully). The first school there was instituted in 1760 by the Society for the Propagation of Christian Knowledge, to be replaced in the 19th century by the present 'handsome Board School'.

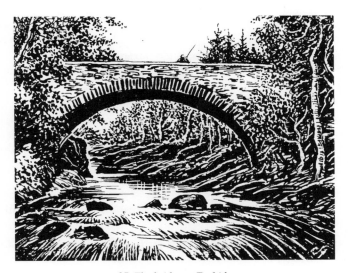

35 *The bridge at Tarfside*

Tigerton Tigerton is the Gaelic equivalent of Preston ('priest's farm'); but since the folksy version of its derivation is still current it will be repeated here for the purpose of demolition. Tigerton is traditionally the spot where in 1452 the earl of Crawford rested after taking revenge on the lands of a neighbouring laird, through whose supposed treachery the earl's followers had lost the battle of Brechin. The connection with the farm name is that Crawford was known as 'The Tiger', on account of his ferocious temper; his other soubriquet was 'Earl Beardie' because of the profusion of his facial hair. Tigerton, once a thriving community of a dozen families, is now a single farm.

Tilliebirnie Originally a property of the earls of Douglas, this name appears in 1462 as Tulybirnie and in 1472 as Tulyberny. A stock farm, it was described *c*1682 as being 'well accommodate in grass parks and meadows'.

The name appears to derive from the Gaelic word *braon,* which means a drizzling rain – thus, a damp place; it corresponds to **Slack of Barna** and to the nearby **Birnie Burn**. It is possible on the other hand that it has the same origin as **Tillybardine**.

Tillyarblet The earliest recorded form of this old name (1232 'Tulach mac earbaloch') leaves no doubt as to the etymology. By 1462 it has been shortened to 'Tullyarblate', approximately its modern form. The 'pig's tail' apparently referred to a winding track leading to Menmuir Hill. East Tillyarblet belonged to the Erskines of Dun and is now part of the Panmure estates.

Tillybardine The modern form shows a wrong assimilation to Tullibardine in Perthshire. The early forms of the name (1554 'Tillybarnis' and 1511 'Tulibernis') are better indicators of the etymology.

The farm lies below the Clash of Wirren, which is the gap referred to. It is situated at the beginning of the Priest's Road to Glenesk, which was proposed in the 18th century as the line of a trunk road to the north; perhaps mercifully, the road was never constructed.

An Edzell tombstone of 1746 records the 'award of 500 merks for a Schoolmr at Tillibardin'. A merk was thirteen and a half English pence, indicating that the master wasn't exactly overpaid; has nothing changed?

Tulchan The Lodge is the most northerly habitation in the wilds of upper Glen Isla, but there has probably been habitation there for several centuries; the name is recorded in 1463 as 'Tulquhan'. A secondary meaning of tulchan is 'calfskin', a reference to the practice of laying a skin over a little mound in order to promote lactation in the mother of her dead calf. The term came to be used figuratively for a man of straw, specifically to a bishopric created by Regent Morton in 1572 for the purpose of appropriating church revenues. The name Tulchan has therefore a much greater resonance beyond Highland topography, and 'Tulchan bishop' is a term used by many scholars unfamiliar with the 'little mounds' of Glen Isla.

Vayne (sometime 'Waine' or 'Vane') The castle stands on the rocky and precipitous north bank of the Noran Water, with a natural terrace-walk along the stream. Little survives of what must at one time have been an imposing three-storey edifice. Built in the 1550s or 60s by the Lindsays, who held the lordship of Vayne, it was sold to the Carnegie family a century later. Tradition associates the name with Lady Vayne (or Bain) a paramour of Cardinal Beaton of St Andrews, but this is probably mere gossip. In the 17th century the amenities included 'ane excellent fine large great park called the Waird' ('ward' being an old Scots term for pasture).

Like many ancient monuments, the dilapidation of Vayne Castle came about not through the ravages of war or wind or weather, but through the vandalism of neighbouring farmers-turned-quarriers.

West Water There is an interesting street-name in Edzell – 'Invereskandy'. Dissected, it shows Gaelic *inbhir* (a confluence) plus *uisge* (water) plus an obscure suffix which was probably *dy* (as in 'Water of Dye') but might also have been Gaelic *dubh* (black). *Dye* comes from Gaelic *dia,* a god, and is an ancient water-name; compare Glen Dye at Cairn

o Mount and the one in Glen Quharity at NO 295 620 (which scarcely deserves such an august name). The explanation is that until the 16th century Eskandie was the name of the West Water, and for another two centuries it was called 'Water of Dy'. Inveriskandye still appears on the map (NO 620 761) as a croft two miles southeast of Edzell on the Kincardine boundary and near where the West Water joins the North Esk. (Confusingly, Gordon's map gives 'Eskenduy' as the name of the <u>South</u> Esk – in cartography nothing is ever straightforward.)

Westside The only notable thing about this now-disappeared croft is that it was the home of a centenarian who attained fame as 'the king's oldest enemy'. Peter Grant was his name, but he was always known as Dubrach, after a small place which he tenanted in his young days near Braemar. Let Colin Gibson tell the story: 'When he was 32, Dubrach fought for Prince Charlie at Culloden. He was captured, taken south and imprisoned in Carlisle Castle. He escaped however, and eventually settled in Lethnot. In 1820, when he was 105, a petition was sent on his behalf to King William IV, pleading for the grant of a pension, and it was signed "His Majesty's Oldest Enemy". The King good-humouredly granted the pension, and Dubrach lived till he was 110. Even in his last years he could give a spirited demonstration of the Highland broadsword, and often said that he would be delighted "to fecht Culloden ower agen"'.

Wheen A contraction of a much earlier name. In the 17th century it was 'Eglis-maquhen', later reduced to the bizarre form of 'Heglish-Mackwhyin'. It was the site of a mediaeval church, and it is possible to reconstruct the name in its Gaelic form as *eaglais mo Chomghan* – church of St Comgan, a contemporary of St Fillan and St Maelrubha. (*Eaglais* was often corrupted to 'eccles', and there are numerous place-names embodying this term throughout the UK, but this is the only example in our area.)

Wheen was once an important settlement in Glen Clova; in 1745 it was said that at Wheen and Rottal there were 'no less than sixty reekin lums'. But the site of the village was ploughed up for tree-planting, and no trace of it or the church remains. See also *Adielinn*.

Whisky Road This is a less respectable name for the *Priest's Road*. In the 18th and 19th centuries the manufacture of whisky was a flourishing concern, and almost every remote glen in Angus had its own illicit still. These whisky bothies were particularly common in Glen Lee, Glen Mark and Glen Esk, as well as in Lethnot. The discovery was reported in 1967 of the head of an illicit still buried in the peat near the top of Craig Soales behind Tarfside, and the stone remains of cooling systems are still to be seen if you know where to look. The local supply of fine quality whisky was insufficient to quench Lowland thirst, and additional supplies were brought from Moray and Aberdeenshire by long strings of pack ponies led by local guides on nocturnal crossings over the notorious Whisky Road to Strathmore.

White's Pool So-called because of a tragic accident which took place there in October 1820. Two brothers, David and Archibald Whyte (aged 27 and 18 respectively) were attempting to cross the Water of Mark after collecting their father's sheep for sale at

Cullow Market. Archibald slipped on the wet rocks, fell into the rapid torrent and was swept into the deep pool below ('a black boiling abyss'); and David died attempting to save him. (The change in spelling from Whyte to White reflects no more than the relaxed attitude to the orthography of surnames in the 19th century.)

Wirren The complex of hills between Lethnot and Glen Esk comprises Hill of Wirren, East and West Wirren and Bulg (all around 2000 ft), and dominates the landscape of these glens at their lower ends. From the distant viewpoint of North Fife, the various hills coalesce, and Wirren has the appearance of an elongated Table Mountain (it is in fact six miles long). It is all the more surprising therefore that a local scholar maintained that the derivation is Gaelic *bearn*, a gap, and that the whole massif means 'hill of gaps'. As further evidence he names the gaps as Clash of Wirren and Slack of Forbie; but *clais* means a furrow and *slochd* a hollow, and both are quite inconspicuous and unimportant in terms of human geography.

The name Wirren does not appear to have been recorded before 1678. It is therefore necessary to postulate an earlier Gaelic form, which might be *meall nan fhurain*. This would have meant 'hill of springs', pronounced **hwooran**, and spelt elsewhere as Ouran (cf. Sgurr nan Ouran in Perthshire). Most commentators until the 1950s had accepted the 'spring' interpretation, and it is a geographical fact that the Wirren massif is the source of an unusually large number of hill burns. See also ***Bettywharren***, which also contains the term *fhurain* .

As an odd footnote it may be added that the hill was often used as the burial-place of suicides, who in days gone by were forbidden to lie in consecrated ground; the skyline was said to have been dotted by several grave-shaped hillocks which marked their last resting-places.

Witter, The Not a very old name, by the look of it. The hill at one time had a feature called 'Prap o' the Witter', which would be a slender man-made cairn or marker of some kind ('prop' in English.) There were apparently three 'praps' on ***Fascheilach***, another hill on the county boundary. See also ***Brown Holm***.

Gazetteer

This is the reference section of the book. Gazetteer is a term that is found much less frequently now that road atlases are indexed. The word is defined in Collins' English Dictionary as 'the section of a book that lists and describes places' – a fair description of what now follows. Its origin is said to be Italian *gazetta*, a news sheet costing one 'gazet', a small copper coin of little value. Not so appropriate, one hopes, to the present case.

Notes

1 The three-letter contraction after each place-name indicates the parish, the conventional abbreviations being as follows:

AIR	Airlie
COC	Cortachy & Clova
EZL	Edzell
FER	Fern
GLI	Glenisla
KGM	Kingoldrum
KRR	Kirriemuir
LEN	Lethnot & Navar
LIN	Lintrathen
LLE	Lochlee
MEN	Menmuir
TAN	Tannadice

Places straddling parish boundaries are given two or more attributions. Parishes were appropriated to monasteries, bishoprics and cathedrals and were the ecclesiastical equivalent of baronies. In time past they were important administrative units, and although their names and boundaries are no longer recorded on current maps they are important elements in place-name study.

2 The parish name is followed by NO, the Instance Letters of the National Grid for our part of east Scotland; then comes a six-figure Ordnance Survey Grid Reference. An asterisked number indicates that the name is not to be found on modern maps, but can be identified from earlier ones. Four-figure numbers indicate that only an approximate location is known.

3 'Pron.' is followed by an attempted rendering of the pronunciation in modern Scots/ English, and is given only where the pronunciation or accentuation is in some doubt. It is assumed that readers will know that 'ch' is invariably pronounced as in 'loch'. Any attempt to give a phonetic rendering of a Gaelic name would be pointless, since nobody now knows what the local pronunciation would have been. Similarly no attempt is made to reproduce the Scots accent of some older inhabitants of the glens.

Abernethan Well KRR NO 365 562
Appears at first sight to be Pictish *aber* +
[Saint] Nechtan, but see below. A spring 2
miles NW of Kirriemuir.

Elsewhere, *aber* means a confluence of streams or
a river-mouth, and there are none in the locality.
Also, the the element *aber*, common in the rest of
Pictland, does not occur anywhere else in the
Angus glens. It may be that the original Gaelic
form of the name was *Tobar Nechtan* – which
would mean 'Nechtan's Well; the reference is to a
Pictish king, Nectan, commemorated in the nearby
Dunnichen, the putative site of the battle of
Nectansmere in 865.

Acharn COC NO 281 762
Gael. *achadh chuirn* – 'field of the cairn'.
Pron. **ach arn**.

Glendoll Lodge (a shooting-box built by the earls
of Southesk, who were owners of the glen) was
formerly known as Acharn. The name now applies
to the nearby farm; *achadh* indeed sometimes
meant 'farm'.

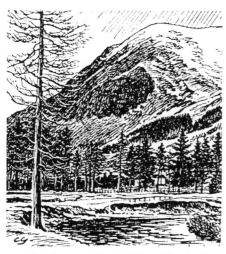

36 *Acharn and Craig Mellon, Glen Doll*

Addabing LIN NO 307 607
?Gael. *allt a beinge* – 'burn of the bank',
between Craig Marloch and the Cat Law nr
Balintore. Pron. **addy bing**.

Adebae LIN NO 271 616
Gael. *aite beith* – place of birches; hill-
slope E of Backwater reservoir; pron. **addy
bay**.

Adedazzle, Burn of LLE NO 471 850
Gael. *alltaidh deasail* – '[burn of] south-
flowing streamlet'. Tributary of Water of
Tarf (which does flow south). Pron. **addy
daz il**.

Adekimore, Burn of LLE NO 470 850
Gael. *alltaidh cam mor* – [burn of the]
'burnie of the large bend'; joins Water of
Tarf 3 miles NE of Invermark; pron. **addy
kee-more**.

Ademannoch EZL NO 521 753
Gael. *alltaidh meadhonach* – 'mid burnie';
tributary of Burn of Deuchary, Glen Esk.
Pron. **addy man och**.

Adenaich, Hill of COC NO 305 654
Gael. *alltaidh an each* – '[hill of] the horse
burnie'; hill (*c*1700 ft) in Glen Prosen,
opposite Balnaboth; poss. a reference to
grazing for horses. ?Pron. **a din ay ich**.

Adielinn COC NO 350 715
Gael. *alltaidh linne* – 'burnie of the pool';
former croft 2 miles SE of Clova village;
pron. **addy lin**; now marked by OS as a
plantation; also Burn of Adielinn.

Adikinear, Burn of LEN NO 428 727
Gael. *alltaidh coin uidhir*; '[burn of] otter
burnie'; joins Burn of Duskintry then Water
of Saughs; pron. **addie kin ear**.

Afflochie FER NO 476 643
Gael. *ach(adh) cloichridh* – field of the
stony place (cf. **Auchlochy** and **Pitlochrie**);
farm on Cruick Water 5 miles W of
Menmuir. Pron. **aff loch y**. Earlier written
'Auchenlochy; Ainslie has 'Ansshlochy'.

Airlie Castle AIR NO 315 502
?Pictish *ar ol* – 'on the ravine'; 15th
century castle of the Ogilvies; also Kirkton,

Mains, Braes, Newton of Airlie. See p.32. Earlier written 'Erolyn', 'Eroli' (1242).

Aldararie, Lair of COC NO 312 780
Gael. *allt dairiridh* + Scots *lair* – 'lair (place for lying) of the burn of the loud rattling noise'; hill (2726 ft) N of Glen Clova. Pron. **al dar arry**. See p.32.

Aldorch COC NO 345 635*
From ? O Ir. *all* + Gael. *dorcha* – ?dark rock; woodland on E side of Glen Prosen.

Algeilly Burn see **Altgillie**

Allrey LLE NO 539 825
Poss. contraction of Gael. *ard shealbh-mhoraidh*, see **Arsallary**. Hill-slope 2 miles SW of Mount Battock. Pron. **all ray**; also written 'Alrey'.

Alltanseilich Burn GLI NO 182 723*
Gael. *alltan seilich* – streamlet of willows; joins Glen Brighty Burn W of Tulchan.

Allt na Beinne GLI NO 196 666
Gael., prob. as written – stream of the hills. Tributary of the Isla; name also given to outflow of Auchintaple loch at NO 198 646. Pron. **alt na benn ie**.

These two names are the only examples in Angus of the familiar Gael. *allt na* formation, which is so common in the neighbouring shires of Perth and Aberdeen. (An alternative etymology might be Gael. *allt na beingidh* – burn of banks.)

37 *Afflochie, a sheep-farm on Cruick Water*

Alrick GLI NO 191 619
Gael. *eilerg* – a defile used as a deer-trap; landholding in sub-glen off Glen Isla. Also Alrick Burn. Pron. **al rik**.

Commonly known as 'the Alrick' and formerly spelt 'Elrick'; Ainslie's map has 'Aldrig'; Over Alrick is included in the 1561 rental of Coupar Angus Abbey.

Altaltan GLI NO 185 635
Poss. Gael. *ail alltan* – rock-streamlet; farm on R. Isla, S of Forter, part of the 'mill-lands of Auld Allan'; pron. **alt al tan**. No stream shown on OS map; see also *Auldallan*.

Altantersie Burn COC NO 255 796*
Gael. *alltan tarsuinn* – '(burn of the) cross or athwart streamlet', joins S Esk at Bachnagairn; pron. with stress on '**ters**'.

Altbuie Burn GLI NO 233 697*
Gael. *allt buidhe* – [burn of the] golden or yellow burn; streamlet joining Finlet Burn. Pron. **alt boo yu**.

Altduthrie, Den of COC NO 255 785
Gael. *allt duthrach* – den [valley] of the burn of ?willingness; corrie SW of Bachnagairn; pron. with stress on '**duth**'. Also Burn of Altduthrie; 'den' seems modern.

Altgillie Burn GLI NO 202 704
Gael. *allt geallaidh* – shining burn; joins the Isla nr Linns. Formerly appeared as 'Algeilly'; revised spelling suggests *allt gille* – lad's burn. Pron. **alt gil y**.

Altochy, Meikle LIN NO 275 650*
Scots *meikle* + Gael. *allt achaidh* - 'big burn of the stream-place', nr Glenhead Lodge, Glen Isla. Also Little Altochy; pron. **alt ochy**.

Altvraigy Burn GLI NO 202 703
Gael. *allt bhreac-aich* – either 'trout burn' or 'speckled burn' [burn]; joins the Isla at Linns. Pron. **alt vraig y**.

Angus

Celtic pers. name *Aonghus* – 'one choice';
name since 1928 of Forfarshire. See p.32.

Anniegathel LEN NO 416 627

Gael. *ath na geadhail* – ford of the
ploughed field; ruined croft 4 miles NE of
Dykehead, Clova; pron. **anny gath l**. Name
appears as 'Annagathal' on Ainslie's map
of 1794. There is another Anniegathel in
Tannadice parish.

Ardbeast EZL NO 561 724*

Gael. *aird beist* – height or high land of the
beast or brute; grouse moor E of Hill of
Corathro, Glen Esk. Pron. with stress on
beast.

Ardoch LLE NO 508 792

Gael. *airdeachd* – height, high place. Farm
in Glen Esk, 2 miles SE of Tarfside. Pron.
ard och (locally '**Airdie**'). See p.33.

Argeith LEN NO 541 687*

Gael. *ard gaothach* – windy height;
settlement in Lethnot (now known as
Townhead). Early forms are Argeich (1511)
and Ardgyth (1699). Pron. **ar geeth**.

Argyll's Barony GLI NO 24 63*

Area of hill and moorland occupying most
of Glenmarkie, in the ownership of a cadet
branch of the Campbells of Argyll until
1695; see p.52.

Arlone, Shank of EZL NO 554 729*

Scots *shank* + Gael. *aird loinn* – 'spur of
hill of enclosure-height'. Hill-slope N of
Hill of Corathro; pron. **ar lone**.

Arnagullan, Burn of COC NO 340 680*

Gael. *ard na guaillean* – '[burn of the]
shoulder-like height'; upper reaches of
burn of Glen Cally. Pron. **ar na gull an**.

Arntibber COC NO 327 732*

Gael. *earran tobar* – land-division of the
well; part of Clova Village. Pron. **arn tib er**.

Arsallary LLE NO 472 822

Prob. Gael. *ard sealbhmhoraidh* – hill of
possessions (sc. cattle); remote croft NW
of Tarfside, Glen Esk. Pron. **ar sal ary**.

Formerly a farm, it is now part of large sheep-run.
The early forms are interesting – Auchsallary
(1554); Auschallary (1588), both of which indicate
'field' rather than 'hill'; but Ainslie's map of 1794
has 'Arslary'.

Artithol COC NO 380 606

?Gael. *aird feudail* – height of treasure (sc.
cattle); former croft 1 mile NW of
Cortachy Castle. Pron. **arty thol**.

Ascreavie KGM NO 333 573

Gael. *ath creagach* – ford of the rocky
hillside. Estate NE of Lintrathen with
notable gardens. Also Ascreavie Hill and
Nether Ascreavie. Pron. **a scree vy**. Earlier
written 'Aqhkragy' (1250). Ogilvy
property from 1539 until modern times.

Ashens LIN NO 307 598

Poss. Scots *aish* – ash-tree place; hill-side
above Auldallan; but topography makes
this etymology suspect.

Ashnamuck COC NO 28 72*

Gael. *achadh na muc* – field of swine; area
between Glens Clova and Prosen (but this
is unlikely pastureland).

Atton COC NO 303 735

Poss. Scots *haugh toun* – farm-stead at the
river-meadow; croft, 2 miles W of Milton
of Clova. Topography rules out Hatton
('hall farm').

Aucharroch KGM NO 330 565

Gael. *achadh ?Charraig* – field of The
Carrach; farm NE of Lintrathen. Pron. with
stress on 'arr'. No doubt takes its name
from nearby *Carrach* hill qv.

Auchavan GLI NO 191 697

Gael. *achadh bhan* – white field; croft in
upper Glen Isla; pron. **auch a van**. Was a
property of Shaw family in 18th century.

Aucheen, Mill of LLE　　NO 536 795
Gael. *ach aodainn* – field on the brae;
former mill on the Laurie Burn, Glen Esk;
Pron. **och een**. Early forms are Auchedin
(1511) and Auchedyne (1539); also West
Aucheen, a croft 1 mile to NW.

Auchinleish GLI　　NO 195 603
Gael. *ach an lios* – field of the enclosure or
'of the press'; farm and mansion in Glen
Isla 1 mile S of Brewlands. Pron. **och in
leesh**; see also *Auchleish* and *Auchlishie*.

Early forms are: Achinlesk (1304), Auchynlech
(1234), Achinlesk (1571); later we find Auch-
nalese and Auchnalesch. Nether Auchenleish is
included in the 1561 rental of Coupar Angus
abbey.

Auchinree GLI　　NO 186 657*
Gael. *achadh an ruighe* – field of the
shieling-ground; former croft nr Dalvanie,
Glen Isla; pron. **och in ree**.

Auchintaple Loch GLI　　NO 192 648
Prob. Gael. *achadh* + chapel (it was
formerly written 'Auchenchapel') – field of
the chapel (cf. Chapelhill nearby); artificial
loch 1 mile E of Forter Castle.

The loch was formed in the 19th century from
Auchintaple Well (shown on Ainslie's map),
reputed to be a place of healing and worship
resorted to by the inhabitants of Glen Isla. The
property now attaches to Glenisla House; the OS
map indicates remains of a chapel at NO 198 652.

Auchintoul LLE　　NO 5247 885
Gael. *ach an t-sabhail* – field of the barn;
farm in Glen Esk, part of lands of
Carrecross. Pron. **auch in too ul**.

The early forms are Auchintowill (1511) and
Auchintowle (1539). The former croft of East
Auchintoul on the south slope of Modlach Hill is
now known as Modlach Cottage.

Auchleish TAN　　NO 416 613
Gael. *ach lios* – field enclosure, garden;
farm 2 miles NE of Dykehead. Pron. **auch-
leesh**; see also *Auchenleish* and
Auchlishie.

Auchleuchrie TAN　　NO 435 575
Gael. *ach luachrach* – field of rushes; farm
on a wide bend on S Esk, between Cortachy
and Tannadice; pron. **aff looch ry**. A fosse
and earthworks show remains of a castle.

Auchlishie KRR　　NO 392 572
Gael. *ach ?liosaidh* – field enclosure,
garden; farm 3 miles N of Kirriemuir; pron.
och lish y.

Auchlochie LLE　　NO 46 80*
Gael. *ach cloichridh* – stony field; croft in
Glen Esk, N of Dalbrack; pron. **auch loch y**.
This area of large stone-heaps of ancient
date is now known (along with *Glack*) as
Westbank. Early forms include Auchlochie
(1554) and Auchlochry (1611). See also
Afflochie.

Auchmull EZL　　NO 584 746
Gael. *ach muile* – mill field. Croft on E
side of N Esk, part of Gannochy estate;
also Burn of Auchmull. See p.33.

Auchmure COC　　NO 345 662*
Gael. *ach mor*–big field; former habitation
in Glen Cally, Prosen, not now identifiable.

Auchnacree FER　　NO 464 638
Gael. *ach na craobh* – field of the tree;
farm NE of Glenogil, built in 1836 on the
site of an old laird's house. Pron. **ach na
cree**.

Auchnadoes COC　　NO 383 613*
Gael. *ach na ?dos* or *?dus* – field of the
thicket or of ?dust/ashes; plantation on
Tulloch Hill, Clova. Pron. **ach na dos**[?].

Auchnafoe LEN　　NO 503 735*
Gael. *ach na faithce* – exercise-field; hill-
spur between W Wirren and W Craig,
Lethnot. Pron. **ach na foy**.

OS map shows only Shank of Auchnafoe at NO
504 740; was once a pendicle of *Auchowrie*.

Auc

Bad

Auchnavis EZL/LLE NO 54 79/55 79*
Gael. *ach neimhidh* – church fields, glebes; former lands in Glen Esk, nr Millden; pron. **ach nay vis**.

The lands of Auchnavis (not identified on OS maps) lay in the barony of Newdosk and county of Kincardine.

Auchowrie LEN NO 505 730
Gael. *ach chomharraidh* – target field; farm in Lethnot 6 miles NW of Bridgend; pron. **auch oor ie**. Said to have been a former mustering ground for sport or war – see **Auchnafoe**; also Burn of Auchowrie.

Auchrannie GLI NO 280 523
Gael. *ach roinneach* – share field; farmstead in lower Glen Isla which gives its name to a beauty spot – see **Slug**. An alternative derivation from Gael. *ach raineach* ('field of ferns or bracken') is not impossible.

Auchronie LLE NO 448 808
Gael. *ach roinneach* – share field; isolated croft nr Invermark. Pron. **och ro ny**. Early forms include Auchrynie (1511), Auchrany (1554) and Auchrennie (1588); the land consisted formerly of E & W Auchronie.

Aud, The COC NO 378 668
Gael. *uchd* – breast, hill-face; hill (1325 ft) on E side of Glen Clova. Roy's map calls it 'Aught Hill', and cf. **The Ought**.

Auld Darkney TAN NO 423 665
Derivation and meaning unknown; hill (1788 ft) in Glen Ogil; perhaps from *allt deargan* – 'red-stained burn'.

Auldallan LIN NO 315 584
Gael. *allt ailean* – burn of the green place; farm and mill in deep glen S of Cat Law; Pron. **ald al an**. Also Knowehead of Auldallan. An earlier form is thought to be 'Uskalan' (*uisge* = water), the name of a stream which joins the Carity Burn. See also **Altaltan**.

Auldmannoch KGM NO 319 591
Prob. Gael. *allt manaich* – monk's burn. Tributary of Auldallan Burn. Pron. **ald man ach**.

'Monk' would recall the prescence of Arbroath abbey, which owned much of the land hereabouts; alternatively the derivation might be Gael. *allt meadhonach* – 'mid burn', cf. **Ademannoch**.

Bachnagairn COC NO 255 796
Gael. *bac na gharain* – crook or hollow of the crying one (with reference to the wind). Site of shooting lodge in upper Glen Clova. Pron. **bach na gairn**. See p.33.

Back Latch COC NO 23 80*
Back Latch GLI NO 193 698*
Scots as written – 'rear bog-stream'. (1) streamlet joining Burn of Gowal S of Broad Cairn; (2) stream nr Tulchan, Glenisla; also Easter and Wester Latch.

Backie, Burn of LLE NO 362 846
Scots as written (but with Gaelic word-order) – tardy, sluggish stream. Trib. of Water of Mark; also Backie Grain (streamlet).

Backwater Reservoir LIN NO 255 605
The meaning is as written – see p.33.

Bad Buidhe LIN NO 255 665
Gael. *bad buidhe* – yellow clump; hill (1720 ft) 5 miles N of Backwater Res. Pron. **bad boo yu**.

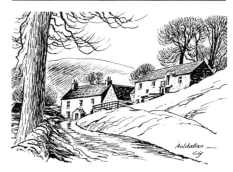

38 *Auldallan, Glen Carity*

82

Bada Crionard GLI NO 225 665
Gael. ?*bad a chrion ard* – ?thicket on the
small height; hill (1300 ft) 7 miles N of
Kirkton of Glen Isla. Pron. **bada <u>creen</u> ard**.
The thicket is now a large plantation.

Bada na Bresoch GLI NO 214 717
Gael. *bad nam preasach* – spot of the
thicket-places; hill (2174 ft) E of Tulchan.

Bada na Goibhre GLI/LIN NO 236 668
Gael. *badaidh na goibhre* – little clump of
the goat-place; hill in Glen Taitney. Pron.
bada na <u>gaury</u>.

Badabay LLE NO 469 822
Gael. *badaidh beithe* – small clump of
birches; croft 2 miles W of Tarfside. Pron.
bad a <u>bay</u>. Appears as Bodybae on Ainslie's
map of 1794.

Badadarroch LLE NO 442 822
Gael. *badaidh daraich* – oak thicket. Hill
(1575 ft) 2 miles N of Invermark. Pron.
bada <u>darr</u> ach.
There are no oaks hereabouts nowadays.

Badagee, Shoulder of LIN NO 272 605
Gael. *badaidh ?gaoithe* – hill of the clump
of the ?wind or ?marsh; summit in Glen
Quharity. Badagee itself does not survive
on OS maps.

Badalair LLE NO 455 827
Gael. *baideal iar* – west tower (sc.
towering hill). Hill (1753 ft) 2 miles NNE
of Invermark; pron. **bad al <u>air</u>** (but in Gael.
would be *baj al ear*); compare **Badlearie**.

Badandun Hill GLI NO 207 679
Gael. *bad an dun* – clump on the hill (hill).
Hill (2429 ft.) 7 miles N of Kirkton of Glen
Isla. Pron. **bad an <u>dun</u>**; also written
'Badenden'.

Badderdoune, Burn of
LLE NO 377 855
Gael. *bodan diomhain* – lazy little spout.
Tributary of Water of Mark. Also written

'Badderdowan', which gives the
pronunciation.

Badlearie Burn of EZL NO 575 798
Gael. *baideal ear* – stream of the east
tower (sc. tower-shaped hill); tributary of
Burn of Meallie; cf. **Badalair**.

Badlessie, Burn of LLE NO 490 811
Gael. *bod leisge* – 'lazy nozzle burn' (sc.
intermittent water-spout); tributary of
Water of Tarf. Pron. **bog <u>lass</u> ie**.

Badmorrow, Shank of
KRR NO 312 612
Scots *shank* + Gael. *bad ?marbh* – hill of
the dead [men]. A spur of the Cat Law.

Badrone, Burn of LLE NO 367 815
Gael. *bad droighinn* – [burn of the]
blackthorn-clump. Tributary of Water of
Lee; pron. **bad <u>drone</u>**.

Bady LLE NO 467 782
Gael. *badaidh* – thicket, small clump.
Unidentified feature N of Cowie Hill, Glen
Esk. Pron. **<u>bad</u> dy** (also written 'Bauddy').

Baikies TAN NO 421 632
Gael. *bacaidh* – 'hindrance'. Estate nr
Glenquiech, 2 miles N of Dykend.
There is a Scots word *baikie* meaning a tether, but
it is not current before the 19th century, and this
name is much older: the farm is on the site of a
mediaeval castle built by the Fenton family.

Baillies LLE NO 483 820
Gael. *am beulaibh* – the fore hill (sc. one
with a southern aspect). Croft (now empty)
in Glen Esk, 4 miles N of Tarfside; pron.
?**<u>by</u> lees**. Formerly East and West Baillie
(1511 Bailye).

Balbae, Hill of COC NO 350 669
Gael. *baile beith* – [hill of] birch-tree farm;
hill (*c*1500 ft) between Glen Prosen and
Glen Clova. Pron. **bal <u>bay</u>**. At one time the
name of a farm, now lost.

Balbui COC NO 415 690
Gael. *baile buidhe* – yellow farmstead. Hill
(*c*2000 ft) between Glen Clova and Glen
Lethnot.

The topography does not indicate a settlement-
name; could this be a mis-transcription of *meall* or
bad buidhe ('yellow hill or spot')?

Balconnel MEN NO 522 640
Gael. *baile Conall* – Conall's farm or
township. Farm 2 miles W of Menmuir;
pron. **ba <u>con</u> nel**.

Baldoukie TAN NO 465 587
Gael. *baile* +? (meaning unknown). Farm 2
miles NW of Tannadice (also Den of
Baldoukie); pron. **bal <u>dook</u> y**. Site of ancient
earthworks.

Baldovie KGM NO 324 542
Gael. *baile domhan* – stead of the deep (sc.
low-lying) farmstead; 18th century laird's
house, now a farm, 1 mile SW of
Kingoldrum. Pron. **bal <u>duvv</u> y**. (Dundee's
Baldovie is pron. as written.)

Balfield LEN NO 546 685
Scots *ba' field* – recreational land
(formerly written 'Bafield'). Farm 1 mile E
of Bridgend of Lethnot.

Balfour KGM NO 337 546
Balfour MEN NO 532 643
Gael. *baile phuir* – pasture village. (1) farm
and castle (ruin); (2) farm and burns. Pron.
<u>ba</u> foor. See p.33.

Balgray KGM NO 346 588
Balgray, Nether KGM NO 354 589
Gael. *baile greagh* – farm of horse-studs;
or from personal name Gray. Farms W of
Cortachy.

Balhangie LLE NO 492 797*
Gael. *baile chumhangaidh* – 'township of
the narrow land'. Pron. **bal <u>hang</u> y**; see p.34.

Balintore LIN NO 287 592
Gael. *baile an torraidh* – place of the little
heap. Farming hamlet (with Mains,
Westerton, and Burnside, plus Balintore
Castle); pron. **bal an <u>tore</u>**. See p.34.

Balloch GLI NO 167 649
Balloch KRR NO 355 578
Gael. *bealach* – pass or defile. (1) croft nr
Forter Castle; (2) farm NW of Kirriemuir;
pron. **bal uch**.

Pont's map has 'Bhealloch Fortyr', i.e. 'pass of
Forter'.

Balloch Burn COC NO 267 689
Gael. *bealach* – [burn of the] pass or gap.
Stream in Glen Prosen; also nearby Craigs
of Balloch.

Balloch, Easter LLE NO 347 801
Balloch, Wester LLE NO 341 791
Gael. *bealach* – pass or gap. Hills (2731
and 2631 ft) above Water of Unich;
bealach must refer to the gap between
them.

Balmadity FER NO 505 622
Gael. *baile madadh* – place of dogs; farm 3
miles NE of Noranside. Pron. **bal <u>mad</u> ty**.
The 'ty' ending corresponds to that in
'Auchtermuchty'.

Balmennoch GLI NO 195 635
Gael. *baile meadhonach* – middle croft.
Farm in Glen Isla 2 miles SE of Forter.
Pron. **bal <u>men</u> och**.

In Scots this name would be 'Middleton'; it is the
home of a noted shorthorn herd.

Balnaboth COC NO 315 665
Gael. *baile na both* – stead of the hut;
former Ogilvy estate and mansion in Glen
Prosen. Also Craig of Balnaboth. Pron. **bal
na <u>bawth</u>**, locally '**bonny both**' (Edward's
map has 'Bonaboth'). See p.34.

Balnagarrow KRR NO 378 573
Gael. *baile na garadh* – stead of the garden
or enclosure. Farm 2 miles N of
Kirriemuir; pron. **bal na gar o**.

Pont shows a settlement in Glen Prosen (NO 36
62*) which he calls 'Balnagarrak' and which prob.
has the same etymology. The afforestation of this
south-facing part of the lower glen has obliterated
it and several other crofts.

Balnamoon's Cave LLE NO 396 833
Gael. *baile na moine*. The name (meaning
peat-moss croft) comes from the estate of a
Jacobite laird who hid here in 1746 – see
pp.23, 34.

Balquhader see **Glack of Balquhader.**

Balquhadly FER NO 476 622
Gael. *baile* + ?; meaning unknown. Farm 7
miles SW of Menmuir. Pron. **ba whad ly**.

Balquharn FER NO 488 625
Gael. *baile chuirn* – stead of cairns or
stones. Farm 5 miles SW of Menmuir;
pron. **ba wharn**.

Balstard KRR NO 356 560
Gael. *baile stair* – poss. 'place of the
stepping-stones'. Farm 2 miles NW of
Kinnordy. Pron. **bal stard**.

The pronunciation of this name (which Ainslie
writes as 'Bastard') does nothing to help with the
etymology; but the earlier spelling 'Balsture' on
Edward's map is more rewarding. The second
syllable could be one of several Gaelic terms in
addition to the one suggested: *stur* (Scots *stour*, or
dust), *sturr* (hilltop), or even *sturd* (the herb
darnel) – all of them understandable settlement-
names. The modern pronunciation may have been
affected by a (wrongly) perceived association with
illegitimacy.

Balzeordie, Castletoun of
MEN NO 568 652
Gael. *baile gheardaich* – castle-farm of
watching or guarding. Farm 5 miles NW of
Brechin; also Den of Balzeordie; pron. **ba
jor dy**.

Ochterlonie calls it 'Baljordie', Ainslie 'Balyordie'
and Edwards 'Baljordo'; also variant spelling of
'Ballourthy' (1319) and 'Badjordie'. But the
etymology is not in doubt.

Bankhead LIN NO 277 578*
As written, and with obvious meaning.
Deserted croft, no longer shown on OS
map.

Banks, The GLI NO 226 681*
As written, with obvious meaning.
Hillsides on W side of Glen Finlet.

Barns Lairs GLI NO 16 73*
Prob. Gael. *bearn* + Scots *lairs* – gaps in
hills where cattle lie; grazings in Glen
Brighty. Also Stone of Barns (Eng. 'barn'
does not seem to fit).

Barns, Cairn of COC NO 320 713
Gael. *bearn* + Scots *cairn* – rocky hill with
notches; hill (2129 ft) S of Clova village;
also Shank of Barns to S.

Barnton KGM NO 323 559
Scots *barn toun* – steading with barn; farm
3 miles E of Lintrathen. Nearby Baron's
Hill may suggest 'baron toun' etymology.

Barny LIN NO 250 635
Gael. *bearnach* – notched (sc. 'place of
gaps'). Croft in Glen Damff. Also Little
Barny, Meikle Barny, Glack of Barny: cf.
Bairny Cairn, now known as Berry Cairn.

Baron's Hill KGM NO 321 567
?'Moot hill for baron baillie'; wooded hill
2 miles NW of Kingoldrum; see *Barnton*.

Bassies COC NO 295 735
Scots *bassies* – bowls, basins; steep rough
hillside on S side of Glen Clova.

Bathach Beag GLI NO 160 759
Gael. as written – little byre. S part of Glas
Maol, on Perthshire march. Pron. **ba ach
bake**; also Batheachbeg Burn.

Bathie, Burn of LLE NO 466 784
Gael. *badaidh* or *bathaich* – '[burn of]
small thicket' or 'of byre, cowshed'.
Stream joining N Esk 3 miles W of
Tarfside.

Ainslie shows 'Bauddy'; but the burn prob. takes
its name from a lost croft or farm.

Battock, Mount LLE NO 549 845
Gael. *monadh bathaich* – cow-house
upland; summit (2555 ft) on Aberdeeen-
shire border.

An alternative derivation from Gael. *biatach*
('raven hill') seems less likely.

Bawhelps COC NO 227 722
Gael. *bo* or Scots *bow,* meaning cattle, but
suffix is obscure; hill (2722 ft) at head of
Glen Prosen.

Beag, Burn of EZL NO 553 773
Gael. *beag* – little [burn]. Streamlet joining
N Esk in lower glen; pron. **beg**.

Beanie, Glen GLI NO 187 660
Gael. *gleann mheadhonach* – middle glen,
i.e. between Shee and Isla. A sub-valley of
Glen Isla, 2 miles N of Forter; pron. **benny**.

Loch Beanie, on the other side of the county
boundary, is not drained by the Glen Beanie burn.
It was formerly, and properly, called Loch
Schechernich (Gael. *sith charnaich* – 'rocky shee
or fairy hill').

Bearfauld COC NO 370 602
Prob. Scots as written – barley field; farm
in Glen Prosen, 2 miles W of Dykehead.

'Barfauld' on Ainslie's map. The farm was at one
time used as a hostel for children.

Beattie's Cairn FER NO 501 649
From the personal name Beattie. Cairn
(which here means a heap of stones) on a
wooded hill NE of Noranside. See p.35.

Bellaty GLI NO 238 593
?O Ir. *belat* – cross road, path; hamlet in
lower Glen Isla. Pron. ?**bal a ty** (also
Bellaty Lodge, Hill, Corrie).

Same formation as Bialaid in Badenoch.

Belmonies COC NO 339 633
Poss. Gael. *baile moineis* – place of
slowness; farm between Glen Prosen and
Glen Uig. Pron. **bal mun ees**.

Alternatively, stem could be Gael. *i mbun eas* – 'at
the foot of the waterfall' (on analogy with Moness
at Aberfeldy); but this does not fit the topography.

Ben Reid COC NO 318 752
Prob. Gael. *beann reidh* – smooth peak; hill
(2601 ft) N of Clova village.

'Reid' is poss. just the Scots version of 'red'.
Lower slopes are rugged, but summit is smooth, so
reidh is more probable.

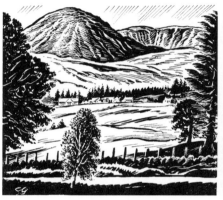

39 *Ben Reid, above Clova village*

Ben Tirran COC NO 369 742
Gael. *beinn* +? Scots *tarn* – tarn hill (ref. is
to Stoney Loch). Hill (2860 ft) above Loch
Wharral, Glen Clova. Also Burn of Ben
Tirran, source of the West Water.

Bennyfunnar LLE NO 505 825
Gael. *beingidh fionnair* – cold bank; hill
ridge in Glen Tennet. Pron. **benny fun ar**.
Also Burn of Bennyfunnar; Bennygray is
part of same ridge.

Bennyglower LLE NO 512 829
Gael. *beingidh lomhar* – bright bank; part
of hill ridge in Glen Tennet; also Burn of
Bennyglower; cf. Bennyfunnar and
Bennygray, all part of same ridge.

Bennygray LLE NO 525 835
Gael. *beingidh reidh* – smooth or level
ridge or bank. Hill (1828 ft) in Glen Tennet
(not sufficiently elevated to be Gael. *beinn*
(ben)).

Benscravie COC NO 401 628
Poss. Gael. *beinn sgribhinn* – point of the
rocky hillside; hill (1402 ft) 2 miles N of
Dykehead, Clova. Pron. **ben scrave** y; but
cf. *Ascreavie*.

Benty Roads COC/LLE NO 331 766
Scots *bent* (rough grass) – grassy tracks;
moorland hilltop (2753 ft.) NW of Loch
Brandy; name may be relatively modern.

Bentyfauld EZL NO 552 786
Scots as written – bent-grass sheepfold;
cottage in Glen Esk; pron. **benty faad**
(locally).

Berran, Hill of LEN NO 451 716
Gael. *bearn* – hill of the notch or gap (sc.
steep rocky valley). Hill (2014 ft) in Glen
Lethnot; also Corrie na Berran, NO 442
725.

Berry Cairn LEN NO 512 679
Gael. *bearnach* + Scots *cairn* – rocky hill
of the notch or gap; hill (1433 ft) 5 miles
W of Edzell; formerly written 'Bairny
Cairn'; see also **Tilliybirnie**.

Berryhill, Burn of LLE NO 509 764
Gael. *bearnach* – gap-hill burn (there is a
gap in the hills nr its source). Trib. of N
Esk; there is a former croft and limekiln at
NO 500 768 See p.35.

The hill from which the name derives is no longer
named on the map.

Bessie's Cairn GLI NO 185 745
A cairn of stones below Monega Hill in
upper Glen Isla; sometimes said to be the
grave of the laird's favourite dog – but see
p.35 for definitive account.

Bettywharren FER NO 444 678
Gael. *badaidh fhuarain* – little thicket of
springs; unidentified feature in upper Glen
Ogil.

Between ye Burns LLE NO 470 823*
Old name of a lonely croft at the junction
of the Easter and Kirny burns nr Arsallary.
Name found on Ainslie's map of 1794; it is
now called Burnside.

Birken Hill LEN NO 532 867
Scots as written – birch hill. Knoll nr
Bridgend; earlier known as Birken Hillock.

Birkentree GLI NO 224 726
Scots as written – birch tree; hill (1900 ft)
at head of White Glen, Prosen.

Birches are not in evidence now.

Birkhill GLI NO 205 598
Scots as written – birch hill; farm in lower
Glen Isla. Site of a Bronze-Age burial
mound.

Birnie Burn LEN NO 517 665
Gael. *braonaigh* - [burn of the] wet place.
Trib. of Paphrie Burn; cf. Tilliebirnie.

Birse Shades LEN NO 441 693
Pictish *preas* + Scots *shades* – 'sheds at the
thicket'; unidentified feature 1 mile SW of
Mount Sned.

The term 'shades' meaning 'divisions' makes no
sense in hilly landscape such as this.

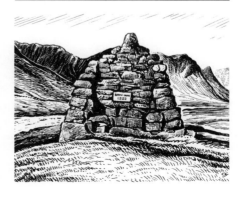

40 *Bessie's Cairn in Glen Isla*

Black Binks LIN NO 259 651
Scots *bink* – '[black] peat-banks'; hill
(1470 ft) 5 miles NE of Kirkton of
Glenisla.
Scots *bink* is cognate with Eng. bench and can also
mean 'shelf'.

Black Doups EZL NO 548 729
Scots as written – lit. black bottoms, sc.
'low-lying land'; land formation 1 mile SE
of E Wirren.
Reference is to hollows nr Mooran burn.

Black Hill
There are five of them in the area under
survey; usually indicates heather-covered
hill in contrast to grassy hill (names prob.
19C). The area has six White Hills and one
Green Hill; also Blackhills, and Burn of
Blackhill (NO 509 764).

Black Latch COC NO 304 771
Black Latch COC NO 315 689
Scots, as written – black bog-streamlet.
(1) burn nr Braedownie, Clova; (2) burn in
Glen Logie, Prosen

Black Rigging GLI NO 735 205
Scots as written – Hill (*c*2250 ft) between
Glen Isla and Glen Doll.
'Rigging' is a high ridge of land; 'black' prob
refers to heather or moorburn.

Black Shank COC/LEN NO 385 749
Scots as written – lit. black leg; hill (2691
ft) N of Loch Wharral in Clova. A broad
ridge bare of grass.

Black Skellies COC NO 25 71*
Gael. *sgaoileach* – ridge of [black]
crumbling rocks; rock formations bet.
Mayar and Driesh. Topography rules out
'shiels'; cf. *Glittering Skellies*.

Black Skelly LLE NO 412 826
Gael. *sgaoileach* – ridge of [black]
crumbling rock; outcrop in Glen Mark.

Blackcraigs LLE NO 532 805
Scots as written - black crags; farm in mid-
Glen Esk; name prob. 19th century – see
also Blackhills nearby.

Blackdykes LIN NO 246 544
Scots as written – black walls; farm 2 miles
W of Loch of Lintrathen.

Blackhaugh LEN NO 469 718
Scots *haugh* – [dark-coloured] water-
meadow; farm at head of Glen Lethnot.
Pron. **black hauch**.

Blackhills LLE NO 537 805
Scots as written; farm in Glen Esk. Name
prob. 19th century; see also Blackcraigs.

Blackness LLE NO 466 785
Gael. *innis* – [black or wet] meadow; croft
in upper Glen Esk.

Blackpots, Burn of EDZ NO 563 796
Scots as written – stream of black pools;
sub-stream joining N Esk in lower Glen
Esk. Name is poss. connected with illicit
whisky stills.

Blackstock, Burn of LLE NO 395 816
Scots as written – prob. 'stream of the
black tree-stump'. Trib. of Water of Lee.

Blair a Bhuids GLI NO 19 65*
Gael. *blar a buidseach* – witch field; haugh
on R Isla N of Forter bridge. Pron. **a boods**.
The place was also known in Scots as 'the Bleatin'
Ghaist' – the legendary haunt of a ghost-sheep.

Blair Muir MEN NO 574 657
Gael. *blar* + Scots *muir* – moor on the plain
(or 'of the battlefield'); forestry plantation,
3 miles SW of Edzell; moorland, not
designated on older maps.

Blair, The EZL NO 571 709
Gael. *am blar* – the plain, moss; knoll 4
miles NW of Edzell.

Blairantosh GLI/LIN NO 243 637*
Gael. *blar an toiseach* – plain or field of
the chieftain; unidentified piece of ground
nr Glenmarkie Lodge; history unknown.

Blairno LEN NO 523 680
Gael. *baile airneach* – sloe-tree place.
Farm in Lethnot; pron. **blair no**. (Pont map
gives 'Blairna'). Also Clash of Blairno.

An attempt has been made to derive this name
from Gael. *baile earranaiche* – 'place of sharers'
and this was backed up by evidence that the land
was let in two halves in the 18th century. But
the name is very much older than that (1463
'Ballernoch'), and invites comparison with
Balerno in Midlothian

Blindarg, Burn of LEN NO 476 718*
Prob. Gael. *blaigh dearg* – [stream of the]
red portion. Tributary of West Water; pron.
blin darg.

This could poss. be a *bal*-name, but no evidence
available.

Bodandere Hill LIN NO 306 616
Gael. *bad an ?deoradh* – [hill of the]
thicket of the ?sacred relic. Hill (1570 ft) in
Glen Dye; Pron. **bod an deer**. No inform-
ation concerning a relic.

Boddam LLE NO 509 673*
Scots *bottom* (cf. Black Doups) – low-lying
ground. Site of croft at junction of Keeny
and Berryhill burns; (appears only on
Ainsie's map).

Bodleckmartine Burn
GLI NO 233 697*
Gael. *bad leac* + personal name – 'spot at
Martin's gravestone'. Streamlet joining
Finlet Burn, between glens of Isla and
Prosen.

Nothing is known about Martin or his grave.

Bog Inch EZL NO 526 764*
Scots, from Gael. *innis bothaig* – wet field;
hill-slope S of Glen Esk. Name seems to
refer to a hill and not a field.

Bogancur COC NO 412 671
?Gael. *bog an currach* – ?'bog of the wet
plain'. Hill-slope on E Burn of Glenmoy.
Pron. **boggan cur**; no settlement now shown
on map.

Boggandure, Bogs of COC NO 435 645
Gael. *bog an ?dobhair* – [bogs of the] bog
?of the streams. Marshland W of Glenogil
reservoir; pron. **boggan doo er**. ('Bogs of'
will be a recent Scots usage.)

Boggieshallow LEN NO 43 71*
Gael. *bothagaidh sealbhach* – cattle cot-
town. Site of old croft at head of Corscarie
Burn, not now identifiable from map.

Early forms are Bogyshalloche (1617) and
Bogyschello (1671).

Bogside COC NO 395 615
Scots as written – beside the marsh; farm in
Glen Clova 2 miles NE of Dykehead.

This was an Ogilvy property in 1668.

Bogton LEN NO 552 701
Gael. *bothagach* + Scots *toun* – 'place of
crofts'; farm nr Edzell.

The farm is one in a row of three above West
Water, so 'wetlands farm' does not really fit.

Bolyell GLI NO 182 650
Gael. *baile ghil* – at the white croft (or *both
geal* – white hut). Croft in Glen Isla nr
Forter Castle.

Bonhard EZL NO 592 687
Poss. Gael. *bothan cheard* – tinkers' (sc.
tinsmiths) cottages; group of houses 1 mile
W of Edzell (but see p.35).

Bonhard, Corrie of COC NO 315 755
Poss. Gael. *bothan cheard* – corrie of the
?tinkers' (sc. tinsmiths) cottages. Corrie in
Glen Clova (also Burn of Bonhard). Ainslie
shows former crofts of E & W Bonhard.
See p.35.

Bon

Bri

Bonsagart EZL NO 586 718
Gael. *baile an sagairt* – priest's home-
stead. Site of dwelling nr former chapel at
Drumbog; pron. **bon sag art**. (1511
Ballinsagart). See *Tigerton*.

Bontyre COC NO 301 748
Gael. *bun tir* – bottom land; croft in Glen
Clova. Pron. **bon tyre** (also written
'Bantyre'; and Ainslie has 'Bentyre').

Bottom LIN NO 286 538
Scots as written – low-lying land. Farm nr
Bridgend; cf. *Boddam*, *Black Doups*.

Boustie Ley LLE/COC NO 323 759
Gael. *buailteach* + Scots *ley* – 'shieling
ground'. Hill (2868 ft) on N side of upper
Glen Clova; pron. **boos ty lee**.
Ley is the same word as lea, but in Scots it can also
mean desolate or barren land (cf. the Burns song
'O wert thou in the cauld blast, on yonder lea').
Here perhaps it refers to summer hill-grazings.

Boyach, Burn of EZL NO 533 775
Gael. *buidheach* – (stream of the) yellow
place. Tributary of N Esk; pron. **boo yach**.
Ainslie has 'Baisach Mansion' at NO 622 480.

Braco LEN NO 505 703
Gael. *breacach* – speckled place; croft
beside Burn of Calletar. Pron. **bray co**.
Early forms are Breky (1404), Brako (1484); and
cf. Braco in Strathearn.

Braedownie COC NO 286 756
Gael. *braigh dhunaidh* – upper ground of
Downie (a hill to the N); farm at head of
Glen Clova. Pron. **brae doon ie**; see also
Dun Mor.

Braeminzion COC NO 365 665
Gael. *bruach ?muinighinn* – (river) bank of
?the fortress; croft in lower Glen Clova.
Pron. **bray min yon**.
The situation of this farm on the bank of the S Esk
indicates that the Scots element 'brae' is not
involved. The farmland was said by Colin Gibson
to have had a green bank used for bleaching linen
– but there is no sign of a fortress. The farm gave

its name to a corrie on the hill opposite and to a
plantation further down the glen. Timothy Pont's
map shows another 'Braeminnon' at NO 28 75*.

Braeshellach COC NO 314 665
Prob. Gael. *bruach saileach* – bank of
willows; croft in Glen Prosen nr Balnaboth.
Pron. **bray shell ach**. (Gael. *braigh* fits the
topography less well.)

Braid Cairn LLE NO 425 873
Gael. *braghad carn* or Scots 'broad hill'.
Upland stony hill (2907 ft), a neighbour of
Mount Keen, on county boundary.
(Broad Cairn is a different hill.)

Brandy Den FER NO 479 611
Prob. Gael. *bran* +Scots *den* – raven den
('black glen'); deep defile nr Noranside. Or
perhaps a contrived name, from contra-
band liquor.

Brankam Hill LIN NO 299 558
Poss. Scots *brank holm* – bridle, halter
haugh (cf. Branksome in Borders); hill nr
Loch of Lintrathen, site of Bronze Age
cairn and barrows.

Branny, Burn of LLE NO 445 813
Gael. *bran* – raven (black) stream;
mountain torrent rising nr Mount Keen and
joining N Esk.
The name is also written as 'Brawny' – cf. Loch
Brandy.

Brewlands GLI NO 193 607
Scots *brewland* – sc. land connected with
brewing on an estate; property in lower
Glen Isla, which gives its name to nearby
Brewlands Bridge (see p.35).

Brewston FER NO 586 676
?Scots *brewis toun* – homestead associated
with brewing. Farm 3 miles W of Edzell.
Unlikely to be from pers. name Bruce.

Bride's Bed LLE NO 39 79*
As written – green hollow on Craig
Maskeldie, said to be where a bride died in
a snowstorm when crossing from Clova.

Bride's Coggie COC NO 376 646*
Scots as written. Marsh nr Glenarm farm,
Glen Clova.

A cog in Scots was a wooden pail or bowl, and the
landscape-feature here referred to is a large
circular bit of marshland; it was at one time fertile,
and traditionally was used for growing corn, the
crop being given as a bride's tocher or dowrie. A
more likely possibility is that the 'coggie' was at
one time used for retting flax.

Bridge of Lee LLE NO 396 802*
A former settlement at the old bridge in
Glen Lee; it appears on Ainslie's map, but
it is difficult to locate in this now
depopulated glen.

Bridgend LLE NO 536 684
As written – 'at the end of the bridge';
hamlet beside the West Water – see p.35.

Bridgend of Lintrathen
LIN NO 284 546
As written; hamlet at S end of Lintrathen
Loch. See *Lintrathen*.

Broad Cairn COC NO 241 817
As written; 'broad stony hill' (but see
Braid Cairn for alternative derivation).
Hill (3268 ft) on county march between
Glen Doll and Dubh Loch.

Noted at one time for agates and garnets.

Broadford Bridge KGM NO 327 551
As written – bridge nr Kirkton of
Kingoldrum. Site of the ford is not clear
from OS map.

Brocklas COC NO 383 638
Prob. Gael. *broclach* – badger den place;
farm 4 miles N of Dykehead. Pron. **brok** las.

Pont shows 'Brecklaes' at NO 44 63*, which
might indicate Gael. *breacach* – speckled place'.

Broom Craig LEN NO 463 734*
Broom Craig EZL NO 526 756
Scots as written – broom hill (the ever-
green shrub). (1) hill in Glen Lethnot; (2)
hill in Glen Esk.

No broom bushes are in evidence now, but in
former times broom was cultivated for fuel.

Broom Shank COC NO 344 754
Prob. Scots as written – spur of hill
covered with broom; hill E of Loch
Brandy, Clova.

Ecology does not suggest broom bushes, but see
Broomhill below.

Broomfauld COC NO 402 600
Broomfauld LLE NO 523 801
Scots as written – enclosure with broom-
bushes. (1) farm nr Dykehead; (2) former
croft, Burn of Laurie.

Broomhall GLI NO 238 551*
Prob. Scots *broom haugh* – river meadow
with broom bushes. Site of habitation nr
Kilry in Glen Isla (no longer shown on
maps).

Broomhill COC NO 235 712
As written; hill (2302 ft) in Glen Prosen.

Broom (the evergreen yellow-flowering shrub)
was frequently grown as a quick and convenient
source of fuel for domestic heating (there are six
'Broomhills' in Angus).

This particular Broomhill, a small field at the
junction of the Burn of Kilry with the Isla, was
however noted as the site of the Standing Stone,
a huge amorphous monolith of whinstone.

Broom Hill GLI NO 223 573
Hill (1230 ft) in Glen Isla. See *Broomhill*
above.

Brown Holm COC NO 343 737
Scots as written – stretch of low-lying land
beside a river. Name of a hill 2 miles NE of
Clova village. Pron. **howm** in Scots.
(Ainslie calls this 'Witters' – see *Witter*).

If the suggested etymology is correct the hill-name
must be a transfer from the river-side.

Brown's Towers LLE NO 515 815*
As written – rock formations nr Craig
Soales, Glenesk. Perh. 'tower' is from
Gael. *torr*, a mound or heap.

Brudhach Mor GLI NO 175 767*
Gael. *bruthach mor* – great steep. The E
summit of Glas Maol; pron. **broo** ach.

Bruff Shank FER NO 472 660
Scots as written – hill-spur with ?'broch'
(heap of stones). Low hill above Cruick
Water.

Bruntshields COC NO 267 862
Scots *brunt shiels* – burnt huts; hill (1731
ft) on S side of Glen Prosen.
See notes on *Shieling*, p.71.

Bruntwood Craig LLE NO 387 808
Scots as written – burnt wood crag (poss.
refers to timber burnt for charcoal). Crag
above Water of Unich.

Buckhood COC NO O353 635
Prob. Scots *buckhowd* – buck hide, i.e.
stag's lair; farm at foot of Glen Prosen.
Written 'Buckwood' in error (1865). Another
Buckhood is shown by Ainslie at NO 37 59*.

Buckies COC NO 416 642
?Gael. *bocaidh* – swellings, blisters (i.e. on
the landscape); croft 6 miles NE of
Dykehead, Clova; but cf. Baikies.

Bulg EZL NO 543 762
Gael. *am bulg* – belly, bulge (hence, round
hill); hill (1986 ft) in Glen Esk, 6 miles
NW of Edzell (also known as 'Mount
Bulg').

Burnfoot MEN NO 538 674
Burnfoot LLE NO 484 807
As written – 'end of the stream'. (1) croft
nr Bridgend of Lethnot; (2) croft nr
Tarfside (both are at a burn-mouth).
The Menmuir name was formerly written as
Burnroot; with the meaning given under that
heading. The farm is nr the junction of a streamlet
with the Paphrie Burn, and 'root' could mean
an offshoot (see ***Makindab***). Possibly some
cartographic draughtsman took 'Burnroot' to be a
misprint and duly amended it.

Burnhead FER NO 492 631
As written – head of the stream. Farm 3
miles NE of Noranside.

Burnroot TAN NO 45 65*
Prob. as written, and meaning the point at
which a small stream diverges from a
larger one – but see note to ***Burnfoot***.
Former habitation in Glen Ogil.

Burnside
There are at least twenty habitations of this
name in Angus, incl. one nr Cortachy and
one at Tarfside; all are 'bestowed names'
indicating 'beside the stream'.

Burnt Hill LLE NO 417 779*
As written – hill S of Loch Lee; (name
prob. refers to moorburn).

Buskhead LLE NO 492 788
Prob. Scots *buss* – end of the bush or
thicket. Croft and limekiln in Glen Esk, S
of Tarfside.

Bykenhillock KGM NO 363 602
Scots as written – 'byke hillock' i.e. bee-
hive shaped hillock (or poss. where bees
swarm). Croft 3 miles W of Dykehead.

*41 Bykenhilllock croft,
overlooked by Airlie Monument*

Ca Whims GLI NO 215 788
Gael. *cadha fuaim* – pass of ?echoes. Hill
(2962 ft) above Canness Glen; (also Ca
Whims Burn).

Caddam COC NO 331 724
Prob. Scots *cauld howm* – cold haugh
(river meadow). Croft 1 mile S of Clova
Village; pron. with stress on **cad**. An
alternative derivation is to be found in
Cauldhame (cold home); and cf. Caddam
woods at NO 37 56.

Caderg GLI NO 199 768
Gael. *cadha dearg* – red pass; hill (2940 ft)
over-looking Canness Glen. Pron. **cah derg**.

Caenlochan GLI NO 196 760
Gael. *cadha an lochain* – pass of the tarn.
A steep and narrow glen, source of the R
Isla; pron. **cahn loch an** (see p.36.)

Cairn Baddoch COC NO 276 704
Gael. *carn badag* – tufted hill. Hill (1915
ft) N of Glen Prosen; pron. **bad och**.

Cairn Broadlands COC NO 270 778
Prob. Scots as written (but poss. Gael.
braghad – upland cairn). Rocky summit
(2796 ft) on W side of Glen Clova; (plateau
is broad but hill very steep).

Cairn Broom COC NO 290 685
Scots as written. Stony hill covered with
broom, above Glenprosen Lodge; see
Broomhill.

Cairn Caidloch LLE NO 431 783
Gael. *carn Cathelach* – Kedloch hill (2117
ft) 1 mile S of Loch Lee. Pron. **caid loch**.
Edward has Kaitlo Hill; see ***Kedloch Burn***.

Cairn Corse LIN NO 285 643
Scots as written – cairn of the cross(ing).
Hill (*c*1970 ft) in Glen Quharity. Prob. the
same name as ***Cairncross***.

Cairn Curr GLI NO 207 760
Gael. *carn corr* – ?tapering stony hill
(above Canness Glen).

Cairn Damff COC NO 241 779
Gael. *carn damh* – stag hill (or poss. 'hill
of the ox'). Hill (2750 ft) in Glen Doll; also
Craig Damff, a precipice to the S.

Cairn Daunie LIN NO 241 681
Gael. *carn donnaidh* – hill of evil or mis-
chance. Hill (2066 ft) at head of Glen
Damff; pron. **dawn uh**.

Cairn Dearg GLI NO 158 664
Cairn Dearg COC NO 301 765
Gael. *carn dearg* – red hill; pron. **carn jerr
ag**. (1) hill nr Forter; (2) hill in Glen Clova;
both are *c*2000 ft.

Cairn Doos GLI NO 190 705*
Prob. Scots as written (although word-
order is Gaelic) – doves' hill. Rocky hill 1
mile S of Tulchan, Glenisla, nr Lang Howe,
but not now identified.

Cairn Dye COC NO 248 724
Hill (*c*2000 ft) between Glen Prosen and
Glen Clova. The name is unexplained and
may have a connection with Glen Dye or
Water of Dye; Dye was the old name for
West Water, see p.74. An etymology from
Gael. *carn dia* – 'hill of the god' – is neat
but unconvincing.

Cairn Gibbs GLI NO 183 593
Scots *cairn* + surname Gibbs – Gibbs Hill
(1706 ft) between Glens Shee and Isla. The
Gibbs family have for long been owners of
Glenisla House (but see also ***Gibs Knowe***).

Cairn Hill GLI NO 220 595
Cairn Hill GLI NO 226 617
As written – hill with a cairn (sc. heap of
stones). One is a hill in lower Glen Isla, the
other a wooded hill nr Kirkton. See poss.
alternative origin under ***Cairny Hill***.

Cairn Inks COC NO 305 725
Scots as written – hill (at) river-meadow.
Hill (2483 ft) 1 mile SW of Clova village;
also Sneck (notch) of Inks, 1 mile S; (see
p.36).

Cairn Leith COC NO 345 647
Cairn Leith COC NO 346 679
Gael. *carn liath* – grey hill. Two hills
between Glen Prosen and Glen Clova, 1197
ft and 1436 ft. respectively, just over 4
miles apart.

Cairn Lick LLE NO 392 783
Gael. *carn lic* (genitive of *leac*) – hill or
cairn of the flat or slab stone. Hill (*c*2000
ft) SW of Loch Lee; cf. *Lick*.

Cairn Lunkard COC NO 235 784
Scots, from Gaelic *carn laghart* – hill of
the encampment; hill (2700 ft) nr Jock's
Road at head of Glen Doll; also **The
Lunkard**, see p.134.

Cairn More LEN NO 527 694
Gael. *carn mor* – big cairn or stony hill.
Hill NW of Bridgend, Lethnot.

Cairn Motherie LIN NO 271 594
Scots *cairn mote* – ?cairn mound; burial
mound on Creigh Hill (a substantial Bronze
Age burial cairn). Cairn na Glasha -see
Cairn of Claise.

Cairn of Claise GLI NO 183 788
Prob. Gael. *carn na claise* – hill of the
hollow. Summit (3484 ft) on Angus-Mar
boundary. Pron. **cairn of clash**. Also Pyes of
Clash.

There is a deep gully on the NW side, topped
in snowy weather by a heavy cornice. The
name appears on some maps as Cairn na Glasha
(1463 Carn of Glascha); a derivation from Gael.
glaiseach (grassy place) is possible.

Cairn of Meadows LEN NO 435 749
Gael. *carn ?meadhon* – ?middle hill. Hill
(*c*2000 ft) on N side of Glen Lethnot.

The term 'meadows' (even in its Scots sense of
rough grass) seems unlikely in this terrain.

Cairn Plew LIN NO 264 584
?Scots as written – cairn of the ?plough.
Cairn on Creigh Hill, Lintrathen, locus of
round Bronze Age burial cairn.

Cairn Robie LLE NO 468 805
Gael. *carn robain* or *reabainn* – hill or
cairn of robber or cateran (reivers were
common in this area). Small hill 3 miles E
of Invermark. Pron. **cairn <u>roa</u> bee**.

Cairn Shiel COC NO 303 691
Scots as written – hill with shieling. Hill
(1490 ft) on N side of Glen Prosen; now
incorporated in Glenclova Forest; also
Nether Shiel.

Cairn Trench LEN NO 394 745
Scots as written, or poss. OIr. *treinse* – [hill
of] grooves or water-runnels. Hill (2196 ft)
on N side of Glen Clova. The word-order
indicates a Gaelic formation.

Cairncross LLE NO 498 795
Gael. *carn chrosg* – hill-crossing. Farm at
Tarfside, Glen Esk. Pron. with stress on
cairn. Also Upper and Mid Cairncross, later
known as Townhead and Midtown.

The farm marks the beginning of the old track
from Tarfside to Deeside, recorded in 1511 as
Carnycors and in 1539 as Carnecors.

Cairndrum EZL NO 588 666
Gael. *carn druim* – ridge-hill. Hamlet 3
miles SW of Ezdell; pron. **carn drum**.
Ainslie calls it 'Westerton'.

Cairnton TAN NO 423 595*
Scots as written – farm-stead at or with a
cairn. Former farm 1 mile NW of Memus,
not now on OS map. Ainslie shows a
former settlement of the same name at NO
621 640.

Cairny Hill LEN NO 555 706
Either Pictish *carden* or Gael. *carn* – could
equally well be 'thicket-hill' or 'hill of
cairns'. A small hill 6 miles W of Edzell.

Nearby Fettercairn was earlier 'Fothercardine'.

Calanach, Burn of LLE NO 477 810
Gael. *callanach* – [stream of] clamour;
tributary of the Water of Tarf; pron. **<u>cal</u> an
ach**. The 'clamour' or crying is said to
describe the noise of the water.

Cald Burn COC NO 285 775
Prob. Scots 'cold burn'; tributary of S Esk in upper Glen Clova. Alternatively, perhaps a variant of 'Calder' (a common river-name, from O Ir. *calad* – 'hard water').

Call, The GLI NO 204 723
Prob. a Scots form of Gael. *cadha* – a pass. Hill 2254 ft, 1 mile E of Tulchan. Name pron. as written. Also Little Cull (*sic*) and Sneck of Call.

The etymology offered is the most straight-forward, and is strengthened by the fact that these hills (together with Calls of Finlet) are near to the track which leads from upper Glen Prosen through to Glen Isla. But the spelling ties in more closely with Gael. *call*, which means loss or damage (cf. Call Ghaig 'the loss or disaster of Gaick'). Yet another possibility is that the names are connected with Glen Cally, which is at the Glen Isla end of the 'pass'.

Calletar, Burn of LEN NO 523 692
Gael. *chaladair* – hard water (from Pictish *caleto dubron*). Trib. of West Water. Pron. **cal at er**. Compare Glen Callater in Mar.

Calls of Finlet GLI NO 222 702
Gael. ?*cadha fionn leathad* – passes of the white hillside. Terrain bet. Glen Isla and Glen Prosen (see **Call** and **Finlet**).

Cally Burn COC NO 372 697
Gael. *caladh* – hard water. Tributary of S Esk in lower Glen Clova; appears on OS map as Burn of Heughs.

Camlet LLE NO 405 815
Gael. *cam leathad* – crooked slope. Steep slope on E side of Glen Lee; also Burn and Cairn of Camlet. Pron. **cam let**.

Cammie, Hill of LLE NO 525 855
Gael. *camaidh* – [hill of the] bend. Hill (2028 ft) in Glen Tennet. The name refers to the nearby Aberdeenshire Burn of Cammie, which has a bend.

Cammock Farm GLI NO 231 586
Cammock Lodge GLI NO 229 592
Gael. *camaig* – stick, shepherd's crook. Farm (formerly Easter & Wester Cammock) and shooting lodge in lower Glen Isla; also Burn of Cammock. Pron. **cam ok**. The reference is prob. to a bend in the River Isla. (1234 Cambok, *sic* 1541).

Campsie, West LIN NO 282 532
Gael. *cam sith* – crooked hill. (Also East Campsie). Formerly an estate, but the name refers to the farms.

The lands of 'Campsy' were granted by James III in 1471 to Sir James Ogilvy, son of John Ogilvy of Lintrathen; an even earlier spelling is 'Camsy' (1443). Sir James was the first of the family to take the 'of Erolly' (i.e. Airlie) title. The name no doubt has the same derivation as the better-known Campsie Fells.

Canness GLI NO 197 753
Gael. *cadha an eas* – pass of the waterfall; narrow glen at headwaters of Isla. Pron. **ca ness**. OS maps show Canness Glen and Burn.

Cantempkin GLI NO 19 76*
Gael.?*cadha an tuim* – pass of the ?knoll. Unidentified feature in Caenlochan Glen; an obscure name.

Capel Mounth COC NO 293 785
Gael. *chapall monadh* – upland of horses (it was a bridle path). Hill at summit bet. Glen Clova and Loch Muick; also Capel Mounth Burn (see p.36).

Cardenswell TAN NO 46 61
Poss. Gael. *carden* + Scots *swail* – thicket at boggy place – 'bog-copse'. Former habitation in Glen Ogil. It could simply refer to somebody's well.

Carlochy (of Mark) LLE NO 411 831
Gael. *coire lochaidh* – corrie of the tarn;
corrie-lochan in Glen Mark. (See p.37).

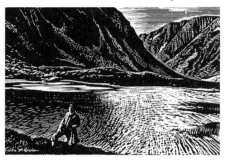

42 *Carlochy of Mark*

Carlochy (of Lee) LLE NO 397 788
Gael. *coire lochaidh* – corrie of the tarn;
corrie-lochan in Glen Lee. (See p.37).

Carn Ait GLI NO 143 733
Poss. Gael. *carn ait* – pleasant hill. Hill
(2824 ft) 3 miles NE of Spittal of Glen
Shee; formerly styled 'Carn Aighe', which
suggests Gael. *each* – horse [hill]. Pron.
like **ate**. Connected to Creag Leacach by a
steep and narrow ridge forming the march
with Perthshire.

Carn an Fhidhleir GLI NO 175 656
Gael. as written – cairn of the fiddler; hill
(*c*1500 ft) 1 mile NW of Forter, Glenisla.
Pron. **carn an ee lur**; not known which
violinist is commemorated.

Carrach, The KGM NO 306 567
Gael. *a' charraig* – the pinnacle. Small
peak 2 miles NE of Lintrathen.

Carrecross LLE NO 492 798*
Gael. *an cathar chrosg* – the moss road
crossing. The name (not on current maps)
applied to the lands at the start of a track
from Glenesk to Deeside, now known as
the Fir Mounth – see p.37.

Carroch KRR NO 361 581
Gael. *charraig* – pinnacle. Farm and mill 4
miles NW of Kirriemuir; cf. **Carrach**.

Cat Law LIN NO 319 610
Usually taken to be as written – 'cat hill' –
but see p.37. Hill (2196 ft) 4 miles N of
Kingoldrum.

Cat, Burn of LLE NO 483 937
As written; trib. of the Tarf; reference is
prob. to the wildcat's mythic qualities –
stealth, ferocity. Also Hill of Cat.

Cateran Grain LLE NO 454 765*
Scots, from Gael. *ceathairne* – streamlet of
the marauder or cateran. Tributary of Burn
of Cochlie, Glen Esk.

Caterthun, White MEN NO 548 661
Caterthun, Brown MEN NO 555 668
Pictish *caer* > Gael. *cathair* ?*dun* –
?fortress hill. Twin hills (*c*900 ft) *c*5 miles
SE of Edzell. See p.38.

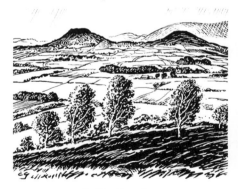

43 *The Caterthuns*

Catstae see under ***Shank of Catstae***

Chapel Craig EZL NO 546 793*
As written. Small hill nr Millden, Glen
Esk. Once part of Colmeallie, sometimes
thought to be an ecclesiastical complex.

Chapman's Holms LLE NO 494 761
Scots as written – pedlars' or packmen's
haughs. Flat ground on track from
Stonyford in Lethnot to Dalbrack in
Glenesk, also known as *The Priest's Road*
or The Whisky Road (see p.66).

Clachnabrain COC NO 374 662
Gael. *clach na bran* – stone of the raven.
Farm in Glen Clova; pron. **clach na brain**.
The actual stone or rock was traditionally one on
which woven cloth, after having been washed, was
beaten with mells and beetles (clubs and mallets).

Clacknockater GLI NO 195 623
Gael. *clach an fhucadair* – stone of the
fuller (clothes-bleacher). House, cottage,
mill and limekilns in lower Glen Isla; pron.
clak nok atter. (See p.39.)

Clash COC NO 383 603
Clash KGM NO 349 595
Gael. *clais* – furrow or hollow. (1) farm nr
Dykehead; and (2) croft W of Pearsie.

Clash Cairny COC NO 458 689
Gael. *clais carnaigh* – furrow or hollow of
the cairns or rocks. Dip between Mount
Sned and Garbet Hill.

Clash of Wirren LEN NO 493 750
Gael. *clais fhuaran* – defile of Wirren, see
p.76. A deep cleft nr the S part of a pass
between Lethnot and Glen Esk.

Clash Rodden LLE NO 434 852
Prob. Gael. *clais rodain* – gap of the little
road. Defile in the hills N of Glen Mark.
Derivation fr. Scots *rodden* ('of the rowan')
is poss. but unlikely, since the word order
is Gaelic.

Clashindall LIN NO 271 598
Gael. *clais an dail* – hollow of the field.
Dip in hillside E of Backwater Reservoir.
Pron. **clash in dal**.

Clautschip GLI NO 238 650
Prob. Scots *claut schip* – an implement for

scraping dirt off sheep. Wooded hill in
Glen Taitney. May be a contrived or
facetious name – cf. 'Scrapehard', and see
p.70.

Clayleith COC NO 320 730*
Gael. *cladh leathad* – ditch (poss.
cemetery) ?on a slope. Former croft across
the S Esk fr. Clova village. Pron. like (but
prob. not connected with) the Edinburgh
Leith.

Clearach, Burn of LLE NO 488 823
Gael. *cliaraidh* – singing [burn]. Trib. of
Water of Tennet. Pron. **clear ach**.

Clinking Cauldron LIN NO 293 628
Prob. Gael. *cluain cinn gobhal druim* –
'green place of Kingoldrum'. Hill (1464 ft)
in Glen Quharity; the map form gives a fair
rendering of the original Gaelic name. See
Kingoldrum.

Clintlaw LIN NO 291 539
Prob. Scots as written – 'cliff hill [hill]'.
Sawmill 1 mile S of Bridgend of
Lintrathen. Also Corrie and Plantation of
Clintlaw at NO 26 61; see p.39.

Clochie LEN NO 546 683
Gael. *clochaidh* – stony, pebbly place (cf.
clachan) – farm nr Bridgend. See p.39.

Clova [village] COC NO 326 732
Derivation unknown (but see pp.39, 49);
hamlet incl. PO, hotel, kirk and farm with
mill (Milton).

Cluan, Burn of LEN NO 453 767*
Gael. *cluain* – [stream of the] meadow or
green place. Tributary of Burn of Cochlie,
Lethnot. Elsewhere usually found as
'Clunie'.

Cnoc na Cailliche GLI NO 203 647
Gael. *cnoc na cailleach* – knoll of the nun
(or old woman). Hill 5 miles N of Kirkton
of Glen Isla. Pron. (in Gael.) **crock na kell
ach**; no known explanation for name.

Cnocandon GLI NO 192 702*
Gael. *cnocan donn* – little brown hillock.
Woodland 2 miles S of Tulchan, Glenisla.
Pron. **nok an don**.

Cochlie, Burn of LLE NO 446 778
Gael. *coll-choille* (>*cochlaich*) – [burn of
the] hazel-wood. Burn joining Water of
Effock, noted for semi-precious stones;
also Shank of Cochlie.

Cock Cairn LLE NO 463 887
Scots as written – cairn or hill of the
(black)cock. Hill on Aberds. county
boundary NW of Tarfside; also Little Cock
Cairn.

Coiliamy COC NO 375 599
Gael. *coille ?maighin* – wood of ?the little
plain or spot. Farm 1 mile NE of Pearsie.
Pron. **coil am eh**; but Ainslie has
'Ceillymie'.

Coire Breac LEN NO 465 745
Gael. as written – speckled corrie; high
valley, offshoot of Glen Lethnot; pron.
corrie breck. Also Burn of Coire Breac.

Coire na Cloiche COC NO 308 651*
Gael. as written – corrie of the stone.
Corrie in Glen Uig, Lednathie. Pron.
cloy ch.

Coire nan Dun LEN NO 483 756*
Gael. as written – corrie of the heaps or
hummocks. Valley N of West Water, also
written (and pron.) **Corrienandun**.

Coledunes KGM NO 320 575
Prob. Gael. *comhdhail dun* – assembly,
tryst hill. Knoll nr Aucharroch. Not marked
on maps, but known to be the site of a
justiciary court in 1263. See *Cothelhill*.

Collfrusk LLE NO 49 77*
Gael. *cul chroisg* – back of the crossing.
Ridge on N-facing Cowie Hill, Glen Esk
(see *Corharncross*).

Collie Shiel Burn GLI NO 169 734*
Prob Scots as written – burn of Colly's
shieling; stream in Glen Brighty. Name not
on map, and no shieling now identifiable.
Colly was a mythical giant in Glen Isla.

Colmeallie EZL NO 565 782
Poss Gael. *cuil Maillidh* – recessus or
retreat of St Mallie. Farm in lower Glen
Esk. Pron. **col meal y**. Now part of
Gannochy estate. See p.40.

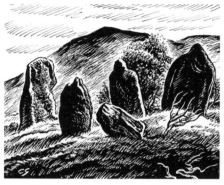

44 *The Standing Stones of Colmeallie*

Colthill EZL NO 595 703*
Gael. *coilltich* – a wood. Former holding in
Dunbog, Glen Esk, known locally as
'Coltie'. Not on OS map.

Conlawer Hill TAN NO 429 627
Gael. *con labhair* – [hill of the] ? loud
(barking) dog. Low hill 4 miles NW of
Noranside.

Corathro, Hill of EZL NO 556 722
Gael. *cor uachdarach* – upper round hill.
Hill (1321 ft) 4 miles NW of Gannochy
Bridge; pron. **cor ath ro**.
Ainslie has 'Corethrie'. Gael. *uachdar* (usually
rendered *auchter* and meaning 'upper part') is a
common place-name element.

Cordamff, Brae of COC NO 337 703
Scots *brae* + Gael. *cor damh* – high ground
of the stag hillock. Hillside in lower Glen
Clova.

Cordormachy COC NO 347 660
Gael. *coire?dornaig*. Prob. corrie of the
pebbly place. Corrie in Glen Cally, Prosen;
pron. **cor dor machy**.

Coreffie Plantation LIN NO 247 619
Gael. *?cor eibheadh* – round aspen hill.
New woodland on W side of Backwater
dam; Pron. **cor eff y**. Was originally the
name of a submerged farm at NO 24 61*.

Coremachy COC NO 333 704
Gael. *coire ?enachaidh* – corrie ?of the
marshy place. Hill (1780 ft) between Glen
Clova and Glen Prosen. The hill-name is
derived from the corrie. Pron. **cor em achy**.

Corharncross LLE NO 512 783
Gael. *coire a' charn-croisg* – 'corrie of the
cairn crossing'. Croft in Glen Esk, across
the river from The Retreat. Pron. **cor harn
cross**.

Early forms are Kercarncors (1511) and Cor-
quharncors (1538). The crossing is from Lethnot
to Esk; this is the S portion of the track which
continues at nearby Cairncross .

Corhaughie, Burn of
KGM NO 345 597*
Gael. *cor achaidh* – [burn of the] round-hill
place. Tributary of Burn of Corogle.

An alternative derivation of the suffix might be
Pictish *uchel*, which would give 'burn of the
height' and would point to Corhaughie and
Corogle being one and the same name. (Ainslie
shows croft of 'Carhaughie'.)

Corhidlin Rock EZL NO 532 797*
Gael. *cor* + Scots *hidlin* – ?round hill of the
secret, hidden [rock]. A boulder 1 mile NW
of Millden, Glen Esk; not known why rock
was so named.

Corlick – see *Lick, Corrie of*

Corlowie COC NO 299 733*
Gael. *cor* or *coire laoigh* – little hill (or
corrie) of calves. Crag E of Bassies, S side
of Glen Clova; also Burn of Lowie.

Cormaud COC NO 307 629
Gael. *cor madaidh* – little hill of the dog or
fox or wolf. Hill (1663 ft) 1 mile W of
Glenuig. Pron. **cor maud**. Same name as
Corrie Maud, and cf. *Todstone* ('fox
stone') nearby.

Cormuir COC NO 305 604
Prob. Gael. *cor* + Scots *muir* – moor of the
little hill. Farm in Glen Prosen, W of
Balnaboth; also Burn of Cormuir.

Corn, Hill of LLE NO 480 863
Gael. *coran* – [hill of] little round hill. Hill
(*c*1800 ft) 7 miles N of Tarfside. The
ecology rules out cereal.

Cornie Burn LLE NO 374 806
Gael. *correinidh* – [stream of the] little
corrie. Tributary of Burn of Damff.

Cornacleuch GLI NO 216 613*
Prob. Gael. *cor na cluich* – round hill of
the game, sport, playing. Cottage, limekiln
and former estate nr Kirkton. Pron. **cor na
cleuch**, but sometimes as **corny cloich**. The
terrain makes a derivation from Scots
cleugh (ravine) very unlikely.

The property is included in the 1561 rental of
Coupar Angus abbey, and was apparently the
residence of the abbey's 'storemaster'. It had
become a brewhouse in 1556, but does not now
appear on the OS maps.

Cornamoon, Burn of
LLE NO 504 757*
Gael. *coire na moine* – [burn of the] corrie
of the peat-moss Trib of Burn of Berryhill,
Glen Esk; cf. Balnamoon. Stress on **moon**.

Cornescorn EZL NO 573 742
Gael. *coire an escearain* – corrie of the
place of streams. Croft in Glen Esk; also
Craig and Shank of Cornescorn. Pron. **cor
nes corn**; cf. *Inveriskandy*. Early forms are
Cornskorne (1511) and Corneskorne
(1554).

Corogle KGM NO 366 602
Gael. *coire* +?Pictish *uchel* – corrie of the
height. Also Burn of Corogle, a tributary of
Prosen Water.

Corrie Breac LLE/EZL NO 519 748
Gael. *coire breac* – dappled, variegated
corrie. Hanging valley on N slope of Hill
of Wirren. Pron. **corrie brek**. Also Burn of
Corriebreac.

Corrie Burn COC NO 325 728
Scots as written. Stream that drains the
Corrie of Clova; tributary of S Esk, flows
past Clova village. Prob. not so-named
before 19th cent., and not named on OS
maps.

Corrie Cleach LEN NO 495 677
Prob. Gael. *coire cleitheach* – corrie of the
hidden one. Corrie bet. Putney Maol and
The Old Man. Pron. **clee** ach (as in 'loch').
Or poss. Scots *cleuk* – corrie of the cleik or
claw.

Corrie Doune LLE NO 435 763
Scots (from Gael.) – corrie of Doune.
Miniature valley on S side of Glen Effock.
Pron. **doon**, but called locally **Cardowan**.

Corrie Duff LLE NO 459 830
Gael. *coire dubh* – prob. black corrie, but
poss. from pers. name Duff. High valley
NNE of Invermark.

Corrie Finnie LLE NO 384 832
Gael. *coire fionnaidh* – clear bright corrie.
Hanging valley on S side of Glen Mark.
Also Burn of Corriefinnie.

Corrie Lawen COC NO 315 655*
Gael. *coire ?laghan* – corrie of ?sowens (a
type of porridge). On S side of Glen Prosen.

Corrie Livery LEN NO 543 727*
Gael. *coire liomharraidh* – corrie of the
glinting stream, on SE side of East Wirren.
Pron. **liv** ery. An alternative derivation is
from Gael. *leabhrac* – long corrie. The
stream is now known as Oldtown Burn.

Corrie Maud LLE NO 397 827
Gael. *coire madaidh* – corrie of the dog,
fox or wolf. Above Balnamoon's Cave in
Glen Mark; sometimes written 'Cormaud'.
Also Craigs of Cormaud – cf. **Cormaud**.

Corrie Murrin LLE NO 465 765
Gael. *coire mothairain* – corrie of place of
noises (?lowing cattle). High valley 2 miles
S of Dalbrack, Glenesk (not same name as
Mooran Burn).

Corrie Scharroch COC NO 25 72*
Gael. *coire searrach* – corrie of the colt or
foal. Corrie between Mayar and Driesh,
noted for its profusion of montane willow
scrub; also Burn of Scharroch.

Corrie Vanoch GLI NO 173 632
Gael. *coire bheannachd* – corrie of
blessing; on steep NE side of Mount Blair
(cf. Bennachie). Pron. **van** och.
The corrie was famed for a well with medicinal
properties, and was also the site for propitiatory
offerings of silver at Beltane.

Corriehausherun LLE NO 435 790
Gael. *coire a' choisirain* – 'corrie sounding
like a choir'. Pron. **corrie house run**. The
Burn of Corriehausherun joins N Esk at
Loch Lee; it prob. gave its musical name to
the corrie.

Corriehead LIN NO 356 598
Scots as written – end of the corrie. Croft 3
miles W of Cortachy. Pron. **corrie head**.

Corrienagoe EZL NO 547 754*
Gael. *coire na cuaich* – corrie of the cup-
like hollow. Corrie in which rises the Burn
of Forbie. Pron. **corrie na go**. Also known
as 'The Punchbowl'.

Corscarie, Burn of LEN NO 467 715
Gael. *crosg choire* – [burn of the] crossing
(athwart)-corrie. Tributary of Water of
Saughs, Lethnot. Pron. **cor scar y**.
The corrie is not now identified on maps, but
the 'crossing' referred to appears to be an old

track leading from Glen Ogil to Hunthill Lodge, roughly parallel to the more celebrated Priest's Road to the east.

Corse Craigs COC NO 348 703
Scots as written – cross (athwart) crags. Rocky ridge on S side of Glen Clova.

Cortachy COC NO 395 595
Gael. *cuairtacheach* -'place of surrounding [hills]'. Castle and castleton at foot of Glen Clova and Glen Prosen; seat of the earls of Airlie. Pron. **cort** achy. See p.40.

Cortrystie COC NO 355 653*
Usually taken to be Gael. *cor Drosten* – Drostan's hill, a place in Glen Cally, Prosen. Pron. **cor tryst y**. St Drostan however is usually associated with Glenesk, and a more prosaic derivation would be Scots *tryst* – hill of meeting-place.

Corwharn LIN/COC NO 288 651
Gael. *cor* or *coire chuirn* – hill or corrie of the cairns or stones. Hill (1998 ft) at head of Glen Uig, Prosen. Pron. **cor wharn**.

Corwhattie Burn KGM NO 346 609*
Gael. *coire cataidh* – [burn of] wildcat corrie. Stream on S slope of Cat Law; pron. **cor what y**.

Corwhindle, Corrie of
LIN NO 290 639
Gael. *coire a' chinn dal* – [corrie of the] corrie of the head meadow. High valley in Glen Quharity. Pron. **cor whin del**.

Corwiry Burn COC NO 375 704*
Gael. *coire fuaire* – [burn of the] coldest corrie. Trib. of Kennel Burn, Clova. Pron. **cor wire y**.

Cot Craig GLI NO 178 643*
Scots as written – cottage hill. Site of cottage nr Forter.

Cotgibbon COC NO 365 626
Prob. Scots *cot* + pers. name – Gibbon's cottage. Former cottage, now plantation

NW of Dykehead. Pron. **cot gib on**. Pont's map shows it as a croft. The Gaelic word-order of the name is puzzling.

Cothelhill LIN NO 288 547
Gael. *comhdhail* – assembly, tryst [hill]. Farm at Bridgend (now owned by Dundee Council). Pron. **coth el hill**. Local common-law courts were frequent in mediaeval Scotland; the trysting-place was usually located at a hillock or marked by a stone.

Alternatively, the name may be related to Kedloch and hence to the surname Pitcaithly ('Cathelan's place').

Cottertown GLI NO 216 544
Scots as written – cluster of farm cottages in lower Glen Isla.

Coul, Braes of LIN NO 283 576
Gael. *cuil* + Scots *braes* – uplands of the nook. Sheep farm N of Loch of Lintrathen. Pron. **cool**; also farms of Easter, Wester and Middle Coul.

Court Hillock LLE NO 52 77*
Gael. *coirthe* – [hillock of the] pillar or standing stone. Mound at foot of Modlach Hill, Glenesk. Name does not appear on OS maps; and prob. derives from a mistaken etymology of ***Modlach***.

Courtford Park FER NO 466 612
As written; estate at Noranside (also Courtford Bridge). See p.40.

Couternach COC NO 356 660
Couternach LLE NO 412 837
Gael. *colternach* – place of coulters, i.e. furrow-like paths. (1) hill bet. Prosen and Clova; (2) crag in Glen Mark. Pron. **coot er nach**.

Cove LLE NO 505 825
Gael. *cobh* – nook, recess, hollow. Croft and limekiln on Tennet Burn (shown on Ainslie's map). Scots equivalent would be 'neuk'.

Cowhillock TAN NO 430 611
As written. Farm 1 mile E of Dykend.

Cowie Hill LLE NO 494 774
Cowiehill EZL NO 574 719
Prob. Scots *cow* (twig, branch, tuft of
heather or broom); but poss. Gael. *culaibh*
('back') or *collaidh* /*calltuin* ('hazel
place'). (1) hill in Glen Esk; (2) hill nr
Edzell.

Cowiehillocks LLE NO 425 817
?Gael. *collaidh* – hazel-covered hillocks.
Plantation in Glen Mark. Or poss. Scots
cowie – see **Cowie Hill** above.

Craig Breostock LLE NO 416 826*
Gael. *creag bhristeach* – crag of frangible
or broken rocks. Crag in Glen Mark. Pron.
bree stak; see p.40.

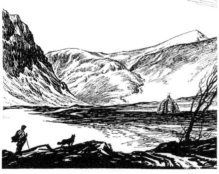

45 *Craig Breostock and Mount Keen –
'breaking crag' and 'smooth hill'*

Craig Brawlin LLE NO 467 839
Scots as written (from Gael. *creag braol-
igean*) – crag of the cranberries or whortle-
berries. Hill (1643 ft) NW of Tarfside.

Craig Buck LLE NO 416 800
Scots as written (from Gael. *creag buic*) –
crag of the roebuck or he-goat, on N side of
Loch Lee.

Craig Crane LLE NO 518 790
Gael. *creag crainn* – hill of trees. Steep hill
in Glen Esk, nr The Retreat.

Craig Damff COC NO 243 775
Craig Damff LLE NO 376 789
Gael. *creag damh* – hill of the stag (cf.
nearby Hunt Hill). (1) crags in Glen Doll;
(2) hill W of Loch Lee (also called 'Rough
Craig'). See also Glen Damff. Pont's map
gives 'Daif' (which is nearer the Gaelic
pronunciation).

Craig Duchrey LEN NO 498 715
Gael. *creag dubh chatharaigh* – crag of the
black broken ground. Hill in Glen Lethnot;
Pron. **doo** chray (as in 'loch'). See also
Deuchary.

Craig Duff COC NO 325 719
Gael. *creag dubh* – black crag. Rocky hill S
of Clova village.

Craig Dullet LLE NO 427 793
Gael. *creag diollaid* – crag of the saddle;
on S side of Loch Lee.

Craig Haig COC NO 232 719
Prob. Scots *craig haigle* – crag with the
hack or cut. Rocky outcrop in White Glen,
Prosen.

Craig Hill TAN NO 437 662
Scots as written – crag hill. Hill (1399 ft)
in Glen Ogil.

Craig Lair GLI NO 216 697
Prob. Scots as written – hill of grazing. Hill
(2323 ft) between Glen Isla and Glen
Prosen. Or poss. Gael. *creag lair* – mare
hill.

Craig Leacach GLI NO 165 745
Gael. *creag leacach* – hill of the smooth
stone slabs. Ridge (3238 ft) between Glen
Beag and Glen Isla. Pron. **lek** ach. Summit
marks the boundary with Perthshire.

Craig Lour LLE NO 445 796*
Gael. *creag lomhar* – shining, bright rocky
hill. Hill above Loch Lee. Pron. **craig loor**.

Craig Marloch LIN NO 315 606
Gael. *creag meirleach* – hill of thieves. Hill
(1559 ft) 2 miles NE of Balintore, part of
Cat Law group. Stress on **mar**.

Craig Maskeldie LLE NO 392 797
Gael. *creag maoil sgoilte* – crag of the split
brow. Hill (2224 ft) at W end of Loch Lee.
Pron. **ma** <u>skeld</u> **y**.

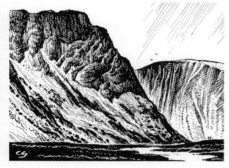

46 Craig Maskeldie – a fine winter climb

Craig Maud GLI NO 237 767
Gael. *creag madadh* – crag of the dog or
fox or wolf. Rocky hill (*c*2440 ft) at head
of Glen Doll. Formerly written as 'Craig
Maid'; prob. a dog is referred to.

Craig Mellon COC NO 265 769
Gael. *creag meallan* – crag or hill of the
little lumps. Hill (2815 ft) in Glen Doll.

Craig Michael LLE NO 366 854
Gael. *creag maothail* – crag of the soft
[terrain]. Crag in Glen Mark; does not refer
to personal name Michael.

Craig Mou TAN NO 425 672
Prob. Scots as written – crag of the mouth.
Rock formation bet. Glen Moy and Glen
Ogil. Pron. **craig** <u>moo</u>; also Hill of Craig
Mou. See *Craig Michael* above for an
alternative Gaelic etymology.

Craig na Heron LLE NO 388 819
Gael. *creag na h-airne* – crag of the sloe.
Small hill in Glen Lee; cf. Badrone.

Craig Nann LLE NO 407 792*
Prob. Gael. *creag an eoin* – bird crag. Hill
above Inchgrundle, Glenlee. Also spelt
'Craignaan'. 'Nain' was a jocular term for
a Highlander in the 18th century, but this is
an unlikely derivation.

Craig Narb LEN NO 536 712
Gael. *creag na h-earb* – roe-deer hill. Hill
4 miles N of Bridgend of Lethnot.

Craig of Balloch LIN NO 273 612
Scots *craig* + Gael. *bealach* – hill of the
gap or pass. Crag in pass between Glen
Quharity and Glen Damff.

Craig of Glenisla GLI NO 253 528*
Name of former estate – see p.41. Also
Over, Easter and Nethercraig.

Craig of Gowal COC NO 235 805
Scots *craig* + Gael. *gobhal* – craggy hill of
the fork. Hill (3027 ft) N of Loch Esk.
Pron. **gow** al. Reference is to Y-shaped
gulley, conspicuous under snow.

Craig of Weston EZL NO 582 755*
As written – hill of the west farm-stead.
Low hill on E side of lower Glen Esk. No
evidence now of a Weston settlement.

Craig Our LLE NO 432 795*
Gael. *creag odhar* – dun-coloured hill. Low
hill nr Loch Lee (not shown on OS map).

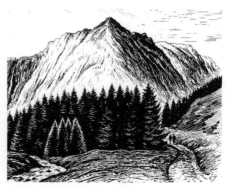

47 Craig Rennet, formerly a haunt of wild goats

Craig Rennet COC NO 252 758
Prob. Gael. *creag rinniche* – chisel-crag
(sc. with sharp point). Precipitous hill 3
miles W of Glendoll Lodge. An impresss-
ive crag, but not very suitable for climbing.

Craig Soales LLE NO 509 813
Gael. *creag solus* or *soillse* – hill of bright
light. Hill (1648 ft) in Glen Esk, 3 miles N
of The Retreat. See p.41.

Craig Tillielet COC NO 264 696
Gael. *creag tulich leathad* – hill-slope cliff.
Steep hillside in upper Glen Prosen. Pron.
with stress on **let**. 'Craig' is poss. a later
Scots addition to a Gaelic hill-name.

Craig Turner LLE NO 415 787
Gael. *creag tuarneir* – crag of the 'turner'.
Rocky hill-face SW of Loch Lee. A
'turner' may have been a wheelwright or
perhaps had some hunt function.

Craigancash EZL NO 586 776
Gael. *creagan caise* – steep crag. Hill
(1780 ft) in lower Glen Esk, on border with
Kincardineshire (cf. *Creagan Caise*
below). Pron. with stress on **cash**. See p.41.

Craigangowan EZL NO 586 788
For Gael. *creag an ghobhar* – hill of the
goats. Hill (1665 ft) on E side of Glen Esk.
Pron. with stress on **gow**. Here 'gowan' is
neither Gael. *gobhainn* (a smith) nor Scots
gowan (a daisy).

Craigangower EZL NO 539 750
Gael. *creag an ghobha*r – goat hill. Hill
(*c*2000 ft) bet. Lethnot and Glen Esk.

Craigdamf COC NO 408 683
Gael. *creag damf* – crag of the stag or ox.
Hill on E side of Glen Moy. Pron. with
stress on **damf**. Sometimes shown as
'Rough Craig'.

Craigendowie LEN NO 521 693
Gael. *creagan dubha* – black rocks. Farm
nr Bridgend. Pron. **craig en <u>dow</u>** y. See p.41.

Craigenloch Hill GLI NO 166 699
Gael. *creag an loch* – crag of the loch
[hill]. Steep hill (2470 ft) on Perthshire
boundary, taking its name from a loch
(Beanie) which it overlooks.

Craighead GLI NO 211 636
Scots as written – end of the crag. Croft
3 miles N of Kirkton; pron. with stress on
head.

Craigie Broch LIN/COC NO 250 696
Prob. Scots as written – broch hill; rocky
area in Glen Prosen.

A broch is a pre-Pictish circular drystone tower, of
which there is no evidence in the area. Gael. *broc*
(badger) is unlikely, since a burrowing animal
would not be found in this terrain. Gaelic *bruach*
(bank, edge) is possible.

Craigie Doubs GLI NO 178 675*
Scots as written – hill surrounded by dubs
(marshes) or pools (but these are not
evident in the landscape). Crags on E side
of Glas Maol, overlooking Caen-lochan
Glen. Pron. **doobs**.

Craigie Glasalt GLI NO 17 76*
Scots. *craigie* + Gael. *glas allt* – crag of the
grey burn. Crag above Caenlochan.

Craigie Laigh COC NO 312 733
Scots as written – lower crag. Rocky
outcrop on S side of Glen Clova.

Craigie Law GLI NO 226 649
Scots as written – rocky hill. Hill 3 miles
NNE of Kirkton. Ainslie has 'Craigley'.

Craigie Lay COC NO 395 705*
Scots as written – ?hill of uncultivated
land, or grazing; S of Kennel Burn.
Ainslie's map has 'Craigley'; both *lay* and
ley, as well as meaning fallow, can also
mean barren and wild, which better fit this
terrain. See *Boustie Ley*.

Craigie Shirrna LEN NO 493 796*
Gael. *creagan searganach* – decayed or weather-beaten rock. Rocky outcrop nr Tamhilt.

Craigie Thieves GLI/COC NO 243 700
Scots *craigie theves* – lapwing crag. Hill (2256 ft) at head of Glen Prosen (perhaps an unusual place for lapwings).

Cragieloch West LIN NO 275 537
Cragieloch East LIN NO 278 536
Scots as written – little rocky place by the loch. Farms S of Loch of Lintrathen. Pron. with stress on **loch**.

Craigieloch (earlier written 'Craigyloch') is prob. a contrived name, referring to the old estate of Craig (see *Craigisla*). The place was formerly known as 'Townhead of Lintrathen'. which in 1750 was a community of 150 persons.

Cragiemeg COC NO 305 678
Gael. *creag* + Pictish *mig* - crag of the bog. Hill-croft 1 mile E of Glenprosen village. Pron. **craigie meg**. The name of nearby Craigiemeg Hill (NO 305 685) looks like an afterthought.

Craigies COC NO 404 603
Plural form of Scots *craigie* (from Gael. *creagach* – rocky places). Farm 2 miles E of Dykehead.

Craigisla House GLI NO 253 535
Scots. *craig* + *Isla*. Seems to be a contrived name, from former estate of Craig (see p.41).

Craiglea Hill LIN NO 243 567
Looks like Scots *craig lea* – rocky hill of the uncultivated area [hill]. Hill 2 miles NW of Loch of Lintrathen. Possibly a made-up name with no real meaning.

Craigmekie GLI NO 193 695
Gael. *creag* + Pictish *mig*, ?with Gael. suffix – 'rock at the bog place'. Ruined crofts with limekiln in upper Glen Isla. Pron. **craig meek y**.

Craigmouth TAN NO 44 66*
Prob. Gael. *creag monadh* – moor crag. Former habitation noted by Timothy Pont, but not on OS map; Pont's hand is hard to decipher.

Craigness Burn GLI NO 199 604
Scots (from Gael.) as written – rock point burn. Tributary of River Isla. Pron. with stress on **ness**. Craigness seems to be a settlement name.

Craignity GLI NO 213 632
Prob. Gael. *creag neimhidh* – hill of the shrine. Ruined croft N of Kirkton of Glenisla; pron. **craig nit y**.

Edward's map of 1678 has 'Craigniete'; an earlier form, 'Craigneuethyn' (1164), seems to confirm the proposed etymology of this name, which may be compared with Navar and with Navity in Fife.

Craigoshina EZL NO 575 764
From Gael. *creag sine* – hill of the wind or weather. Croft in lower Glen Esk, which takes its name from the hill across the Esk (see under *Shanno*). Pron. with stress on **sheen**.

Craigrood COC NO 345 720*
Prob. Gael. *creag ruadh* – red craig. Former croft 1 mile SE of Clova village; Pron. with stress on **rood**. Scots 'craig of the cross' is another possible reading; the name is not on OS map.

Craigthran COC NO 393 673
?Scots *craig thrawn* – crooked, twisted hill. Hill (1792 ft) between Glen Clova and Glen Moy. Pron. **craig thran**. (Gael. word-order is puzzling.)

Craigton COC NO 397 615
Scots *craig toun* – hill farm. Farm nr Dykehead, Clova. Pron. **craig ton**; a common farm name.

Craigwhaut GLI NO 257 628*
Poss. Gael. *creag a chait* – 'cat craig'. Part of large plantation E of Backwater Reservoir. Pron. **craig whaut**.

Cramie COC NO 297 679
Gael. *crom* or *cromadh* or *cromag* (all from
Gaelic word for bend). Croft in upper Glen
Prosen. Pron. **crah mie**. The croft may take
its name from the Cramie Burn, and is
poss. a version of 'Cromby', which is how
it appears on Anslie's map; see ***Cromie***.

Cramsfauld Plantation
COC NO 325 633
Most likely from surname – i.e. 'Cram's
sheepfold'; wood in Glen Uig.

Crandard, The KGM NO 332 592
?Gael. *cran aird* – ?tree height. Hill-slope 5
miles N of Kingoldrum village.

Crandart GL NO 186 676
?Gael. *cran aird* – ?tree height. Estate in
upper Glen Isla; see ***Crandard***, and p.41.

Crannel, The EZL NO 571 732
Gael. *cran mheall* – tree hill. Hillock in
lower Glen Esk, 3 miles NE of Edzell.
Pron. **cran el**.

Creag an Fhithich GLI NO 179 641*
Gael. *creag an fhitheach* – rock of the
raven. Hill-face nr Forter, Glen Isla. Prob.
pron. **craig an fee ach** (in Gael. it would be
craig an ee ach).

Creag an Torraidh GLI NO 187 713
Gael. *creag an toraidh* – prob. from *torr*
('heap'); thus, 'hill of lump-place'. Crag
overlooking R Isla, S of Tulchan Lodge.
Pron. **craig an torr y**.

The nature of the terrain casts doubt on another
proposed etymology – 'hill of fruitfulness'.

Creag Caorach GLI NO 19 76*
Gael. as written – sheep crag. Crag E of
Caderg at head of Glen Isla, not readily
identifiable. Pron. **craig coor ach**.

Creag Ghlas LLE NO 396 840
Gael. as written – grey crag. Also Burn of
Creag Ghlas, a trib. of Water of Mark;
pron. **craig glas**.

Creag Loisgte GLI NO 182 635*
Gael. *creag loisgeach* – fiery crag. Rock-
face S of Forter (not defined on OS maps).
Pron. **craig losh ty**.

Creag na Cuigeal GLI NO 176 636
Gael. as written – rocky hill of the distaff
(or stick). Outcrop on NW flank of Mount
Blair. Pron. **craig na coog ial**. Reason for
nomenclature unknown.

Creag na h-Iolaire LLE NO 473 845
Gael. as written – eagle's crag. Crag above
Water of Tarf. (Gael. pron. would be **craig
na yoo lur uh**; but see p.42.)

Creag Phris GLI NO 182 637*
Gael. *creag pris* (genitive of *preas*) – crag
of the bush or thicket. Crag in Glen Isla nr
Altaltan.

Creag Reamhar GLI/LIN NO 242 610
Gael. *creag reamhar* – fat stony hill;
(*c*1500 ft) 2 miles E of Kirkton of Glen
Isla, and now covered by plantations. Pron.
craig rah var.

Creag Ruadhard GLI NO 182 670*
Gael. *creag ruadh aird* – crag of the red
height. Outcrop nr Presnerb; pron. **craig roo
ard**.

Creagan Caise GLI NO 182 685
Gael. *creagan caise* – steep crags. Steep
hillside on W side of upper Glen Isla.
Gaelic pron. would be **craigen ca she**.
Ainslie has 'Craigengash'; cf. Craigancash.

Creagan Soillear GLI NO 182 672*
Gael. *creagan soilleir* – bright or
conspicuous rocks. Outcrops in lower Glen
Isla. Pron. **craigan soll er**.

Creigh Hill LIN NO 269 590
Gael. ?*critheach* – ?aspen [hill]. Hill (1630
ft) E of Backwater Reservoir. Pron. **cree ch**.
Another possible derivation must be Gael.
crioch, meaning end or boundary.

Crieff KRR NO 406 572
Gael. *craobh* – tree. Farm 3 miles NE of
Kirriemuir; pron. same as Crieff in
Strathearn.

Crock GLI NO 226 632
Gael. *cnoc* – round hillock. Hill 3 miles NE
of Kirkton. Pron. as written (as it is in
Gaelic). *Cnoc* usually becomes knock in
Scots place-nomenclature; an alternative
derivation from Gael. *croc* (antler) is poss.

Cromie Burn KGM NO 306 530
Gael. *crom* – winding stream. Tributary of
the Melgam Water. Pron. **croam** y. Name
appears in 1256 as 'Crumbyn'; Timothy
Pont gives 'Krommie'.

Cromlet COC NO 305 644*
Gael. *crom leathad* – crooked slope. Hill-
slope on N side of Glen Uig. Pron. **crom** lit;
also Shank of Cromlet and West Cromlet.

Cross Stone LLE NO 485 798
A boulder incised with a cross on the old
road over Rowan Hill; see p.42.

Crossbog COC NO 383 625
As written, i.e. bog associated with a cross,
(or poss 'athwart bog'). Farm 3 miles N of
Dykehead. Nearby Crossmiln may confirm
'cross' theory.

Crossmiln COC NO 382 628
Scots as written – mill at the cross. Farm N
of Dykehead; cf. *Crossbog*.

Crosspit Burn LLE NO 507 828
As written. Stream in Glen Tennet; but may
be a modern name. 'Pit' as a suffix usually
refers to boundary post-holes.

Crow Craigies COC NO 223 799
Scots as written – crow crags. Comb-like
ridge (*c*3000 ft) between Glen Doll and
Glen Callater, in effect a shoulder of
Tolmount. Possible alternative derivation
of 'crow' might be from Gael. *cro*
(sheepfold).

Cruick Water MEN NO 472 638
Scots *cruik* – crook, bent stick. Winding
stream joining N Esk at Strathcathro. (The
OS ref. given above is not the mouth of the
stream, which is outside our area).

Cruys LLE/LEN NO 422 756
Gael. *creachann* – bare summmit. Hill
(2424 ft) in Glen Effock. Pron. as Eng.
cries; also East, West and Mid Cruys and
Crags of Cruys.

Cuilt Hill LIN NO 251 635
Gael. *chuilt* – nook [hill]. Hill (1557 ft)
between Isla and Prosen.

Cuirgard GLI NO 195 666*
Gael. *coire a' ghaird* – corrie of the arm or
hand. Rocky outcrop in Glen Isla, opposite
Presnerb. Ainslie's map calls this 'Conart
Hill'.

Culfuarie LEN NO 512 743*
Gael. *cul chomharraidh* – back of the mark
or target. SW slope of West Wirren. Pron.
cul foo ry The name relates to Auchowrie in
the valley below.

Culhawk KGM NO 347 555
Gael. *cailleach* or *cailleiche* old woman,
nun (or perhaps a malign spirit). Farm, on
S slope of Culhawk Hill (1018 ft); pron. **cul
hawk**. The earliest form was 'Drumna-
calyowcht' or 'ridge of Culhawk'; Ainslie
has 'Culhauk'.

Cullow COC NO 386 609
Gael. *cullach* – stirk or boar. Farm nr
Dykehead; also Cullow Market Stance –
see p.42.

Cuttlehaugh LLE NO 515 785*
Prob. 'cattle haugh', a croft in Glen Esk, nr
The Retreat. Alternatively, it may be a
corruption of *Kedloch*, see p.42.

Cuys LLE NO 403 840
From Gael. *culaist* – recess, cave. Crag in
Glen Mark 2 miles NW of Queen's Well.
Pron. ?**kyce**; see p.42.

Dacies, The GLI NO 208 775
?Scots *daices* (for Eng. dais) – pews,
settles, benches, stone seats. Crags at head
of Canness Glen, seen as resembling such
furniture. Pron. **day sees.**

Dail na Sneachd GLI NO 191 672
Gael. as written – snow-field. Deserted
croft in upper Glen Isla, on E (far) side of
river, nr Forter. Pron. **dal na snachk.**

Dairy, Burn of LIN NO 290 599
Gael. ?*deireadh* – back [burn]. Trib. of
Quharity Burn. Other possibilities are Gael.
dairirich – loud rattling noise (cf.
Altdararie) and *doire* – a grove or thicket
(cf. *Derry*).

Daker, Burn of LLE NO 466 768
Scots *daiker/dacker* – to dawdle;
'meandering burn'. Tributary of Burn of
Dalbrack, Glen Esk. Also Shank (hill-spur)
of Daker.

Dalairn COC NO 320 663
Gael. *dail earrann* – river-meadow portion.
Riverside croft in Glen Prosen, nr
Balnaboth. Pron. **dal airn.**

Dalbhraddan LIN NO 280 522
Gael. *dal bhradain* – salmon haugh. Farm
nr Auchrannie. Pron. **dal vrad an.** Poss.
refers to salmon-leap at Auchrannie.

Dalblae LLE NO 56 76*
Gael. *dail blaighe* – meadow of division or
partition. Ruined croft in Glen Esk. Pron.
dal blay – cf. Auchinblae.

Dalbog EZL NO 586 718
Gael. *dail bothaig* – cot field, shieling
grazing. Farm in Glenesk 1 mile NW of
Gannochy Bridge. See p.42.

Dalbrack LLE NO 473 782
Gael. *dail breac* – speckled field. Farm in
upper Glen Esk W of Tarfside. Pron. **dal
brack.** *Breac* can also mean trout, but prob.
not here. The locus of copper mining in the
18th century. (1511 'Dalbrek'.)

Dalcane LLE NO 404 834
Prob. Gael. *dail caoin* – smooth haugh – cf.
Mount Keen. Hill in Glen Mark. Pron. **dal
cane.** Other poss. etymologies are Gael.
dail cadhan – field of the ?passes or even
of the ?goose.

Dalchip COC NO 365 620
Gael. *dail chip* (genitive of *ceap*) – field of
the (stumbling-) block or snare. Old croft
NW of Dykehead, now covered by a
plantation. Pron. **dal chip.**

Dalforth EZL NO 57 77*
Gael. *dail coirthe* – field of the pillar.
Former farm-toun nr Colmeallie in Glen
Esk. Name is preserved in Dalforth Burn,
which joins the N Esk at NO 570 772*.
Pron. **dal forth.** See p.43.

Dalhally GLI NO 206 702
Gael. *dail chaladh* – field of the Cally Burn
(base is *cal*, a call or cry). Keeper's house
in upper Glen Isla. Name is connected with
Glencally. Pron. **dal hah ly.**

Dalhastnie EZL NO 540 786
Gael. *dail Shassanaich* – haugh of the
Sassenach (or Lowlander). Farm in mid
Glen Esk. Pron. **dal hace nay**; also Craig of
Dalhastnie, NO 542 779; and see p.43.

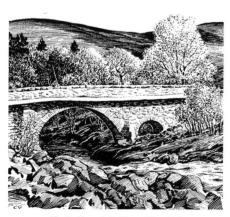

48 *Dalbrack Bridge, Glen Esk*

Dalinch, Wester COC NO 330 651
Gael. *dail innis* – haugh field. Cottage in
Glen Prosen. Pron. **dal inch**. Now just
known as 'Dalinch'; Easter Dalinch is no
longer on OS maps.

Dalkilry GLI NO 232 557
Gael. *dail Kilry* – Kilry haugh or field.
Dwelling nr Kilry Lodge. Pron. **dal kil ry**;
poss. a modern name.

Dalloanach EZL NO 55 78*
Gael. *dail lonach* – marshy meadow.
Former brewhouse, later known as
Bridgend of Greenburn. Pron. **dal loan ach**.

The apparently apt etymology of *lionn-theach* –
'ale-house' – has been disputed. There was also a
Dalloanach at NO 18 65* in Glen Isla where the
Highland Games were first held in 1856.

Dalmochy Burn GLI NO 202 605
Gael. *dail ?mucaidh* – [burn of the] ?swine-
haugh. Tributary of River Isla at
Auchenleish. Pron. **dal moch y**.

Dalmoulin COC NO 367 605*
Gael. *dail muillean* – mill field. Croft in
lower Glen Prosen. Pron. **dal moo ln**.

Dalnakebbuck GLI NO 194 616*
Gael. *dail na cabag* – ?cheese-making field
(cf. Scots *kebbuck*). Farm in Glen Isla, nr
Brewlands Bridge. Pron. with stress on
kebb. Dalnakebbuck was the former name
of *Doldy*.

Dalscampie EZL NO 551 783*
Gael. *dail sgeimhe* – field of scheme (sc.
division). Former croft, now ruin, nr
Millden, Glen Esk. Pron. with stress on
scam. Also Burn of Dalscampie. Early
forms are Dilskamfie (1544), Dilskeamvie
(1638); and Ainslie has 'Dalscamphie'.

Dalvane LLE NO 405 832
Gael. *dioll(aid) mheinn* – saddle-hill of the
ore or mine. Crag above Glen Mark, with
remains of old mine-workings. Pron. **dal
vane**.

Dalvanie GLI NO 187 660
Gael. *dail meadhonach* – literally, middle
field (but see p.43). Croft at the foot of
Glen Beanie. Pron. **dal vah ny**.

Dalwhirr LIN NO 233 560
Gael. *dail chuir* – haugh of the bend or
twist. Croft nr Kilry. Pron. **dal whirr**. The
name is also written Dalcur; the suffix
could poss. be *currach* (wet plain).

Damff, Burn of LLE NO 385 792
Gael. *damh* – [stream of the] stag or steer.
The burn, which flows into Loch Lee, is
noted for its waterfalls.

Danger Point LEN NO 419 723
A modern addition to the map, a feature on the
Burn of Duskintry, where a stalker's pony might
stumble.

Darnich, Burn of LEN NO 508 725
Gael. *doirneag* – [burn of] pebbles. Trib. of
West Water. Also Shank of Darnich. Same
name as Dornoch.

Dead Water COC NO 2807 110
As written, refers to the Burn of Farchal, a
slow-moving burn in Glen Prosen.

Dellpy, Burn of COC NO 315 636*
?Gael. *dal pighe* – [burn of the] ?magpie
field. Tributary of the Glen Uig burn, prob.
taking its name from a vanished croft.
Pron. ?**dall pay**.

Delnamer GLI NO 189 683
Gael. *dail an amair* – field of the trough.
Sheep farm in upper Glen Isla. Pron. **del
nah mer**.

Denniferne LEN NO 543 689*
Gael. *dun na fearna* – fort of the alder tree.
Unidentified, but must have been nr
Newbigging in Lethnot. Traces of a castle
are said to be still visible.

Derachie TAN NO 450 604
Gael., prob. *doire achaidh* – place of
thickets. Farm 2 miles W of Noranside.
Pron. **derr** achy. Ainslie has 'Dearachie';
etymology will depend on pronunciation.
See also *Pinderachy*.

Derry, Easter GLI NO 238 543
Gael. *doire* – thicket. Farm in the Barony
of Craig, now known as Kilry. Also Mid
and Wester Derry, Derryhill and Faulds of
Derry.

Deuchar FER NO 466 622
Gael. *dubh* ?*cathair* or *chatharaidh* – black
?fort or black ?moss (cf. Duchray,
Perthshire). Estate and farm, 6 miles SW of
Menmuir. Pron. **dew** hur. Also Deuchar Hill
NO 466 626; and see p.43.

Deuchary, Burn of
LLE / EZL NO 516 765
Prob. Gael. *dubh chatharaidh* – black moss
[stream]. Sub-tributary of N Esk. The name
however is apparently unconnected with
Deuchar, whether lands or surname.

Dhuclash GLI NO 19 64*
Gael. *dubh clais* – black furrow or dip.
Hollow on footpath nr Balmenoch, said to
be haunted by ghost of weeping infant.
Pron. **doo** clash.

Differin Burn LEN NO 502 657
Gael. *deifirean* – 'hurrying one' [burn].
Main trib. of Paphrie Burn; pron. **diff** er in.

Dikehead LEN NO 534 692
Scots as written – end of the dyke/ditch.
Croft 1 mile N of Bridgend of Lethnot.

Dochty LLE NO 402 798*
Prob Gael. *dabhach* ('davoch' being a term
for an agricultural unit). Croft in Glen Lee.
Pron. **doch** ty. A more romantic etymology
– Gael. *deoch tigh* ('dram house') –
remains possible.

Dodavoe COC NO 351 624
Gael. *dail dabhach* – davoch field (see
Dochty above). Farm in Glen Prosen, at
one time a Shaw property, and known as
'Shawfield'. Pron. **daw da** vo. Edward has
'Doldavo', Ainslie 'Dudavoes', and in
1745 it is misspelt as 'Dolvado'.

Dog Hillock COC NO 206 920
Dog Hillock TAN NO 286 794
A name usually given to a small mound
with long grass. (1) hill (2369 ft) in Glen
Clova; (2) hill (2400 ft) in Glen Ogil. Also
Dog Hillocks in Glen Lee at NO 389 809.
These all have the appearance of being
modern names.

Doldy GLI NO 194 616
Gael. *dail dubh* – black stance or meadow.
Farm nr Brewlands Bridge. Formerly
known as Dalnakebbuck; see also
Dodavoe.

Donald's Hill COC NO 415 651
As written; reference unknown. Hill NE of
Glenmoy farm.

Donaldsons Den MEN NO 566 865
Scots as written – deep cleft NW of Blair
Muir. See p.43.

Doonies GLI NO 192 623
Gael. *dunan* – hillock(s). Farm and
limekiln nr Brewlands Bridge (see p.43).

Douf Hole TAN NO 453 625
Scots as written – gloomy cave. Recess on
banks of Noran Water. Pron. **dowf**. See
Falls of Drumly Harry.

Doulin Haugh COC NO 394 609
Gael. *dubhlaidh* + Scots *haugh* – dark,
wintry water-meadow. Farm 1 mile NE of
Dykehead, Clova. Pron. **doo** lin. Doolie is
also found in the Kincardine part of Glen
Esk.

Dounalt, The COC NO 242 762
Gael. *dun allt* – ?hill-fort stream. Cliffs on
W side of Glen Doll. Pron. **doon alt**. The
English definite article makes this
derivation problematic.

Doune, Burn of LEN NO 452 731
Gael. *dubhan* – black stream. Trib. of
Water of Saughs. Pron. **doon**. Gives its
name to nearby Craig of Doune. See p.44,
and see other entries below for '**Doune**', all
pron. **doon**.

Doune, Burn of LLE NO 395 835
Doune, Burn of LLE NO 422 733
Gael. *dubhan* – black stream or *deubhan*. –
shrinking burn (sc. liable to dry up). (1)
trib. of Water of Mark; (2) trib. of Water of
Effock. Also Corrie, Burn and Craig of
Doune; and cf. 'Black Burn' over the
Aberdeenshire march.

Doune, Hill of LLE NO 390 859
Hill (2342 ft) N of Glen Mark. Takes its
name fr. *Burn of Doune* (NO 395 825).

Doups Burn COC NO 243 715
Scots as written – *doup* means buttocks,
and name prob. refers to a stream draining
low-lying land. Trib. of Prosen Water.
Pron. **dowps**.

Dowelly Den COC NO 417 619
Scots *doolie* – dark, gloomy glen (poss.
from Gael. *dubhlaidh*, with similar
meaning). Deep valley nr Horniehaugh,
described by Colin Gibson as 'that chasm
of fir'; cf. Doolie Cottage on Burn estate,
Edzell.

Downie Hillock COC NO 345 686
Gael. *dunadh* – hillock. Small hill on W
side of Glen Clova; also Downie Burn.

Downiepark COC NO 4088 585
Prob. Gael. *dunan* – [field with] hillock.
Farm and estate 2 miles SE of Cortachy;
prob. a modern name – see p.44.

Driesh COC NO 272 736
Thought to be from Gael. *dris* – bramble or
thorn. Hill (3105 ft) between Glens Clova
and Prosen. Pron. **dreesh**; also Shank of
Driesh. See p.44.

Drosty LLE NO 445 806*
Prob. from St Drostan, patron saint of
Glenesk. Former croft nr Invermark; also
Stripe (streamlet) of Droustie. Pron. **drow
stee**. The name appears on Ainslie's map of
1794, but the place is no longer identi-
fiable. See *Lochlee* and note on p.44.

Druim Dearg GLI NO 212 585
Gael. as written – red ridge. Hill (1487 ft)
in Forest of Alyth. Pron. **drum jer ag**.

Druim Mor GLI NO 190 770
Gael. as written – large ridge. High ridge
(2880 ft) above Caenlochan. Pron. **drum
more**; cf. Drumore Loch between Glen
Shee and Glen Isla.

Drum LLE NO 433 805*
Drum GLI NO 183 666
Gael. *druim* – ridge, spine, back. (1) a
former croft at Lochlee; (2) a hill nr
Dalvanie. Also Craig of Drum and Drum
Plantation, Invermark.

Drumbeg FER NO 495 635
Gael. *druim beag* – little ridge. Low hill 4
miles W of Menmuir. Pron. **drum beg**.

Drumboy LEN NO 50 65*
Gael. *druim buidhe* – golden/yellow ridge.
Deserted settlement above Paphrie Burn,
which appears on Ainslie's map but is not
now identifiable. Pron. **drum boy**.

Drumcairn LEN NO 542 682
Gael. *druim charn* – ridge of the stony hill.
Farm in Lethnot 4 miles N of Menmuir.
Pron. **drum cairn**; later known as Mill of
Lethnot. Also Burn of Drumcairn.

Drumcuthlaw FER NO 473 615
Gael. *druim* ?*cath* + Scots *law* – ?hill of the
battle-ridge. Bronze Age burial ground nr
Noranside. Pron. **drum <u>cuth</u> law**; also
Drumcuthlaw Wood.

Drumenach COC NO 201 716
Gael. *druim aonach* – summit ridge. Hill in
Glen Cally, between glens of Isla and
Prosen. Pron. **drum <u>enn</u> ach**.

Drumfollow, Shank of
COC NO 259 740
Scots *shank* + Gael. *druim* ?*folach* –
'shank' of ridge of ?rank grass. High
ground between Mayar and Driesh; also
appears on OS map as Shank of
Drumwhallo, see p.45.

Drumfurhouse LEN NO 54 7691*
Gael. *druim furachais* – ridge of watching.
Former farm nr Bridgend. Also written
(1699) as **Drumfuries** (and so pronounced);
does not appear on OS maps.

Drumgell GLI NO 233 553
Gael. *druim geall* – bright ridge. House nr
Kilry Lodge. Pron. **drum <u>gell</u>** (with hard
'**g**').

Drumgreen LLE NO 476 784
Gael. *druim* + ?Scots *grain* – ridge of the
side streamlet. Ruined croft 2 miles SW of
Tarfside, Glen Esk. Pron. **drum <u>green</u>**.
Alternatively, 'ridge of the grass or green'.
Locally called 'The Kirn' (churn).

Drumhead, Nether GLI NO 217 550
Gael. *druim* – [lower farm at the head of
the] ridge. Farm nr Kilry; former croft of
Over Drumhead not on OS map. There was
also Drumhead croft at Lethnot (NO 508
705*).

Drumhilt LLE NO 345 804
Gael. *druim shuilt* – ridge of the fat (i.e.
good grazing). Hill above Water of Unich
in Glen Lee. Pron. **drum <u>hilt</u>**.

Drumly Harry – see under **Falls of ...**

Drummachie TAN NO 44 63*
Gael. *druim moighe* – ridge on the plain.
Part of lands of Glenogil. Pron. **drum <u>mach</u>
y**. Also known as Drummichie.

Drummennoch LIN NO 248 602*
Gael. *druim meadhonach* – middle ridge
(but see **Drumenach** above). Part of large
plantation E of Backwater Reservoir, exact
place not now identifiable. Pron. **drum <u>men</u>
och**.

Drummore Hill LEN NO 582 690
Gael. *druim mor* – big ridge (hill). Rise
beside Edzell castle (which is 'large' only
in relation to Castle Hillock). Pron. **drum
<u>more</u>**.

Drumnaskelloch GLI NO 16 62*
Gael. *druim na sgaoileadh* – ridge of rocky
outcrop; on S slope of Mount Blair. Pron.
drum na <u>skell</u> och. See *Skellie*, p.71. The
legendary site of a battle between Picts and
Scots in 9th century.

Drumniche TAN NO 431 620
Prob. Gael. *druim nigheadh* – washing
ridge; farm 4 miles NW of Noranside.
Pron. **drum <u>niche</u>**. Also written
Drumnechie; and cf. **Drummenoch**.

Drums, The COC NO 359 692
Gael. *druim* – the ridges. Croft, former
smiddy, in Glen Clova, now a plantation.

Drumshade LIN NO 275 653
Gael. *druim* + Scots *shed* – division of
ground at the ridge. Plantation 7 miles NE
of Kirkton of Glen Isla. Pron. **drum <u>shade</u>**.
Probably an old name used for a modern de-
velopment.

Drumwearie COC NO 324 619*
Gael. *druim geamraidh* – winter ridge. Hill
in Glen Uig, Prosen. Pron. **drum <u>weer</u> y**; cf.
Balwearie, Fife.

Drumwhallo, Shank of
COC NO 262 738
Poss. Gael. *druim falamh* + Scots *shank* –
empty, void ridge (shank also means ridge
or spur). A high ridge (2646 ft) between
Mayar and Driesh. Pron. with stress on
whal. See ***Drumfollow*** and note on p.45.

Drumwhern COC NO 335 687
Gael. *druim chuirn* – ridge of the cairn.
Summit of track between Prosen kirk and
Clova known as the ***Minister's Road***. Pron.
drum whern.

Dry Banks COC NO 259 690*
As written; terrace-like hill-slope on SW
side of upper Glen Prosen.

Dry Burn EZL NO 536 762
As written; tributary of Burn of Duskintry,
Glen Esk. Common stream-name.

Dubh Choire LIN NO 253 656
Gael. as written – black corrie; in Glen
Damff, pron. **doo** corrie. See ***Duchray***.

Duchray Hill GLI NO 163 673
Gael. *dubh choire* – black corrie. Hill
(2297 ft) between Glen Shee and Glen Isla.
Pron. **doo** chray. Alternatively, *dubh chreag*
(black crag) or *chatharaigh* (moss). Also
known as ***Mealna Letter***; and see ***Craig
Duchray*** and ***Dubh Choire***.

Duchrey, Corrie of LLE NO 423 783
Prob. Gael. *dubh creag* (but see ***Duchray***
above) – black rock corrie, S of Loch Lee.
Pron. **doo** chray. Also gives name of Burn
of Duchrey, a stream joining the loch from
the South.

Duke's Lairs GLI NO 183 602*
Scots, as written – 'place where duke lay':
rocky outcrop in Glen Isla nr Delnamer.
There is no recorded ducal visit to the area,
and a more likely meaning is 'haunt of
ducks' (Scots *deuk*).

Dullet, Clash of LLE NO 478 769*
Gael. *clais dubh leathad* – furrow of the
black slope. Gap between Blue Cairn and
Garlet, Glen Esk. Another poss. etymology
is *dail leathad* – sloping field; the local
pronunciation would give a good indication
of the correct meaning.

Dun Hillocks GLI/COC NO 225 755
As written. Summits (2911 ft) bet. Glen
Isla and Glen Doll. 'Dun' is poss. a
translation of the common Gael. adjective
odhar, meaning drab.

Dun More COC NO 291 754
Gael. *dun mor* – big hill or fort.
Protuberance above Braedownie, Clova.

The climbs in this area have been classified as
'very severe' (The Doonie) and 'hard severe'
(North-west Craig).

Dunlappie EZL NO 578 679
Gael. *dun leabaidh* – fort-like hill of the
bed or grave. Farm 2 miles W of Edzell,
and site of an earthwork (Dunlappie Dyke).
Pron. **dun** **lap** y. See p.45.

Dunsie LEN NO 523 691*
Gael. *diomhain lasaidh* – lazy little
waterfall; nr junction of Calletar Burn with
West Water. Pron. **dun** sy.

Durward's Dike LIN NO 257 545
A bank-and-ditch earthwork forming the
boundary of Alan Durward's 13th century
deer park at Lintrathen; see p.45.

Duskintry, Burn of LEN NO 435 734
Gael. *dubh uisgean araidh* – [stream of
the] little black watery place. Main trib. of
the Water of Saughs; pron. **du** **skin** **tray**.
Also written 'Duskandry' and 'Dunscarny'.
Its head-waters are known as Head of
Duskintry.

Duthriss Hill TAN NO 434 683
Gael. *dubh ros* – [hill of the] black point.
Hill (1729 ft) at head of Glen Ogil; pron.
duth riss – cf. Durris in Kincardineshire.

Dykehead GLI NO 245 536
Dykehead COC NO 386 404
Scots, as written, meaning 'end of the wall
or ditch'. (1) a croft, poss. at the end of
Durward's Dike; (2) the PO hamlet for
Cortachy.

Dykend LIN NO 250 377
Dykend TAN NO 420 607
Scots as written – end of the dyke or ditch.
The first is a former smiddy, the second a
hamlet nr Inshewan. Pron. **dike end**.
Dykend and Dykehead poss. refer to the
same dyke.

Dykeneuk LLE NO 473 786
Scots, as written – corner of the dyke. Croft
in Glen Esk, 2 miles SW of Tarfside.
Ainslie's map has 'Dyke Nook', and also shows
Dykefoot at NO 47 80*.

Earn Craig LLE NO 385 806
Scots as written – eagle crag. Crag above
Water of Unich; the situation rules out
Gael. *earrainn* (see **Earn Stone**).

Earn Scar LIN NO 275 614*
Scots *earn scaur* – steep bare hillside of the
eagle. Grouse-shoot in Glen Quharity.
(*Scaur* is from ON.) See **Earn Stone**.

Earn Skelly LEN NO 438 729*
Prob. Scots *earn* + Gael. *sgaoleadh* – eagle
rock. Hillside in Glen Lethnot. See notes
on **Skelly**, p.71.

Earn Stone LLE NO 36 83*
Prob. from Gael. *earrain* (division), with a
possible meaning of 'boundary stone';
feature on hillside above Water of Mark.
A simpler etymology would be Scots *earn
stone*, eagle rock. Name is sometimes
written as 'Iron Stone'.

East Mill of Glenisla GLI NO 223 604
As written (formerly 'Eastmiln'). Mill
farm, 1 mile E of Kirkton; scene of
celebrated murder in 1764 – see p.45.

49 *Elly – still operating as a farm in Glen Moy*

Easter Burn LLE NO 417 831
Scots as written – eastmost of two streams.
Tributary of Water of Mark. Formerly
called 'Burn of Duff' (it rises in Corrie
Duff). No 'Wester Burn' identified on map.

Easterton LLE NO 499 829*
Scots as written – east croft. Ruin between
Clearach and Crosspit Burns (shown on
Ainslie's map).

Eddiechockertie, Bogs of
COC NO 429 649
Gael. *aodann ?cloichreach* – [marshes of
the] hill-face of ?the stony place. Wet
ground W of Glen Ogil. Pron. **edi chok erty**.
Etymology uncertain; and 'bogs' will be
recent Scots term.

Edzell NO 612 687
Name of an old castle and parish and
'planned' village. Etymology still
uncertain; see p.46.

Eggie, Wester COC NO 355 700
Gael. *eagach* – notched, indented
[westmost place]. Farm SE of Clova
village, now dominated by a forestry
plantation. See p.46.

Elf Hillock COC NO 344 705
Small hill on W side of Glen Clova. Prob. a
modern name – cf. **Downie Hillock**.

Elly COC NO 388 621
Gael. *eileach* – mill-race. Farm in Glen
Moy, N of Dykehead. Ainslie's map has
'Eallie'.

Erne Craigs COC NO 246 755
Scots as written – eagle crags. Rock face
SW of Craig Rennet, Glen Doll.

Esk, Rivers North and **South**
Pictish *isca* > Gael. *easg* > *uisge*, meaning
water (as a common noun, not proper
name). S Esk drains Glen Clova, N Esk
drains Glen Esk; both join N Sea nr
Montrose. 'Glenesck' (1260). See p.46.

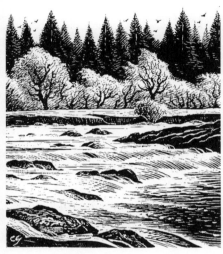

50 *The South Esk at Inverquharity*

Eskielawn LIN NO 275 665
Prob. Gael. *easgaigh lon* or *lann* – 'at the
marsh or bog of the meadow-land'. Hill
(1992 ft) in Glen Prosen. Pron. **esky** <u>lon</u>.
The name must refer to some boggy terrain
nearby.

Eskielawn, Burn of COC NO 268 717
Eskielawn, Burn of COC NO 360 725
For etymology and pronunciation, see
Eskielawn. (1) tributary of Burn of Louie;
(2) tributary of Burn of Adielinn.

Eskielogie Burn GLI NO 193 707*
Gael. *easgach lagach* – [stream of] hollow
with ditches; joins River Isla above Linns.

Everan Hill LLE NO 367 810
Scots *haiverin* (or *averin*) – cloudberry
[hill]. Hill (*c*1755 ft) on S side of Glen
Lee; prob. not same etymology as *Earn
Stone*.

Ewe Hows GLI NO 19 74*
Scots as written – sheep hollows. Low
ground E of Bessie's Cairn, Glen Isla.

Ewegreen COC NO 384 748*
Scots as written – sheep pasture. Hill bet.
The Goet and Cairn Trench, Clova.

Fafernie COC NO 206 825
Gael. *feith fearnach* – alder bog-stream;
bare summit (3274 ft) on plateau bet.
Angus and Mar. Pron. **fa** <u>fern</u> **ie**. Name is
from a stream or bog not shown on OS
map; also Knapps (knobs) of Fafernie.

Fair Head LEN NO 495 734*
Poss. as written: but first element is more
likely to be Gael. *feur,* which would mean
'grass height'. Hill above West Water,
Lethnot.

Falloch, Little and **Muckle**
LEN NO 41 74*
Scots as written + Gael. *falach* –
concealment; thus, [small/large] hidden
streams. Tribs. of Water of Saughs. Cf.
Glen Falloch.

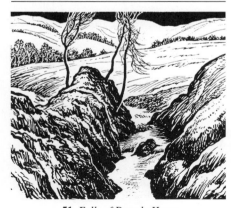

51 *Falls of Drumly Harry*

Falls of Drumly Harry
TAN　　　　　　　　　　NO 454 625
Prob. Gael. *drum liath h'airidh* – [water-
falls] of the grey ridge of the shieling (but
see p.47). Rapids on Noran Water.
Formerly written 'Airy'.

Farchal, Burn of COC　　NO 288 680
Farchal, Burn of COC　　NO 290 750
Gael. *?fothair coille* – [burn of the] wooded
slope. (1) trib. of Prosen Water; (2) trib. of
S Esk. Pron. **far chal** ('**ch**' as in loch). Also
Corrie, Sneck, Scars and Stone of Farchal.

Faschelloch Burn GLI　　NO 160 734*
Gael. *feith seilich* – willow bog-stream
[burn]. Tributary of Glen Brighty Burn.
Pron. **fa shell ach**. See also *Fasheilach*.

Fasheilach LLE　　　　NO 342 857
Gael. *feith seilich* – willow bog-stream.
Hill (2362 ft.) marking NW extremity of
Angus. Hill takes its name from the Burn
of Fasheilach, a trib. of the Water of Mark.
Site of former whisky bothy. For
pronunciation, see *Faschelloch*.

Fauldheads LLE　　　　NO 447 788*
Scots, as written – end of the sheepfold.
Farm in policies of Gleneffock House.

Fean Corrie GLI　　　　NO 206 757*
Gael. *fionn coire* – white corrie. Corrie
between Finalty Hill and Canness Glen.
Also Fean Corrie Burn, trib. of Canness
Burn.

Fechliemore, Burn of LLE NO 342 768
Gael. *feith chaochlaidh mhoir* – bog stream
of the big change (sc. intermittent stream).
Trib. of Burn of Longshank. Formerly
written 'Eechliemore' (which gives the
pronunciation).

Fee, Corrie [of] COC　　NO 261 578
Gael. *coire feidh* – corrie of the deer.
Corrie S of Craig Rennet in Glen Doll; also
Fee Burn and Knapps (knolls) of Fee. For-
merly written 'Fiadh', 'Fiagh' and 'Phee'.

Fergus GLI　　　　　　NO 193 682
Poss. Gael. *a' feurachaidh* – grazing or
feeding (or from pers. name Fergus). Sheep
farm in upper Glen Isla. Also known as
'Burnfergus'.

Fern FER　　　　　　　NO 484 616
Prob. Gael. *fearna* – alder tree. Habitation
1 mile NE of Noranside; also Hilton of
Fern.

The parish of the same name 'belonged totally to
the earl of Southesk'.

Fernybank EZL　　　　NO 539 789
As written. Victorian shooting-lodge nr Millden in
Glen Esk, built in 1861.

Fernyhirst GLI　　　　NO 213 550
As written – fern-covered knoll. Hill 6
miles W of Lintrathen; also Hill of
Fernyhirst.

There is some doubt about the origin of this
linguistically intrusive and un-Scotttish name,
which is prob. modern.

Ferrowie COC　　　　NO 304 795
Gael. *feith ruadh* – red mire. Hill (2628 ft)
3 miles N of Braedownie, Clova. Pron. **fer
row y**. Summit marks Angus-Aberds.
boundary. (Compare nearby Red Craig and
Cairn Dearg.)

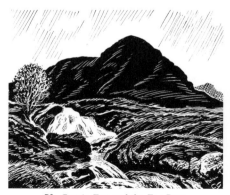
52 *Corrie Fee and the Fee Burn*

Fettereggie COC NO 35 70*
Gael. *fothair eagach* – terraced slope of
Eggie. Croft shown in Pont, apparently.
now called Wester Eggie. Pron. **fetter egg y**.
See p.46.

Fialzioch, Burn of GLI NO 235 774
Gael. *feith ailcheach* – [burn of the] stony
bog-stream. Trib. of White Water, Glen
Doll. Pron. **fee al yoch**. Ainslie has 'Feular
Burn', which may represent the 18th
century Scots pronunciation.

Fichell, Tops of COC NO 385 686
Poss. Gael. *fiacail* – tooth ('serrated tops')
Hill (*c*1500 ft) in Glen Clova. Pron. **fih el**.
Alternatively, Gael. *feith chaochlaidh* (see
Fechliemore). Edward refers to 'lands and
[farm] town of Fichell'.

Fichenal, Burn of COC NO 383 724*
Gael. *feith cianail* – forlorn, dreary bog-
stream [burn]; trib. of Burn of Heughs.
Pron. **fee hin al**.

Finalty Hill GLI NO 214 751
Gael. *fionn alltan* – white streamlets. Hill
(2954 ft) on E side of upper Glen Isla (also
Finalty Burn). Pron. **fin alt y**. OS map used
to carry the absurd misspelling 'Finality'.

Finbracks COC NO 403 705
Prob. Gael. *fear breige* – false men (sc.
cairns to mark hill paths). Hill (2478 ft) on
E side of lower Glen Clova. Pron. **fin brax**.
See p.47.

Fingray, Hill of EZL NO 570 815
Gael. *fionnairidh* – watching [hill]. Hill
(1593 ft) 3 miles SSE of Mount Battock.
Pron. **fing ray**. Name is thought to be
shortened from *da fhir-fionnairidh* – 'two
watchmen' (in the form of stone cairns).

Finlet COC NO 315 647
Gael. *fionn leathad* – white slope. Hill
(1668 ft) between Glen Prosen and Glen
Uig. Pron. **fin let**; also Shank (leg) and
Calls (*cadha* or pass) of Finlet; and cf.
Glen Finlet.

Finnoch LEN NO 517 707*
Gael. *fionnach* – fair/bright place; former
croft 3 miles N of Bridgend. Pron. **fin och**;
also Craig of Finnoch at NO 524 708.
See p.47.

Fleurs COC NO 393 729
Poss. Scots *fluirs* – flat lands, floors.
Hillside SE of Lochanluie, N of Clova; also
Burn of Fleurs. Not a very plausible
derivation, given that the terrain reaches
1800 ft..

Flobbit LEN NO 472 754
Gael. *feith lab-aite* – stream of the miry
place. Hill-slope on S side of West Knock,
Glen Esk, but originally a stream-name;
also Shank of Flobbit.

Folda GLI NO 188 642
Poss. from Gael. *fal davoch* – land-portion
of the wall, hedge, fold. Farm, post office
and former school (now public hall) in
upper Glen Isla. Ainslie's map has 'Faldo'.

Foldend LIN NO 286 556
As written – end of the pen or small field.
Farm and sawmill, Loch of Lintrathen;
pron. **fold end**.

Foldhead COC NO 363 669*
As written – same meaning as Foldend.

Forbie, Burn of EZL NO 575 746
Gael. *choirbe* – [burn of the] black one (sc.
corbie or crow). Tributary of N Esk, lower
Glen Esk; also Slack ('den, furrow') of
Forbie at NO 541 758.

Formal GLI NO 254 541
Gael. *for meall* – projecting hill. Farm in
lower Glen Isla. Pron. **for mal**; gives name
to Knock and Hill of Formal.

Formal, Hill of LEN NO 536 700
Gael. *for meall* – projecting hill. Hill (1120
ft) N of West Water; see also ***Formal***.

Fornethy LIN NO 246 556
Gael. *fearn-ach* – alder-tree place. Mansion 2 miles W of Bridgend. Pron. **for neth y**; see p.47.

Forter Castle GLI NO 182 646
Pictish *gwerthyr* – fortified place. Castle in Glen Isla. See p.47.

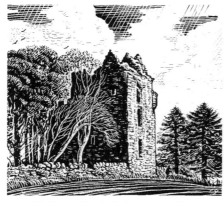

53 *Forter Castle (before restoration)*

Forthill MEN NO 554 656
As written; farm on S slope of White Caterthun. Name recalls the presence of nearby hill fort.

Freoch, Burn of LEN NO 512 713
Gael. *fraoch* – [stream of] heathery place. Small tributary of West Water, Lethnot. Pron. **free ach** ('ch' as in 'loch').

Freuchies GLI NO 225 607
Gael. *fraoch* – heathery place. House, former farm and mill, 1 mile E of Kirkton. For pron. see *Freoch* above. See p.47.

Fystie, Burn of LEN NO 458 709*
Gael. *fois tighe* – rest house [burn]. Trib. of Burn of Corscarie, nr Waterhead.

Gair Clash EZL NO 555 723*
Gael. *gair clais* – furrow of the cry or noise. Hollow west of Hill of Corathro. Same element occurs in Lochnagar.

Gairlaw LIN NO 307 577
Prob. Scots *garlaw/gairlie* – north-facing hill. Croft 4 miles NE of Loch of Lintrathen. Also written as 'Gairlow' and 'Garlow'. Alternative derivation might be from Gael. *gair* (noise – see *Gair Clash*)

Gairney, Hill of LLE NO 447 875
Gael. *gair* – [hill of] cry. Hill (2478 ft) 4 miles E of Mount Keen. Pron. **gair ny**.
Takes its name from Water of Gairney on Aberdeenshire side; and cf. Lochnagar and Glen Gairn.

Gallow Hill GLI NO 205 615
Gallow Hill COC NO 411 601
As written. (1) hill 2 miles N of Kirkton of Glenisla; (2) hill 2 miles E of Cortachy. The latter one is thought to have been a prehistoric burial site. See p.47.

Gallow Hillock COC NO 296 797
Gallow Hillock MEN NO 542 647
(1) part of Capel Mounth; (2) knoll nr Tigerton. As written, see p.47.

Gallows Knowe COC NO 326 726*
Scots as written – gallows hill. Knoll half mile S of Clova Village. See p.47.

Gannochy EZL NO 599 708
Gael. *gainmheachaidh* – sandy place (gravelly beaches in Esk gorge). Shooting lodge (1853) on N Esk 1 mile N of Edzell. Pron. **gan ohy**; gives its name to nearby bridge over N Esk (see p.48).

Garbet, Hill of LEN NO 464 685
Gael. *garbhachd* or *garbh-bhad* – [hill of] roughness or 'rough clump'. Hill (1900 ft), 2 miles S of Waterhead. Pron. **garb it**.
A charter of 1256 refers to 'Aldegaruok', which looks like a stream-name – *allt garbhachd*; the name should also be compared with Garvock (a hill in the Mearns and a village south of Greenock).

Garharry Burn GLI NO 232 582
Prob. Gael. *gar h-airbhe* – copse of the division, or 'boundary copse'. A tributary of the Isla. Pron. **gar har y**.

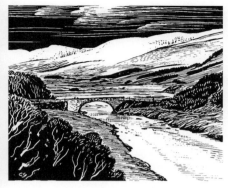

54 *Gella Old Bridge*

Garie Burn MEN NO 572 668
Gael. *gaothaire* – windy, exposed [burn].
Stream between Brown Caterthun and
Lundie Hill. The name (pron. **garry**) is
doubtless related to *Kilgarie*.

Garlet LLE NO 480 771
Gael. *garbh leathad* – rough slope. Hill
between glens of Lethnot and Esk. Pron.
gar let. Also Garlet Burn at NO 472 741,
the site of a whisky bothy. Ainslie shows
'Garlot', a hill at NO 30 63*.

Garrets Burn GLI NO 216 649
Gael. *garadh* – enclosure or copse [burn].
Stream which joins Backwater Reservoir.
from N. Ainslie shows 'Mid Hill of
Garret', not on OS map.

Garth Head COC NO 293 696
Scots as written – enclosure (sc. field); so,
'top of the field'. Hill N of Glenprosen
Lodge. Pron. **gart hed**.

Garthead LLE NO 467 820*
Scots as written – enclosure (sc. field);
so, 'top of the field'. Former croft NE of
Lochlee Church.

Gaskhillock KRR NO 360 573*
Gael. *gasg* – 'tail-of-land [hillock]'. Farm/
croft 3 miles NW of Kirriemuir, not named
on OS map.

Gealat, Burn of LLE NO 481 845
Gael. *diollaid* – saddle, i.e. '[burn of]
saddle-back ridge'. Tributary of Water of
Tarf. Pron. **jal lut**.

Gella COC NO 375 656
Gael. *gellaidh* – clear one. Croft in Glen
Clova, 6 miles N of Dykehead; also Gella
Bridge and Cottage. See p.48.

Gibs Knowe LEN NO 408 738
Prob. Gael. *caob* + Scots *knowe* – knoll of
clods. Hill (2274 ft) in upper Glen Lethnot;
but see *Cairn Gibbs*.

Gilfummen LLE NO 428 818
Gael. *dioll fuaim-ain* – echoing ridge (lit.
'saddle'). Cliffs in Glen Mark, Pron. **gil
fum min**. See p.48.

Glacanbuidhe, Easter
GLI NO 15 73*
Prob. Gael. *glacag buidhe* – [eastmost]
little yellow hollow. Former croft in Glen
Brighty, not readily identifiable. Pron. **glak
an boo ye**.

Glack TAN NO 99 638
Scots *glack*, from Gael. *glac* – hollow (or
perhaps an open area in woodland). Croft
in Glen Moy. Ainslie's map shows 'Glak'
at NO 48 79*. See p.48.

Glack of Balquhader COC NO 237 707
Scots *glack* + Gael. *baile foder* – 'defile of
the fodder farmstead'; pass on S side of
Glen Prosen. Pron. prob. as in Balquhidder;
no trace left of Balquhader settlement.

Glack of Corraich COC NO 315 630
Scots *glack* + Gael. *?coireach* – ravine of
corries. High narrow valley S of Glen Uig,
Prosen. Also Burn of Corraich. Pron. **cor
raich**. Earlier written 'Corriach', indicating
perhaps *coire riabhach* ('rough corrie').

Glack of Glengairney
GLI NO 173 714*
Scots *glack* + Gael. *gleann carnach* – hollow of glen of cairns. Dip in hills on county march W of Tulchan. Takes its name from Glen Carnach on Perths. side.

Glack of the Barnetts
GLI NO 169 618*
Scots *glack* + Gael. *bhearna* – hollow of the gaps. Dip in hills on county boundary, W of Brewlands Bridge.

Glackburn
COC NO 369 607
Scots as written – glack stream (see *Glack* above). Croft in Glen Prosen. Also written 'Glack Burn', the stream which gives the croft its name.

Glad Stane
GLI NO 195 627*
Scots *gled stane* – kite, hawk stone. Boulder on hillside in lower Glen Isla. Ainslie's map has 'Gladstone'; and see p.49.

Glanny, Moss of
GLI NO 255 640
Scots *moss* + Gael. ?*glanadh* – peat-bank of the cleansing (stream). Narrow glen 5 miles NE of Kirkton.

The derivation makes sense only if Glanny was originally a stream-name.

Glansie, Hill of
TAN NO 431 698
Gael. *glasanaich* – [hill of the] green place or pasture. Hill (2383 ft) at head of Glen Ogil. Metathesised form of *Glassney*. Also Burn of Glansie at LEN NO 465 716.

Glasallt Burn
GLI NO 183 766
Gael. as written – grey/green burn [burn]. Trib. of Caenlochan Burn; pron. **glas alt**.

Glas Burn
GLI NO 185 735
Gael. *glas* – grey/green [stream]. Trib. of River Isla, N of Tulchan. Takes its name from Glas Corrie.

Glas Corrie
LLE NO 438 833
GLI NO 181 748
Gael. *glas coire* – grey/green corrie. (1)

corrie (at 2162 ft) nr Invermark; (2) corrie on Monega Hill.

Glas Maol
GLI NO 167 766
Prob. Gael. *a ghlas mheall* – grey/green lump (but see note on p.49). Hill (3502 ft) at head of Glen Isla. Pron. **glas male**.

Glascorrie
LEN NO 478 733*
Gael. *glas coire* – grey/green corrie. Croft in Glen Lethnot; also Burn of Corrie.

Glascorry
GLI NO 196 760*
Gael. *glas coire* – grey/green corrie (sc. hanging valley). Formerly Glascorry Mor and Glascorry Beg, now part of Caenlochan Forest.

Glasslet
COC NO 368 689
Glasslet, The
COC NO 305 782
Gael. *glas leac* – grey slab (?or *leathad* – 'slope'). (1) farm nr Rottal, Clova; (2) hillside nr Braedownie. Pron. **glas let**.

Pont gives 'Glashlyick' (which points to the *leac* derivation). The Glasslet was a Lindsay property until the 1650s.

Glassney
EZL NO 532 758*
Gael. *glas-anaich* – place of green-ness (i.e. hill pasture). At head of Burn of Begg, Glen Esk; cf. *Glansie*.

Glen Beanie
GLI NO 185 660
Gael. *gleann mheadhonnaich* – middle glen (between Glen Shee and Glen Isla). See p.49.

Glen Brighty
GLI NO 187 723
Gael. *gleann bruaich* – ?glen with high banks. Deep glen joining Isla at Tulchan. See p.49.

Glen Cally
COC NO 355 630
Glen Cally
GLI NO 202 703
?Pictish. *caled* – prob. 'glen of hard water'. (1) side shoot of Glen Prosen; (2) glen NE of Glen Isla. The earlier forms – Kalathyn and Caladyn – seem to confirm this etymology, although the -dyn suffix is obscure. There was also a farm of Glencally in Prosen. See p.51.

Glen Clova COC NO 375 655
Origin and meaning unknown – see p.49;
also Castle of Clova, Corrie of Clova,
Milton of Clova.

Glen Damff LIN NO 250 630
Gael. *gleann daimh* – glen of the stag (or
poss. bullock). Valley which runs north
from Backwater reservoir.

The name, seldom used since the flooding of the
glen, would be pron. '**dav**' in Gaelic; the area is
now part of Glenisla Forest.

Glen Doll COC NO 2407 555
Pictish *dol* > Gael. *dal* – [glen of the]
haugh or meadow (but see p.50). A steep
and narrow glen, NW of Clova.

Glen Dye LIN NO 290 620
Pictish *Dewa* – [glen of the] ?river-goddess
(see note on *West Water*, p.74). Short, steep
offshoot of Glen Quharity.

Glen Effock LLE NO 458 787
Gael. *gleann eibheag* – glen of the little
cry. Branch of Glen Esk, 3 miles W of
Tarfside; also Water of Effock. See p.50.

Glen Esk see **Esk, River.**
The valley of the River N Esk. The Lindsay
domain of 'Glenesk' also included the lands of
Lethnot and Edzell.

Glen Finlet GLI NO 235 650
Gael. *fionn leathad* – [glen of the] white
hill-slope. Narrow wooded glen N of
Kirkton of Glen Isla. Pron. **fin let**. The glen
is part of so-called 'Glenisla Forest'. Also
Burn of Finlet and *Calls of Finlet*.

Glen Lee LLE NO 439 805
Valley drained by Water of Lee. For
etymology, see *Loch Lee*.

The map still shows a croft called Glen Lee at
NO 410 795, but this is now a ruin and the whole
glen is deserted. Before 1800 there was a clachan
at the other end of the loch called Kirkton of
Glen Lee, one of the most remote 'kirk towns' in
Angus – see p.58.

Glen Logie COC NO 315 667
Gael. *gleann lagach* – glen of the hollow.
Side glen running N from Balnaboth, Glen
Prosen; also Burn of Glen Logie. Pron. **lo
gee** (hard '**g**').

Glen Mark LLE NO 445 385
Gael. *gleann marc* – glen of the [burn of
the] horse. Side glen at top of Glen Esk;
also Glenmark cottage at NO 419 831. See
also *Mark, Water of*.

Glen Moy COC NO 390 630
Gael. *gleann a' mhuigh* – glen at the plain.
Side glen running N from Cortachy; also
'Burn of Glenmoye'. See p.50.

Glen Ogil TAN NO 446 633
Pictish *uchel* – [valley of the] height. Glen
6 miles NE of Dykehead, drained by Noran
Water. See also *Glenogil*. *Uchel* is also the
basis of the surname Ogilvy.

Glen Prosen see under **Prosen.**

Glen Quharity LIN NO 280 600
Said to be Gael. *gleann charaide* – glen of
the pair (of streams). Glen N of Loch of
Lintrathen. Pron. **whar itty**. See *Quharity
Burn*, *Inverquharity* and also p.67.

Glen Tairie COC NO 329 660
Gael. *gleann teamhra* – glen of eminences
(sc. hillocks); or poss. *doire* (thicket). Side
glen nr Prosen village. Pron. **glen terry**
(which suggests *doire* etymology); and cf.
Irish Tara; also Glentairie farm.

Glen Taitney GLI NO 240 650
Gael. *gleann taitneach* – pleasant valley.
Wooded glen 5 miles NE of Kirkton of
Glenisla; cf. Glen Taitneach, Perthshire.

Glen Tennet LLE NO 496 827
Gael. *gleann teineidh* – glen of fire or
glowing stream. Long glen N of Tarfside,
Glen Esk. See p.55.

Glen Uig COC NO 320 630
Gael. *gleann uig* – glen of the cove or
nook. Side glen off Glen Prosen. Pron.
?**yoo-ig**. Formerly 'Glenuge', it was added
to the Lednathie estate in the 19th century.

Glenarm COC NO 375 645
Prob. Gael. *gleann arm* – ?glen of the
weapon. Farm in lower Glen Clova.

Glencally, Burn of GLI NO 202 704
Burn joining R Isla at Linns. For derivation
of name, see *Glen Cally*.

It was hereabouts that the Forfar botanist George
Don found the rare *Hierochloe Borealis* (Northern
Holy grass).

Glencat LLE NO 481 846
Gael. *gleann caitidh* – glen of the cat-like
stream (sc. wild cat). Glen drained by
Water of Tarf.

Primarily a stream-name, referring to the animal's
mythic qualities; also Burn and Hill of Cat.

Glencuilt COC NO 393 654
Gael. *gleann cuilt* – nook (sc. hidden) glen.
Former croft between Glen Clova and Glen
Moy. Pron. **glen cult**. See p.51.

Glenhead LIN NO 258 628
As written – 'top of the glen'. Lodge at N
end of Backwater Reservoir, now a holiday
camp for Balgowan School; formerly
called West Ravernie.

Glenisla, Forest of
A treeless deer forest, comprising also
Glens Finlet, Taitney, Damff, Hole Burn
and Moss of Glanny; see *Isla, River*.

Glenisla. Kirkton of GLI NO 215 605
Scots *kirk toun* – church-settlement of Glen
Isla; See *Isla, River* and p.52.

Glenley TAN NO 453 632
Scots as written – glen of fallow or barren
ground. Farm on Noran Water. Pron. **glen
lee**; and see *Boustie Ley*.

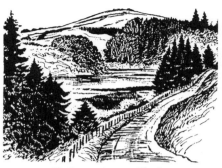

55 *Reservoir near Glenley*

Glenmarkie Lodge GLI NO 240 642
Gael. *gleann marcaidh* – glen of the horse-
burn. Former shooting lodge and farm 3
miles NE of Kirkton of Glenisla, now an
equestrian centre. See p.52.

Glenogil TAN NO 445 635
Pictish *uchel* – [glen of the] high place.
Also Mains of, Den of, Milton of; and see
also *Glen Ogil* and p.52.

Glenquiech TAN NO 425 618
Gael. *gleann cuaich* – glen of the quaich or
drinking cup (pron. like quaich). Farm nr
Den of Ogil reservoir.

This was also the site of the castle of Quiech, a seat
of the Comyn earls of Buchan. From 1692 until the
1750s the estate belonged to a branch of the
Lindsays, the last landed proprietors of their name
in the county – and staunch Jacobites at that.

56 *In Glen Quiech*

Glittering Skellies COC NO 246 794
Prob. Scots. as written; *skellies* is the same
as *skerries* (but see note on **Skelly**). A long
low ridge of rock on the hillside between
Loch Esk and Bachnagairn, Clova.

Goal, The COC NO 365 637
Poss. Gael. *guala* – 'shoulder-hill' (1466
ft) between Glen Prosen and Glen Clova.
Alternatively, the etymology could be
Gaelic *gobhal*, a fork – see *Laigh Gowal*.
There is also Laigh Goal ('low hill') in
Lethnot.

Goat Burn GLI NO 216 743
As written, but perhaps originally Scots
gote (ditch). Trib. of Glencally Burn,
Glenisla.

Gobantor GLI NO 175 647*
Prob. Gael. *gobhan torr* – blacksmith's
knoll. Former croft between Forter and
Balloch, no longer on OS maps. Pron. **gob
an tor**.

Goet, Den of COC NO 291 692
Scots as written – wooded valley of the
ditch. Den nr Glenprosen Lodge, now
covered by plantations.

Goet, The COC NO 374 746
Prob. Scots *gote* – ditch, drain. Hill (*c*2700
ft) 1 mile E of Loch Wharral, Clova; also
Long Goet and Goet Burn. An alternative
derivation might be Gael. *coimhead* (view
or prospect).

Goired Hole COC NO 266 645*
?Gael. *goir* – [hollow of the] ?cry.
Tributary of Burn of Eskielawn, but not on
OS map; poss. same place as *Hole*.

Golan Well GLI NO 197 656*
Gael. ?*gualainn* – [well of the] shoulder-
like hill. Spring, N of Auchintaple Loch.

Gourack, Burn of COC NO 285 752
Gael. *guireag* – [burn of] the pimple. Pron.

goor ak. Protuberance between Broom Hill
and Dog Hillock. Gives name to Gourock
Gully in Winter Corrie.

Gowan Grain LLE NO 332 812
Gael. *diomhain* + Scots *grain* – 'drying-up
streamlet'. Trib. of N Grain and Water of
Mark. Gives its name to **Gowan Knowe**, a
hill (*c*2200 ft) at NO 336 816, at the head
of Glen Lee. Scots *gowan* ('daisy') is
impossible in this terrain.

Gowed Hole COC NO 365 730
?Pictish *gwd* – [cave/hole] 'at the twist or
turn'. Brae-face in Glen Clova; obscure
name.

Goynd TAN NO 445 624
Meaning and derivation unknown. Ruined
house 1 mile S of Glen Ogil; cf. The
Guynd nr Kingennie.

Gracie's Linn LLE NO 489 811
Prob. Scots as written – Gracie's pool (on
the Tennet Burn). Said to commemorate a
girl's drowning; but in the absence of
further information the etymology may be
Gael. *greusaich linne* or 'cobbler's pool'.

Grain, North and **South**
LLE NO 415 768
Scots *grain* – branch or offshoot of a valley
or stream. Two branches of a stream
joining the Water of Effock. Not many
examples of this usage in the Angus glens.

Green Brae GLI NO 235 685
As written – high ground between Glen
Finlet and Glen Taitney. Gael. *braghad* (the
origin of *brae*) means upper part or neck
rather than slope.

Green Hill LLE/COC NO 349 757
Prominent hill (2837 ft) overlooking Loch
Brandy, Clova. Simply means grass-
covered – but this is unlikely to be its
original name.

Greenburn EZL NO 549 788
As written – stream beside the grass plot.
Croft (formerly smiddy) in Glen Esk
(stream not otherwise named); also Craig,
Croft and Haugh of Greenburn. See *Grain*
for another poss. etymology.

Greenbush LLE NO 426 826
As written; steep slope on E side of Glen
Mark. See p.52.

Greenholm, Burn of LLE NO 525 802
Scots as written – burn of the green haugh.
Meadow on Burn of Laurie, Glen Esk.

Greenmyre KGM NO 312 550
As written – *green mire*; farm 3 miles E of
Bridgend of Lintrathen.

Gryp's Chamber LLE NO 396 794
As written; cave below a precipice on E
side of Craig Maskeldie, said to have been
the resort of a freebooter of old. See p.52.

Guyer Clash LEN NO 502 718*
?Scots *guy* – guide, steer + Gael. *clais* –
furrow or hollow. A dip in hills or notch in
skyline E of Craig Duchray, perhaps used
as a landmark. Pron. **guy er clash**.

Gwesk Hillock COC NO 358 720*
Derivation and meaning of *gwesk* not known –
name has poss. been wrongly transcribed on
antique maps. Small hill S of Loch Wharral.

Hard Hill LLE NO 414 821
Poss. as written, but more likely to be Gael.
ard – height, headland. Hill (2185 ft) on S
side of Glen Mark. This hill doesn't seem
to be any harder than the others!

Hare Cairn GLI NO 243 623
Hare Cairn LLE NO 455 775
Scots *hair* (= hoar) *cairn* – grey hill. (1) at
Backwater Resevoir; (2) in Glen Effock.
Reference unlikely to be to an animal.

Harran Plantation LIN NO 277 645
Prob. from Gael. *chardain* – copse/wood.

Plantation NE of Backwater Reservoir; also
Corrie of Harran, Burn of Harran. Ainslie's
map shows a croft (now deserted) at NO
272 637.

Haugh LLE NO 456 794
Scots *haugh* – river-meadow. Croft in Glen
Esk 3 miles W of Tarfside; pron. **hauch**. Or
poss. Gael. *an abhach* – watery place.

Haughend EZL NO 577 749
Scots, as written – end of river-meadow.
Croft in Glen Esk, part of Gannochy estate.
Pron. **hauch**.

Haughead TAN NO 449 625
Scots *haugh* – [end of the] river-meadow.
Farm 3 miles NW of Noranside. Pron.
hauch.

Hazel Burn EZL NO 541 788
As written. Tributary of Burn of Turret,
joins N Esk at Millden. Modern name, or
translation of Gael. *calltun*.

Hazel Den COC NO 358 623*
As written – hazel valley. Defile in Glen
Prosen.

Heughs, Burn of COC NO 375 702
Scots as written – stream with steep banks.
Tributary of Rottal Burn, Clova. Pron. **h-
yoochs**, 'ch' as in loch. Ainslie calls this the
Cally Burn.

High Tree, The COC NO 265 686
Prob. as written, but not known why this
odd name should occur in a treeless
landscape.

Hillock EZL NO 559 783
As written. Farm, formerly known as
Hillocktoun, was once part of lands of
Auchnavis.

Hillockhead GLI NO 200 598
As written; croft in lower Glen Isla; name
prob. refers to nearby Birkhill.

Hirstly Hirst COC NO 40 68*
Scots, as written – barren knoll. Hill in
Glen Moy. Found in Ainslie's map,where it
appears to be same as Rough Craig on OS
map.

Hole GLI NO 266 645
Hole EZL NO 546 788
As written, meaning cave. (1) farm 5 miles
NE of Kirkton of Glenisla; (2) farm in
Glenesk. See p.53.

Hole of Weems COC NO 295 755
Scots *hole* + Gael. *uamh* – hollow of caves.
Broken ground at foot of Red Craig, Glen
Clova. See p.53.

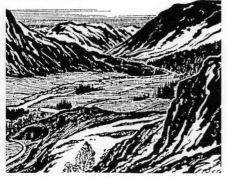

57 *Hole o' Weems in upper Glen Clova*

Holemyre GLI NO 210 603*
Scots, as written – prob. 'marsh hollow'.
Cottage and limekiln at Kirkton of
Glenisla.

Holmhead EZL NO 565 775
Scots as written – 'at the end of the river-
meadow'. Croft and former mill in lower
Glen Esk, now a holiday home. *Holm*
means the same as haugh. Also Burn of
Holmhead.

Horniehaugh COC NO 451 618
Scots as written – meadow of the Devil.
Croft at foot of Glen Moy. Pron. with stress
on **haugh**; also Horniehaugh Wood.

58 *Inchgrundle, at the west end of Loch Lee*

Horse Holm LEN NO 442 749
Scots *holm* – river-meadow associated with
horses. Hillside 5 miles NW of Waterend.
Pron. **horse home**. But it is poss. a
corruption of *corse holm*, meaning 'cross-
lying gulley'.

Hudenky, Hillocks of
COC NO 338 683*
?Scots *howe dinkie* – neat, trim hollow.
Humps on W side of Glen Clova;
etymology obscure.

Hunchar TAN NO 438 624
Poss. Scots *hunker* – thigh, haunch (may be
descriptive of landform). Farm nr Den of
Ogil Reservoir. Pron. **hunk** er (Pont has
'Honchar').

Hunt Hill COC NO 262 719
Hunt Hill LLE NO 379 806
As written – prob. the scene of deer hunts.
(1) hill at head of Glen Prosen; (2) hill in
Glen Lee.

Hunthill Lodge LEN NO 473 718
Edwardian shooting-lodge in Glen Lethnot, which
continues to serve a large sporting estate.

Inchdowrie House COC NO 342 723
Gael. *innis dhobharach*; prob. means 'field
by the streamlet'. Estate in Glen Clova; also
name of corrie between Lochs Wharral and
Brandy; also Craigs of Inchdowrie, and
Burns of N and S Inchdowrie.

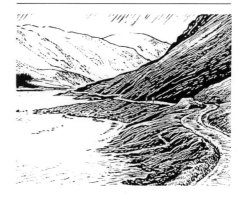

Inchgrundle LLE NO 410 790
Gael. *innis ghronn dail* – field of the boggy plain, or 'silty haugh'. Sheep-farm at the head of Glen Esk, pron. **inch grun d**l. Also Shank ('leg') of Inchgrundle. See p.53.

Inchmill, Burn of COC NO 328 658
Gael. *innis muileann*. Mill at the meadow. Stream draining Glen Tairie, Prosen. See p.53.

Inmost Grain LEN NO 431 709
Scots as written (*grain* means a side-stream). Tributary of Burn of Corscarie. Unnamed companion burn would be 'Outmost Grain'.

Inshewan TAN NO 447 569
Gael. *innis Eoghann* or *Eobhinn* – Ewan's haugh or water-meadow; former Ogilvy estate E of Dykehead, Clova; also Newmill, Newton and Burnside of Inshewan. See p.53.

Invereskandye EZL NO 620 761
Gael. *inbhir uisgean ?dubh* (but see **Esk** and **West Water**) – means lit. 'the inver of the black water', confluence of the West Water and the N Esk. Invereskandye is also the name of a street in Edzell. Pron. **inver isk** andy.

Inverharity GLI NO 191 639
Gael. *inbhir ?charaide* – confluence of the pair (of rivers). Farm and limekiln beside Folda. See p.53.

Invermark LLE NO 443 804
Gael. *inbhir marc* – confluence of the Mark (with the N Esk). Pont gives 'Innermarck'; see p.54.

Inverquharity KRR NO 412 579
Gael. *inbhir ?charaide* – confluence of the pair, sc. Quharity Burn with S Esk. Castle, with nearby farm and mill. Pron. **inver wha rity**. Compare Inverharity, Inverarity, and see p.55.

Inzion TAN NO 278 559
Former farm, now submerged in Lintrathen Loch. Pron. **in shee** an. For derivation and meaning see p.55.

Ireland MEN NO 518 660
Prob. a fanciful name as written. An isolated farm up Paphrie Burn. See p.55.

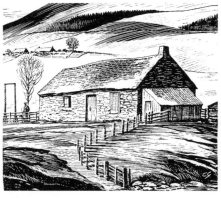

59 Ireland – an old croft on the Paphrie Burn

Isla, Glen and **River** see p.55.

Jock's Road COC NO 220 802
Hill-track leading from Glen Doll to Glen Callater. The route was more correctly called the Tolmount Pass. See p.55.

Juanjorge COC NO 275 795
Mysterious Spanish-looking name of a cliff-range at head of Glen Clova. Ainslie's map has 'June George' – equally baffling. Modern pron. '**jin jorj**'.

Kedloch, Burn of LLE NO 486 830
Gael. *?Cathelach* – [stream of] *?Cathal's* place. Trib. of Water of Tarf. Pron. **ked loch** (see p.56).

Keenie LLE NO 524 774
Prob. Gael. *caoinidh* – dry (stream liable to dry up). Croft on N Esk 4 miles SE of Tarfside. See p.56.

Keillor Burn TAN NO 447 643
Gael. *chaladair* (from Pictish *caleto dubron*) – hard water. Feeder stream for Glenogil Reservoir. Pron. **keel or**. Also Keillor Wood. Same name as Calder; and see ***Callater***.

Kennel Burn COC NO 376 700
Prob. Scots *kingle burn*, 'kingle' being a kind of hard sandstone. Sub-stream which joins S Esk at Rottal, Clova. Unlikely to be 'kennel' – too far from habitation.

Kenny KGM NO 30 53*
Poss. Gael. *coinmeadh* – place of free quartering or billeting. Former estate at Lintrathen. Name prob. relates to nearby Conveth – (see p.56. and ***Loups of Kenny***).

Ketchie Burn COC NO 276 792*
Scots as written – stream of the tossing or jerking, joins S Esk nr Broom Hill.

Kilbo COC NO 249 708
Gael. *?cuil bo* – ?cattle neuk. Ruined shieling in upper Glen Prosen. See p.57.

Kilburn COC NO 358 686
Gael. *?cul* + Scots *burn* – back water. Farm and cottage in Glen Clova 2 miles SW of Rottal. Pron. **kil burn**. Stress rules out *kil* derivation (see notes to ***Kilbo***); formerly known as ***Fettereggo***.

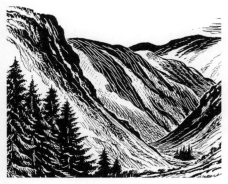

60 *Juanjorge – strange name for a strange place*

Kilfeddery COC NO 350 620*
Gael. *cul ?foithreach* – terraced nook. Plantation in lower Glen Prosen. Pron. **kil fed ery**. Shown on 6" maps as 'Kilteddery', which looks like Gaelic *cul teadraich* – 'place of tethering'.

Kilgarie MEN NO 565 661
Gael. *coille gaothaire* – 'wood in a gap or vent' (prob. not *kil* = church). Farm 1 mile SE of Brown Caterthun. Pron. **kil gar ie**; see p.57.

Kilrannoch, Meikle GLI NO 226 774
Kilrannoch, Little GLI NO 219 771
Gael. *cul raithneach* – bracken-nook. Twin hills bet. Glen Isla and Glen Doll.

Gives name to Kilrannoch Burn (NO 210 772), a tributary of the Canness Burn) and to Burn of Kilrannoch (NO 210 720). Meikle Kilrannoch is the only place in Scotland where *lychnis alpina* is found. (Ainslie has 'Gilrannoch').

Kilrie, Muckle Burn of
EZL NO 564 734
Scots as written – big stream of Kilrie, see **Kilry**. Tributary of N Esk above Gannochy. Pron. **kil ry**.

Kilry GLI NO 235 553
Gael. *ceileiridh* – ?chirping one (orig. a stream name). Hamlet, formerly a barony – see p.57. Pron. **kil ry**.

Kilulock GLI NO 19 67*
Gael. *cuil ?ulaich* – nook of ?rank grass; or poss. Gael. *?ulaidh* – a grave. Estate next to Crandart. Pron. **kil ull ok**. Mentioned in Coupar Angus abbey rental, but not now identifiable.

Kinalty AIR NO 396 607
Prob. Gael. *cinn alltan* – at the head of the streamlet. Farm 1 mile NE of Dykehead, Clova. Also Kinalty Haughs; Pron. **kin alt y**. An earlier form (Kyngaltuy, 1386) might suggest Gaelic *geallaidh*, meaning 'white stream'. The place is believed to have been the centre of a former Pictish thanage.

Kinclune KGM NO 312 549
Gael. *cinn cluain* – at the end of the
meadow. House and farm NW of Kirkton
of Kingoldrum; pron. **kin clune**. Also
Kinclune Hill and E Kinclune. See p.57.

King's Seat COC NO 325 741*
As written. Rocky slope 1 mile N of Clova
Castle ruins.
Charles II was the only king known to have
been in the glen, but a possible reference to
him is not substantiated (see ***Glen Cally***).

Kingoldrum, Kirkton of
KGM NO 33 550
Scots *kirk toun* + Gael. *cinn gobhal druim*
– kirk-settlement 'at the end of the fork-
ridge'. Hamlet 3 miles W of Kirriemuir; see
p.57. Pron. (locally) **kin god rum**.

Kinnaird LIN NO 293 543
Gael. *cinn na h'airde* – at the head of the
point of land. Farm 1 mile SE of Loch of
Lintrathen. Pron. **kin aird** – a common
place-name in E Scotland.

Kinnaniel KGM NO 319 532
Prob. Gael. *ceann an ail* – ?headland of the
rock. Farm SW of Kirkton of Kingoldrum.
Pron. **kin a neel**.

Kinnordy KRR NO 367 552
Gael. *cinn ?ordaidh* – 'at the end of the
hammer-place' (sc. round hill). Hamlet 2
miles W of Kirriemuir; Pron. **kin ord y**.
See p.58.

Kinrive COC NO 387 628
Gael. *cinn ruighe* – 'at the head of the
reach' or portion. Farm in Glen Moy, nr
Dykehead; also Kinrive Plantation. Pron.
kin rive. *Ruigh* can also mean slope or
pasture or shieling-ground. Pont's map has
'Kinruif'.

Kintyrie KRR NO 385 577
Gael. *cinn ?tir ith* – at the end of the corn-
land; or poss. *tiridh* – kiln-drying. Farm 3
miles S of Cortachy; pron. **kin tyr y**.

Kinwhirrie, West KRR NO 367 583
Gael. *cinn currach* – 'at the end of ?the wet
plain'. Former Stormonth estate and farm
SW of Cortachy, now a gravel pit. Pron.
kin whir ry. East Kinwhirries was at NO
377 583.

Kirk Hill EZL NO 565 778
Scots, as written; hillock S of Colmeallie,
prob. refers to 'Kilmeallie' (see
Colmeallie). Also Kirk Burn.

Kirkhillocks GLI NO 214 601*
Scots as written. Cottage, formerly post
office, nr Kirkton of Glenisla; see p.58.

Kirkton LLE NO 435 803
Scots *kirk toun* – church settlement. Farm,
formerly hamlet at Invermark. See p.58.

Kirn, The LLE NO 476 784
Prob. Gael. *cuibhronn* – share or portion of
land. Smallholding in Glen Esk, now
joined with Drumgreen. Locally believed
to mean 'churn', from Scots *kirn* – which is
not impossible.

Kirny, Burn of LLE NO 473 823
Gael. *caorannaidh* – place of rowans.
Shown by Ainslie as a settlement nr
Dalbrack. OS map also has Hill of and
Burn of Kirny: the stream and hill-names
must come from a lost settlement.

Kirriemuir KRR NO 385 540
Gael. *ceathramh mor* – 'big quarter' [land
division]. Large settlement at foot of the
glens of Prosen and Clova. Pron. (locally)
kirrie mair; (1229 'Kerimure, Kermuir').
See p.58.

Knachly COC NO 337 669
?Gael. *cnagach* – knobbly [hill]. Knoll 1
mile N of Glenprosen Village.

Knapps, The GLI NO 195 654*
Scots *knap* – knob, hillock. Protuberances
above Auchintaple Loch.

Knappygreen EZL NO 563 766*
Scots *knappie green* – bumpy grass-patch.
Shown by Ainslie as croft NW of
Holmhead.

Knaptam Hill GLI NO 236 534
An odd name which looks like Scots *knap*
+ Gael. *tom* – 'knob hillock [hill]'. Knoll in
lower Glen Isla. Cf. ***Naked Tam***.

Knock, West LEN/LLE NO 475 757
Scots. *knoc* – hillock, between Glen Esk
and Glen Lethnot (also East Knock).

Knockmist GLI NO 252 550
Scots *knock mist* – ? hill of mist. Dwelling
in lower Glen Isla. Prob. contrived name,
from Knock of Formal.

Knockshannoch GLI NO 235 597
Gael. *cnoc sean davach* – knoll of the old
davach (land division). Property 3 miles
NW of Dykend, Lintrathen. Pron. **nock
shan** och.

Knockshannoch Lodge (1888) is thought to have
been built on the site of the old Newton castle;
for some years it was Glenisla Youth Hostel, and
is now an activity centre. The old spelling was
Knockshandoch, which perfectly demonstrates the
etymology.

Knockton GLI NO 196 584
Scots as written – hillock farm. Small hill
(1605 ft) between Glen Shee and Glen Isla.
There is no evidence of habitation which
would explain the suffix, which may
therefore be Gaelic *dun* – ('knoll hill-fort').

Knowe of Crippley LLE NO 402 848*
Scots *knowe* + Gael. *creapall* – knoll of the
lump. Hill (2196 ft) on southern slope of
Mount Keen. Pron. **cripp** ley. No longer
marked on OS maps.

Knowehead GLI NO 233 544
Knowehead MEN NO 470 593
Scots as written – top of the hillock. (1)
farm at Kilry; (2) farm NW of Tannadice.
Pron. **now head**; see also under ***Auldallan***.

Kylebank LIN NO 263 651*
Prob. Gael. *coille* – copse bank. Hill-slope
N of Backwater Reservoir. Pron. as written.
Now part of a plantation, so the original place is
not identifiable. (Ainslie's spelling – 'Killiebank'
– confirms etymology).

Lackets, The COC NO 39 60*
Scots as written – fastenings or lattices.
Place E of Dykehead, Clova, locus and
description not discoverable.

Ladder Burn LLE NO 411 831
Gael. *leitir* – hill-slope [stream]; burn
which rises SW of summit of Mount Keen.
See p.58.

Laidwinley LEN NO 475 685
Gael. *leathad uainealach* – green slope.
Hillside 3 miles S of Waterhead of Lethnot.
Pron. laid **win** ley. Also Corrie of
Laidwinley.

Laigh Gowal COC NO 377 639*
Scots *laigh* + Gael. *gobhal* – literally 'low
fork', prob. referring to landscape feature.
Hill in Glen Clova (name is poss. related to
The Goal).

Laird's Chamber, The
COC NO 320 741*
As written. Crevice in rocks on SW slope
of Ben Reid, another refuge of Lord
Lindsay – see ***Hole of Weems***. Also Laird's
Stane.

Lang Green Burn LEN NO 414 723*
Scots as written (but 'long' prob. qualifies
'green', not 'burn'). Tributary of Burn of
Duskintry.

Langhillock Wood LIN NO 286 583
Scots as written. Plantation in Glen
Quharity; hillock no longer marked on OS
maps.

Larg Burn LIN NO 306 612*
Gael. *learg* – [burn on the] sunny slope.
Tributary of Burn of Dairy.

Ley

Latch EZL NO 568 760
Scots as written – bog-stream. Cottage in
Glen Esk.

Latch, Burn of LLE NO 390 771
Scots as written – bog-stream; tributary of
Water of Unich.

Laurie, Burn of LLE NO 541 791*
Laurie, Burn of LLE NO 431 801
Gael. *labharaidh* – chattering [stream]. (1)
burn joining N Esk at Millden; (2) burn at
E end of Loch Lee. Name contains same
element as in Lawers.

Learmour Craig GLI NO 205 770
?Gael. *learg mor* – [crag of the] great
slope. Cliffs on N side of Canness Glen.
Pron. **leer more**; (Ainslie has 'Learner').

Ledbackie LEN NO 504 683
Gael. *leathad beitheachaidh* – place of
hillside of birches. Site of former croft on
Burn of Nathro. On Ainslie's map but not
on OS.

Ledenhendrie FER NO 475 644
Gael. *leathad an eunarag* – hill-slope of
the snipe; or poss. *sheanruigh* – of 'old
shiel-ground'. Croft nr Afflochie on Cruick
Water. Pron. **led n hend ry**. Also
Ledenhendrie's Chair at NO 487 648 –
see p.58.

Ledmanie, Shank of LEN NO 524 725*
Scots *shank* + Gael. *leathad meadhonach* –
spur of the middle hill-slope. Hillside 2
miles S of Hill of Wirren. Pron. **led man ny**;
cf. nearby *Torr na Menach*.

Ledmore MEN NO 534 647
Gael. *leathad mor* – big slope (a reference
to old hill-track). Croft on S slope of Hill
of Menmuir. Pron. **led more**.

Lednathie, Easter COC NO 341 631
Gael. *leathad ?neitheach* – 'slope of the
pure [stream]'. Estate with farms and
sawmill at junction of Glens Prosen and
Uig. Pron. **led nath y**.

There is no evidence of 'nathie' having been
originally a stream name – so an alternative
etymology might be *nathair* (snake). Wester
Lednathie is a traditional Braes of Angus sheep
farm; Easter Lednathie incorporates a pleasing
18th century mansion, the home of the Stormonth
Darlings.

Leightnie LEN NO 525 676
Gael. *leth aonda* – 'half agreement' (sc.
half-share of lease). Farm 1 mile SW of
Bridgend; pron. **late ny** (but also written
Lightnie and Lichtnie); cf. Lethendy,
Blairgowrie.

Lethnot, Bridgend of LEN NO 536 685
Gael. *leathad nochd* – 'naked-sided place',
i.e. bare slope. Hamlet and school; also
Mill of Lethnot, NO 539 688. Pron. **leth
not**. See p.59.

61 *Lethnot – erosion in lower glen*

Lethnot, Craigs of COC NO 365 655
See **Lethnot**, above. A rocky ridge in
lower Glen Clova. See p.59.

Leuchary, Burn of EZL NO 562 795
Gael. *luachair* – [burn of] rushes, reeds.
Tributary of N Esk, nr Colmeallie; pron.
leuch ry, and sometimes written Leuchray.
cf. Leuchars, Fife.

Ley LIN NO 261 605
Scots *ley* – fallow land, outfield (cf. Eng
lea, which is similarly pronounced). Farm
overlooking Backwater Reservoir; also
Little Ley, 1 mile N. Cf. *Boustie Ley*.

Leycots EZL NO 570 744
Scots as written – 'cots (huts) at the
pasture-land'. Old grazings nr Cornescorn,
Glen Esk. See *Ley*.

Leytack FER NO 46 36*
Scots, as written – rented grazing. Croft N
of Auchnacree; pron. <u>lea</u> tack. See *Ley*.

Lick COC NO 273 716
Gael. *lic* (dative of *leac*) – 'at the slab,
flagstone'. Spur of Driesh, between Clova
and Prosen. Also Shank and Burn of Lick.
Corrie of Lick is sometimes written
Corlick. Compare Lix in Glen Dochart.

Lindalla GLI NO 206 625
Prob. Gael. *lann dalach* – enclosure of the
fields. Hill 2 miles N of Kirkton of
Glenisla. Pron. **lin** <u>dall</u> **a**. Once written
'Llandilo' but no Welsh connection. Site of
(mythical) hidden hoard of silver.

Linkie Hill KGM NO 339 593
Prob. Scots as written – hill of the roguish
or deceitful person (but reference
unexplained). Small hill nr Pearsie.

Linnbeg LLE NO 499 849
Gael. *loinn beag* – little enclosure or fank.
Hill in Glen Tennet; pron. with stress on
beg.

Linns GLI NO 196 703
Gael. *linne* – pools (not waterfalls). Croft,
limekiln and cottages at head of Glen Isla.
There is also a Burn of Linns in Glen Esk.

Lintrathen, Loch of LIN NO 280 550
Gael. *?lon* or *linn traethen* – ?sandbank
loch or marsh. Loch 6 miles NNE of Alyth.
Pron. **lin** <u>tray</u> **thin**; also Bridgend of
Lintrathen; see p.59.

Littlebridge LLE NO 407 797*
As written: site of remote croft in Glen
Lee. 'Little Bridge' on Ainslie's map of
1794 provides evidence of English-
speaking in the glen in the 18th century.

Loanhead GLI NO 229 559
Scots as written – end of the grass-track.
Farm nr Kilry in lower Glen Isla.

Loch Brandy COC NO 337 755
Gael. *loch bran dubh* – loch of the black
raven (or 'raven-black loch'). Corrie loch
N of Clova village. Pron. as in Eng.; also
Craigs and Burn of Loch Brandy. At one
time written 'Brany', but present OS form
appears in Pont's drawing of 1590s.
See p.60.

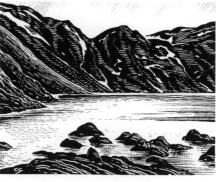

62 *Cliffs above Loch Brandy*

Loch Esk COC NO 236 792
For etymology, see *Esk*. Small loch on
plateau N of Glen Doll, now in Glenmuick
Forest; also Craigs of Loch Esk.

Named as a source (but it is not the main one) of
River S Esk. Also in the vicinity of the loch is a
feature (not marked on the map) called the
Cateran's Cave. The nearby Tolmount pass (*Jock's
Road*) was the usual route taken by cattle thieves
going to or from Clova.

Loch Lee LLE NO 420 795
Gael., prob. *lighe* – 'constant flow of
water' [loch]; or poss. 'chilling water'.
Loch at head of Glen Esk; also Glen Lee,
Water of Lee, Knowe of Lee. Lee is
primarily a stream-name. Earlier forms are
'Ly' (Pont) and 'Lochley'.

63 *"In former times many an outlaw took shelter in the Cave near Loch Esk"*

Loch Shandra GLI NO 216 622
Gael. *sean ?treab* – [loch of the] old homestead. Man-made loch N of Kirkton, which takes its name from a flooded croft 'Shandrew'.

Loch Tennet LLE NO 538 854
For etymology, see *Tennet*. Lochan nr Aberdeenshire boundary. Loch Tennet is not in fact drained by the Tennet Burn, but is the source of the Water of Aven, a tributary of the Water of Feugh and of the River Dee.

64 *Deer at Loch Tennet*

Loch Wharral COC NO 357 744
Prob. Scots *quarrel* – loch of the quarry (but see p.60). Corrie loch in Glen Clova; also Burn and Craigs of Wharral.

Lochanluie COC NO 383 735
Gael. *lochan laoigh* – little loch of the calf; hill tarn 3 miles N of Rottal, Glen Clova. Pron. **lochan lui**; cf. Lairig an Laoigh. Also possible is Gael. *liomaidh* – smooth, shiny lochan.

Lochcraigs Wood LIN NO 273 541*
Scots as written; wooded S shore of Loch of Lintrathen; wood not now shown on OS map.

Lochlee LLE NO 43 80*
(For etymology etc., see under *Loch Lee*, and note on p.60.) The clachan which grew up round the kirk (now largely disappeared) gave its name to a parish in 1723.

Lochnavens LLE NO 493 873
Gael. *lochan* + ?Scots *avens* – lochan of ?water-avens. Tarn on county boundary nr Hill of Cat. Pron. **loch nave ins**.

Lochylinn LLE NO 462 825
Thought to be Gael. *leachd loinn* – enclosure hill. Grazing nr Arsallary. Pron. **lochy lin**. Terrain does not suggest linn, meaning pool.

Logie, Glen COC NO 315 665
Gael. *gleann lagaidh* – glen at the hollow. Side valley of Glen Prosen at Balnaboth. Was a property of the Kinloch family in the 18th century.

Long Craig COC NO 237 722
Scots as written – long crag. Crag above White Glen, Prosen.

Long Goat LIN/COC NO 328 613
Gael. *an coimhead* – [long] hill with a view or prospect. Hill (1970 ft) 3 miles W of Cortachy; same term as in *The Goet*.

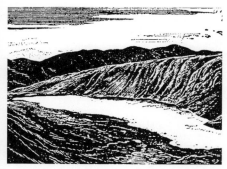

65 *Loch Wharral and the Shank of Catstae*

Long Shank COC NO 353 773
Scots as written – long narrow north spur
of Green Hill, Glen Clova. Gives name to
Burn of Longshank (NO 367 784), a trib.
of Water of Unich.

Long Sough COC NO 404 693
Scots as written (*sough* means the sound of
the wind). Hill above West Burn of
Glenmoy. Pron. **sawch**; also Short Sough.

Longdrum LIN NO 282 614
Gael. *druim* -[long] ridge. Croft in Glen
Quharity. Also hill called Long Drum, 1
mile to N.

Louie, Burn of COC NO 259 697
Either Gael. *laoigh* or *liomaidh* – calves
burn or 'smooth, shiny burn'. Streamlet
joining Prosen Water below Kilbo; (cf.
Lochanluie).

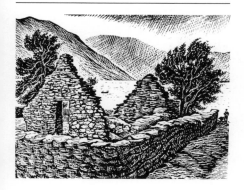

Loup Stripe LLE NO 533 850
Scots as written – streamlet with a leap or
drop in its course. Tributary of Burn of
Tennet.

Loups Bridge EZL NO 595 717
Scots as written – 'bridge of (salmon)
leaps'. Derelict bridge over the gorge of the
N Esk, connecting Gannochy and Burn
estates. See p.61.

Loups of Kenny LIN NO 305 533
Scots *loups* – leaps of Kenny (waterfalls on
Melgam Water). Pron. **lowps**.
The word Leaps usually means waterfalls,
but can also apply to salmon-leaps or to a
narrow water traditionally crossed by
leaping; since the Loups of Kenny are as
impressive in their way as Reekie Linn, the
reference is prob. to a cataract.

Loupshiel, Burn of COC NO 264 792*
Scots *loup shiel* – [burn of the] leap (i.e.
stepping-stones) shieling. Stream joining S
Esk nr Juanjorge. See also ***Loups of Kenny***.

Loward Burn GLI NO 177 726
Prob. Gael. *labhar* – chattering [stream].
Rises in Knapps and joins Glen Brighty
Burn. (Ben Lawers takes its name from a
chattering burn which runs into Loch Tay).

Lowie, Burn of COC NO 306 740*
Gael. *luaidhe* – [burn of] lead; joins S Esk,
nr Whitehaugh. Prob. refers to minerals.

Lownity, Burn of COC NO 475 646
Gael. ?*lonaidh* – [burn of the] little path.
Tributary of Cruick Water. Pron. **loo nity**.
Also Shank of Lownity, NO 465 658.

Lundie Castle MEN NO 568 672
Gael. *lunndaidh* – [castle of the] marshy
place. Farm and castle (modern) 7 miles
NW of Brechin; also Hill of Lundie, part of
Caterthun complex.

66 *The old Lochlee kirk*

Lunkard, The COC NO 235 775
Scots as written (from Gael. *long phort* >
lonchart) – shelter or bothy. The site of a
shieling or shelter, below the wild summit
of Jock's Road. Derived from, or giving its
name to, *Cairn Lunkard* – see pp.61, 94.

Lunkart, Burn of LLE NO 375 856
Prob. Scots as written (see *Lunkard*
above)- [burn] of the bothy (prob. a
shieling). Tributary of Water of Mark; cf.
Luncarty, Perthshire.

Luthrie, Burn of LIN NO 296 621
Prob. Gael. *luachrach* – [burn of rushes].
Stream in Glen Dye; cf. Luthrie, Fife.

Machirn LIN NO 317 616*
Gael. *?magh earran* – ? field of division,
share. Slope on S side of Kinclune Hill.
Pron. **ma** **hirn**.

Mackermack, West COC NO 304 696
Mackermack, East COC NO 325 696
Gael. *muc earranach* – pig share. Hills in
Glen Logie, Prosen. Pron. **ma** **ker** mac. Or
poss. *magh Ernoc* – St Ernoc's plateau.

Ainslie's map of 1794 has 'Muckernach', which
points to the first of the two suggested etymo-
logies; the presence of nearby St Arnold's Seat
makes plausible the second; but a derivation from
Kermack (an Aberdeenshire surname) seems
somewhat unlikely.

Macritch GLI NO 257 599*
Prob. fr. Gael. *machraichean* – place of
grass-plains; former farm and limekiln,
flooded by Backwater dam. Also Macritch
Hill at 270602. Pron. **mac** **rich**.
Derivation.from personal name unlikely.

Makindab LEN NO 465 715*
Gael. *meacan d'abh* – offshoot of two
waters. Obsolete name of *Waterhead*. Pron.
mac an **dab**.

Mallrenheskein GLI NO 150 742*
Gael. *?meall rinn easgann* – hill of the
sharp point of the ?bogland. SW slope of
Creag Leacach; obscure etymology.

Manach Hill EZL NO 595 745
Gael. *meadhonach* – middle [hill]. Small
hill on E side of lower Glen Esk. Pron. **man**
ach. Formerly written 'Mannoch', and so
pronounced; new spelling may suggest
Gael. *manach* (monk), but not very
plausibly.

Mangey Cottage LLE NO 506 790*
Gael. *meinneidh* – ore place. Cottage in
Glen Esk, 1 mile SE of Tarfside. Pron.
main ye; also Burn of Mangey, a well-
known locus for mining in days gone by.

Mansworn Rig MEN NO 506 647
Gael. *mon(adh) suirn* – ridge of the hill of
the kiln. Hill 3 miles W of Kirkton of
Menmuir.

Popular etymology makes this 'perjured ridge',
from a tradition of false testimony: in a dispute
concerning land-ownership, a witness (who had
that morning filled his shoes with earth from land
much further afield) swore that the ground on
which he stood had always belonged to a certain
laird. This motif occurs in other tradional land-
ownership disputes, notably Alltnacealgach
('deceiver's burn') in Sutherland.

Manywee COC NO 393 692
Gael. *monadh bhuidhe* – yellow moss or
moorland. Hill (2228 ft) on E side of lower
Glen Clova. Pron. **monna** **wee**; see
Monawee.

Maolearn LLE NO 587 769
Gael. *maol earrain* – bare [hill] of division
of land. Hill (1350 ft) in Glen Esk, nr
Kincardine boundary. Pron. **mull** **ern**.

Margie EZL NO 567 705
Gael. *margaidh* (Scots *mark/merk*) – mark
land. Farm 4 miles NW of Edzell; also
Burn and Bridge of Margie. Pron. **marg** ee.

The name first appears in this form in 1588.
'Merkland' was a common term meaning a
measure of land of value £1 Scots; in Gaelic it was
margaidh, and could refer to any division of land.
The Margie Burn formed the march bet. Edzell
parish and that of Lethnot & Navar; so it may be
that Margie simply means 'march burn', and that
the farm was called after the burn.

Mark, Water of LLE NO 449 805
Gael. *marc* – horse (referring to the
animal's mythic attributes, eg swiftness).
The main tributary of N Esk, rising in
Aberdeenshire; also Round Hill of Mark,
Black Hill of Mark, Shielin of Mark and
Invermark.

Matthew's Burn COC NO 382 730*
As written – reference unknown. Tributary
of Burn of Fleurs and Burn of Heughs, a
complex of streamlets N of Clova.

Maulen Howe LIN NO 277 618*
Scots, perhaps for *malkin howe* – hollow of
the hare. Dip in Glen Quharity, no longer
shown on map.

Mayar COC NO 241 738
Poss. Gael. *magh ard* – 'plateau height';
hill (3043 ft) beween Glen Doll and Glen
Prosen. But see p.61. There is also a Mayar
Burn. Pron. as written, equal stress.

Meall Bheag GLI NO 185 606
Gael. as written – little lump (sc. round
hill). Hill (1434 ft) 2 miles W of Kirkton,
and companion to Meall Mor. Pron. **mel
vake**.

Meall Mor GLI NO 174 603
Gael. as written – large lump. Hill
(*c*1400 ft) bet. Glenshee and Glen Isla,
whose summit marks the Perthshire
boundary. Pron. **mell more**.

Meallie, Burn of EZL NO 563 795*
Gael. ?*meallan* or *muillean* – burn of the
?little mound or 'of the mill'. Streamlet
joining Burn of Blackpots, Glen Esk. Name
invites comparison with *Colmeallie* and
Moulzie.

Mealna Letter GLI NO 163 673
Gael. *meall na leitir* – lump on the slope.
Hill (2297 ft) bet. Glen Shee and Glen
Beanie. Pron. **mal na late r** – also known as
Duchray Hill.

Meams KRR NO 368 566
Poss. Gael. *mam fhais* – hill-stance. Farm 2
miles N of Kinnordy; pron. **meem us**. (See
also *Memus*). Meams Hill is the site of a
well-preserved neolithic ring-cairn.

Meg Swerie COC NO 405 707
Prob. Pictish *mig* + Scots *swire* – wet
hollow (but see p.61). Feature on a flat-
topped hill at head of Glen Moy.

Meikle Altochy COC NO 272 647*
Scots *meikle* + Gael. ?*allt achaidh* – big
place of streams. Hill bet. Glen Damff and
Glen Prosen. pron. **alt achy**; also Little
Altochy.

Meikle Cairn LEN/LLE NO 378 765
Scots, as written – large hill (or cairn). Hill
(2699 ft) between Glen Clova and Glen
Lee. Also known as Muckle Cairn, which
means the same.

Meikle Douchray LIN NO 283 633*
Scots *meikle* + Gael. *dubh chatharaidh* –
large stream in a black moss. Hill (*c*1000
ft) in Glen Quharity. Also Little Douchray
nearby; and cf. *Deucharie*.

Meikle Tullo EZL NO 576 725
Scots *meikle* + Gael. *tulach* – big knoll;
also Little Tullo at NO 577 717. Farms nr
Gannochy, Glen Esk.

A spring nr Meikle Tullo formed part of Edzell's
water supply until Loch Lee became a reservoir in
the mid 20th century.

Meikle Tullock COC NO 33 73*
Scots *meikle* + Gael. *tulach* – large hillock.
Hill to N of Clova Village.

Melgam Water LIN NO 293 522
Derivation unknown. See p.62.

Memus, East & West TAN NO 426 590
Hamlet and farms 4 miles E of Cortachy.
Has been explained as Gael. *maoim* (burst
or landslide) or *magh meas* – plain of fruit.
Neither is very plausible, and the name
must surely be compared with *Meams*
(whose pron. is the same).

Menmuir MEN NO 520 656
Gael. *meadhon mhoraich* – middle moor.
Name covers a parish, a hill and a kirkton,
5 miles NW of Brechin. Pron. **mem** ure.
See p.62.

Mid Hill GLI NO 221 709
As written. Hill (*c*2500 ft) between Glen
Isla and Glen Prosen.

Middleford LLE NO 494 825*
As written, with straightforward meaning.
Former settlement at Glentennet.

Middlehill COC NO 376 636
As written. Farm in Glen Clova, 4 miles N
of Dykehead.

Middleton LIN NO 244 544
As written – middle farm. Farm (estate) 3
miles W of Loch of Lintrathen, formerly
known as Fornichty or ***Fornethy***.

Midton LLE NO 496 795*
Scots as written – middle farm. Croft nr
Tarfside in Glen Esk, formerly known as
Mid Cairncross.

Migvie (West) LLE NO 475 787
Migvie (East) LLE NO 478 788
Pictish *mig* + Gael. *aghaidh* – marshy hill-
face. Crofts in Glenesk nr Tarfside, pron.
mig vay. Hill of Rowan was properly
known as Migvie Hill. (1511, Mygvy).

Mile Hill LIN NO 312 572
Mile Hill COC NO 375 603
Poss. Gael. *meall* or *maol* – lump or bare
hill. The first is a hill in Lintrathen and the
second a plantation nr Dykehead, Clova.
An early form is 'Meylmoor', so prob.
neither represents Eng. 'mile hill'.

Millden EZL NO 542 789
Scots as written – narrow valley with mill.
Hamlet and shooting lodge in Glen Esk.
See p.62.

Milldewan Hill LIN NO 273 627
Gael. *meall dubhan* – kidney-shaped or
claw-shaped lump. Hill (1650 ft) 4 miles
NE of Kirkton of Glenisla.

Millstone Craig LLE NO 547 829
Scots as written – crag of the mill-stone.
Rocky hill above Burn of Tennet.

Millstone Stripe LLE NO 412 848
Scots as written – streamlet of the mill
stone. Trib. of Ladder Burn, Glen Mark.
Reference to mill-stone is obscure; and
there is no apparent connection with
Millstone Craig.

Milnacraig GLI NO 249 537
Gael. *moulin na creag* – mill of Craig (old
name of the estate). Former mill on Isla nr
Craigisla Bridge, part of barony of Craig
(now Kilry). Pron. **milna craig**.

Milton LLE NO 482 807
Scots. *mill toun* – mill farm. Farm 1 mile
NW of Tarfside, Glen Esk; also Milton
Cottage and Hill of Milton, and formerly
'Faulds of Milton'. See p.62.

Midton LLE NO 496 827
Scots as written – middle farm toun. Croft
in Glen Tennet, shown on Ainslie's map as
'Middleton'.

Middleford LLE NO 494 825*
As written. Cottage and limekiln in Glen
Tennet; shown thus on Ainslie's map.

Minister's Cairn LLE NO 424 806
As written – cairn above Loch Lee, history
unknown.

Minister's Road COC NO 327 657
As written; signposted at Prosen Kirk, but
not marked on map. See pp.34, 62.

Minrie Burn COC NO 32 727
Prob. Gael. *monadh fhraoich* – heather
moor [stream]. Tributary of S Esk, joining
it nr Clova village. Pron. **min ray**? There

was a Well of Minrie, and no doubt a croft of that name, not now on the map.

Mochrie TAN NO 445 654
Gael. *muc* + Pictish *tref* – pig-stead. Derelict croft in Glen Ogil, N of reservoir; Pron. **moch** **ry**. Pont calls it 'Perrymochries' – not named on current OS maps.

Modlach Hill LLE NO 527 786
Gael. *mad(aidh) leachd* – dog hillside. Hill in Glen Esk between The Retreat and Millden Lodge; pron. **mod** lach. See p.62.

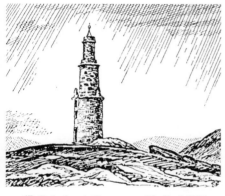

67 *St Andrew's Tower, atop Modlach Hill*

Monagob EZL NO 553 743*
Gael. *mon(adh) nan caob* – hill or moorland of turfs (prob. a source of domestic peat). Moor bet. Craigs of Cornescorn and Shanno. Pron. **monna** **gob**.

Monamenach GLI NO 176 707
Gael. *monadh meadhonach* – middle hill. Hill (2640 ft) 2 miles S of Tulchan, whose summit marks the Perthshire boundary Pron. **mona** **men** ach.

Monash, Burn of LEN NO 462 709*
Thought to be from Gael. *i mbun eas* – 'at the foot of the waterfall'. Tributary of Water of Saughs; cf. Moness, Aberfeldy. Alternatively, from Gael. *moineas* – laziness.

Monawee LLE NO 408 809
Gael. *monadh bhuidhe* – yellow moss or moorland. Hill (2276 ft) between Glen Mark and Glen Lee. Pron. **monna** **wee**; cf. *Manywee* in Clova.

Mondurran, Hill of LEN NO 463 701
Gael. *monadh duirn* – [hill of the] moorland with round stones. Hill (1974 ft) 2 miles S of Waterhead. Pron. **mon** **durr** n; cf. Dornoch and Dundurn. In Gaelic, *doorn* is primarily a fist, but also a round stone of that size and shape.

Monega Hill GLI NO 186 757
Gael. *monadh eagach* – notched hill. Serrated hilltop (2730 ft) at head of Glen Isla. Pron. **mon** **aig a**. Better known as the name of a right-of-way across the Mounth. See p.63.

Monthrey LIN NO 312 623
Gael. *monadh ?threabh* – moorland of the steadings; or *?reidh* – of the plain. Low hill between Glen Quharity and Glen Uig. Pron. **mon** **three**.

Montiney, Burn of LEN NO 477 737*
Gael. *monadh t-sionnaich* – [stream of the] fox moorland. Tributary of West Water. Pron. **mon** **tin ny**. Hill-name no longer shown on map.

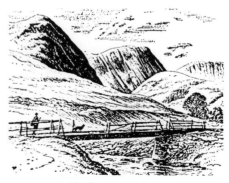

68 *The Monega Pass*

Mooran, Burn of EZL NO 583 735
Gael. *am buirean* – [burn of] the roaring,
bellowing burn. Tributary of N Esk, 5
miles N of Edzell. Pron. **moor** n (locally,
'The Mooran'). Brechin's water-supply
since 1874.

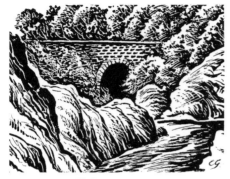

69 Brig o' Mooran

Moorleathers, Craigs of
LIN NO 273 595
Prob. Scots as written + Gael. *leitir* –
'crags of the moor hill-slopes'. Rocky
outcrop E of Backwater Reservoir. A Scots/
Gaelic hybrid and an unusual name.

Moory COC NO 395 642
Scots *muiry* – 'consisting of moorland'.
Moor on E side of Glen Moy.

Moulnie Craig COC NO 26 79*
Gael. *muillean a creag* – mill rock. Crag E
of Bachnagairn, Clova. Pron. **mool** ny. The
name may relate to **Moulzie** in the glen
below.

Moulzie COC NO 283 778
Gael. *muillidh* (from *muillean)* – mill-
place. Keeper's cottage in upper Glen
Clova, and formerly a mill powered by
Moulzie Burn. Pron. **moo ly**. Ainslie's map
has 'Mealie Burn'; and cf. Corriemulzie,
Braemar.

Mount Battock LLE NO 549 835
Gael. *monadh bathaich* – cowshed upland.
Hill (2555 ft.) on march with
Kincardineshire.

A prosaic name for an elegant summit. (Gael.
monadh does not equate to Eng 'mount' – see
Introduction).

Mount Blair GLI NO 167 620
Gael. *monadh blar* – height of the moor.
Hill (2441 ft) between Glenshee and Glen
Isla. See p.63.

Mount Bouie COC NO 302 707
Gael. *monadh buidhe* – yellow hill or
moss. Hill (1922 ft) between glens of
Clova and Prosen. Pron. **boo ee** (but Ainslie
calls it 'Munbowie').

Mount Een LLE NO 523 819
Gael. *monadh ?eoin* – hill of birds; or poss.
?aodainn -'foreside hill' (cf. Aucheen).
Hill (*c*1650 ft) in Glen Tennet.

Mount Keen LLE NO 409 869
Gael. *monadh caoin* – smooth upland. Hill
(3077 ft) N of Glen Mark. See p.64. Pont's
map has 'Month Kyn'; and compare
Rosskeen in Ireland.

Mount Sned LEN/TAN NO 448 695
Gael. *monadh snathad* – sharp, needle-like
hill. Hill (*c*2000 ft). between Glens Moy
and Lethnot. 'Sned' may refer to the shape
of the hill as seen from the track, or to a
cairn or obelisk now gone.

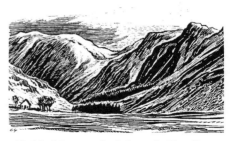

70 Moulzie – a stalker's house in Glen Clova

Mowat's Seat LEN NO 475 675
A personal name; and 'seat' here means a
hill; 4 miles N of Auchnacree; see p.64.

Muckle Burn GLI NO 215 625
Scots, as written – large stream. Burn
flowing into Loch Shandra, Glen Isla.

Muckle Cairn LEN/LLE NO 353 823
Scots as written – big stony hill. Hill (2699
ft.) between Glen Mark and Glen Lee;
prob. a 19th century name coined by
stalkers.

Muckle Corrie Breac LLE NO 358 809
Scots and Gael. as written – big speckled
corrie. Hanging valley in upper Glen Lee.
Also Little Corrie Breac.

Mudlee Bracks LLE NO 511 857
Gael. *meall da bhreige* – hill of two false
(men). Hill (2259 ft) on county boundary,
nr Tarfside.

The theory is that the name refers to two man-like
cairns, now dilapidated; but cf. ***Modlach Hill***.

Muir of Holm LIN NO 315 554
Scots as written – moor of the river
meadow. Plantation 3 miles E of Loch of
Lintrathen.

Muirskeith COC NO 385 595
?Scots *muir skeath* – ?moor of damage,
harm. Farm 1 mile SW of Cortachy.

The Gael. word-order is puzzling; an etymology
involving the personal or family name Keith is
possible.

Muntie, Burn of LEN NO 500 701*
Gael. *mointidh* – [burn of] miry land.
Tributary of Burn of Calletar, Lethnot.
Muntie is no longer a settlement-name.

Murley LLE NO 325 803
Poss. Scots *muir ley* – moorland grazing.
Hill (*c*2300 ft) at head of Glen Lee. Or
poss. moorland of Lee. (Compare
Murlingden, Brechin, which means
'moorland toun').

Murmannoch EZL NO 586 797
Gael. *mon(adh) meadhonach* – mid hill.
Hill (1557 ft) on E side of Glen Esk; pron.
mur man noch (cf. ***Manach Hill***).

Naked Hill LLE NO 441 872
As written – bare hill, 3 miles E of summit
of Mount Keen. But Gael. origin is poss. –
see ***Naked Tam***.

Naked Tam TAN NO 425 649
Gael. *tom nochd* – bare knoll. Low hill
between Glen Moy and Glen Ogil. A good
example of folk-etymology at work.

Nathro LEN NO 509 695
Gael. *nathrachan* – snake or adder-place.
Croft 3 miles NW of Bridgend; also Nathro
Lodge and Nathro Hill. See p.64.

71 Nathair – *an adder*

Navar, Church of LEN NO 535 678
Gael. *neimhidh Bharr* (which later became
'Nethuer') – sacred place of St Findbarr.
Old church nr Bridgend. Pron. **nay ver**; see
p.64.

Navar, Shank of LEN NO 495 681
Scots *shank* + *Navar* – hill-spur of Navar.
Hill NE of Putney Maol. The Shank takes
its name from the parish; it is not near the
old church.

Needs GLI NO 237 580
Prob. Gael. *nead* – [place of] ?nests.
Former Airlie estate 2 miles NW of
Bridgend, Lintrathen. Also Holm of Needs,
a flat stretch of the B 951.

Nether Drumhead GLI NO 216 550
Scots as written, with Gael. *druim* – 'lower
farm at the end of the ridge'. Farm in Forest
of Alyth, nr Kilry. 'Upper Drumhead'
doesn't appear on map.

Nether Shiel COC NO 297 690
Scots as written – lower cottage/shieling.
Former cottage and limekiln N of
Glenprosen Lodge; (name relates to *Cairn
Shiel*).

Nettle Well EZL NO 576 737*
Scots as written. Ancient well on W side of
Glen Esk; also Nettlewell Hillock,
Torantipper.

New Craig GLI NO 246 529
Scots as written. Farm 3 miles SW of Loch
of Lintrathen. Craig was former name of
Craigisla estate.

New Moss TAN NO 46 66*
Scots as written – new moor. Hill (1569 ft)
NE of Glenogil Res. Possibly named as a
new source of peat.

Newbigging LEN NO 543 689
Newbigging COC NO 341 715
Scots as written – 'new building'. (1) farm
nr Bridgend in Lethnot; (2) farm in Glen
Clova. A very common farm and hamlet
name – see p.64.

Newmill KRR NO 367 578
As written; farm and former mill 4 miles
NNW of Kirriemuir.

Newton LIN NO 287 576
Newton GLI NO 231 602
Scots as written – new farm or hamlet, a
common farm name. (1) farm in
Lintrathen; (2) farm nr Kirkton of Glenisla,
also has a Newton Burn.

In the vicintiy of the Glenisla Newton was a castle,
of which there is now no trace; it is thought to have
been built by the Durwards, and later occupied by
another family until the 17th century.

Noran Water FER NO 539 585
Gael. *an dobharan* – 'the little water', a
main tributary of S Esk. See p.65.

Noranside FER NO 473 612
See **Noran Water**. Estate and mansion,
now HM Prison. See p.65.

72 On the Noran Water

Nowtstairs Wood COC NO 332 627*
Scots as written – cattle steps. Plantation
on N slope of Peat Shank, Prosen.

Old Craig COC NO 270 690
Scots as written. Former lodge in upper
Glen Prosen, now house; (name may relate
to *New Craig*).

Old Man, The
LEN NO 495 676 & NO 486 654
As written – two hills in Lethnot within 3
miles of one another. The name may refer
to man-like cairn.

Oldtown LEN NO 546 701
Scots as written – old farm. Hill-farm, one
in row of three above West Water.

Ainslie's map has 'Auldtown'; the presence of a

Ord

Burn of Oldtown suggests that the original form of the name may have been *allt an t-Sean-bhaile* – 'burn of the old farm-toun'.

Ord, Shank of COC NO 334 698*
Scots *shank* + Gael. *ord* – spur of the hammer-shaped (i.e. round) hill. Slope on S side of Glen Clova. Place is now unidentifiable because of afforestation.

Ordies Hill LEN NO 487 721
Gael. *ord deise* – south hammer-shaped (i.e. round) hill. Hill in Glen Lethnot 2 miles E of Waterhead; cf. Loch Ordie in Perthshire (also round).

Ought, The COC NO 268 772
Prob. Gael. *uchd* – breast, bosom; pron. **ocht**. Protuberance on N slope of Craig Mellon, also 'Corrie Auchd', now afforested. Cf. *The Aud*.

Oxen Lairs GLI NO 166 728*
Scots as written (lair is a place where cattle lie). Grazing in Glen Brighty.

Pamphel Burn LLE NO 502 847
Scots *poind fauld* – [burn of the] cattle fold for beasts either impounded by law or seized as plunder. Burn rises near Aberdeenshire march and joins Water of Tarf. Also written 'Pinfold'.

Pandewen LLE NO 418 845
Pictish *pant* + Gael. *uaine* – green hollow. Hill 2 miles N of Glenmark cottage. Pron. **pand ew an**. A hill name which originally referred to a declivity? But another possibility is Gael. *punnd* – a pound or cattle pen.

Paphrie Burn FER NO 543 675
Pictish *pefr* – radiant, shining [stream], joining West Water nr Burnfoot. Pron. **paf ry**. See p.65.

Parkhead GLI NO 246 536
Parkhead COC NO 325 733
Scots *park* (which means field) – 'end of the field'. (1) farm in lower Glenisla; (2) cottage nr Clova village.

Parkhill GLI NO 231 605
As written – hill with a field on or near it. Farm 2 miles E of Kirkton.

Pearsie KGM NO 365 595 Poss.
Pictish *preas* – 'place of thickets' or *parsaidh* 'parcel of land'. Mansion and farm in Glen Prosen. See p.65.

Peat Hill LEN NO 502 673
As written – hill of peat (prob. a source of fuel). Small hill 3 miles SW of Bridgend.

Peat Shank COC NO 329 618
Scots as written – peat hill-ridge (source of fuel). Hill in lower Glen Prosen, nr Lednathie.

Peathaugh, Wester GLI NO 233 579
Scots as written – peat bank. Croft nr Kilry (see p.66).

73 *Peathaugh, Glen Isla, in winter*

Pinderachy TAN/FER NO 458 653
Pictish *pant* or *penn* + Gael. *doire-achaidh* – ?hollow or ?head of the place of thickets. Hill (1632 ft) on E side of Glen Ogil. Pron. **pin der achy**. See also *Derachie*, 5 miles S, prob. the source of the name.

Piper's Hillock COC NO 384 610
Knoll nr Dykehead where Cortachy cemetery was consecrated in 1905.

Pirn Brig LEN NO 577 618
Scots as written – threadmaker's or
reelmaker's bridge; nr Edzell. Also known
as *Pirner's Brig*.
A suspension bridge over the West Water, said to
have been built by the thread manufacturers,
J & P Coats, for the convenience of shooting
tenants. Local picnic site and beauty-spot.

Pitcarity COC NO 328 658
Pictish *peit* + Gael. *caraide* – 'place of the
couple' [of persons]. Former croft, nr
Glenprosen village. Pron. **pit car ity**. See
p.66.

Pitewan LIN NO 257 571
Pictish *peit* + Gael. *Eoghan* – Ewan's
place. Croft 3 miles NW of Loch of
Lintrathen.
The Skulk (defile) of Pitewan is said be the place
where Lord Airlie and his followers lay in ambush
in order to intercept skirmishers who were
scouring the glens in 'rebellion times'.

Pitlochrie GLI NO 220 61
Pictish *peit* + Gael. *cloichrigh* – stony part,
or place of stepping-stones. Former crofts 1
mile NE of Kirkton of Glenisla. Early
forms are Petklochry (1433) and Petclochry
(1443); cf. Pitlochry in Atholl, which
means and is pronounced the same.

Pitmudie LIN NO 275 562
Pitmudie LEN NO 546 671
Pictish *peit* + Gael. *maothaidh* – share of
the soft land. Farms (1) in Lintrathen and
(2) nr Bridgend of Lethnot. Pron. **pit mood**
y. (1319 Petmathy, later Pitmachy).

Plash Mill COC NO 403 592*
Scots as written – fulling mill driven by a
water-wheel. Former mill in grounds of
Cortachy Castle.

Pointfaulds Moss GLI NO 19 70*
Scots as written – moorland with pen for
impounded animals. Peat bank 2 miles S of
Tulchan, Glen Isla.

Potty Leadnar LEN NO 412 712
Gael. *pait an leathadarain* – hump of the
slope- place. Hill-slopes between Glens
Clova and Lethnot. Pron. **potty led nar**; also
Potty Leadnar Burn.

Powskeenie LLE NO 472 782*
Gael. *poll sginnidh* – pool of leaping.
Rocky pool at bridge over S Esk nr
Dalbrack. Pron. **pow skeen y**. See p.66.

Presnerb GLI NO 187 668
Gael. *preas an earb* – roe-deer thicket.
Farm in upper Glen Isla, 2 miles N of
Forter. Pron. **pres nerb**.

Presney, Burn of LLE NO 345 831
Gael. *preasnaidh* – bushy [stream]. Trib. of
Water of Mark. Pron. **prez ny**. The word-
order suggests an earlier Gaelic form *allt*
preasnaidh.

Priest's Road LEN NO 503 727
As written; old track leading from
Stonyford in Lethnot to Tarfside in Glen
Esk (but not named on map). See p.66.

Proctor's Wood COC NO 338 638*
As written – procurator's wood. Wood (no
longer identifiable) nr Lednathie.
A procurator was an official, legal or eccles-
iastical, but name may refer to the surname – in
early 19th century a man named Proctor was factor
of Glamis.

Prosen, Glen COC NO 327 658
Also Water of Prosen. Derivation and
meaning unknown. See p.67.

Prosenhaugh KRR NO 378 590
Prosen + Scots *haugh* – Prosen water-
meadow. Farm in Glen Prosen 2 miles SW
of Cortachy. Pron. **proas en hauch**. Name is
of unknown antiquity and provenance.

Pullar Cuy LLE NO 472 869
Gael. *buaile ard coilich* – cattle-fold of the
high ground of the cock. Hill (*c*1800 ft) 7
miles NNW of Tarfside. Pron. **pool ar kye**;
and cf. *Cock Cairn*.

Purgavie LIN NO 295 552
Pictish *par* + Gael. *gabhaidh* – place of danger. Farm NE of Bridgend, in former Barony of Craig. Pron. **pur gav ie**. Early forms are 'Pergewy' (1256) and 'Purgeyoy' 1561).

Putaichie Burn LIN NO 262 595
Gael. *puiteach* – '[burn of the place of] pot-holes'. Formerly a tributary of the Backwater, now joins reservoir. Pron. **pit aich y**. The potholes are now flooded.

Putney Maol LEN NO 492 678
Gael. *pait na maol* – bump on the bare round hill. Hill (*c*1500 ft) 5 miles NW of Menmuir. Pron. **putt ney male**.

Pyes of Claise GLI NO 190 787
Poss. Scots as written – magpie hollow Features (unspecified) E of Cairn of Claise. It is written on older maps 'Pyes of Clash', but meaning remains doubtful.

Quaichly, Burn of LIN NO 280 605
Gael. *cuaich* (Scots *quaich*) – [stream of the] cup or bowl. A tributary of the Quharity Burn.

Queen's Well LLE NO 429 328
Granite structure built by Lord Dalhousie to commemorate a visit by Queen Victoria; see p.67.

74 *The Queen's Well, Glen Mark*

Quharity Burn LIN NO 287 575
Quharity Burn KGM NO 402 577
Gael. *charaide* – paired [stream]. Pron. **whar rity**. See p.67.

75 *On the Quharity Burn, Lintrathen*

Raes, Burn of LEN NO 545 716*
Scots as written – roe-deer stream. Streamlet S of East Wirren. Compare Rae Burn in Eskdale, which gives the familiar surname Raeburn.

Rags, Brae of the COC NO 35 74*
Scots as written; hill-slope NW of Loch Wharral, Clova. Unexplained name.

Ranoch EZL NO 569 763*
Gael. *roinneach* – share place. Croft shown on Ainslie's map, now gone. Pron. **ran ach**, but also known as 'The Ronnach'; cf. ***Auchronie***.

Rantry, Burn of LLE NO 351 836
Scots *rantree* – [burn of the] rafter or roof-tree. Tributary of Water of Mark. Pron. **ran try**. Suggested reduction of 'rowantree' seems very unlikely.

Rashes, Burn of EZL NO 55 0818
Scots as written – burn of reeds/rushes. Tributary of Burn of Turret, Glenesk.

Rashiebog COC NO 40 63*
Scots as written – bog of reeds/rushes.
Deserted croft in Glen Moy – see p.68.

Ravernie, Easter LIN NO 25 62*
Gael. ?*rath bhearna* – mound in the gap.
Also Mid & Wester Ravernie – former
farms; Pron. **ra ver ny**.

These once formed part of the Lintrathen estate of
the Ogilvies, now submerged by Backwater dam.
Ainslie has 'Revernie' (see also **Glenhead**).

Red Burn GLI NO 207 768
As written. Tributary of Canness Burn.

Red Craig COC NO 296 759
As written – red hill (2119 ft) above
Braedownie in Clova. Red Craig was also
known as 'Dun Mor' (big knoll). The name
of the nearby Ben Reid is often taken to
mean 'red hill'.

Red Holes LEN NO 486 738
Scots howes – hollows nr Tilliebirnie. On
Ainslie's map, but not on OS

Red Shank LLE NO 486 855
Scots as written – reddish hill-spur. Hill
(*c*1200 ft) 6 miles N of Tarfside.

Redhall, Hill of COC NO 390 582
Prob. Scots *redd haugh* – [hill] of the
cleared river-meadow. Low hill beside
Prosen Bridge. There was a Redhaugh
Cottage, but no evidence of a 'hall', red or
otherwise.

Redheugh TAN NO 446 636
Scots as written – red cliff or steep bank.
Property in Glen Ogil, 1 mile SW of
Reservoir. A 19th century mansion built by
the Haig family.

Redlatches GLI NO 206 593
Scots as written – red bog-streams. Croft/
farm in lower Glen Isla.

Redshiel LEN NO 456 709*
Scots as written – red shieling (or poss.
reed = cattle-shed). Croft site nr Waterhead.

Reehewan LLE NO 445 766
Poss. Gael. *ruigh ?eoin* – bird place. Area
in Glen Effock; Pron. **ree hew an**. Another
poss. reading is Gael. *ruigh uaine* – green
shieling-ground; it is not clear what the OS
map refers to – poss. to a shiel, but there is
nothing on the ground.

Reekie Linn GLI/LIN NO 254 536
Scots as written. – 'smoky waterfall-pool'.
Cascade where River Isla falls 90ft over
rocks; see p.68.

Retreat, The LLE NO 508 789
As written. Museum and tearoom in Glen
Esk. See p.69.

76 *The Retreat, Glen Esk*

Rives, The COC NO 275 775
Scots as written – cracks, fissures. Crags,
part of Cairn Broadlands, Clova.

Robert Shiell, Bank of
LEN NO 423 723*
As written – hillside above Burn of
Duskintry. Since there are no records of a
person of that name, it is prob. a Scots
corruption of 'robber's hut'.

Roineach Mhor COC NO 327 732*
Gael. *roinneach mor* – large share-place.
Eastern part of Clova Village. Pron. **ron-
yach more**; cf. **Ranoch**.

Rome MEN NO **523 665**
Prob. Scots *room* (in one of its many
senses) – spacious, cleared; or poss. a tack
or rented farm. Farm nr Hill of Menmuir;
see p.69.

Ronach, Burn of EZL NO 535 777*
Gael. *ronnach* – viscous, slobbery [stream].
Burn joining N Esk opposite Craigshina.

Rottal COC NO 370 697
Poss. Gael. *rath meall* or *muilne* – fort of
the hill or mill. Hamlet in Glen Clova;
Pron. **rot al**. Comprises Rottal Lodge, with
farm and pony-trekking centre. Earlier a
Lindsay property, written 'Rothmel'.

Rottenhaugh LLE NO 44 80*
Rottenhaugh LEN NO 52 69*
Rottenhaugh COC NO 33 72*
Prob. Scots as written – haugh infested
with rats. (1) place nr House of Mark; (2)
place nr Craigendowie; and (3) former
croft on S Esk down river from Caddam.
But claims have been made for Gael.
rathad na h'abhaich – water-side road (see
p.69). The name also appeared in Lochlee
as 'Mill of Ratnovy'.

Rottenmoss TAN NO 415 606
Prob. Scots *rottan moss* – rat-infested
moorland. Croft 1 mile NE of Cortachy
Castle.

Rough Banks LLE NO 378 837
As written; steep hillside on S side of Glen
Mark; also Burn of Rough Banks.

Rough Craig COC NO 408 682
Rough Craig COC NO 350 732
Scots as written – rough, rocky hill. (1) hill
above Glen Moy, formerly called
'Craigdamf' (stag hill); (2) hill in Glen
Clova.

Rough Meadows COC NO 413 695
As written. Hill-slope N of Balbui; name
prob. relates to *Rough Craig* above.
Meadow in Scots meant coarse grass or
rough grazing.

Round Hill LLE NO 461 760
Round Hill LEN NO 422 745
(1) hill S of Glen Effock; (2) hill in Glen
Lethnot. The two hills are within 5 miles of
one another.

Rowan, Hill of LLE NO 464 795
Gael. *an rodan* – little road. Hill at junction
of glens of Tarf and Esk. (Not rowan tree –
see p.70).

77 *The Rowan Tower, Glen Esk*

Runtaleave COC NO 289 680
Poss. Gael. *raon talamh* – arable land (lit.
'earth land'). But in 1745 it is
'Bruntyleave' (Muster Roll of Airlie
Regiment). Croft in upper Glen Prosen.
Locally pron. **runty leave** (but etymology
would demand stress on **tal**).

Ruragh LEN NO 421 711
Gael. *ruigherach* – shieling-ground. Hill
(2410 ft) between Clova & Lethnot. Pron.
roo rach.

Saddle Hill EZL NO 59 75*
Saddle Hill GLI NO 20 56*
Saddle Hill LIN NO 30 57*
As written. Hills nr Edzell, in Glenisla and
in Lintrathen respectively. A characteristic
term descriptive of a hill-form.

Sandy Hillock COC　　　NO 265 805
As written. Hill (2522 ft) 2 miles SE of
Broad Cairn. It is more than a hillock –
terminology may simply echo nearby Dog
Hillock.

Sauchan Burn, Little LEN　NO 42 72*
Scots *sauch* – [little] willow stream. Trib.
of Duskintry Burn and Water of Saughs.
Also Sauchan Burn, Meikle.

Saughs, Hill of LLE　　　NO 444 833
Scots *saugh* – [hill of] willows. Moorland
hill (2141 ft) 4 miles E of Mount Keen;
see p.70.

Saughs, Water of LEN　　NO 470 715
Scots *saughs* – willow [stream]. Drains
upper Lethnot glen; lower reaches are
called West Water. See p.70.

Scad Cairns LIN　　　NO 315 605*
?Scots as written – ?scalded cairns. Rocks
on S slope of Cat Law. (Unsatisfactory
etymology.)

Schurroch, West KGM　　NO 317 542
Prob. Gael. *sgireachd* – a parish. Hill
features nr Baldovie. Pron. **shurr** och. Also
Schurroch, East. The name poss. refers to
parish boundary.

Scithie, Nether LIN　　NO 249 573
Gael. *sgitheach* – hawthorn. Former farm,
now part of large plantation E of
Backwater Res. Pron. as written.

Another poss. etymology is Gael. *sceithe* – shield/
wing. (Pont has 'Schethyn'). Mid and Upper
Scithie were flooded by dam; Dundee owns Nether
Scithie. Map also shows Glack [hollow] of Scithie.

Scorrie, The COC　　　NO 276 751
Gael. *sgorach* – sheer, rugged. The steeply
conical northern spur of Driesh.

Scorrie is the adjectival form of *sgurr* (not found
in the area), lit. a cutting or landslip. A map of
1850 shows 'Scurrie of the Dole'.

Scrabytie LLE　　　　NO 459 786
Scots *scabbert* – a piece of stony,
unproductive land; former croft at foot of
Glen Effock. Pron. **scra** **bittie**. See p.70.

Scruschloch GLI　　　NO 231 571
Seems to have its origin in Gael. *sgrios*,
meaning to scrape or destroy, perhaps a
landslip. Estate in lower Glen Isla, 2 miles
W of Dykend. Pron. as written, stress on
crush.

The estate comprised Drumdarg, South Park,
Drumgill etc. A Kinloch property; Ainslie (1794)
calls it 'Scriochloch'.

Serjan Hill EZL　　　NO 593 713*
Scots as written – sergeant hill. Eminence
on W side of lower Glen Esk. Reference is
said to be to the nearby home of the 'old
sergeant of the barony'.

Shallgreen TAN　　　NO 408 633
Prob. Gael. *sealbh grine* – green place of
stock/possessions. Farm 3 miles NW of
Newmill of Inshewan. Name is poss. just
Scots 'shiel green'.

Shandford MEN　　　NO 491628
?Gael. *sean* – old [ford]. Farm 4 miles SW
of Kirkton of Menmuir; also Shandford
Hill.

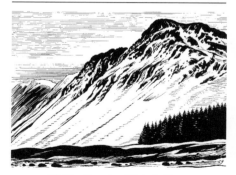

78 *The Scorrie of Driesh, Clova*

Shank COC NO 404 662
Shank GLI NO 216 610*
Shank LLE NO 539 805*
Scots *shank* – descending hill-ridge. Hills in Glen Moy, in Glen Isla and N of Millden, Glen Esk respectively. Shank Burn is now called 'E Burn of Glenmoye' on OS maps.

Shank Hill COC NO 406 672
Scots *shank* (see **Shank** above). Hill in Glen Moy, takes its name from nearby croft. Ainslie calls it 'Badhappies'.

Shank of Auchnafoe LEN NO 504 740*
Scots *shank* + Gael. *ach na faitche* – 'shank' of the field of exercise (sport, arms). Spur of hill above West Water. Pron. **ach na foy**. Formerly part of *Auchowrie*.

Shank of Birks EZL NO 563 814
Scots as written – hill-spur with birches. Near Hill of Fingray, N of Glen Esk.

Shank of Donald Young
LEN NO 421 737
Scots *shank* + personal name – hill ridge of Donald [the] Young. Hill (2152 ft) nr Water of Saughs. Young, a cateran, was slain here in a raid – see p.70.

Shank of Ducharr LEN NO 472 692*
Scots *shank* + Gael. *dubh-chathar* – hill-spur of black broken mossy ground. Hilly land above Burn of Calletar.

Shank of Freoch LEN NO 516 724*
Scots *shank* + Gael. *fraoch* – spur of heathery hill. Hillside above West Water. Pron. **free uch**; also Burn of Freoch.

Shank of Lairs LLE NO 370 822
Scots as written – hill-slope of cattle-folds or enclosures. Hill (*c*1500 ft) in Glen Lee; also Burn of Lairs.

Shank of Ledmanie LEN NO 525 723*
Scots *shank* + Gael. *leathad meadhonach* – spur of middle hill-slope. Hillside above West Water.

Shank of Mondair EZL NO 579 808
Scots *shank* + Gael. *mon(adh) da fhir* – spur of the hill of two men. Hill (*c*1500 ft) 3 miles N of Colmeallie, Glenesk. 'Men' prob. means man-like stone heaps.

Shank of Peats LEN NO 435 705
Scots as written – moorland summit (2310 ft) nr Glen Lethnot; reference is to peat cutting.

Shannally LIN NO 296 538
Gael. *seana bhaile* – old [farm] toun, SE of Bridgend; also Loups of Shannally on Melgam Water.

Earlier 'Myllashangly', poss. Gael. *muillean seana bhaile* ('Old Milton'). Property belonged to Abbey of Coupar Angus; also known as 'Scottismyll'.

Shanno, Craig of EZL NO 559 759
Gael. *siannach* + Scots *craig* – 'rocky hill of the place of wind/storm'. Hill (1300 ft) on W side of lower Glen Esk. See p.71.

Sheerstripes Hill EZL NO 562 712
Scots as written – 'share stripes'. Small fields without buildings, now part of the farm of Margie. The name describes the old Scots 'runrig' method of cultivation.

Shenovan Hill GLI NO 155 729*
Gael. *?sean ath bhan* – [hill of the] old white ford. Hill (2200 ft) in Glen Brighty. Pron. **shen o van**.

Sheriffbank Park COC NO 407 652
As written. Field NE of Glenmoy farm; also Sheriffbank Hill, NO 418 661. Pont has 'Shyrebank', which would be Scots *shirra* or sheriff; but judicial reference unknown.

Shetland Strip COC NO 337 635*
As written. Strip of woodland nr
Lednathie; reason for name unknown.

Shielhill KRR NO 428 574
Scots as written – hill of the shieling.
Mansion and farm 4 miles SE of Cortachy.
Also Shielhill Bridge at NO 428 500, nr a
modern house built on the site of a former
Ogilvy castle. See p.71.

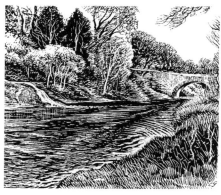

79 *Shielhill Bridge on the South Esk*

Shielin, The GLI NO 197 757
Scots, as written. Ruined hut on grassy
stretch at head of Glen Isla, nr junction of
Caenlochan and Canness glens. (Ainslie
has 'Shielling'); the place was associated
with summer pasture. see p.71.

Shieling of Saughs LLE NO 396 758
See *Saughs, Water of*. Ancient summer
pasture on the Cateran's road.
The ruined shieling was recently restored for the
convenience of long-distance walkers; this is wild
country indeed.

Shiels, Bank of LIN NO 303 597
Scots as written – terrace on which there
were shielings. Hillside N of Auldallan.

Shinfur LLE NO 491 824
Gael. *sianchor* – storm-tossed. Farm and
limekiln at junction of glens of Tarf and
Tennet. Pron. **shin fur**; see p.71.

Shott, The LIN NO 245 695*
Scots *shot* – a piece of land subject to
rotational cropping. Hillside between Glen
Finlet and Glen Prosen. (The terrain
however gives no indication of cropping.)

Shoulder of Badagie GLI NO 272 605*
Gael. *bad a gaoith* – [shoulder] ?of the
windy thicket Part of Macritch Hill. Pron.
bad a ghee.

Skelly LLE NO 515 778*
Gael. *sgaoileadh* – spreading [rock] – see
p.71. Ruined croft in Glen Esk 1 mile W of
Modlach. See also *Skuiley*.

Skuiley LLE NO 402 774
Gael. *sgaoileadh* – fraying, crumbling (as
referring to rocks). Hill (*c*2300 ft) 2 miles
SW of Loch Lee. Also Wester Skuiley. See
note under *Skelly*.

Slack of Barna EZL NO 585 770*
Prob. Gael. *slochd bearnach* – hollow of
the gap (in hills on E side of lower Glen
Esk); but cf. *Birnie* and *Tilliebirnie*.

Slake LEN NO 513 703*
Scots *slock* (from Gael. *slochd*) meaning a
hollow. Landform nr Braco, Lethnot.
Appears on Ainslie's map, but not on OS.

Slates LLE NO 440 786
As written – slab-like rocks on W side of
Cairn Caidloch. Prob. a modern and local
name.

Slaty Burn LEN NO 428 738*
Gael. *slaod* – sluggish [stream]. Trib. of
Water of Saughs; cf. *Slidderies*.

Sleepy Hillock COC NO 344 690*
Knoll on W side of Glen Clova; name
unexplained and prob. of recent origin.

Slidderies, Burn of LLE NO 371 781
Prob. Gael. *slaodair* – sluggard [burn].
Sub-stream joining Water of Unich.
Alternatively, may be 'slithery burn', from
Scots *s[c]lidder* – a downhill track.

Slug of Auchrannie GLI NO 278 529
Gael. *slochd* – ravine [of **Auchrannie** qv.].
Spectacular watercourse on Isla NW of
Airlie Castle. Pron. **och ran y**.

In Gaelic it is pronounced **slochk**, locally **slug**.
A 'long, deep and horrible gulf', it is part of the
Den of Airlie, but no longer visitor-friendly.

Sluggan GLI NO 216 689*
Gael. *slocan* – little hole or pit. Hollow in
hills W of Glen Finlet; cf. Sluggan Pass in
Rothiemurchus.

Smith's Gutter LLE NO 394 792
Precipitous W face of Craig Maskeldie –
no doubt a mountaineering coinage.

Smithy Burn LEN NO 448 728
As written. Trib. of Water of Saughs.

Sneck of Corinch COC NO 362 649
Scots *sneck* + Gael. *coire innis* – 'notch or
dip of the corrie of the green place'. Saddle
between two hills.

Sneck of Lapshalloch COC NO 353 666*
Scots *sneck* + Gael. ?*leaba saileach* –
notch of the ?bed/bog of willows. Dip in
the hills between Glens Prosen & Clova.
('Bed of willows' however makes little
sense.)

Snow Burn COC NO 243 723
As written. Streamlet which joins Mayar
Burn in upper Glen Prosen (presumably
rises nr a snowfield).

Snowholm Burn LEN NO 534 722
Scots as written; dip in S side of Hill of
Wirren where snow lies. Pron. **snow howm**.

Snub, The COC NO 335 757
Scots as written; short steep hill above
Craigs of Loch Brandy, Clova.

South Craig COC NO 235 731
Scots as written. S spur of Mayar.
This impressive 2730 ft bluff, dominating
the head of Glen Prosen, surely deserves a
more descriptive and imaginative name.

Soutra TAN NO 446 610
Pictish *sulw tref* – outlook place. Farm 7
miles E of Dykehead. Pron. **soo** tra. Pont
has 'Sautra'; and cf. Soutra in Lauderdale.

Spott COC NO 330 654
Prob. Gael. *sput* – spout (waterfall). Estate
in Glen Prosen, half mile S of village.
See p.72.

80 *Spott Bridge, Glen Prosen*

Sron Bhorrach GLI NO 202 766
Gael. as written – point (lit. nose) of the
mountain grass. Peak above Canness Glen.
Pron. **stron vorr rach**.

Sron Deirg GLI NO 220 732
Gael. *sron dearg* – red point (lit. nose). Hill
(2300 ft) at head of Glen Cally. Pron. **stron
jer rag**; also Altan Deirg (red streamlet) at
NO 216 736.

Sron Meadhonach GLI NO 212 726
Gael. as written – middle point (lit. nose).
Hill in Glen Cally. Pron. **stron may nach**.

Sron Reidhe GLI NO 195 765*
Gael. as written – smooth point (lit. nose).
Southern slope of Caderg. Pron. **sron ray**.
Name contrasts with that of **Sron
Riabhach**.

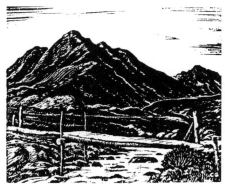

81 *The steep part of Jock's Road*

Sron Riabhach GLI NO 163 752
Gael. as written – rough nose. Rocky
outcrop on N of Creag Leacach, marking
the W limit of Caenlochan Forest. Pron.
stron <u>ree</u> ach.

Sron Saobhaidhe GLI NO 180 732
Gael. *sron saobhaidh* – peak of the fox's
lair. Spur of hill-land on S of Caenlochan
Forest. Pron. **stron <u>soo</u> vy**.

St Arnold's Seat TAN NO 432 649
As written – hill of St Arnold. Hill (1615
ft) 2 miles NW of Glen Ogil. Should be St.
Ernan or ?Eunand – see p.72.

St Mary's Well LEN NO 542 681
As written; old well E of Bridgend of
Lethnot. The Blessed Virgin was patron of
Lethnot, and the well was for long the
depository for votive offerings of silver.

Stanks, Hill of LIN NO 296 615
Scots as written – hill of ponds, ditches or
swamps. Hill (1572 ft) in Glen Quharity.

Steeps, The COC NO 32 77*
As written; where the track climbs to the
summit of Jock's Road in Glen Doll. Not
marked on OS map.

Stile Burn COC NO 255 795
Gael. *steall* – torrent, waterfall [burn].
Streamlet joining S Esk at Bachnagairn.

Pron. as written (but Gael. would be
'**shtaull**').

Near the waterfall is a wooden bridge 'erected by
family and friends of Roy Tait who died on
Lochnagar 16 August 1981'.

Stobie Hillock EZL NO 566 817*
Scots *stobbie* – rough, bristly hill, in lower
Glen Esk.

Stoney Loch COC NO 369 751
Gael. *lochan stanna* – vat- or tub-like
pond. Tarn N of Loch Wharral, Clova, nr
the source of the Water of Saughs. The
name sometimes appeared as 'Staney', but
the Scots word *staney* means stony.

Stonyford LEN NO 505 725
As written; also Craigs of Stoneyford. A
bridge replaced the ford in the 1770s;
Stonyford is the keeper's house for Hunt
Hill estate. The place was formerly *ath
dornach* – see **Darnick**.

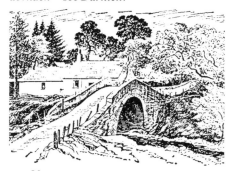

82 *The hump-back bridge at Stonyford*

Stonywell LLE NO 467 819*
As written. Croft NW of Tarfside, nr
Arsallary.

Stramile, Burn of LEN NO 553 746
Gael. *sruth mall* – tardy stream. Burn on E
side of Hill of Wirren; also Shank of
Stramile; pron. **stra <u>mile</u>**.

Stranoketie EZL NO 595 703*
Gael. *srath na coillteach* – strath of the
wood. Former landholding nr Dunbog in

Glen Esk; pron. **stra <u>nok</u> etty**; not on OS maps.

This appears to be the only occurrence in the Angus glens of the familiar element *srath* or *strath*. The area is of course bounded by Strathmore ('the great strath') on the south; and in the 18th century the valley containing the Den of Ogil was apparently known as Strathbeg (the 'little strath'). 'Strathisla' (for Glen Isla) has also occurred.

Stripe of Glack LLE NO 547 834
Scots as written – streamlet of the hollow. Trib. of Burn of Turret, Glen Esk.

Strone COC NO 423 602
Gael. *sron* – nose (i.e. nose-like contour or protuberance); farm nr Inverquharity.

Strone Hill LIN NO 294 566
Gael. *sron* – nose (i.e. nose-like protuberance). Hill (*c*1000 ft) 1 mile N of Lintrathen Loch. A group of boulders on the summit, arranged in the form of a cross (and known as the Abbot's Cross) marks the boundary of the Arbroath Abbey lands. Also Shank of Strone to south.

Strone, Hill of COC NO 289 670
Gael. *sron* – [hill of] nose (i.e. nose-like protuberance). Hill (1875 ft) 1 mile south of Glenprosen Lodge.

Strone, The COC NO 273 785
Rock spur on N side of Cairn Broadlands, upper Glen Clova; Gael. *sron* – nose (i.e. nose-like protuberance). Site of an eagle's eyrie in days gone past.

Strypeside LLE NO 48 82*
Scots as written – 'by the side of the streamlet'. Deserted croft nr Baillies; appears in Ainslie's map of 1794.

Sturdy Hill EZL NO 593 780
Gael. *stuird* – dizziness, a disease of sheep. Hill N of Edzell whose summit (1784 ft) marks the boundary with Kincardineshire.

Sturt GLI NO 236 638*
Prob. Scots, as written – trouble, strife. Former cottage S of Glenmarkie Lodge, marked on map simply as 'ruin'. But see *Sturdy Hill* above.

Stylemouth LLE NO 465 798*
Gael. *steall* – [mouth of the] spout or torrent. Site of croft on Hill of Rowan, Glen Esk. Ainslie has 'Stylemon': and cf. *Stile Burn*.

Taidy Burn LEN NO 553 692*
Gael. *taitidh* – 'peeping [stream]' – compare Scots 'teetie-bo'; name poss. refers to a disappearing stream. Beside Bogton, W of Edzell. See p.72.

Tamhilt LEN NO 486 714
Gael. *tom shuillt* – knoll of the fat (sc. 'good grazing'). Hill (1759 ft) above Burn of Calletar. Pron. **tam <u>hilt</u>**.

Tammytessny see **Tom Tessny**

Tannadice TAN NO 475 582
Gael. *tamhnach deas* – 'fertile field of the south'. Name of parish and of hamlet; pron. with stress on **tan**. In 1242 there is a reference to a 'Kirk of Tanatheys'. See p.72.

Tampie LLE NO 496 868
Prob. Scots *tumpie* – rounded knoll or mound. Hill (1825 ft) 4 miles N of Glentennet; Pron. **tam py**.

Tarabuckle COC NO 352 675
Gael. *tor a' bhuachaille* – knoll of the herdsman. Croft in Glen Clova, 8 miles N of Dykehead. Sometimes written, and always pronounced, **Tarry buckle**.

Tarapetmile GLI NO 299 638
Poss. Gael. *teamhradh* (or *torr*) *peit milidh* – 'isolated hill of the warrior's place'. Hill (1695 ft) in Glen Uig. Pron. **tar a pet mile**. A highly conjectural etymology – cf. Tara and Carmyllie.

Tarf, Water of LLE NO 493 791
Gael. *tarbh* – bull [stream]; trib. of N Esk;
also **Tarfside**, NO 492 798, the only village
in Glen Esk. See p.73.

Tarmach Cairn COC NO 225 713
Gael. *tarmachan carn* – stony hill of
ptarmigan. Hill (*c*2500 ft) in upper Glen
Prosen.

Tarryhead LEN NO 50 65*
Prob. Gael. *torr* – hill [head]. Deserted
settlement above Paphrie Burn. Appears on
Ainslie's map, but not on OS maps.

Tarsney, Burn of LEN NO 488 735*
Gael. *tarsuinn* – cross or athwart [stream].
Trib. of West Water.

Tarson, Burn of LLE NO 407 696*
Gael. *tarsuinn* – oblique or traverse stream.
Trib. of Burn of Inchgrundle, Glenlee.

Tigerton MEN NO 538 644
Thought to be Gael. *an t-sagairt* – priest's
'toun'. Cottage and smiddy nr Kirkton of
Menmuir. See p.73.

Tilliebirnie LEN NO 512 664
Poss. Gael. *tulach baornaigh* – knoll of the
soggy place. Farm 3 miles NW of Kirkton
of Menmuir. See **Nathro**, and p.73.

83 *Tilliebirnie, a farm in Menmuir*

Tillyarblet LEN NO 521 671
Gael. *tulach (muc) earballach* – knoll of
the pig's tail. Farm 2 miles N of Hill of
Menmuir; Pron. **tilly <u>arb</u> let**; see p.74.

Tillybardine LEN NO 487 733
Gael. *tulach bearnais* – gap-hillock. Farm
in Glen Lethnot, formerly known as (and
pron.) **Tillybairns**. Also Burn of
Tillybardine; see p.74.

Tillybuckle LLE NO 482 786*
Gael. *tulach buachaille* – herdsman's knoll.
Croft in Glen Esk, 2 miles SW of Tarfside.

Tillybuckle Hillock LEN NO 493 736*
Gael. *tulach buachaille* – herdsman's knoll;
hill in Glen Lethnot nr Tillybardine.
(Ainslie has 'Tarrybuckle').

Tillycoulter LLE NO 472 826*
Gael. *tulaich coltair* – coulter-hill. Lonely
croft on Easter Burn, Glen Mark. Pron. **tilly
<u>coot</u> er**. Cf. Tillicoultry.

A coulter is the iron blade in front of a plough;
prob. the reference is to zig-zag paths.

Tillydovie LEN NO 557 694
Gael. *tulach duibhe* – knoll of blackness.
Farm 2 miles NE of Bridgend, Lethnot.
Early forms are Tullidiffy (1511),
Tullidovy (1544) and Tulliedowie (1638).

Tillyoran LLE NO 517 770*
Gael. *tulaich odharain* – cow-parsnip or
hogweed knoll. Site of croft on Burn of
Keenie, Glen Esk. Pron. **tilly <u>oar</u> an**;
appears in Ainslie's map (1794) as
'Tillyoaram'.

Tillywhillie LEN NO 51 70*
Gael. *tulaich chulaibh* – back-lying knoll.
Former croft beside West Water.

'Tulyquhilly' (1462) and 'Tuliquhuly' (1463), are
two of the early forms – both rather clumsy
transliterations of a straightforward Gaelic
construction. Although the exact site of the croft
cannot be determined, it must have been on the
sunless north-facing slope of the West Water
valley, and it has been contrasted with **Finnoch**
(which means 'bright place').

Tirlybirly LLE NO 486 789*
Said to be Gael. *tulach beurla* – knoll of
the [English] speech. Croft in Glen Esk, 2
miles SW of Tarfside. An alternative
etymology might be Scots *tirliewhirlie*, a
nick-nack.

Toardy Hill TAN NO 422 682
?Gael. *toll ardach* – ?'hole-point' hill, sc.
hill full of holes. Hill (1935 ft) between
Glen Clova and Glen Ogil (also Toardy
Burn). Compare Toward, Argyll, a 'holey'
place on magnesium limestone.

Tobar a Chinn GLI NO 179620
Gael. as written – well of the head. Well on
the S slope of Mount Blair. Pron. **tober a
kin**; also written 'Tobar na ceann'. The
alleged site of a legendary battle between
Picts and Scots in the 9th century.

Tod Craig LLE NO 437 796*
Scots as written – fox hill. Hill above Loch
Lee.

Tod Grain LLE NO 328 796
Scots as written – streamlet of the fox (or
perhaps 'sly, slinky, foxy stream').
Tributary of Water of Mark.

Tod Hillock LLE NO 487 818
Scots as written – fox hill. Knoll above
Water of Tarf.

Todhills Wood COC NO 385 613*
Scots as written – fox hills wood.
Woodland 1 mile N of Dykehead.

Todholes LIN NO 253 606
Todholes EZL NO 585 722*
Scots as written – fox-holes. The first was
a croft flooded by Backwater dam,
Lintrathen, the second a croft in Edzell.

Todholes Wood COC NO 385 614
Scots as written – fox-holes wood.
Plantation N of Dykehead.

Todstone COC NO 308 631*
Scots as written – fox stone. Boulder on
hillside on S side of Glen Uig.

Tolmount COC NO 210 800
Gael. *dol monadh* – 'high moorland of the
Doll' (see **Glendoll**). Hill (3143 ft)
marking W boundary of Angus, and near to
an ancient Mounth pass.

Tom Buidhe GLI/COC NO 214 787
Gael. as written – yellow hill. Round-
topped hill (3140 ft) N of Canness Glen.
Pron. **tom boo yu**. Prob. so called because
the grasses turn yellow when the snow
melts.

Tom Darroch EZL NO 568 793
Gael. *tom darach* – knoll of oaks. Hill
(1157 ft) half way up Glenesk; devoid of
oaks in modern times.

Tom Dubh na Cabair GLI NO 212 742
Gael. as written – black knoll of the
antlers. Hill between Glen Isla and Glen
Doll.

Tom Mhoraire GLI NO 19 74*
Gael. *tom morair* – knoll of the (?law) lord.
Small hill in vicinity of Bessie's Cairn,
Caenlochan; pron. **tom more ar**. There is
also a 'King's Seat' nearby, but neither
name has any known history.

Tom Tessney LEN NO 528 686
Gael. *tom an-t Sassanaich* – knoll of the
Lowlander or Englishman. Hillock between
Craigendowie and Bridgend, prob. a stance
for drovers. Also pron. and written **Tammy
tess ney**. Compare 'Englishman's Hillock',
Menmuir, and **Dalhastnie**.

Tom Titlach LEN NO 384 761
Gael. *tom tuilteach* – knoll of torrents.
Little hill at source of Water of Saughs.
Compare **Watery Knowes** between Clova
and Lee.

Tombay LIN NO 288 604
Gael. *tom beith* – birch knoll. Hill (1190 ft)
in Glen Quharity. Pron. **tom bay**.

Tombeth COC NO 313 673
Gael. *tom beith* – birch knoll. Cottage nr
Balnaboth, Glen Prosen. Pron. **tom beth**.

Tomnun LIN NO 272 642
Gael. *tom ?nuin* – knoll of the ?ash-tree.
Low wooded hill between Glens Isla and
Prosen. Pron. **tom nun**.

Took's Burn COC NO 438 633
As written – may refer to person unknown;
or poss. Gael. *tuirc* (a boar). Burn
(?artificial cut) nr Glenogil reservoir; also
Took's Wood.

Tornafemyre TAN NO 44 62*
Gael. *tor na ?feith* – mound ?on the wet
moor. Habitation shown by Pont in Glen
Ogil, not on OS maps. Pron. **tor na fay
mire**.

Torr Breac LLE NO 485 821
Gael. *tor breac* – speckled knoll. Small hill
nr Water of Tarf. Pron. **tor breck**;
companion to Torr Duff.

Torr Duff LLE NO 485 823
Gael. *tor dubh* – black knoll. Small hill nr
Water of Tarf; companion to Torr Breac.

Torr na Menach EZL NO 535 763*
Gael. *tor na h-iomainaich* – hillock of
cattle-driving. Small hill above Burn of
Beg, Glen Esk.

Torr Tempen LLE NO 483 817
Gael. *tor tiompan* – drum-like knoll (sc.
round and one-sided). Knoll nr Water of
Tarf. Pron. **temp en**.

Torrantipper EZL NO 574 735*
Gael. *tor an tiobair* – hillock of the well.
Covered reservoir on W side of Glen Esk.
Pron. with stress on **tip**; corresponds to
Nettle Well.

Torrax LIN NO 271 558
Gael. *torraich* – place of torrs or lumps.
Farm 2 miles NW of Bridgend of
Lintrathen, now part of land of Lintrathen
water-supply; also Torrax Wood.

Torrnacloch EZL NO 588 719*
Gael. *tor na cloiche* – hillock of the
boulders. Croft on W side of Glen Esk.
Pron. **tor na cloch**. Name refers to an old
stone-circle, now removed.

Torrnaflossie EZL NO 597 777
Gael. *torr nam fal losgaidh* – knoll of the
burning-turf (a local peat-source). Little
hill N of Edzell village; pron. **torny flossy**.
The old name was Tornyflosky, but now
commonly known as 'Peat Sheds').

Torrnamuck EZL NO 58 71*
Gael. *tor na muic* – hill (lit. 'heap') of the
swine. Croft 2 miles W of The Burn, Glen
Esk.

Townhead LLE NO 497 799*
Townhead LEN NO 541 687*
As written – 'top-end of the homestead'.
(1) croft nr Tarfside, Lochlee, site of a
former whisky bothy; (2) cottage at
Bridgend (see ***Argeith***).

Troopers Haugh GLI NO 19 74*
Scots as written – cavalry meadow. Open
ground in upper Glen Isla, nr Bessie's
Cairn. Name unexplained.

Trusta FER NO 483 652
Gael. *?trasda* – cross/athwart [place].
Croft 5 miles W of Kirkton of Menmuir;
also nearby Craig of Trusta.

Tulchan GLI NO 187 723
Gael. *tulachan* – little knoll. Airlies'
shooting lodge at head of Glen Isla. See
p.74.

Tullo Farm MEN NO 535 660
Gael. *tulach* – knoll, rounded hill. Farm 1
mile NW of White Caterthun, Lethnot.

84 *The Airlie memorial, Tulloch Hill*

Tullo Hill FER NO 496 646
Gael. *tulach* – rounded hill. Knoll 3 miles W of Kirkton of Menmuir; also written Tulla, Tulloch.

Tulloch GLI NO 219 630
Gael. *tulach* – knoll, rounded hill. Croft, 3 miles N of Kirkton.

Tulloch Hill COC NO 373 614
Gael. *tulach* – knoll, rounded hill, 1 mile NW of Dykehead, Glen Clova, (locally 'Tullo'). Site of Airlie Monument, a tower built in memory of the 9th earl, who fell in action at Diamond Hill nr Pretoria in 1900.

Tullummallochy COC NO 75 28*
Gael. *tulach ?malaichean* – knoll of the eyebrows (sc. grassy edges). Pron. **tully mall ochy**. Said to have been nr Braedownie, but impossible to locate nowadays.

Turf Hill LEN NO 484 744
Turf Hill KGM NO 354 616
As written. (1) hill above Priest's Road in Lethnot; (2) hill at Pearsie. Turf in Scots means surface peat, so names prob. apply to parts of moorland where peats were cut.

Turfachie TAN NO 417 585
Gael. *torr ?faich* – ?meadow hillock. Farm 1 mile NE of Inverquharity. Pron. **tur fech ie**; also written 'Turfechie'.

Turnabrain LLE NO 502 787
Gael. *torran a' bhraoin* – mound of the dribble (streamlet). Farm in Glen Esk, 1 mile SE of Tarfside; pron. **turn a brain**. Also East Turnabrain. Early forms were 'Cornavrane' (1511) and 'Turnabrane' (1588).

Turnygob LLE NO 46 79*
Gael. *tor nan caob* – mound of the lump or turf. Site of croft on old Rowan road, shown on Ainslie map of 1794, and also written 'Turny gub'. Pron. **turny gob**; cf. *Monagob*.

Turret, Burn of EZL/LEN NO 540 790
Gael. *turthaid* – little dry burn (sc. subject to shrinkage), marking boundary between the parishes of Lochlee and Edzell. Gives name to Hill of Turret, NO 553 813, nr Mount Battock, where it has its source. (1239 'Turrathd'.)

Unich, Water of LLE NO 394 803
Gael. *?uinich* – bustling, hurrying stream; the ultimate source of River N Esk. (Moll and Edward both have 'Wnch'); also Falls of Unich.

Vayne FER NO 494 601
Poss. Gael. *ban* (qualifying a lost noun) – ?white, fair. Farm and ruined castle on Noran Water. See p.74.

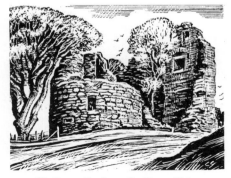

85 *Vayne Castle on the Noran Water*

Waggles EZL NO 573 769
Gael. *na h-uamhagan* – 'the hollows'.
Croft in lower Glen Esk; also Burn of
Waggles. An English plural 's' has crept
into this odd name. The reference is to the
Hole of Greenburn and Upper Hole.

Wardend LIN NO 304 548
Scots as written – end of the pasture. Farm
2 miles E of Bridgend of Lintrathen; pron.
ward <u>end</u>.

The Scots term ward, in a place-name context,
means an enclosed piece of land or a meadow. This
farm was recorded in 1234 simply as 'Ward', and
in 1465 as 'Ward in Glenyleff'. In 1745 it was
farmed by a Jacobite named Thomson.

Watchen Knowe COC NO 280 690*
Scots as written – watch(ing) hill. Knoll 1
mile NW of Glenprosen Lodge.

Waterhead LEN NO 465 715
As written – head of the water (West
Water). Farm in Glen Lethnot.
The farm gets its name from its situation at
the point where the Water of Saughs
changes its name to the West Water (itself
something of an oddity). Also curious is the
non-Scottish appearance of the name – but
apparently the place was formerly called by
the Gaelic name of ***Makindab***.

Watery Knowe, Easter & Wester
LLE NO 359 719
Scots as written – wet hill, i.e. source of a
large number of burns. Hills (*c*2400 ft)
between Glen Clova and Glen Lee.

Wathead TAN NO 43 67*
Scots as written – wet headland. Former
habitation in Glen Ogil, across Noran
Water from Shiels of W Ogil.

Wellbank TAN NO 408 597
As written – slope with a well or spring (a
common settlement name). Farm 1 mile E
of Cortachy; pron. **well <u>bank</u>**.

Wellford EZL NO 567 770
As written – ruined croft, part of a line of
smallholdings in lower Glen Esk. Not on
OS map.

Wellsden MEN NO 568 658
Scots as written. Den or cleft, acting as a
water-source. Farm NW of Menmuir. Pron.
wells <u>den</u>; cf. nearby Wells Den.

Welton, The KGM NO 307 558
Scots as written – farmstead of the well or
spring. Farm 2 miles NE of Bridgend of
Lintrathen. Also Welton Hill. The name
occurs in this form in 1440, and poss.
refers to St Peter's Well.

West Bank LLE NO 465 802
As written. Farm on S slope of Cairn
Robie, on line of former road from Edzell
to Loch Lee and track from Brechin to
Ballater. There was a communal peat-bank
here at Cock's Hillocks, which may
account for the name.

West Corrie LEN NO 464 728
West Corrie COC NO 255 785
Scots from Gael. *coire* (hanging valley).
(1) corrie on Broom Craig, Lethnot; (2)
corrie on Craig Mellon.

West Craig LEN NO 437 735*
Scots as written – west rocky hill, above
Water of Saughs.

West Mill of Glenisla GLI NO 195 632
As written (appears on OS maps as 'The
Mill'). See also ***Isla***, p.55.

West Water LEN NO 615 665
Main tributary of N Esk, which it joins at
Edzell. See p.74.

Westerton LIN NO 84 595
Scots *wester toun* – west farmstead. Farm 5
miles N of Bridgend and W of Balintore.

Westside LEN NO 50 70*
As written, former croft on west side of
Glen Lethnot, S of Stonyford. See p.75.

Wheen COC NO 362 710
Complicated source and meaning – see
p.75. Sheep farm in Glen Clova; also Burn
of Wheen and Wheen Cottage (now known
as *Adielinn*).

Whigginton LLE NO 485 786*
Said to be Gael. *a' chuing ain* + Scots *toun*
-[farmstead] of the narrow part or share.
Ruined croft in Glen Esk, SW of Tarfside;
cf. Whigstreet (*a' chuing sreath*).

Whisky Road – see under **Priest's Road**
and p.75.

White Bents COC NO 309 761
Scots as written – moor covered with
coarse white grass (i.e. a hill grazing). Hill
(2776 ft) on N side of Glen Clova (does not
appear on earlier OS maps).

White Brae GLI NO 174 773
Scots as written – 'bare upland'. N
shoulder of Glas Maol – an accurate
description of the terrain.

White Burn TAN NO 422 586
White Burn LLE NO 544 827
Scots as written. (1) tributary of S Esk,
which also gives name of Whiteburn Farm
at Tannadice, NO 422 603; (2) tributary of
Burn of Turret, Lochlee.

White Craig GLI NO 220 751
Scots as written – white rocky hill. Hill
between Glen Isla and Glen Doll.

White Glen COC NO 235 715
Scots as written – bare, stony glen; narrow
valley at head of Glen Prosen; prob. a
modern, local usage.

White Hill COC NO 402 731
White Hill COC NO 367 753
(1) hill NE of Rottal; (2) hill nr Craigs of
Loch Wharral, both in Glen Clova. 'White'
in this context usually refers to a bare,
stony hill.

White Strone GLI NO 192 733
Scots (fr. Gael. *sron*) – white nose-shaped
hill. Small hill in upper glen. Also Mid
Strone.

White Top TAN NO 431 606
As written – small hill above Den of Ogil
Reservoir. (The adjective 'white' refers to
vegetation or geology, not snow.)

White Water COC NO 286 757
As written; stream that drains Glen Doll.
Moll (1725) has 'Whith Water'.

Whitehaugh LIN NO 254 593
Whitehaugh LLE NO 544 827*
Scots as written – white meadow. (1) croft
flooded by Backwater dam, Lintrathen; (2)
field nr Allrey, Lochlee.

Whitehillocks COC NO 369 672
Whitehillocks LLE NO 453 797
(1) farm in Glen Clova, formerly known as
Fichell; (2) farm in Glen Esk and a nearby
filter station for Loch Lee reservoir.

Whitehills GLI NO 226 595
Farm 2 miles W of Backwater dam.

Whitesheal GLI NO 225 566
Scots as written – white shieling. Croft
north of Hill of Kilry, Glenisla (poss. a
modern name).

White's Pool LLE NO 395 834
Rocky pool in Water of Mark – see p.75.

Whitestane Burn LEN NO 435 714*
Scots as written – white stone stream.
Tributary of Burn of Corscarie.

Whiteston LLE NO 47 80*
Scots as written – prob. White's toun. Croft
nr Kirny Burn, belonging to a person of
that name.

Whitestone, Lair of COC NO 313 764
Scots as written – fold or enclosure of
Whitestone. Feature of unnamed hill (2829
ft) on N side of Glen Clova; also Latch
(bog-stream) of Whitestone.

Whups Craig EZL NO 548 797
Scots as written – whelp or puppy-dog's
hill. Rocky hill (968 ft), in Glen Esk, 1
mile N of Millden (not identified in recent
OS maps).

Winnochs, The COC NO 30 78*
Scots *winnocks* – windows. Features (not
identified) on plateau E of Capel Mounth.

Winter Corrie COC NO 280 745
As written; Winter is a surname and corrie
(fr. Gael. *coire*) a high valley. Corrie 1 mile
SE of Braedownie, Glen Clova. The name
is modern, the corrie having been named
after John Winter, a local stalker.

Wirren, Hill of
LEN/EZL/LLE NO 523 739
Prob. Gael. *fhuaran* (but see p.76) – 'hill of
springs'.

Witches How COC NO 331 724*
Scots as written – witches' hollow. Low
ground at Caddam, Clova Village.

The nearby Witches' Knowe was said to be the
spot where in July 1662 the last witch in the glen
was burnt; her name was Margret Adamsone, her
specific misdemeanours unrecorded.

Witter, The COC/GLI NO 21 78*
Scots *witter* – signpost, marker, trig-point.
Undefined area straddling Angus-Mar march.
See p.76.

Witton LEN NO 564 702
Prob. Scots *wid toun* – woodland farm.
Hill-farm 4 miles W of Edzell. (Derivation
is poss. 'white toun', but colour is seldom
used in farm-names.)

Wolf Craig LLE NO 381 825
Scots as written – hill (2343 ft) between
Glen Lee and Glen Mark.

Wolf Hill COC NO 332 778
As written – hill (2703 ft) 5 miles N of
Clova village. (No known history of
wolves hereabouts.)

Woodend GLI NO 189 631*
As written; croft in Glen Isla, 2 miles N of
Brewlands Bridge; one-time home of
Johnnie Coutts, Jacobite and cateran.

Woodhaugh LLE NO 489 789
Scots as written – woodland water-
meadow. Farm 1 mile S of Tarfside in Glen
Esk. Pron. **wood hauch**, as in loch.

Woodside EZL NO 577 668
As written – [dwelling] beside a wood;
farm 3 miles SW of Edzell.

Yellowfaulds Wood COC NO 336 625*
Scots as written – [wood of the] yellow
field, or pen for yellow (dipped) sheep.
Wood nr Lednathie, Prosen.

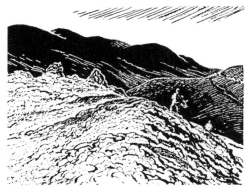

86 *The Wirren, from Caterthun rampart*

Tailpiece

This book contains several thousand items of information on names, places and people relating to the glens of Angus. It is inevitable that many of these items will be incomplete and several of them perhaps erroneous. Since the compilation of a database on the place-names of the area is an ongoing – not to say never-ending – process, the author would welcome additional information and comments from readers. The glens still have facts to be uncovered and secrets to be disclosed. Local knowledge is vanishing with greater rapidity than the melting of the icecap, and there is urgency in preserving our history and folklore before it is too late.

The Pinkfoot Press
Balgavies, Forfar, Angus DD8 2TH, Scotland